THE
FINE ARTS IN
AMERICA

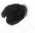

The Chicago History of American Civilization

Daniel J. Boorstin, Editor

Peggy Bacon, *Frenzied Effort* (or) *Whitney Studio*
Club, 1925. Courtesy of the Weyhe Gallery,
New York, New York.

THE
FINE ARTS IN
AMERICA

Joshua C. Taylor

The University of Chicago Press

Chicago and London

The University of Chicago Press, Chicago 60637
The University of Chicago Press, Ltd., London

Printed in the United States of America
83 82 81 80 79 54321

Library of Congress Cataloging in Publication Data

Taylor, Joshua Charles, 1917–
 The fine arts in America.

 (The Chicago history of American civilization)
 Bibliography: p.
 Includes index.
 1. Art—United States. 2. Art—American.
I. Title. II. Series.
N6505.T373 709'.73 78-23643
ISBN 0-226-79150-5

JOSHUA C. TAYLOR is director of the National Collection of Fine Arts
at the Smithsonian Institution. His many publications include *America
as Art, To See Is to Think,* and *Learning to Look,* the last also published
by the University of Chicago Press.

Contents

1900-1945

151

Since 1945

205

Series Editor's Preface

Today the United States is one of the world's great centers for the fine arts. Yet only a century and a half ago a snide English critic could indict this country by the mere question, "Who looks at an American picture or statue?" The rise of American civilization has seen the nation transformed from a colony, a remote and insecure outpost of European cultures, into a nursery and a refuge of artists, an exporter of works of art, a dynamic influence on the artists of the world, and a refresher of the vision of art lovers. How has it happened?

In this book Joshua Taylor tells the story and offers some explanations. He has given us a short, readable, and lively history of painting, sculpture, and the graphic arts in the United States since early colonial times and has shown us how and why they flourished—or languished—on the American scene. He helps the artists tell us what they have to say about our civilization and about the fine arts. And incidentally he shows how they have shaped our very definition of culture.

The fine arts whose story we read here have been a neglected touchstone of our history. A cliché, which has reinforced our American limitations and substantiated foreign prejudices, is that we are primarily and preeminently a "practical" people. But the dictionary tells us that the fine arts are "produced or intended primarily for beauty alone rather than utility." At the same time specialist-historians have tended to chronicle the fine arts as the impersonal product of movements rather than as the lifework of artists. They have been inclined, then, to treat the fine arts in America as a backwater, populated by minor figures imitating the work of the European masters who made the movements.

Joshua Taylor might have called his book *The Fine*

Artists in America, for he shows us how a large and varied cast of artist-characters responded to American opportunities for new visions and for giving new shapes to old forms. Of course this is a history of art in one country. But Taylor reminds us that what distinguished an artist in the United States was how he used (or neglected) the traditions and resources of the whole world of art. We see that in art, as in so much of the rest of our civilization, what made us American was how we brought together the currents of the world. The community of artists—in its inspiration, its motives, and its motifs—is peculiarly international. All this helps us understand how Joshua Taylor can confidently describe American artists without pigeonholing American art.

Taylor captures deftly and concisely the unique achievement, the powers, and the limitations of each artist. Through them we can see what the American experience adds to our understanding of the artists' quest—and how their work has enriched people everywhere who want to enjoy the fine arts.

By setting the fine arts in the mainstream of our civilization, this book admirably serves the purpose of the Chicago History of American Civilization, which aims to make every aspect of our past a window to all our history.

DANIEL J. BOORSTIN

Author's Preface

There are many advantages to treating the art of a single country, concentrating on its particular struggles and moments of triumph. Art so considered can be seen in close association with its public and with its local sources; it can be encountered at home. With a bit of care one can thus avoid the abstract history of art by styles, so favored by historians earlier in this century, a method that rarely penetrates the realm of content and that makes art seem self-contained and self-perpetuating, with only tangential human contact. For the inhabitants of the country whose art is being considered, it also has the advantage of treating material that relates directly or indirectly to the area where they live—to what they see around them, what they do, what they remember—and leads them to reflect on values that have gone into the making of their own society. Even if history hands down a somewhat negative report on local achievement, there is significance to be found in a study of efforts made and in the goals themselves, for aspirations are a living part of culture. A frank look at one's own artistic past and present can only be helpful, and when it turns up unexpected and rewarding insights that well might be bypassed in treating history as a sequence of general, international movements, one begins to doubt the truth of history without people—specific people.

There are also dangers. As soon as the term "American art" appears in the heading, many temptations arise. One of the most perilous is the desire to isolate what is American in American art, to isolate and synthesize cultural characteristics as though a succinct definition makes things what they are. Art has often been used for nationalistic purposes, in the United States and elsewhere, and theorists have sometimes marshaled

their evidence as if they were arming an aesthetic warrior to defend the nation's honor on the field of international artistic values. Out of a definition an unspoken scheme of values often emerges: the work of one artist is referred to as "more American" or "less American" than that of another: always the artist who best fits the national stereotype becomes the popular hero—though at the same time another critic might use the same criterion as a mode of disparagement. Consequently, for the nationally oriented mind "European influence" becomes a subtle opponent, a force luring the artist away from his true national character. Moreover, in this conflict the idea of what is European is frequently based on even less information than the idea of what is American, often consisting of tired generalizations about the work of a handful of artists acknowledged as both "national" and "great."

Such a procedure hardly deserves to be called history—national mythmaking might be a better term. Such myths have had their historical function and should be studied as part of the cultural complexity, but one should be wary of accepting one's own myths as the structure, rather than the material, of history.

Of course it is possible to distinguish the works of many American artists from those of artists in other countries, but not because of any collection of isolated traits. On one occasion the difference might be an obsession with the material world that makes acceptance of the ideal in art unlikely; at another time it might be a longing for the past and for romantic associations that causes the artist to resist an art based on direct observation. Art in the United States, as elsewhere, has had its pattern of change and development, and though many writers have tried to prove the contrary, the pattern here has rarely coincided exactly with those discernible in other countries. To see the development of American patterns alongside those of Europe is to understand what at any one moment is characteristic of America. To try to distill an essence out of this changing past, with its shifting pattern of relationships, is to lose, not gain, an understanding of the national character, which, regardless of protestations of unity, remains complex.

The first person who set out to do something about the fact that art in the United States had a history was

the elderly William Dunlap. He had studied painting in England with Benjamin West, had trouped his large religious paintings about the country in the 1820s, and had involved himself in almost every aspect of theater in America and become its chronicler. In the early 1830s he began to gather information on American artists for a history that would record their struggles and their achievements. Dunlap's *Rise and Progress of the Arts of Design in the United States* was published in New York in 1834. In spite of the title, the volumes do not trace the systematic progress toward a predetermined goal as a stylistic development. Unlike his Renaissance prototype Vasari, Dunlap did not believe he was standing on a cultural summit, though he was justly proud of the expansion of art he had witnessed in his own lifetime. His book gathered together the past to serve as a foundation for what he saw as a creative future. It called the attention of public and artists alike to the magnitude and importance art had attained in America, and so enhanced art's respectability. His study itself became an important element in the history of art in America.

Like Dunlap, Henry T. Tuckerman, in his *Artist-Life, or, Sketches of Eminent American Painters* (1847) and his later *Book of the Artists: American Artist Life* (1867), concentrated on the individual artist, though Tuckerman felt much freer to comment on trends and goals and could picture the life of the artist in more optimistic terms. His books had a promotional air. No one now doubted the importance of art, but Tuckerman wanted to broaden its popular base. Only toward the end of the century was there an effort to see art in America as a loose but persistent continuity, brought together according to nineteenth-century concepts of history. A major prompting came in 1876 with the celebration of the centennial of the American Revolution. The art galleries of the great exposition in Philadelphia presented not only a cross section of contemporary art, both European and American, but a selection of American artistic achievements from the past, boasting for the first time of a local artistic paternity. In 1879 S. G. W. Benjamin's *Our American Artists* and in 1880 his *Art in America: A Critical and Historical Sketch,* indicated a trend toward assessing the accomplishments of art in America on more general, national terms. Finally, with Sadakichi

Hartmann's *History of American Art* in 1902, Lorado Taft's *History of American Sculpture* in 1903, and Samuel Isham's *History of American Painting* in 1905 (brought up to date in 1927 by Royal Cortissoz), something like comprehensive histories were made available and came to be considered worthwhile and even necessary. Unlike Dunlap three-quarters of a century before, Isham could talk about styles and schools and tendencies: American art had gained its place in the critical language of the day.

In the 1920s theoretical considerations of American art became popular, and since the 1930s studies in American art of every sort, in recent years including careful archival research, have expanded enormously. It is as if the international acceptance of American art after World War II made its whole history worthy of exploration.

This book does not set out to create new patterns, though it pointedly fails to honor some existing ones. My aim has been to trace the course of painting, sculpture, and, to a lesser extent, the graphic arts in America as they have entwined themselves in the broader cultural activities of the country. The book hints at more than it discusses, in the hope that it might provide an entrance to many realms of further investigation. It is not so much a history as a sketch for a history, and like any good sketch it tries to formulate that which is basic rather than lose itself in detail. For those looking for endless lists of names and events it is bound to be a disappointment. In the past few years profusely illustrated texts and catalogs on individual artists and circumscribed periods or movements in American art have been published with increasing frequency. The amount of material now available makes a single compendium almost meaningless. Each artist and each realm of artistic exploration deserves a separate history. The choice, then, now lies between the sketch, with its consideration of basic ideas and structure, and the infinite detail and particularities of the parts. Although the two must always maintain a healthy relationship, there is no longer a place in history for a "finished" picture.

The numerous marginal illustrations throughout the text are meant as points of reference, not as substitutes for looking at original works of art. Some are well-

known examples, widely reproduced elsewhere, but many are not those of the standard repertory. Sometimes a work less frequently seen jogs the mind to a fresh consideration of the artist. Almost all, however, are in public collections where they can be seen, or from which one can at least obtain slides and reproductions.

As the foregoing discussion suggests, the "fine arts" of the title do not here include music, dance, theater, or architecture. The book considers the life and times in the United States of sculpture, painting, some of the graphic arts, and their associated institutions. The various arts, though related, have followed different courses and have depended for the most part on different contexts in their search for support and acceptance within the fabric of American society. An analysis of their differences might provide material for fruitful separate study.

I should like to thank Richard N. Murray for his help in checking innumerable details in the text, Rachel M. Allen for assembling the photographs, and Alison H. Fenn for translating my handwriting into a readable manuscript. I am grateful also to the many institutions who have given permission to reproduce works from their collections.

Introduction

The term "America" is used in this book in the curious way in which it has been employed since at some point in the eighteenth century it came to mean the cultural and geographic entity first formed by the predominantly English colonies on the eastern seaboard and eventually occupying the entire central portion of North America. By what quirk of history or nationalistic myopia such a term was accepted—effectively ignoring Canada and Mexico, to say nothing of the countries of Central and South America—is not for discussion here. It is a fact, however, that though various parts of the present United States of America were first settled by explorers and colonists from other countries, the culture spreading from the eastern colonies eventually dominated, and it is with that culture that this book deals.

The Spanish in Florida, the Gulf area, and the vast Southwest, and the French in the area of the Great Lakes, the Mississippi, and Louisiana, did leave their mark in place names, in some architectural remains, and in local traditions, but their contributions to the fine arts entered the picture later rather than earlier. Only in the early twentieth century were traces of other cultures, including those of the native inhabitants, sought after as lost flavors by a country becoming conscious of itself.

An exception to this lack of continuity might seem to exist in the southwestern United States, which until the 1840s was part of New Spain, then part of the independent nation of Mexico. San Francisco was founded by settlers from New Spain in the auspicious year of 1776, but for more than a century mission centers had been established throughout a wide area, and they continued well into the nineteenth century. These European cultural enclaves in the Southwest varied widely in the style of work they produced, depending on the

religious orders that founded then and on the response of the native population. Especially in what is now New Mexico, the merging of imported Spanish images with local traditions created a rich flowering of building and crafts, some vestiges of which still persist. Nonetheless, the potent forms of this culture, isolated from its Spanish sources in the nineteenth century, did not enter the main course of American art until the early twentieth century. It was also principally in the early twentieth century that California and Texas began to reappraise their Spanish heritage, and much that is Spanish in the crafts and architecture of Texas and California dates only from that time. To try to trace a direct line of descent in the arts from Spanish and Mexican periods would be misleading. The major developments in art, once the area was part of the United States, belonged not to the local inheritance but to established practices "back east."

The often splendid mission churches have kept little in the way of painting and retain only sparse sculpture, and none of it seems to have had an effect on the settlers who moved into the territory from the East. Although the settlers were willing, at least temporarily, to borrow forms of building, since these were well suited to the local materials and climate, they brought along their own cultural images and tended to spurn what existed locally. No people are less inclined to emphasize the picturesque and romantic aspects of a cultural frontier than those who find themselves on it. "The West" furnished artistic content for the East; in the West the dream of art tended to be eastern.

The other area not covered in this study is the art of the native Americans. This significant body of material, from early to more recent times, represents a separate tradition. From an early period in the colonization of what is now the United States, interest was shown in Indian crafts and artifacts, but so little did the native art agree with European principles that it was given consideration only as an ethnic curiosity. Although the image of the Indian himself caught the artistic imagination, his art had to wait for appraisal unitl its impetus had been almost totally lost. Again, it was only in the early years of the twentieth century that artists sought inspiration in the native American arts and that native Americans

were encouraged, little by little, to try to recover their all but lost traditions.

Because the art we have accepted as American initially radiated from the eastern seaboard, centers of art elsewhere in the country—as they have come into being and established their own direction—have often found themselves submerged by the eastern image. Our histories of art have reinforced the attitude that art of any significance has existed only in a restricted area. But since at least the 1870s much that is vital in art has been generated elsewhere. Although from the mid-nineteeth century New York was the center of the art market, with increasing frequency it was supplied by artists from an ever-widening geographic area. To speak of regional art in the United States would be misleading, for regional roots usually turn out to be runners linked to the root structure of the East. Yet, as art has developed in the United States, local tendencies have gradually become more discernible, reflecting particular situations and the thinking of distinct groups of artists. This change is, in its way, exactly the reverse of the process in many European states. There, through the course of the nineteenth century, local diversity in art was progressively taken over by national standards. The individuality of art centers in the United States has grown through deliberate effort and is a cultural phenomenon that should not be overlooked.

Over some three hundred years American art has become increasingly complex, taking in a widening range of experiences both from local sources and from abroad. It has moved from early efforts at unity, prompted by the need to establish identity in what seemed a cultural wilderness, to a celebration of diversity, gradually leaving behind the obsessive fear that artistic differences would signify to the world a national cultural weakness. If there is a central character to American art, it is that it has come to mean more and different things to an ever-expanding public. There is no single scale by which to determine its total character or measure its values, a lack that is not without advantages. America's individual artists have contributed much both to their own society and to the worldwide range of artistic experience. They have provided a wealth of insights by which America, for all its diversity, might better know itself.

THE
FINE ARTS IN
AMERICA

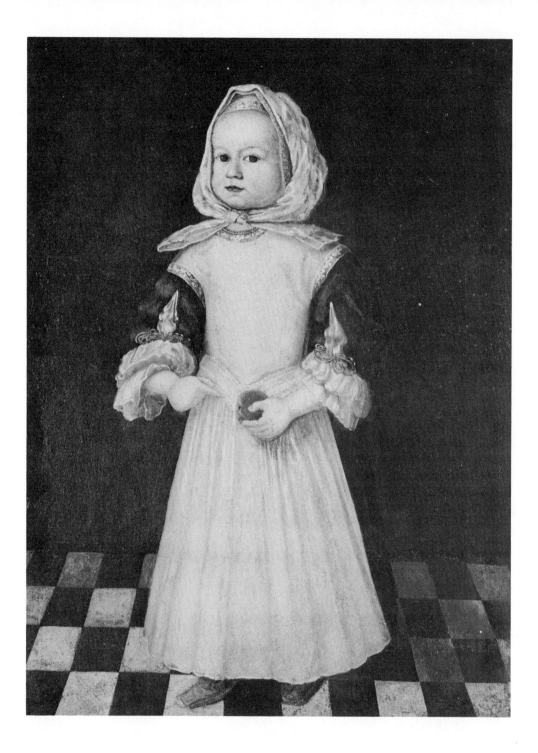

1670-1776

Beginnings

It has become something of a historical commonplace to say that for the first two centuries or so European settlers in America were too busy with practical matters to concern themselves much with the arts. Such a rationale is not a modern invention. In the eighteenth century the colonists were already using it to explain their situation, and it was repeated over and over from the Revolution onward. The formula, expounded with a good measure of self-righteousness, maintained that science, commerce, and political organization had first to meet their goals to produce the leisure necessary for a flowering of the arts. In such a rationally stated program, no one supposed that the fine arts were more than an embellishment to culture, though they were considered necessary to guide in a moral direction the leisure that was to make their creation possible.

Although it is true that the fine arts had relatively little support in those colonies that eventually became the United States, the statement has little merit as a general historical principle in defense of a lack of concern for art. In most cultures, the arts have been an integral part of the formative stages, closely interwoven with science and political development. There is no generic reason that the arts had to be pushed aside in the early stages of forming a new cultural entity in America. It should be remembered, however, that the American colonies represented not a new but a transplanted culture and could only in a very special sense be considered at a formative stage. The colonists' values were already established when they set out to take up residence in a new place,

and only gradually did they discover that they had formed an identifiable society of their own. The visual arts were left out of serious consideration not because the colonists were too busy with other things, but because the arts had not figured in any essential way in the environment from which the predominantly English colonists came and did not have much place in their life. Such attitudes toward art and life are usually laid at the door of the Puritans, and certainly Puritan precepts were hostile to many aspects of the arts. But the matter should not be dropped quite so simply. There is no evidence that those Englishmen of the same class who stayed at home and expressed no militant religious convictions were any more inclined to favor the visual arts than were those who came to America. This seems equally true for the Swedes, though possibly less so for the Dutch. In most northern countries the artist had not yet achieved significant status in the eyes of the middle class, though he might be looked upon as an asset to the court.

Much depended on the cultural image and hierarchy of values that the colonists brought with them when they set out to organize their own societies. From other colonial areas on the American continents it is evident that quite another course was possible had the colonists been so inclined. The hard-won leisure of the later eighteenth century was not the cause of a gradual artistic flowering; the arts took on a significant role in American society when attitudes changed enough to admit them into the hierarchy of values by which society judged itself. A similar change was taking place in Europe, but at a much faster pace; to some degree it was a matter of America's catching up. For the artist the struggle was long and filled with frustrations. Fine arts in a democratic society were defended in theory far before they were actually accepted. In fact, so slow was the integration of the arts into American social patterns that one would be hard pressed to determine just when the transformation took place. Possibly the long process had its justification, however, because when the arts did gain acceptance they were supported by a wider public than in many nations where their place had long been assumed. In the colonies and later in the United States the artist was not protected by special patronage but had to prove himself

as a member of the public at large. Nor was he accorded a special place in the cultural hierarchy; at best he was a craftsman serving utilitarian ends. His stature in society depended on such values as the public could accept, and he had to defend himself against the prejudices that still lingered from art's earlier association with royalty and with hierarchical religion.

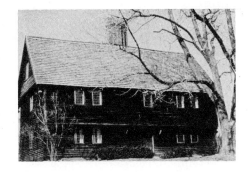

Parson Capen House, Topsfield, Massachusetts, 1683.

The history of the fine arts in the United States and their colonial antecedents is, then, a chronicle of the struggle between conflicting values—differing attitudes toward the nature of man and his ultimate goals. Possibly the struggle, insofar as it concerns the arts in America, has never been resolved and never will be. Because of the nature of the challenges, however, America has proved a conspicuous arena for the continuous public questioning and reexamination of art and its meaning not only for its own people but for mankind. Because of this, America has often seemed resistant to art. In fact, it has been obsessively preoccupied since early in the nineteenth century with assuring that the arts be publicly justified, though not publicly supported. One might debate, of course, what impact this earnestness—this unwillingness simply to accept art as a welcome ingredient of normal life—had on the directions American artists would choose to take.

Old Forms in a New Wilderness

Images are carried not only on painted canvas or in illustrated books but also, perhaps primarily, in the mind. To be sure, the mind needs help in keeping the important images alive, although sometimes only a hint is necessary—some familiar shape or a crude but aptly formed artifact. The necessary cues will depend on how the society has customarily maintained its visual identity.

Unlike the colonists from Spain and Portugal to the south, the northern colonists in the Americas had not been notably dependent on the continuous stimulus of imagery through public art. In a Spanish town, the lowliest peasant could find solace in the soul-stirring or comforting images and the luxurious ornament in his church. A part of the grandeur of the empire of Christ belonged to him. By extension, a similar grandeur was bestowed on the ruling class whose commanding portraits were the convincing symbols of impalpable but

indisputable rights. Although subject to the whims of patronage, art was not the exclusive privilege of the lord or the clergy but was the means of sharing a highly emotional image of church and state. Art in the service of religion and, by extension, the state acquired a special public value, making it both a necessity and a celebration. Moreover, by its religious and aristocratic association, art was quite naturally imbued with an ingredient of mystery—a kind of magic. The touch of art transformed the material thing into an instrument of the world of ideas and exalted values. Yet, for all this, art was a commonplace, a normal part of the environment.

It is not surprising, then, that from the early years of the conquest, in Latin areas artists and skilled artisans were an active part of the colonizing community, both clerical and secular. On the North American continent, as early as the sixteenth century, Mexico could boast of momumental religious complexes embellished with elaborate sculpture and painting, as well as palatial municipal structures. Painters, sculptors, and architects vied for commissions in the New World, and the religious orders often included talented artists and builders. Since art was so integral a part of the culture, which was at once religious and secular, it left its mark everywhere that the culture reached. Sustained by continuous contact with the artistic centers abroad through immigrant artists, art in New Spain kept pace with the change in taste in the mother country, even while establishing a character of its own. It was an actual, not a reminiscent art. Although imported, it soon dominated its environment and gave the new community a sense of established place. The political system supplied the arts with the necessary patronage as well as with a broad public. Hardly a democratic art in its concept, it nonetheless reached a wide segment of both the native and the colonial population, and the native craftsman working under the direction of artisans from abroad found himself caught up in both a new art and a new social structure.

The image the English settlers brought with them in the early seventeenth century was different indeed. Successive waves of iconoclasm in England had stripped the great medieval churches of much of their grandeur, substituting austere religious symbols for the appealing

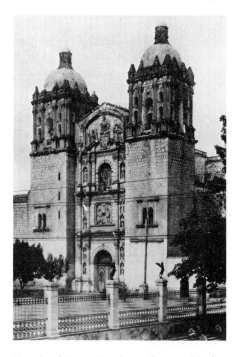

Church of Santo Domingo, Oaxaca, Mexico, sixteenth century.

emotional depictions of sacred subjects. The arts of design did indeed come under the purview of religious thought, but in a pointedly negative way: an appeal to the senses in a religious context was considered papist and was therefore to be avoided. By extension, those of strongest Protestant persuasion considered all display of sensuous exuberance to be against the tenets of true religion and thus immoral. What spoke of mystery and religion to the Spanish colonists and their conquered peoples conveyed only a sense of moral depravity to the sterner colonists who settled in what was to become the northeastern United States. By the early seventeenth century, court circles in England were toying with the Italian idea that art had transcendent capacities of its own. There was, however, little opportunity for these ideas to gain popular currency through public imagery, as they had in the Catholic countries, and in England an identity of art and the beautiful with religious and social unity had to wait a long time for even partial acceptance by the larger public.

Yet to think of art as only the visible celebration of spiritual joy or the monumental glorification of centralized institutions would be to forget another aspect of art, one dear to even the northern settlers in the New World. Quite aside from its power to enliven the present and project a glowing account of future and imaginary worlds, art has the power to retain the past, standing as a bulwark against the passage of time. This quality in art was given currency in the sixteenth and seventeenth centuries in the form of sophisticated poetic conceits, but it also had its meaning for the literal-minded members of the middle class, no matter how much they might profess to disdain the transient material world. Sometimes by only a slight hint, the work of artist or artisan can evoke a sense that the past, and all associated with it, is still present in spite of separations of time and space. Evidence of traditional crafts, for example, is a reassurance of continuity and can provide a welcome feeling of stability in an otherwise precarious world. This is not nostalgia as a reluctance to relinquish the past; it is a visual proof of living tradition, a genealogical sanction to a present act. Individual whimsy that turns its back on tradition becomes a threat to the way society regards itself and to its belief in its own legitimacy. To a society

dependent on this reassuring aspect of art, innovation is suspect and even immoral. Quite aside from purely religious connotations, the preservation of custom and technique becomes linked with the moral destiny of society. One could speak of "morally good" craftsmanship with the satisfying reflection that it was proof of a sound background and a stable future.

For the most part, the settlers in the northeastern colonies were neither patrons nor specialized artisans. In spite of the audacity that had moved them to cross the sea to establish settlements in an unknown land, they were not frontiersmen seeking the new but conservative, God-fearing men looking for a place to preserve the old. They built their settlements in the image of what they remembered, adapting the new materials to old uses as best they could with little thought of exploiting the new and unexpected properties they encountered. The simple wooden houses of New England, centering on the fieldstone hearth, were built for utility, not delight; yet whenever possible a turned newel post, reminiscent pendants on a second-story overhang or iron hardware (much of it brought from England) hinted at a form that had been left behind. Little by little houses were added to, and touches of modest luxury such as wall paneling—which also had its uses—and wainscoting became accepted as legitimate improvisations on sheer necessity. Even when the buildings were large and complex, however, there seems to have been little interest in creating them in accordance with a predetermined formal plan that would give them a monumental presence. Rather than being Renaissance scholars, devoted to unifying concepts in design or in thought, these people believed that a thing was a thing and moved with deliberation from part to part. It was the association connected with each part that mattered, not the beauty or expressiveness of the whole. Each object in a house was valued—as is evident from the inventory of objects in wills—and given special attention, whether a book, a chest, or a specially carved chair. Yet the art of creating them seems not to have been singled out for particular praise. So long as the needs of the growing population could be met, household objects were imported from abroad; specialized crafts and manufactories were slow to develop, and domestic crafts served only the simplest

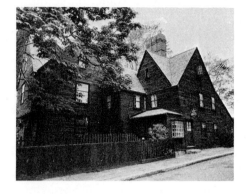

Turner House (House of the Seven Gables), Salem, Massachusetts, 1668. Photograph by Peter Zaharis.

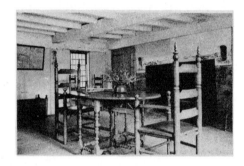

Parlor of the Parson Capen House, Topsfield, Massachusetts, late seventeenth century.

necessities. The object, not its producer, was considered worthy of esteem.

The more gentlemanly colonies farther south in Maryland and Virginia were even more persistent in recreating remembered forms. With emphasis on the country estate and the plantation, they took as their model the English country house and persisted in maintaining a sense of its style even if building materials had to be imported. These builders had a more formal notion about living and the enclosure it requires, and they constructed on a more monumental scale. Yet they too were limited in the skilled services they could command, since they could not draw on the established skills of the native population as the Spaniards had done farther south. Though importing slaves from Africa eventually eased the labor problem, it did not at once provide trained artisans. The handsome furnishings came mostly from abroad, and as long as there was a lively import trade of furniture, chinaware, household utensils, and textiles, there was little incentive for local artisans. As the population grew and prospered, craftsmen came from Europe expecting to find a ready market, but it was well into the eighteenth century before many crafts, such as furniture-making and silversmithing, could find a local base, and some, such as textiles, glass, and ceramics, did not really flourish until after the Revolution. Painting and sculpture were initially in the same situation, and the general craftsman was expected to carve tombstones, paint inn signs, or varnish furniture to supply those needs not covered by importations.

Though the Dutch in what became New York and the Swedish settlers in the Delaware Valley remembered somewhat different images, the principle was largely the same. Settling meant not so much developing the new countryside as re-creating a corner of home. The remembered craftsmanship can be seen in the way bricks were laid, the shaping of a gable, or the organization of living space. Art, even in its humble forms, was proof of tradition and stability.

By the beginning of the eighteenth century, patterns of life had stabilized and one could distinguish the distinct centers of culture that had taken form along the eastern seaboard, each having formulated its character in its own way. Local institutions had been established,

Mulberry Plantation House, 1714. Photograph courtesy of the Carolina Art Association, Gibbes Art Gallery, Charleston, South Carolina; George W. Johnson Collection.

and prosperous commerce in the North and large-scale agriculture in the South produced an affluence that provided a greater market for artist and craftsman. At the same time, taste had been undergoing a major change abroad. The greater expansiveness in English taste under Charles I and the resumption of art on a greater scale when the monarchy was restored did not escape the notice of the colonies. Furnishings and the building arts moved from recalling the past to demonstrating how current the more affluent felt themselves to be. Engravings of portraits showing the fashionable modes and books on architecture and design effectively substituted new images for those remembered.

Yet the shift to new modes did not come easily in a newly rooted society. The fashionable styles often did not at once produce a genuine change in taste but only provided new subject matter—new material to be added to the inventory of significant things. This contrast between traditional values and new perceptions in the colonies is at its clearest in the development of painting.

The Family Portrait

In an age like ours in which the multiplication of visual images is taken for granted, it is hard to conceive of a time when the very act of taking a likeness assumed momentous importance. The significance of the family portrait should not be underestimated. Often to the despair of the artist, portraiture remained the dominant branch of painting in the new country for well over a century. Throughout the eighteenth century there was little demand for the landscapes and subject pictures so popular abroad—for mythological fancies or sweeping views of nature. With few exceptions the portrait limner's art held sway. Why this preoccupation with portraiture in a society that considered itself classless and insisted on preaching life's transience?

It is worth giving a moment's thought to just why portraits are painted in the first place—what purposes they serve. The isolated individual likeness was a fairly late arrival on the modern artistic scene, with a history of only some three centuries; so it cannot be considered an inevitable aspect of art. Yet a favorite story for eighteenth-century writers on art was Pliny's account of the origin of painting. It all began, according to the tale,

when a young woman outlined her lover's shadow on the wall to preserve an image of him as he went off to war.

To preserve a likeness has, however, more than sentimental meaning; it is a way of testifying to existence, of establishing permanent benchmarks in a fleeting current of time. For the newly established families, and those cut off from their roots in Europe, this ritual was of particular importance. Who had their portraits painted? Traditionally, portraits had been largely the prerogative of royalty or the landed nobility, whose lineage was of political moment. The succession of kings or the persistence of title was duly noted by the effigies that provided a visual record of their aristocratic genealogy. Specific likeness was of less concern than rank, and in such portraits the trappings of social position were indicated at least as carefully as peculiarities of feature or signs of individual character. By the seventeenth century this had already begun to change somewhat in northern Europe with the growth of the mercantile class, which wished to grant its own honors for individual accomplishment. Especially in the Low Countries, a new kind of portrait became popular, emphasizing individual character rather than social position. Eventually, two quite different kinds of portraiture came to exist side by side: one that, with an eye to history, celebrated the subject's position, and one that carefully recorded the subject's specific features, proving the historicity of the likeness by its particularity. For this second kind of representation, it seemed that existence alone was reason enough to be remembered in paint.

This attitude toward portraiture became dominant in the eighteenth century, and in America, where there were few noble lines to be celebrated, portraiture tended to establish the truth of the individual with some candor. Even in America, however, the awareness that a portrait could confirm rank and help impart social status was not lost. Nor did everyone want to be pictured for posterity exactly as he appeared to his contemporaries. Yet there was a persistent concern for setting down those particularities that distinguished this man and this family from others as if one might otherwise be lost in the expanding, heterogeneous society that was developing.

Evidence of the concern for the intimate, individual

portrait was the development of the portrait miniature. Magically tiny like a jewel, it not only preserved the likeness of a favored person but seemed almost a token of possession. The miniature had a tradition of its own, maintaining its own techniques and materials. Once it gained currency in America in the eighteenth century, miniature painting became one of the most accomplished branches of the visual arts. Probably more painters sustained themselves by painting miniatures than by any other exercise of their profession. Furthermore, many whose full-scale portraits were routine and weak proved masters in the smaller form, sharply observant and technically adept.

Until late in the eighteenth century the process of painting was usually called limning, a word that came rather late into English and referred back to the tradition of manuscript illumination. From the sixteenth century onward, however, to limn meant to depict a likeness; and there was no suggestion that limning need do more than that. So the earliest painters in America have been called limners, which aptly suits the task they set out to accomplish. To refer to them as "mere" limners would not be just, for they were upholding a specific value in art—its capacity to preserve an image—and their procedure was appropriate to the ends they sought.

In the eastern colonies, the earliest surviving portraits date from about 1670. Some of the most appealing are of children, painted young so as to leave an image in the world in case they did not survive childhood. The portraits of the Mason children, bearing the date 1670, have preserved in unequivocal fashion each detail of their elegant New England dress and childish faces. The self-possessed Alice Mason is not depicted in some fleeting moment but stands as a complete being while the limner describes each detail of her appearance. There is something very positive about the statement, so positive that the painter is doubly anonymous: he left neither his name nor the strong mark of his painterly hand. The object is there to be valued for itself. Yet to talk about the subject in such a picture as existing in actual space would be as foolish as to say that the painting suggests passing time. Such fleeting dimensions had no bearing on this kind of likeness. Little Alice Mason

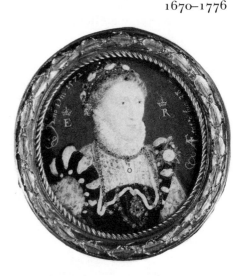

Nicholas Hilliard, *Elizabeth I,* 1572, miniature. National Portrait Gallery, London.

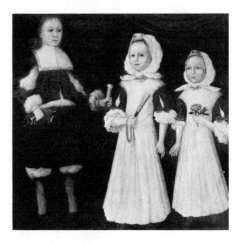

Unidentified artist (Mason Limner), *The Mason Children*, 1670. Private collection, New York.

exists as a treasured family fact with the same note of permanence established by recording her name in the family Bible.

There was a long tradition behind this clear and frankly linear kind of depiction. In a manuscript on the art of limning written about 1600, Nicholas Hilliard, a favorite court painter in England, wrote: "Forget not therefore that the principal part of painting or drawing after the life consisteth in the truth of the line . . . for the line without shadow showeth all to a good judgment, but shadow without line showeth nothing." As for the dramatic use of heavy shadow, which became an obsession with many painters in the seventeenth century, Hilliard asserted that "great shadow is a good sign in a picture after the life of an ill cause, and showeth plainly that either the drawer has no good sight to discern his shadows except they were gross, or had a bad light to draw in." That a painting done some seventy years later in America follows Hilliard's dicta closely does not mean that the painter was a follower of Hilliard. This point of view belongs not to a time in history but to an attitude toward painting and, indeed, toward reality. Like Hilliard, the anonymous painter of Alice Mason considered that truth lay in the definition of the object, not in its appearing in an environment of shifting light and shade. Modeling served to describe substance without creating the illusion of looking at the thing in particular circumstances. Had illusion been suggested—a hand suddenly seeming to hover in actual light—the permanent reality of the described parts would have been compromised. The purpose of this kind of painting was to assert the permanent existence of the object— whether Alice Mason's serious face or her richly decorated gown—not to remark on its transience. Illusion was just that, not a substitute for real values.

By the time the portrait of Alice Mason was painted, concepts of art had changed markedly in England. Under Charles I, Rubens and Vandyke both painted for the court, and the Dutch painter Sir Peter Lely had a fashionable clientele that continued in the reign of Charles II. Coming to England from Germany in 1675, Sir Godfrey Kneller attracted attention with his boldly painted canvases and was much in demand to record the reigning beauties. Eventually engravings of the court

Nicholas Hilliard, *Sir Anthony Mildmay,* 1596 or later. The Cleveland Museum of Art, Ohio; purchase from the J. H. Wade Fund.

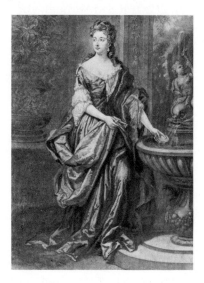

John Faber, Jr., after Sir Godfrey Kneller, *Isabella, Duchess of Grafton,* 1691. Courtesy of the Henry Francis du Pont Winterthur Museum, Winterthur, Delaware; Waldron Phoenix Belknap, Jr., Research Library of American Painting.

13

paintings found their way to the colonies, their flamboyant manner surely contrasting rudely with such paintings as that of Alice Mason or the often reproduced portrait *Mrs. Freake and Baby Mary* (ca. 1674). While women were dazzled by the engravings' depictions of elaborate gowns and aristocratic poses, the busy limners translated their accomplished technique, with its freely brushed evocations of light and shade, into the positive flat patterns of their own more permanent terms. Captain Smith of Boston was obviously aware of the elaborate court painting when he painted his melancholy self-portrait, probably in the 1670s, and included a glimpse of the sea and an unexplainable piece of drapery in deference to the newer mode. For all its complexity, however, his light and shade falls back into a flat pattern that is closer to the limner tradition than to the fully modeled forms of Lely or Kneller. It is as if he looked upon the light and the shadow as things—substance—in much the way he saw the isolated qualities of the lace and the skull. In this translation of the new into his traditional way of seeing he was like most of the limners who traveled through the countryside finding subjects where they could. Taste might change, but truth was truth.

The prosperous Dutch settlers in New York and the Hudson Valley (patroons) had a more expansive concept of art than the colonists of New England. Records indicate that they decorated their houses with paintings of various kinds, and the handsome portraits produced by the busy limners in the area during the early eighteenth century tended to be both larger and more striking in effect than others of the North.

The portrait of Mrs. Jacobus Stoutenburgh is a monumental likeness. In presence she can hold her own with the elegant ladies of Lely or Kneller; yet she does not exist in a shadowy space with pools of light and mysterious glimpses of almost hidden prospects. She seems very close indeed. In spite of this sense of presence, though her ample drapery shines and bristles the paint does not transform itself into cloth. Each highlight and fold is as exacting and individual in its compositional function as the polished line of the neck and the elegantly detached hand holding the solitary rose. These patroon limners excelled in their sense of design—their

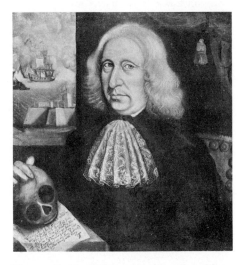

Thomas Smith, *Self Portrait,* circa 1670. Worcester Art Museum, Massachusetts.

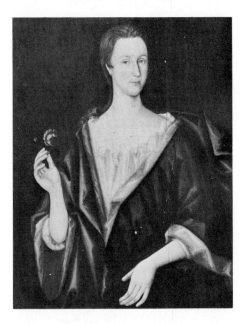

Unidentified artist (patroon painter), *Mrs. Jacobus Stoutenburgh,* early eighteenth century. Museum of the City of New York, New York.

14

appreciation for pattern and subtly shaped contour. The light and shade that shimmered over forms in the elegant English and Dutch engravings simply furnished them more material to weave into rhythmic patterns. Shiny satin was treated less as substance than as an excuse for all manner of patterned movement. The reality of things was somehow transferred to the reality of the painting as a decorative object. No smudge of darkness or graying of color interfered with the painting's direct decorative impact.

Yet for all their charm as decoration, these paintings convey an extraordinary quality of life and character. Each new set of features provided the limner with a new problem of design. He began with no assumptions about the oval shape of the head or the proportions of the features. The design he wove grew out of the individual face. To be sure, each limner had his own tricks of the trade—how to paint an eye, a nose, or a mouth, for example. But no two limners followed quite the same formula. Although there was a general limner perception and predisposition to form, there was no limner style in the sense of the later academies. Willy-nilly, they were very much on their own.

There were no schools for limners. They learned their trade by apprenticeship or simply through their own experiments. "Taking a likeness" was only one of the activities they engaged in. A painter was expected to be a jack-of-all-trades as well as a dealer in paints and other specialties. He was expected to gild the frame as well as paint the picture. Since it was normal for the painter to seek out his subjects rather than wait in his studio for clients, portrait painting tended to be a seasonal occupation, limited by the possibilities of travel. The resourceful painter used the time when he could not travel to prepare his canvases, occasionally painting in the figures of his future sitters ahead of time. This not only speeded the eventual sittings, it allowed his subjects to choose, within limits, how they wished to appear. They chose, for the most part, to be painted as dukes and duchesses in spectacular costumes and in idyllic settings. If one were to take the paintings literally, one would have to conclude that formal gardens, silken draperies, and monumental architecture were common on the estates along the Hudson. Common they were in the im-

aginations of the ambitious colonists, who now sought an image to match their affluent state. As usual, the image preceded the realization in brick and stone; the paintings project a wish more than they record a fact. Yet the building trades were not far behind, nor were the cabinetmakers, and materials for sumptuous dress had been regular imports for some time. The skillful limners, doubtless goaded by their ambitious clients, could create a picture of how people wished to see themselves, even before it was physically possible; yet they retained a degree of candor that brought the imaginary into the realm of the actual.

The courtly image was also in favor farther south. In Maryland and South Carolina, a German painter named Justus Engelhardt Kühn, who died in 1717, transported the affluent local citizenry to fantastic arbors and vast, well-maintained gardens. Like his anonymous contemporaries in New York, Kühn was making visually real an attitude toward life that was actually only beginning to be modestly realized.

At the time Kühn painted, however, great new buildings were in fact being erected in Virginia and South Carolina, following the formal Renaissance principles that had by now become prevalent in England. But brick and stone could hardly repeat the fantasy Kühn created. One wonders, in fact, if this refined dream was not meant to be just that. It was not so much a model for the growing luxury as an imaginative complement, giving daily life a dimension that no amount of building could provide.

The limners of New York applied their considerable decorative skills to more than portraiture. There remains a remarkable group of religious paintings, based for the most part on woodcuts from illustrated Bibles, that translate sophisticated narrative compositions into images that make a direct and colorful impression. Little is known about the circumstances in which the paintings were created, but they give further evidence that the inhabitants of the area were not unaware of the power of visual appeal in art.

Who were these many painters who are known only through the families for whom they painted? Although records reveal the names of some painters, and though many paintings have survived, it is rarely possible to

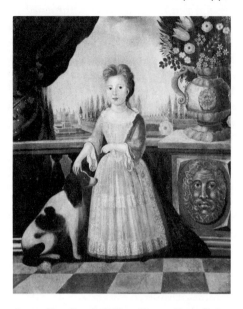

Justus Engelhardt Kühn, *Eleanor Darnall*, before 1717. Maryland Historical Society, Baltimore.

Unidentified artist, *The Adoration of the Magi*, early eighteenth century. Abby Aldrich Rockefeller Folk Art Center, Williamsburg, Virginia.

16

match names to paintings in any convincing way. Five members of the Duyckinck family, scattered through four generations, were involved with art beginning in the mid-seventeenth century; yet no work can be attributed to them with complete certainty. Pieter Vanderlyn (1687–1778), who came to New York from Holland in 1718, painted in Albany and Kingston, but it is impossible to be sure just which surviving paintings are his. One would like to believe that the pensive Mrs. Petrus Vas was indeed painted by him.

As if in answer to the expanding demands for portraits, professionally trained painters began to appear in America in growing numbers, seeking their fortunes in the new society. Although they were not major talents, they brought more sophisticated techniques than those traditional with the limner, as well as a very different concept of what makes a picture a picture.

One of the first was the Swedish painter Gustavus Hesselius (1682–1755), who came in 1711 to what had been new Sweden. Although his training seems to have been rudimentary, he had some understanding of the painterly unity that had developed out of principles first reestablished in Renaissance Italy. His heads are not expertly painted, but they show a concern for light and shade and a consistent modeling of form that was of little interest to the itinerant limners. Hesselius was a cultivated man of many interests and became a distinguished member of society, first in Wilmington, Delaware, then in Philadelphia. In 1721 he was commissioned to paint *The Last Supper* for Saint Barnabas Church in Queen Anne County, Maryland, a work that unfortunately did not survive. He also repaired organs, painted signs, and performed other useful services. Clearly as means to put his society in touch with the wider world of culture, he fabricated at least two mythological paintings in the 1720s, "fancy pictures" whose efforts at baroque rhetoric contrast dramatically with his two portraits of Indians, Lapowinsa and Tishcohan, painted about 1735. The Indian portraits are remarkable for their candor and sympathy; Hesselius obviously was determined to make the portraits look like the Indians themselves and not to conform to a preconceived notion of ideal humanity. He studied them with the analytical eye of the scientist, yet re-

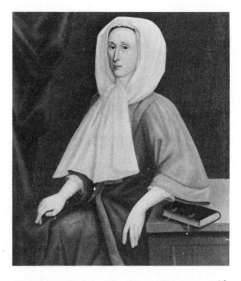

Pieter Vanderlyn, *Mrs. Petrus Vas,* 1723. Albany Institute of History and Art, New York.

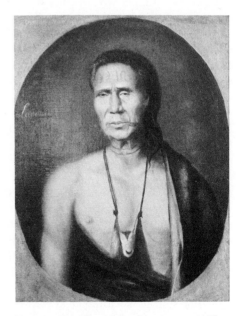

Gustavus Hesselius, *Lapowinsa,* 1735–37. The Historical Society of Pennsylvania, Philadelphia.

17

sponded to them as human beings. His candor, however, was not always appreciated. The prominent James Logan of Philadelphia, writing in 1733, remarked that he "generally does Justice to the men, especially to their blemishes, which he never fails showing in the fullest light, but is remarked for never having done any to the fair sex, and therefore very few care to sit to him." Nonetheless, his inquiring mind made him a welcome guide to the Swedish naturalist Peter Kalm when that indefatigable investigator arrived in Philadelphia in 1748.

A totally different contribution was made by John Smibert (1688–1751), a mature English painter who quite by chance settled in Boston in 1729. Although he was a serious and competent man, had he remained in England he would probably have left no mark on the history of art. As it turned out, he and the copies of old masters and antique casts he brought along played a major role in furthering painting in the United States. Smibert came to America in 1728 with a group organized in England by Bishop Berkeley to establish a school for Indians and children of plantation owners in Bermuda. The school did not materialize, and Smibert married and settled down in Boston. What did his paintings and studio properties mean to aspirant painters that propelled the neophytes into practicing art with new determination? In spite of their routine execution, Smibert's paintings placed his subjects in a unified artistic environment where, in contrast to the aggressively flat canvases of the limners, they took on substance and a convincing sense of self-determination. Miraculously to eyes not accustomed to this kind of work, the plane of the painting was dissolved and the spectator was invited to accept the space in the picture as an extension of his own space. Equally important, Smibert, with his academic training and study in Italy, saw form first as a simple whole which was then modified to admit of particularities, a procedure almost exactly opposite from that of the limner. Smibert knew all the rules for organizing sight, providing a key to the visual chaos of multiplied things. This was the kind of order that pervaded the old masters and the works of antiquity, and it suggested a new role to the American artist. Even in

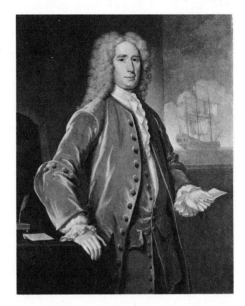

John Smibert, *Richard Bill*, 1733. Courtesy of the Art Institute of Chicago, Illinois; Friends of American Art Collection.

America, perhaps he could create works worthy of the great traditions of Western art.

The times were right for this visual sophistication. Architects had already discovered the rule of symmetry and the persuasions of taste, though they were sometimes heavy handed in expressing this. Boston was acquiring its monumental churches—Old North in 1723 and Old South in 1729—and bringing some of its early wide-ranging architecture within Palladian bounds. Great private homes were being built that combined traditional building methods with more formal planning and often with encrustations of Palladian detail. In Virginia, Stratford (1725–30) and Westover (1730–34), for example, displayed both affluence and deliberate taste. In Philadelphia, the new state house—which would be called Independence Hall—was begun in 1732, consciously planned to conform to a rule of taste. More remarkable for its sophistication in planning and its high-church grandeur was Christ Church in Philadelphia, begun in 1727. It is evident that architectural design had gone well beyond painting in sophistication, and it seems inevitable that the unquestioning procedure of the limner would soon have to be subjected to review.

Smibert's most important painting was produced before he had really settled into America. It was an ambitious group portrait showing himself and the other members of the Bermuda group, including the portly Bishop Berkeley, gathered around a table; beyond the columns in the background he presented an imaginary but convincing bit of American landscape. Everyone in the painting looks at or reacts to someone else in a way quite unthinkable in most earlier colonial painting. Clumsy as it is, the painting has an interior animation that provided an inspiring lesson to those who had not thought paintings could have this kind of private life. Smibert's paintings and his all-important studio collection awakened a generation of painters and patrons to the possibilities of art. In a lengthy self-congratulatory poem published in 1730, Mather Byles described the situation:

Ages our Land a barb'rous Desert stood,
And Savage Nations howl'd in every wood;

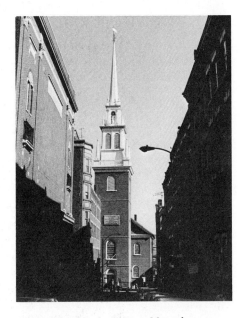

Old North Church, Boston, Massachusetts.

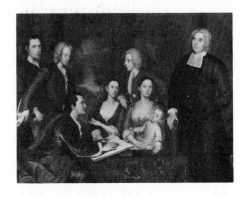

John Smibert, *The Bermuda Group*, 1729. Yale University Art Gallery, New Haven, Connecticut; gift of Isaac Lothrop.

No laurel'd Art o'er the rude Region smil'd,
Nor blest Religion dawn'd amidst the Wild;
Dullness and Tyranny, confederate, reign'd,
And Ignorance her gloomy State maintain'd.

. .

Solid, and grave, and plain the Country stood,
Inelegant, and rigorously good.
 Each Year succeeding the rude Rust devours,
And softer Arts lead on the following Hours;
The tuneful nine begin to touch the Lyre,
And flowing Pencils light the living Fire.
In the fair Page new Beauties learn to shine,
The Thoughts to brighten, and the Stile refine;
Till the great Year the finish'd Period brought,
A *Smibert* painted and a—————— wrote.

To call the year Smibert arrived the beginning of "the
finished Period" was more than a bit presumptuous, but
his arrival did mark a moment of change. Although the
itinerant limner would offer his varied services for many
years to come, helping families to hold on to their past,
the aspirations of artists—and the demands of dis-
criminating patrons—would be quite different from this
point on.

 What Smibert represented can be seen in the work of
Robert Feke, whose origins are obscure—he was proba-
bly born in the colonies about 1707—but whose work
from the early 1730s on became known from Boston to
Philadelphia. Whether he actually worked with Smibert
is not known, but his large group portrait of the Isaac
Royall, Jr., family (1741) is obviously patterned after
Smibert's *Bermuda Group*. Yet Feke's painting retains
much of the patterned vitality of the limner tradition;
Smibert's academic formulas were appropriated only
where useful to give greater spatial unity and an added
sense of volume. Like many of the limners, Feke often
took an English print as his point of departure, but he
saw its intricately modeled forms and luxurious drapery
in his own way. His interpretations of the stiff, glossy
satin that seemed so desirable to his self-conscious sitters
was less an imitation of its appearance than an apprecia-
tion of its smooth rhythms and dazzling variations of
light and shade. The drapery never quite becomes just
the thing seen, solidly existing in space; at some point
Feke stopped short of complete description and rhap-
sodized. As a reult his images hover between the flat,

Robert Feke, *Mrs. William Peters*, circa 1746–50.
The Historical Society of Pennsylvania, Phila-
delphia.

John Hesselius, *Mrs. Richard Brown*, circa 1760.
National Collection of Fine Arts, Smithsonian
Institution, Washington, D.C.; museum pur-
chase in memory of Ralph Cross Johnson.

20

patterned world of the limners and the illusionistic painterly world hinted at in the works of Smibert and the fashionable engravings. The buoyancy of Feke's likenesses, in which every highlight and shadow has a life of its own, makes the more accomplished but rather routine depictions of Smibert look limp. Clearly the younger painter was not ready to give up his kind of reality, in which the substance in his painting is meant not to "look like" but to "be," for a more detached vision of the world.

This lively union of expressive pattern and descriptive vision is also evident in the work of others. Gustavus Hesselius's son John (1728–78), for example, seems not to have been content with his father's modest and literal rendering of form. Like Feke, whose paintings he doubtless knew, he worked to make every form assertive, so that the image seems to burst with restless energy. His figures exist in Smibert's kind of space, but their angular forms and resistance to an overriding scheme of gracefulness gives them an almost insolent vitality. They refuse to withdraw into a purely artistic realm.

It is dangerous to generalize about conceptions revealed by style and about actual changes in perception, but it is tempting to speculate on the new sense of form that seems to underlie the paintings of Feke and John Hesselius because a comparable change seems to underlie the design of objects with which the affluent now liked to surround themselves. For example, if a fashionable chair of the 1740s is compared with an equally elegant chair from before 1700, it is evident that a significant change has taken place in the way forms are related. The earlier chair is made up of well-proportioned parts, each handsomely turned in measured, repeated forms. Each part keeps its place with respect to others and to the whole, never seeming to push beyond the limits assigned to it. In contrast, every form in the chair of some fifty years later seems to have an energy of its own. No part is contained within itself; each mimics a rhythm that seems to pervade the entire work. The rhythmical chair expresses an overt and aggressive sense of design and calls attention to daring exploits of craftsmanship that triumph over material. A similar change in character can be found in other crafts, notably silver-

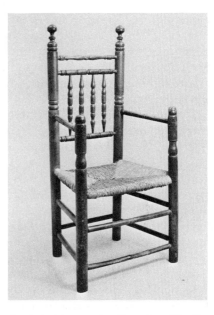

Armchair, late seventeenth century. The Bayou Bend Collection of the Museum of Fine Arts, Houston, Texas.

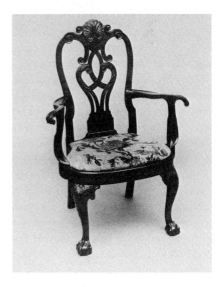

Armchair, circa 1760. The Bayou Bend Collection of the Museum of Fine Arts, Houston, Texas.

21

smithing. By the mid-eighteenth century, energetic interruptions of form replaced the more solid, contained parts agreeable to an earlier taste. Quite evidently a sense of "style," of a willful expression of a dominating, creative unity, became an important quality of mind. It was proof, in its way, that individual perception was more significant than the measurable aspect of the things perceived.

This change in the way of looking at forms, seeing them as allied to the exercise of perception and thought, did not originate in America but was also taking place in England at just this moment. At this period fashionable taste in the colonies had caught up with that of England, and it is sometimes difficult to decide whether an object was imported or made in America. A generation or so earlier there had been a far greater time lag between European and American tastes, caused less by the inaccessibility of models than by the cautious conservatism of the colonies. In the half-century after 1700, confidence grew along with affluence, and the desire to be current was tempered only by pride in local accomplishment. Each urban center now had its group of skilled craftsmen, each providing his distinctive adaptation of the favored modes. The crafsman was important in a new way, since he not only produced objects of the desired degree of opulence but also reinforced the new sense of pervasive style, which became an aggressive expression of opulence and progress.

This change in attitude toward form and its contents doubtless had greater significance in America than in England, since it represented not only a change in taste but the first acceptance in America of the thesis that a publicly expressed taste can become an important factor in social organization. Although only a tacit assumption, it encouraged a new patronage for the arts in America and allowed native artists and craftsmen to see their activity in a new light. Espousing the same goals and techniques as their brethren across the sea, they were no longer isolated on a static cultural fringe but could see themselves as helping to create a new style and hence a new cultural frontier.

At midcentury other artists came to the colonies to take advantage of what they assumed would be a lucrative market. All seemed devoted to portrait painting,

and few made excursions outside the field. The English painter William Williams (1727–91) came to Philadelphia at the age of twenty and remained for some thirty years, painting portraits and, on occasion, stage scenery; John Wollaston (ca. 1710 to after 1779) came from England in 1749 and painted in New York, Philadelphia, Maryland, and Virginia; Joseph Blackburn set up his business in Boston in 1755 and painted in the area until 1763. In Charleston, South Carolina, the Swiss painter Jeremiah Theüs (about 1719–74) was active from about 1740. All these painters had adequate training, but none was in any sense near the top of his profession. Why, one wonders, were not more accomplished painters drawn to the new market in America? With the awakening of landscape interest in England, why were not some painters attracted by the American landscape? A variety of reasons suggest themselves, but the fact remains that they did not come. Possibly it is just as well. The journeyman painters brought their knowledge of methods and material and served as mentors for a good many young artists, without prematurely fixing a goal for art. They opened the door through which aspiring artists might enter a tradition whose great masters were clearly to be found elsewhere.

This process is well demonstrated in the career of John Singleton Copley (1738–1815), who in skill and artistic concept eventually far surpassed the painters from whom he had learned. Born in Boston and brought up as the stepson of Peter Pelham, a conservative artist from whom he probably learned the rudiments of art, Copley could have had as models the work of Smibert, Feke, and, after 1775, Joseph Blackburn. Like his older contemporaries, he had also the image of English mezzotints to furnish the grandeur Boston might lack. He made use of all of these sources to develop an extraordinary skill in drawing. He was fascinated by natural materials and was able, by the late 1750s, to catch the quality of stuff and a full rotundity of form without losing the effect of sensuous immediacy so essential to a man like Feke. Like the limners, he began by working from part to part, but the parts were so sharply observed and strikingly rendered that the unity of the whole is readily assumed. By the 1760s, his candidly rendered likenesses stood out so sharply in what

23

seemed to be a piercingly clear light that his Boston patrons found themselves confronting a vision of reality never before encountered in America. As he moved along, his fascination with objects caught and defined in light became almost an obsession, and he went out of his way to pose his well-dressed subjects with polished furniture and shining accessories to emphasize his pleasure in seeing. In the later 1760s he posed the silversmith Paul Revere looking with appreciation at the precise form of a silver teapot much as Copley himself looked with an appraising eye at the forms he painted.

Copley, however, was not simply a painter of vision without thought. Not only did he respond with sympathy to the individual characters of his sitters, he had at the back of his mind an idea about art possibly first kindled by a glimpse of Smibert's studio treasures. He was well read in the history and theory of art and, though he had never seen any actual works by the masters, felt that he thoroughly understood them and their principles. As a portraitist he was much in demand and had all the commissions he could handle, but he was not satisfied with local fame. Copley wished to join the larger tradition of art.

At the time Copley was painting in Boston, the status of the artist was also changing in England. The idea of the artist as an educated man, at one with poets, philosophers, and the well-informed gentleman amateur, was gradually being accepted by both artists and patrons. The academic principles of art, formulated in Italy in the sixteenth century, were being recast in modern terms, and artists banded together to show their works in annual exhibitions as they had been doing in France for a century or so. Excited by this activity, Copley sent one of his finest works, *Boy with a Squirrel*, to London for exhibition with the Society of Artists in 1766. It met with extraordinary acclaim, though there were reservations, and Benjamin West, a compatriot of his own age from Pennsylvania, who had settled in London in 1763 after a tour of Italy, wrote him a letter of praise and helpful criticism. Tantalizingly, he wrote, "You have got to that length in the art that nothing is wanting to perfect you now but a Sight of what had been done by the great Masters, and if you Could make a visit to Europe for this Purpose for three or four years, you

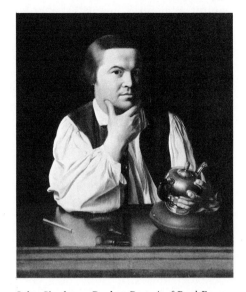

John Singleton Copley, *Portrait of Paul Revere*, 1765–70. Courtesy of the Museum of Fine Arts, Boston, Massachusetts; gift of Joseph W., William B., and Edward H. R. Revere.

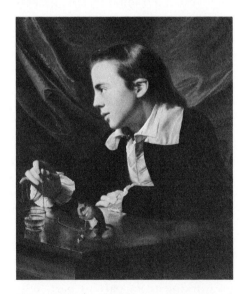

John Singleton Copley, *Boy with a Squirrel*, 1765. Courtesy of the Museum of Fine Arts, Boston, Massachusetts; anonymous loan.

would find yourself then in Possession of what will be highly valuable."

Although Copley went abroad only in 1774, studying in Italy, then settling in England for the rest of his life, the seeds of the academic tradition had been firmly planted in his mind. His further submissions for exhibition in London were not so well received. The criticism struck close to what had been something of an accepted tradition in America. The difficulty arose, wrote West, quoting Sir Joshua Reynolds, "from Each Part of the Picture being Equal in Strength of Coloring and finishing, each Making too much a Picture of its self, without that Due Subordination to the Principle Parts, viz., the head and hands." Copley was eager to conform to established criteria for painting and doubtless was pleased to be listed among the fellows of the newly chartered Royal Academy, but he foresaw the problems that many American artists would eventually confront. "Why I must either return to America, and Bury all my improvements among people destitute of all just Ideas of the Arts..." he wrote in about 1767, "Or I should set down in London in a way perhaps less advantageous than what I am in at present." Not only the artist but the public as well had to discover the nature of genius and the elevated goals of art.

Unlike Copley, Benjamin West had not matured as an artist or developed an enthusiastic clientele before he left for Europe. Born near Springfield, Pennsylvania, in 1738, he early showed an interest in art. He copied engravings and whatever other works he could find, and developed a painting style somewhat akin to that of Wollaston or, more remotely, Feke. His chief guide, it seems, was the English painter William Williams, who introduced him to books on the history and theory of art, opening up the vision of artistic genius that eventually drew him to Europe. In 1759, supported by a local subscription, he left for Italy, where his interest in artistic theory was stimulated by the active movement in Rome centering on Cardinal Albani. There, during the next three years, he developed into an accomplished painter. By the time he wrote to Copley in 1766, he was well established in London, where he settled in 1763, and had already begun his long service as mentor and protector of American artists studying there. He was

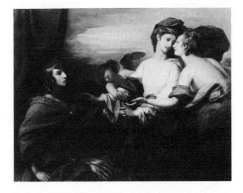

Benjamin West, *Helen Brought to Paris*, 1776. National Collection of Fine Arts, Smithsonian Institution, Washington, D.C.; museum purchase in memory of Ralph Cross Johnson.

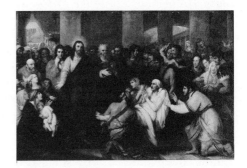

Benjamin West, *Christ Healing the Sick in the Temple*, 1815. Courtesy of Pennsylvania Hospital, Philadelphia.

active in establishing the Royal Academy of Arts in 1768 and became its president in 1792.

West became an influential English painter, his large history paintings demonstrating the principles of Sir Joshua Reynolds and the academy perhaps more convincingly than those of anyone else. Yet he remained much involved with the course of painting in America. He not only served as a much-cited example for young artists, but he freely accepted American artists into his studio and saw that they made useful contacts. American promoters of the arts watched with both pride and shame his continued rise in favor—he was appointed historical painter to George III in 1772. They took pride in his accomplishments but were ashamed that such a painter could not have carried on his career in America. Some of his historical works were shown in Philadelphia and others were known from engravings. His large *Christ Healing the Sick in the Temple* was painted for the Pennsylvania Hospital in 1815 to serve as a model for local artists.

The importance of West for the progress of art in the United States cannot be overestimated. Few of those who were attracted to London by his presence imitated his manner of painting, and few had a chance to develop his ideas of history painting; but he served as an introduction to art as it then existed, enjoying its new stature in England, and as an inspiration—proof that an artistic genius could come out of a small Pennsylvania town.

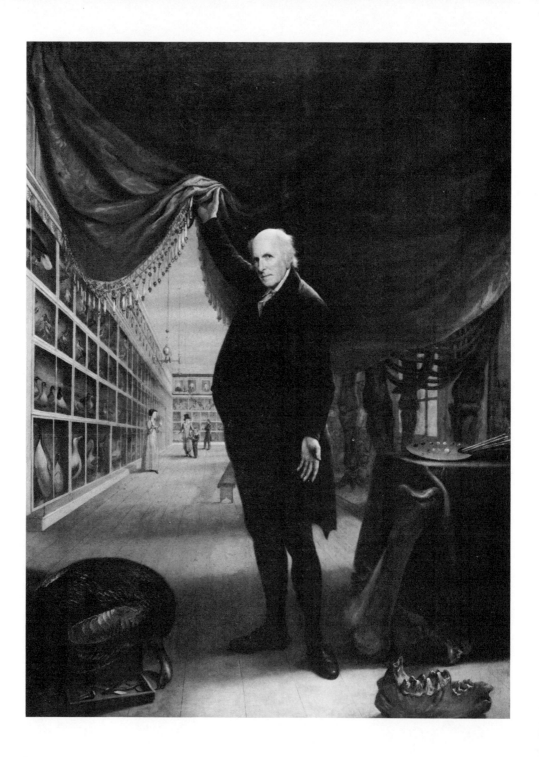

1776-1860

Art and the New Republic

Political events do not necessarily change the course of the arts, but the change from colonial to independent status, with its strong ideological significance, had several seemingly inevitable effects. Although many continued to look to England as a cultural source and though artists sought out Benjamin West in London during and after the Revolution, once the republic was founded there was a new motivation for both patron and artist. As consciousness grew of the entity called the United States of America, artists saw themselves on the threshold of a new era offering great promise and opportunity, and they were sharply aware that their actions would form the foundation of what was to come. Their public suddenly was posterity. They had an obligation to prove the virtues of their experimental democratic society under the scrutiny of the entire western world and to uphold the national honor achieved in the war of independence. The artists were not alone, of course, in seeing themselves in the focus of history; statesman and intellectual leaders in all fields saw their accomplishments in more universal terms than before and began to look at their society as a whole to determine its needs and to theorize about its destiny.

Art as Symbol

Since there was a fundamental difference between a large group of people united principally by geography and the same group integrated as a social whole, defining which factors spelled unity rather than diversity was of prime concern to those who accepted responsi-

Facing page:

Charles Willson Peale, *The Artist in His Museum*, 1822. Courtesy of the Pennsylvania Academy of the Fine Arts, Philadelphia; Joseph and Sarah Harrison Collection.

29

bility for the developing nation. It gradually became clear that the arts had a place in this public program of unity, though no one knew just how they were to function. The need to give visual form to the concepts of the new republic was recognized, and after much debate an official seal was adopted, as well as a flag. People of the period were responsive to symbolic thinking, and the American eagle with its arrows of war and its olive branch of peace became a badge of national consciousness that appeared on furniture, bandboxes, and any document that sought public support. Almost as persuasive was the svelte young lady with the Phrygian cap who personified liberty. Edward Savage's 1796 engraving entitled *Liberty as Goddess of Youth Feeding the American Eagle* not only was copied many times in various media and with varying degrees of skill, but turned up on imported Liverpool ware and in behind-glass paintings from China. Although this adoption of symbols and their use may seem superficial, it had important implications, for it was the first time a centralized imagery, understood by all, was carried by the arts throughout the republic. Shortly there would be many other manifestations that the arts could perform a special symbolic function of broad significance.

Ironically, many of the prints and objects that carried the symbols of the new country and its much-discussed moral principles came from abroad, many from England. Printed cottons, ceramic ware, and popular engravings celebrating the victory of Liberty over British Tyranny flooded the American market. Obviously the spirit of the American Revolution was looked upon by producers abroad as providing a lucrative market for the arts.

This was true not only for the humble arts. There was no lack of interest by established artists abroad in helping to monumentalize the historical fact of the Revolution and its heroes. When Congress first commissioned medals, Benjamin Franklin saw to their being entrusted to French specialists in medallic art, and they were struck in France. Even earlier, the first monument to be erected at the behest of the Continental Congress—in honor of General Montgomery, who was killed in Quebec in 1775—was commissioned in 1776 from the French sculptor Jean Jacques Caffiéri, again as arranged

Edward Savage, *Liberty as the Goddess of Youth Feeding the American Eagle*, 1796. Library of Congress, Washington, D.C.

Augustin Dupré, *Medal of Brigadier-General Daniel Morgan*, 1789. National Museum of History and Technology, Smithsonian Institution, Washington, D.C.

by Benjamin Franklin. Because of the commission Caffiéri thought he had priority on all future governmental commissions—he assumed, as others did, that there would be many to commemorate the heroes of the Revolution—but, like most artists who have set their sights on congressional commissions, he was disappointed.

For the most part, major artists were not interested in coming to America but hoped to execute their commissions abroad. Caffiéri made a bust of Franklin in Paris in 1777, as did Jean Antoine Houdon in 1778. Houdon, however, did come to America with Franklin in 1785 to model a likeness of George Washington from life. The visit was occasioned by a congressional decision in 1783 to commission an equestrian statue of Washington. The commission did not materialize, but Houdon's likeness of Washington became a kind of national symbol, much imitated and much debased. Of Houdon's various representations of Washington based on the terra cotta bust and life mask he took in the United States, the elegant standing figure commissioned for the Virginia state capitol in Richmond is the most impressive. Houdon did busts also of Jefferson, John Paul Jones, Robert Fulton, and the author of America's epic *The Columbiad,* Joel Barlow.

Attracted by the possible market in heroes and the announced congressional commission, another sculptor of considerable accomplishment came from Europe about 1791. He was Giuseppe Ceracchi, a Roman sculptor with an extensive but ill-starred career behind him. During his stays in America—he was here in 1791–92 and again in 1794–95—he modeled busts of several American statesmen, including George Washington, hoping without reason to be reimbursed for his work. But his great achievement was the model for an immense monument, one hundred feet high and three hundred feet in circumference, "to Perpetuate the Memory of American Liberty." It was to include allegorical groups, portraits, and an equestrian statue of George Washington in Roman dress, the whole surmounted by a marble rainbow. He tried in vain to get support for his monument, which was to cost $30,000, but finally gave up and settled in France, where some years later he was guillotined for alleged complicity in a

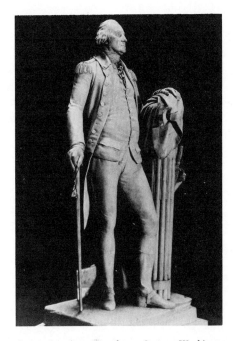

Jean Antoine Houdon, *George Washington,* 1788–92. State capitol, Richmond, Virginia. Courtesy of the Metropolitan Richmond Chamber of Commerce.

Giuseppe Ceracchi, *George Washington,* 1795. The Metropolitan Museum of Art, New York, New York; bequest of John L. Cadwalader, 1914.

31

plot on Napoleon's life. James Madison, who had been sculptured by Ceracchi and dunned for money, remarked that the avid man was "an enthusiastic worshiper of Liberty and Fame and his whole soul was bent on securing the latter by rearing a monument to the former."

What attracted foreign artists and stimulated a lively trade in patriotic artifacts was the new cult of the hero. Portraiture, which had constituted almost the whole of American art, expanded from its domestic context to take on a public responsibility. Instead of giving dignity and permanence to family, the portraits of prominent men helped dignify and place firmly in history the accomplishments of the Revolution and of the initial government of the republic. As "founding fathers," the military heroes and statesmen became instant ancestors, and the idea of the family portrait took on an enlarged significance.

The artist most zealous in recording the heroes of the Revolution was John Trumbull (1756–1843), who had himself been in the continental army until, affronted over a minor incident, he withdrew in 1776 to study painting in London. Moved by academic principles such as those ennunciated by Sir Joshua Reynolds, then president of the recently established Royal Academy, Trumbull aspired to be a history painter but saw this as closely allied with protraiture. In his *Death of General Wolfe* (1770), Benjamin West had shown that the principles of historic composition that served to remove an incident to an ideal level of contemplation quite remote from the whims of time could be applied to current history with striking effect. Normally the history painter concerned himself with subjects from antiquity that provided elevated moral examples for all time. By using an approximation of the "grand style," reserved by protocol for timeless history, West gave General Wolfe status alongside the Homeric heroes and the demigods. Trumbull was fully aware of the tenets of history painting and produced several works on accepted classical themes, but on West's suggestion he devoted the major effort in his career to memorializing great events of the Revolution and their heroes, to serve as the founding imagery of what promised to be a new culture.

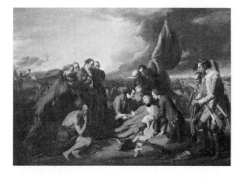

Benjamin West, *The Death of General Wolfe*, 1770. The National Gallery of Canada, Ottawa; gift of the duke of Westminster, 1918.

Trumbull's paintings were meant to be both elevating and accurate, and to ensure accuracy he painted all the participants he could locate from life or from a close relative. As for the compositions, they were constructed in a bold but traditional manner, centering on decisive moments so as to fix the significance of the action indelibly in the mind. In their stable organization they suggested that the scheme was there before the event took place: that the specific action was an inevitable part of history.

Trumbull hoped that the government would commission him to execute his paintings on a monumental scale as great public images, but Congress was wary about expenditures for art, and no one was willing to take the responsibility of spending public money for paintings. Finally in 1817, some thirty-five years after he began his ambitious project, Trumbull was commissioned to execute four of the panels for the rotunda of the Capitol. By then he was a disillusioned man in his sixties, and much of the original fire of his conceptions had been extinguished.

The theorists were insistent about the importance of history painting in a democracy. Jacques Louis David, the most prominent French painter of the time, whom Trumbull met in Paris, said in a notable address to the Assembly in France in 1792 that it was the duty of the painters to kindle in the hearts of their countrymen a love of their country, by depicting acts of heroism and civic virtue to galvanize the souls of the people. But painters in the United States had little opportunity to make such a contribution. Neither the patrons nor the public showed any special interest in elevated paintings of history. In fact, lacking government commissions, there was the question of how an artist would manage, no matter what the strength of his convictions, to get his serious creations before the public. Some artists turned showman and arranged to have their large paintings impressively exhibited in public places with paid admission. There was precedent for this in England, and the practice was tried with no great success in France. As Trumbull foresaw in 1789, when he wrote to Thomas Jefferson that "the memory and enthusiasm for actions however great, fade daily from the human mind," the

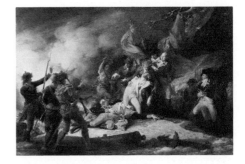

John Trumbull, *Death of General Montgomery in the Attack on Quebec,* 1788. Yale University Art Gallery, New Haven, Connecticut; copyright Yale University Art Gallery.

The rotunda of the United States Capitol, Washington, D.C. Trumbull's paintings were completed in 1824.

33

attraction of revolutionary scenes wore thin. In the 1820s one could see circulated in small towns and cities throughout the country William Dunlap's *Christ Rejected*, Robert Weir's *Paul Preaching at Athens,* Thomas Sully's copy of the French painter Granet's *Capuchin Chapel,* and a variety of other works. One of the most famous traveling pictures was Rembrandt Peale's *Court of Death,* painted in 1820, which toured the country for some years. The one major painting with a political subject was Samuel Finley Breese Morse's large *Old House of Representatives* (1822), filled with identifiable subjects and painted to give a fascinating effect of light. The public would have none of it. *The Court of Death* was clearly more fascinating than the United States Congress, no matter how well painted. Dependence on this showing on the road was risky; in some towns paintings drew enthusiastic throngs, in others the painter was treated with suspicion and could not even meet expenses. Taking historical art to the public made better theory than practice.

But the American public was still interested in portraits, and the painters coming back from England at the turn of the century had something new to contribute within the framework of this acceptable genre. No longer self-effacing limners, they brought with them a sense of their own genius, a belief that the portrait painter had something of his own to impart, manifest not only in his capacity to catch a likeness but in the very style by which he created the image. One mark of genius was facility, the brio with which the artist conjured from the paint a seemingly effortless evocation of personality. The artist's genius of transforming a common likeness into a painter's tour de force gave the sitter stature, in his own eyes as well as in the eyes of others, through the evident accomplishment of art. The master at this was Gilbert Stuart (1755–1828), who came back to America in 1793, after gaining notable success in England and Ireland, to paint the leaders of the new society. The likeness of George Washington, which he painted from life in Philadelphia, probably first in 1795, was his principal stock-in-trade for the rest of his life. He made three portraits of Washington from life, each of which was proliferated in a long series of replicas and in copies by other artists. Regardless of the many other likenesses,

Rembrandt Peale, *The Court of Death,* 1820. The Detroit Institute of Arts, Michigan; gift of George H. Scripps.

Samuel F. B. Morse, *Old House of Representatives,* 1822. In the collection of the Corcoran Gallery of Art, Washington, D.C.

34

some of which were considered to resemble the president far more closely, it was Stuart's rendering—especially his third type, the least particularized "Athenæum" portrait—that signified Washington to the public eye.

Stuart was striving not simply for a likeness, but for that fusion of facial particularity and generalized painterly form that would be an unchanging, timeless image of a great man. His final portrait is a curiously disembodied image; its power lies not in its reference to an individual who exists in a normal environment and is engaged in ongoing activity but in its inalterable formal integrity that cuts off all association with bodily activity or specific locale. The portrait is not just Washington, but Stuart's Washington, a pictorial conception made by an artist, created to live in the world of ideas.

Gilbert Stuart, *George Washington*, 1796. Courtesy of the Museum of Fine Arts, Boston, Massachusetts; on deposit from the Boston Athenaeum.

A Sense of Style and Its Classical Echoes

The artist's contribution through style, if not through allegory, was not reserved for the public hero. Not only were Gilbert Stuart's privately commissioned portraits often extraordinary characterizations, achieved by a catching suavity of brushwork, but others returning from England brought with them the fashionable English manner of painting. Young painters appeared in various parts of the country. Even Chester Harding (1792–1866), who boasted of being self-taught, a total product of local American genius, painted in a modest form of the English style well before he reached England in 1823. A high point in the fluid, winningly graceful manner was reached by Thomas Sully (1783–1872), who was born in England, brought up in the United States, and went to London to study in 1809. Much lighter and more lyrical than Stuart's, Sully's fluid brushwork, akin to that of Sir Thomas Lawrence, could transfrom even the most modest subject into an object of suave beauty. His soft transitions of light and shade surrounded his sitters with an air of poignancy and mystery, suggesting that the perfection of the moment was real but fleeting. His reality was far from that of the limners, or from the American works of Copley, in its persuasive suggestion of ideality, and it required a different judgment on the part of the viewer. His paintings had to be seen as subtle fabrications as well as fresh

Thomas Sully, *Lady with a Harp: Eliza Ridgely*, 1818. National Gallery of Art, Washington, D.C.; gift of Maude Monell Vetlesen.

35

visions of familiar forms. It was through the craft of genius that the language of forms could speak of perfect balance and harmony even with respect to everyday life.

The language of forms no longer seemed remote to the educated classes of the new republic. Judgments were no longer based on the identity of things and the assessment of isolated parts. One could speak of harmony and order whether treating of governments, city planning, or the visual arts, and order meant restraint and rationality. Simple forms relating to each other clearly in the creation of a structure whose harmony was more than the sum of its parts could be considered a visual paradigm for rational thought. If one believed in associationist theories, well ordered form might be considered the means for educating the mind to rational discipline. To the earnest theorists of the late eighteenth and early nineteenth centuries, a glowing model of just this identification between sensuous and moral order was to be found in the ancient world. As if in confirmation of their own aesthetic judgment, they summoned up the images of Greece and Rome to justify their taste and to add a useful, complementary iconography.

Of course there were other reasons for associating the American present with ancient Rome and Athens. Those who led the republic were educated through Latin literature and Roman history, so it is not strange that they should draw their images from the classical past. Among them were modern Ciceros, and the citizen soldier returning to his plow after righteous battle—an image deeply rooted in America—was a Cincinnatus. Thought of in this way, the local leader and the social program took on convincing authority. Although earlier towns had often been named in memory of places left behind, now they were likely to be named after great ancient cities. By taking the name Athens, Sparta, or Rome, even a modest settlement could surround itself with an aura of history and proclaim its belief in the new ideology.

Peculiar to this period—not only in America—was the combining of this identification with the ancient world and a particular aesthetic judgment, uniting taste with a widely held ideology and by extension with morality. The new concern for style—the language of form—and the use of classical reference went hand in hand. No

Calligraphy exercise from R. E. LaFetra, *R. E. LaFetra's System of Penmanship or Male Instructor, Designed for the Use of Writing Schools, Colleges, Academies, Common Schools, and Private Instruction.* Pekin, Ohio, 1852.

specific reference to ancient architecture or design was necessary to bring an object into this realm of association. A "republican" plainness and justness of proportion could make an unadorned sideboard into a proper moral lesson in taste. Only later, in the 1820s or 1830s, did historical reference separate itself from the chaste formal judgments of the turn of the century, calling more attention to historical associations than to the direct language of form.

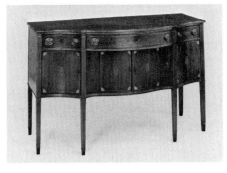

Sideboard, probably Connecticut, 1790–1810. Abby Aldrich Rockefeller Folk Art Center, Williamsburg, Virginia.

In architecture the way had been well paved for the consciousness of design by the interest in Palladian rule that grew through the mid-eighteenth century. The transition from this to an architecture of more subtly adjusted relationships and more directly classical reference was at first hardly discernible. By the end of the century, however, the program was conscious and its significance widely appreciated. An early, major protagonist was Thomas Jefferson, who had become fascinated with the new studies of ancient architecture in France and could easily bring the classical models into the fold of his Palladian taste. It was he, then minister to France, who arranged that the capitol building in Richmond, Virginia, begun in 1785, be based on the Roman temple at Nîmes. Much later, between 1817 and 1826, he saw his ideas of a didactic architecture carried out at the University of Virginia. The identification of the new republic with classical design was doubtless in part the result of his prompting, but there were others who also encouraged it.

Benjamin H. Latrobe, *Design for the Bank of Pennsylvania.* 1880. The Historical Society of Pennsylvania, Philadelphia.

Of particular importance in giving architectural form to the new taste was Benjamin Henry Latrobe (1764–1820), who came to Virginia from England in 1796 and helped out on Jefferson's capitol building in Richmond. There was nothing lingeringly Palladian in his Bank of Pennsylvania, built in Philadelphia between 1798 and 1801, nor is it a historical reconstruction. It is a happy union of taste and general historical reference, so well combined that it must have seemed to connoisseurs of the day more purely classical than any one actual classical building. Latrobe was a man of considerable culture and was able to defend eloquently the place of the arts in a republic, as he did at the opening of the Society of Artists exhibition in Philadelphia in May 1811. The proof, he said, that art and democracy are

compatible was Greece. "But to explain the source of her eminence," he continued, "few words are sufficient: *Greece was free.*" Art that reflected Greece, then, was not only a contribution of beauty but a symbol of freedom, a fitting model for America. Furthermore, because they were based in a free society, the arts in America had the possibility of reaching heights like those attained in Greece. In fact, it was America's obligation to restore art to its former grandeur, to become the counterpart of ancient Greece in the modern world.

The most obvious expression of the belief in symbolic order, even when not closely linked to the ancient world, was the plan for the capitol of the United States. Drawn up by the French engineer Major Pierre Charles L'Enfant in 1791, it reflected both the practical thinking of a military man planning for defense and the concepts for utopian cities such as those devised by the French architects Claude Nicolas Ledoux and Etienne-Louis Boullée. Every function and agency of government was to have its place, clearly symbolized by a major building and existing in symbolic relationship to each other. It was to be a city in which rationality predominated over chance, and in which beauty would be the companion, if not the product, of function. However, when actual construction began in the city, rationality was outstripped by opportunism, administrative bungling, and indecision. Furthermore, the variety of designs submitted in the competition for the Capitol clearly indicated that not all American designers had been persuaded by the symbolic virtues of classical design or the republican virtues of simplicity. As the building actually evolved through the endeavors of several architects, it was finally Latrobe's classical taste, more than any other's, that served as a unifying force in its design. He expressed his belief in the identity of the ancient and modern worlds by designing some classical capitals decorated with American tobacco and Indian corn.

Architects and artists flocked to the new symbolic capital of the country, vying for commissions from Congress to give artistic body to the heroic acts and noble concepts. Architects, on the whole, did better than local artists. Italian sculptors, among them Giuseppe Franzoni and Giovanni Andrei, who were brought over in 1806, carved marble decorations for the Capitol, and

Pierre Charles L'Enfant, Detail of *Plan of the City of Washington,* 1791 (engraved 1886). The National Archives, Washington, D.C.

Benjamin H. Latrobe, *Presentation Drawing of the United States Capitol,* 1806. Library of Congress, Washington, D.C.

Luigi Persico supplied some of the freestanding sculptural work as well as decoration. Their work was in style and ideological direction quite suitable, but, as was acidly pointed out at the time, theirs was hardly a creation of free American genius. Not until 1832 was an American sculptor given a commission by Congress; this went to Horatio Greenough for his monumental seated statue of Washington, intended for the rotunda of the Capitol. For the most part, painters and sculptors had to put aside their classical aspirations, to be content with making portraits of government leaders in the hope that the statesmen's families and admirers would want replicas. The proliferation of public figures in the United States was in itself a stimulus to painting and sculpture; but, as artists more and more complained, it was a stimulus only to the painting and sculpting of portraits.

Samuel Seymour after Thomas Birch, Certificate of the Society for the Relief of Distressed and Decayed Pilots, circa 1810. The Library Company of Philadelphia, Pennsylvania.

Popular Imagery: The Graphic Arts and Sculpture

One art that grew under the impulse of the Revolution and its need for popular symbols was printmaking, which furnished the means of impressing popular images, like the face of Washington, on a wide public. In a short span of years, from Henry Pelham's and Paul Revere's desperate and much-repeated engravings of the Boston Massacre in 1770 to the accomplished prints of American heroes produced from the 1780s on, engraving had made an extraordinary jump in sophistication.

The engravings, meant for a wide audience, demonstrate more openly than paintings the symbolic thinking that supported heroic images of still-living men as well as a panoply of allegorical representations. Through the earlier eighteenth century, engraving was undertaken in the colonies chiefly for maps and occasional city views. Printing facilities were limited, and large plates had to be executed abroad. The Revolution, however, brought a whole new demand for engraving of various kinds, and English-trained engravers or their locally trained students developed a high degree of efficiency. Since much engraving had to do with official matters—bank notes, organizational certificates, and so forth—it is not surprising that the artists were encouraged to employ the symbolic style and language that stood for society as a whole. The engravers perpetuated the images of Columbia, Freedom, Justice, and such, and were adept at

showing a classically garbed America blessing science, commerce, or the arts. By picturing these national goddesses in an elevated, graceful style, the trade card for a common manufacturer could add an aura of permanence and national significance to his humble activity. Insurance certificates granted by a suave group of classical virtues, rather than simply by a financial organization, were more comforting, since the image suggested both the stability of the government—identified with the abstract qualities personified by the winsome ladies—and the permanence of the classical, ahistorical world.

John James Barralet (1747–1815), who came to Philadelphia in 1795 after a career in Dublin and London, was particularly successful at supplying convincing designs from the allegorical world. His certificate for the Hibernian Society, for example, gives Charity—and the state of Pennsylvania—a dignified, official stature with no taint of humiliating condescension. Nothing could be more official than bank notes, and their finely engraved designs spoke only the language of classical virtues and harmoniously depicted personifications. In this context the likenesses of governmental heroes range from the more or less factual to the frankly transcendent. Even the profile engravings by the French exile Charles B. J. Fevret de Saint-Mémin, although recorded with the deadly mechanical accuracy of a copying device called the Physiognotrace, suggest a classical world by their cameolike isolation. Robert Field's engraving of George Washington as president, after a design by Barralet, engulfs the literal likeness of the man in a proliferation of patriotic symbols. The engraver's art seemed freer than painting in slipping into the realm of ideality, whether in style or in allegorical appendages.

On the death of George Washington in 1799, the power of the symbolic image propagated by engravings was especially evident. Classical virtues in Arcadian groves were depicted weeping over Washington's tomb, and John Barralet showed the hero being translated to heaven in the presence of various mourning figures, including the American eagle and an Indian. Washington, shown as in Stuart's Athenæum portrait, seems no less a personification than the others. The memory of Washington seemed justly placed in an abstract world.

Although painters were denied the opportunity of

H. H. Houston after John J. Barralet, Certificate of the Hibernian Society, circa 1796. The Historical Society of Pennsylvania, Philadelphia.

Robert Field after John J. Barralet, *George Washington*, 1793. The Historical Society of Pennsylvania, Philadelphia.

projecting their great historical and moral concepts to mural size, the elevated style and its classical imagery was carried to the public through the graphic arts. In a way this humble means effected a more widespread and democratic diffusion than would have been possible with monumental painting, even if the paintings were exhibited from town to town. Certainly the engraved images influenced how the individual saw the young culture of which he was a part, creating a common vision that had nothing to do with locale or national origins. The world depicted by the graphic artist, elegant and rhythmic in style and classically simple in its generalizations, served as a liberating complement to the pragmatic, mercantile environment in which most people found themselves.

Another quite unexpected area in which symbol and allegory were accepted with complete ease and touching faith was carved wooden sculpture. This was not sculpture in any elevated sense, but that which supplied figureheads for ships, emblems for shops—especially tobacconists—and other useful monuments. Out of this relatively humble activity emerged an extraordinary sculptor, the carver William Rush (1756–1833) of Philadelphia. He early supplied the fierce American eagles that were much in demand and produced the handsomest figureheads carved in America, as well as an occasional portrait bust. In 1808, using much the same imagery as the printmakers, he created larger than life-size figures of Comedy and Tragedy for the Chestnut Street Theatre in Philadelphia and followed these with his famous *Water Nymph and Bittern* for the fountain in front of Latrobe's waterworks. His vigorous standing figure of Washington, so different from Houdon's figure in Richmond, was carved in 1814. Possibly his most remarkable allegorical works were the two pediment figures carved for the entrance to the millhouse of the Fairmont waterworks in 1825. *The Schuylkill Chained* is particularly remarkable for its rather tortured anatomical modeling. These vigorous works that show so well the popularization of allegorical rhetoric in America were carried out at the same time that Italian marble carvers were producing the decorative symbolic figures for the Capitol in Washington. A comparison of the traditional and the naturalized style is instructive.

John J. Barralet, *Sacred to the Memory of Washington,* circa 1800. The Historical Society of Pennsylvania, Philadelphia.

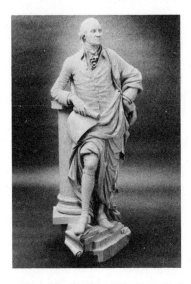

William Rush, *George Washington,* 1814. Independence National Historical Park Collection, Philadelphia, Pennsylvania.

Rush was accepted as a serious artist in the art circles in Philadelphia, serving with Charles Willson Peale as one of the two artist members on the first board of the Pennsylvania Academy of the Fine Arts. It was publicly regretted, nonetheless, that he had not had the advantages to become a "high" artist working in marble. Producing as he did in a popular idiom, however, supplying a whole range of sculptural needs, Rush probably had greater impact on the vision of his contemporaries than he would have had operating in the newly rarefied atmosphere of the fine arts.

The Institutions of Art

Even though the serious painter may have been forced to devote himself to painting faces, in the years following the Revolution the fine arts had grown in magnitude and stature. The public might be whimsical in its appreciation, but art had begun to take its place in society. Doubtless because of the new conception of art associated with Benjamin West and the activity of artists in England, well-educated young men of impressive intellectual curiosity were being attracted to the field. John Trumbull was a college graduate; Robert Fulton, who went to London in 1786, was torn between engineering and painting and turned to his inventions full time only after developing into an accomplished portrait and miniature painter. A somewhat unlikely forerunner of these educated men with their elevated notion of art was that most fascinating example of the artist as inventor, educator, and practical scientist, Charles Willson Peale (1741–1827).

Peale, who was born in Maryland, had little formal education but a strong inclination to learn. He read widely, but he was practical, not theoretical, and once he had mastered art in his own way he set about devising ways of teaching it. He taught his brother James to paint, as well as four of his sons, whom he had named for great painters of the past, and thus founded a kind of artistic dynasty in Philadelphia. As a young man, having learned to paint chiefly by his own efforts, he was sent to London in 1766 by local subscription and spent three years trying to absorb the higher principles of art. Although he respected high art, his own practical nature barred him from its graces, and his painting remained

literal in detail even when he adopted the generalized forms and oval countenances of academic models. He was a man of infinite ingenuity whether in creating moving transparencies, fireworks, or such delightful tours de force as *The Staircase Group* (1795), which, though not elevated in taste, made art enjoyable to a public not comfortable with classical armor and draped togas. As Peale understood it, art was for everybody, and any alert person who put his mind to it could be an artist. This attitude conflicted with the recently accepted notion of the artist as genius, but it was to simmer in America and serve as the basis for various later schemes of public education.

During and after the Revolution, Peale became a major portrait painter. He painted Washington from life several times between 1772 and 1795 and began his gallery of famous men, which he opened to the public in 1782. In 1786 he opened his museum in Philadelphia, displaying specimens of natural history, curiosities, and works of art. Having been in London at the founding of the Royal Academy, Peale was eager to establish a similar organization for the arts in Philadelphia. He succeeded in gathering a group of thirty artists in 1794 to form an "American Academy of the Fine Arts" called the Columbianum, and the group sponsored an exhibition in May 1795. It is significant that there were enough professional artists, foreign and native-born, in Philadelphia at the time to support such an activity. There were more than 130 works in the exhibition, which included architectural and engineering designs as well as paintings, sculpture, and drawings. Yet the artists turned out to be rivals more than fellows, and the Columbianum was torn by dissension from the beginning. By the end of 1795 it was no more.

In the thinking of social leaders, however, the time was right for institutional support of the arts. They looked upon the matter in a rather abstract way, seeing art as a moral force in the community and accepting responsibility for creating institutions that would support artistic activity, safeguard its moral stature, and make it available to a public that would benefit from its elevating effect. Although artists were a necessary element in this scheme, such an institution was not to be left to their discretion. The intellectual leaders of the com-

Charles Willson Peale, *Staircase Group,* 1795. Philadelphia Museum of Art, Pennsylvania; George W. Elkins Collection.

munity were responsible for art's proper place in the fledgling democracy. In 1802 a group of serious-minded, well-placed citizens in New York banded together to found the New York Academy of the Fine Arts, chartered in 1808 as the American Academy of the Arts. Robert Livingston undertook to have casts made in France of the most famous antique sculptures—most of which were in Paris, having been taken from Italy by Napoleon—and had them sent to New York as inspiration for artists and the public. In 1803 these models of perfect style and expression were put on display and for a short time caught the public interest.

Meanwhile, inspired by New York, a similar group of leaders in Philadelphia determined to organize an academy, and so the Pennsylvania Academy of the Fine Arts was founded in 1805 and chartered in 1806. A proper building of classical taste, somewhat in the style of Latrobe, was designed by John Dorsey and opened to the public in 1807. One of the first acts of the academy board was to order the necessary plaster casts from Paris so that Philadelphia's amateurs and artists could begin with the same principles as their colleagues in New York.

Although the casts in New York and Philadelphia were made available to art students, they were by no means intended for their exclusive use and were often inaccessible. Furthermore, the artists had no say in the academies' annual exhibitions, which included a heterogeneous collection of works, including those purchased abroad by amateurs. Not surprisingly, the artists found this treatment inconsistent with their new consciousness of their role as the founding geniuses of American art and felt it was helpful neither to their training nor to their market. In 1810 the Philadelphia artists organized the Society of Artists of the United States and held their own exhibition in 1811. The next year the Pennsylvania Academy elected twenty-four artists to be academicians and began to take greater interest in operating a school. Classes were instituted and provisions were made for artists to study. The original building was soon expanded, a collection of significant works began to accumulate, and Philadelphia became the proud possessor of the major center for art in the United States.

Benjamin Tanner after John J. Barralet, Building for the Pennsylvania Academy of the Fine Arts, 1809. From the *Port Folio*, n.s. 2 (1809).

44

The American Academy in New York, faced with similar problems regarding the needs and desires of artists, fared less well. Support was not consistent, and the patrons' interest lagged. Colonel Trumbull, who considered himself the only gentleman artist in the city, took charge in 1818, but the artists—a growing number, competently trained—were dissatisfied, as were the young who needed academy resources to advance their careers. In 1825 the artists formed their own organization for drawing classes and exhibitions, which in 1826 took the title National Academy of Design. Both the Pennsylvania Academy of the Fine Arts and the National Academy of Design have continued in operation to the present.

Through the early years of the century, many cities began to consider supporting the fine arts, but talk was more abundant than accomplishment. In Boston, gentlemen associated with the Athenæum, founded in 1804, thought about their responsibilities toward the arts but did little other than acquire a group of plaster casts until they built the Athenæum Gallery in 1826. The first regular Athenæum exhibition was held in 1827. The Peale family early operated a museum in Baltimore that showed curiosities and specimens of natural history as well as art, much like the elder Peale's museum in Philadelphia. From early in the century there was talk of founding a national gallery in Washington, but the burden of collecting and exhibiting was carried by individuals until the National Institute opened its gallery in the new Patent Office in the 1840s.

In addition to the budding institutional concern for art, private drawing schools became available in increasing number, not only catering to those of genteel interest but affording serious students a chance to develop rudimentary academic skills before they undertook an apprenticeship or daringly entered on a practice of their own.

In the last decade of the eighteenth century and the first two decades of the nineteenth, the entire complexion of art in the United States had changed. The artists saw glimmerings of a new place in society, and the cultural leaders had come to accept art as a permanent and valuable element in the life of the country. The technical level achieved by painters and graphic artists was now

respectably high; only sculpture had been given little chance to flourish. Yet to assume that the American public was ready to embrace the arts with the fervor recommended by Benjamin Latrobe and other proponents of the arts in a democracy would be to err. The artist still had many struggles to face.

The Art of Recording America

The View Painter

While some artists were concerned with elevated content and the language of style, others set their sights on less elusive goals. There were, for example, artists who were chiefly occupied in recording what they saw and personally knew—the view of a city, boats in a harbor, or a notable spot in the countryside. Since their concern was more for things than effects, they worked in a highly detailed manner, as if the dimensional definition of a thing was a form of proof. Many had in mind the possibility of engraving, another reason for precision, but they saw themselves principally as recorders, not creators, and adopted a commonsense test for truth.

In England from rather early in the eighteenth century, there was interest in recording country estates and, eventually, picturesque spots. Painters who specialized in this kind of work were called view painters, to distinguish them from landscape painters, a term reserved for a more expressive kind of art. This tradition made its appearance in America late in the eighteenth century, often represented by painters from abroad.

Some painters, such as William Groombridge (1748–1811), who came to America from England about 1793, divided their time between "fancy pictures" and scenes of actual places, employing the kind of stylized trees and rocks that appeared in drawing books of the time. (Fancy, in this use, should be understood as related to fantasy.) Others, like William Birch (1755–1834), who came to Philadelphia from London in 1794 (he was most noted for his enamel paintings), concentrated on more exacting city views. Birch's son Thomas (1779–1851) followed in his father's footsteps so far as detailed procedure was concerned but became famous for his marine paintings, a genre that had great popularity

William Groombridge, *Fairmount and Schuylkill River,* 1800. The Historical Society of Pennsylvania, Philadelphia.

Thomas Birch, *Perry's Victory on Lake Erie,* circa 1814. Courtesy of the Pennsylvania Academy of the Fine Arts, Philadelphia; gift of Mrs. C. H. A. Esling.

along the northeastern coast. He combined some of the natural drama and atmospheric effects of seventeenth-century Dutch paintings with a sharp rendering of nautical detail, producing luminous works that would please both the specialist in art and those who had a keen eye for the American sailing ship. The importance of the shipping and shipbuilding industries and the growth of an American navy gave particular significance to paintings that recorded America's growing importance on the seas. Well-known vessels were painstakingly recorded in "portraits" much as were prized racehorses. A conservative tradition of rendering was established that persisted through much of the nineteenth century.

In Boston, Robert Salmon (ca. 1775–1843) came from England in 1828 and carried on the tradition on a more sophisticated level, bringing to his views of Boston harbor and ships at full sail a luminosity that suggests the radiant skies of the seventeenth-century painter Claude Lorrain. Yet he was careful to depict his visual facts with unerring exactness.

"To the pencil," wrote the editor of the *Port Folio* of Philadelphia in 1809, "our country affords an inexhaustable abundance, which for picturesque effect, cannot be surpassed in any part of the old world." He then invited artists and amateurs to submit sketches of local scenes that could be reproduced, with descriptions, in the *Port Folio*. This interest in the depiction of place remained something of an obsession with those artists who shared the American pride in the growing cities and harbors of the United States and the picturesque aspects of its nature. Many artists, such as Barralet, took time away from other activities to represent in detail the areas where they lived. Thomas Doughty (1793–1856), who eventually became a more self-conscious landscape painter, first made his way as a painter of views. This concern for place was not purely American. English artists not only were busy recording ruins and vistas in their own country but were painting and publishing views of European cities and picturesque Continental and Mediterranean sites. Thus it was natural for English view painters and engravers who came to the United States to set about depicting the best local views that the country then had to offer.

This activity of the view painter gave impetus to an

ambitious publication produced in Philadelphia in 1820–21. *Picturesque Views of American Scenery* was the result of a collaboration between two English artists and two American publishers—first Moses Thomas, then Matthew Carey. With few exceptions the views were drawn by Joshua Shaw (1777–1860), who came from England in 1817 accompanying West's painting of *Christ Healing the Sick in the Temple*, which West had painted in 1815 for the Pennsylvania Hospital. The aquatints were made by the accomplished engraver John Hill (1770–1850), who came from London in 1816. Although Shaw's drawing technique was rather mannered, he had a fine sense of the dramatic, and the resultant aquatints, superbly produced and hand-colored, were an inspiration to artists and collectors. The series was to include thirty-six plates, but the luxurious and expensive publication was stopped after twenty because of disappointing sales. A new edition came out in 1835, however, attesting that by then there was a wider public interest in landscape. Hill's magnificent *Hudson River Portfolio*, with aquatints based on drawings by the English artist William Guy Wall, was published in New York in 1827 and was widely acclaimed. Meanwhile Hill had published a *Drawing Book of Landscape Scenery* (1821) in response to a growing interest in recording American scenery. "Taking" a view became almost as important as "taking" a portrait. Every city had its view taken. Francis Guy (ca. 1760–1820), an Englishman who settled in Baltimore about 1800, decided to record the city as seen by a city dweller, not as viewed from a distant height. Moving to Brooklyn in 1817, he painted his well-known views of that city in such a way as to be recognizable to everyone who had passed through its streets.

Although they did not discuss the elaborate theories of art that interested some other artists and amateurs, these painters, concentrating on what they were looking at rather than on style, often produced refreshing works of impressive artistic quality.

Flora and Fauna

Akin to interest in the local scene was the close study of American nature. Ever since the discovery of America, European scientists had been fascinated by its flora and fauna, much of it unrelated to that they knew.

John Hill after Joshua Shaw, *Falls of St. Anthony on the Mississippi,* from *Picturesque Views of American Scenery,* 1820–21. The Metropolitan Museum of Art, New York, New York; gift of Henry C. Pelton, 1945.

Alexander Lawson after Alexander Wilson, *Pinnated Grous, Blue-Green Warbler, Nashville Warbler,* from *American Ornithology,* 1808–13. National Collection of Fine Arts, Smithsonian Institution, Washington, D.C.; museum purchase.

Throughout the eighteenth century, scientific or philosophical societies were formed in the colonies to encourage investigation and to keep abreast of activities in European academies. For a close study of the birds and beasts of the continent, the ideal person was the kind of artist naturalist who appeared in the United States at the turn of the eighteenth century. Alexander Wilson (1766–1813), a troubled Scotsman who had come to America in 1794, turned his attention to the birds of America, and between 1808 and his death in 1813 provided the plates for the extraordinary publication *American Ornithology*, published by Bradford and Inskeep in Philadelphia. The plates, which were engraved, then colored by hand, were the result of intensive study and were drawn with astonishing meticulousness. Too busy to worry about whether his drawings were artistic or not, Wilson often created plates of great charm and occasional beauty, successful possibly because of his unselfconscious concentration.

Motivated by the same driving desire to know, John James Audubon (1785–1851), far more self-assured than Wilson, gave the study of nature a new excitement and brought American art to a new level of beauty. Audubon was brought up in France and he came to Pennsylvania in 1803. Although initially engaged in a variety of pursuits, he soon settled down to study and draw the birds and animals of the area, first in Pennsylvania, then in the upper Ohio Valley. He was an expert woodsman and traveled widely, never failing to record what he saw in word and image. As early as 1820 he decided to try to publish his studies of birds, but he found no support for his work in the United States. Wilson's work, of which Audubon was contemptuous, had preempted the scene. Nonetheless, he prepared his drawings for publication and in 1826 took them to London. There he was well received and his plates were expertly engraved, mostly by Robert Havell. The first of his many volumes was published in 1827.

Audubon rendered his subjects with evident sympathy, showing them in characteristic action and in appropriate surroundings. He had a sharp sense of drama and often seemed to identify with the creatures he depicted. But besides being an exuberant explorer and a careful naturalist, Audubon was an able painter

John James Audubon, *Common Raven*, 1829. Courtesy of the New-York Historical Society, New York, New York.

and a sensitive artist; each of his plates, some of which he developed into paintings, is approached as a joint problem of drama and design.

With the publication of his works, Audubon became famous throughout the United States and was enthusiastically supported in his further explorations. The concept and image of American nature was quite changed by Audubon's extraordinary capacity to turn a naturalist vision into a means for art.

The Native Inhabitants

The restless desire of artists to explore and record the particularities of America, whether its growing cities or its abundant wildlife, was part of a larger tendency to want to know more about the continent on which the new country was now firmly established. Expeditions were launched in all directions to explore, measure, and study the character of the country. With the Louisiana Purchase in 1803, the boundaries of the country were vastly expanded, and Lewis and Clark's journey to the Oregon Coast in 1804–6 excited the imagination of artists as well as explorers. Although draftsmen accompanied many expeditions, not much that could be classed as art was produced before midcentury. The United States Military Academy, established at West Point in 1802, eventually included drawing as well as topographical drafting in its curriculum, and some of the recording of far-flung posts was carried on by the army itself. Until 1849, Indian affairs were handled by the War Department, and under Thomas L. McKenney, Charles Bird King (1785–1862) was hired to record the likenesses of prominent Indians between 1821 and the early 1830s. King, a well-trained painter who had studied in London from 1805 to 1812, did not seek out his subjects on the frontier but painted them on their visits to Washington, where for many years he maintained a studio and gallery. Seth Eastman (1808–75), however, entered West Point in 1824 and studied topographical drawing, then remained in the army and went west to Fort Snelling, Minnesota, in the 1830s. Stationed there for some years in the 1840s, he recorded not only panoramic views of the countryside and army installations, but also the life of the Indians, whose habits he recorded in careful detail. His knowledge he used in

Charles Bird King, *Young Omahaw, War Eagle, Little Missouri, and Pawnees,* 1821. National Collection of Fine Arts, Smithsonian Institution, Washington, D.C.

illustrating some of Henry Rowe Schoolcraft's influential studies of the Indians, which were published beginning in 1851.

John Mix Stanley (1814–72) also worked around Fort Snelling in Minnesota and toured the western area recording the Indians. In 1852 he placed 151 of his Indian paintings on loan to the Smithsonian Institution for exhibition in its new building. He hoped that they would be purchased by the government, but instead almost all of them were destroyed in 1865 by a fire that also burned most of the original Indian portraits by Charles Bird King.

Rather less concerned with detail than with the whole picturesque scene, Alfred Jacob Miller (1810–74), who came from Baltimore and had studied in Europe in the 1830s, went west to the Rocky Mountains with the Scotsman Captain William Drummond Stewart in 1837 to record the landscape and its native inhabitants on commission for that gentleman. The quickly brushed impressions he recorded on the spot he later translated into full-scale paintings in the early 1840 at the home of his patron in Scotland.

The man most devoted to recording the features and activities of the Indians, however, was George Catlin (1796–1872). Impressed by the Indians he saw on their visits to Philadelphia, he determined to capture their likenesses on canvas before they had been completely degraded by their contact with the aggressive European culture. Like Audubon (who did not, however, think much of Catlin's work), Catlin preferred to study his subjects in the natural environment. He spent some eight years, beginning in 1830, traveling through the country and living with Indians, painting their portraits and depicting their domestic life, their games, and their rituals. He had a high regard for his subjects and preferred life among them to a settled existence in the eastern cities. Catlin was unsuccessful in persuading the government to buy his paintings and in 1839, accompanied by a group of Indians and a collection of Indian artifacts, he took his "Indian Gallery" of 507 paintings to England and later to France, where they were received with great enthusiasm.

Not the least of Catlin's works were his landscapes, some topographical and others painted to catch the ef-

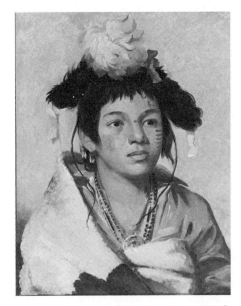

George Catlin, *Great Chief*, 1831. National Collection of Fine Arts, Smithsonian Institution, Washington, D.C.

fect of light on the prairies and the atmosphere of the unspoiled plains. "His skies, especially," wrote Baudelaire in 1849, "have impressed me because of their transparency and lightness." Baudelaire's high praise of Catlin as a painter was not typical. Until recently, Catlin was looked upon more as an ethnologist than as an artist, since his works were so little related to the various ideals sustained in more self-conscious realms of art. To the modern eye, however, his absorption in and complete sympathy with his subjects and his spontaneity in setting down their images, allowed him at his best to create paintings whose freshness and intensity make them far more appealing than many more highly praised works of his time. Like many of his colleagues who were devoted to studying and recording specific aspects of the American world, he was too busy to think much about the aesthetic obligations of art and so escaped the traps of styles and theories that led many of his contemporaries into unproductive byways.

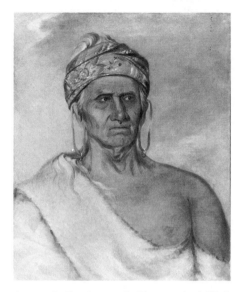

George Catlin, *Goes up the River, an Aged Chief,* 1830. National Collection of Fine Arts, Smithsonian Institution, Washington, D.C.

Europe and the Great Tradition

One of the reasons given for establishing the academies in New York and Philadelphia was that artists would no longer have to go abroad for their training. At the beginning of the century Americans were already suspicious of European morals and social values, and moralists feared art could fall into licentious ways, having an evil rather than an elevating effect on the susceptible public. The danger was made more palpable by the exhibition of some foreign works, especially those showing the female nude. The accomplished Swedish painter Adolph-Ulrich Wertmüller's *Danaë and the Shower of Gold,* shown in Philadelphia in 1806, produced more shock than praise (though it earned him a sizable sum of money), as did the French-trained American painter John Vanderlyn's *Ariadne Asleep on the Island of Naxos,* which he showed in New York in 1815. In 1832–35, Claude Marie Dubufe's paintings *The Temptation* and *The Expulsion* toured the country and were considered more as a peep show than as art, provoking the indignation of the keepers of public morals. Although the much-sought-after casts of antique sculpture were accepted as elevated art, they were eventually shown during sepa-

rate hours for men, women, and families. The American public was asked to distinguish between an abstract realm of beauty and the context of everyday life—a distinction it was reluctant to make when certain delicate matters such as nudity were involved. Although political abstraction and its related allegories could coexist with a mundane reality that was sometimes in open conflict with high-minded idealism, there was resistance in the moralists' minds to accepting the sensuous aspect of man as having existence in other than the material world. As late as 1843 an anonymous critic wrote:

> Long, indeed, may it be ere the walls of our popular
> Academy shall be disgraced with the Ledas, and the
> Cyprian Venuses of heathen mythology, or the
> Potifar's wives, the Susanna and the Elders, and
> Lot and his Daughters of sacred history, or even the
> "moral pictures" of Adam and Eve, or any other
> hypocritical cover to a licentious conception. . . . Long
> may it be before the toadies of foreign slander shall
> shame us out of one of the most honorable traits of
> our national character. [*New World* 6 no. 19 (13 May
> 1843): 577]

Many Americans were convinced that Europe was in a state of decay and that it was America's responsibility to regenerate Western culture and save it from complete moral degradation. There were Europeans who, from the late eighteenth century, were also alarmed by what they saw as a debased, secularized society that had lost its sense of moral values and human worth, but the views held in the United States did not spring, at least initially, from the European reform movements. They were rooted in part in the still-strong Puritan tradition and in a middle-class suspicion of everything that had characterized the monarchical society of Europe; Americans liked to believe that their culture was based on reason, high-minded principles, and what came to be thought of as native common sense.

The artist who was imbibing the heady nectar of academic theory was placed in an awkward position. His desire to become part of the great tradition of art, to feel kinship with the old masters, was continually frustrated by a local taste that rejected as false, for reasons quite other than aesthetic, some of the very means by which he would achieve his goal. Inevitably, a split developed

in the critical basis for the arts. Some believed that art must be rooted in its country of origin and that a work should be judged by how well it reflected local values. Art created in accordance with European standards was the "legitimate fruit of the school and skies of other nations," said a commentator in the *Bulletin of the American Art Union* in May 1851. Others believed that artistic values were universal and had nothing to do with national limits or the artist's paternity. Art belonged to humankind as a whole. Although the controversy raged most furiously in the field of literature, it was also central in discussions of the visual arts. Collectors were avid for works they thought were old masters and commissioned artists to make copies of major paintings in the galleries abroad; but not all of the public was ready to accept exercises in this tradition by their own painters. Why should an artist, it was argued in the *Bulletin*, "ruin all his pictures by going back to subjects with which neither he nor his age had any sympathy?"

The artists who worked abroad did not consider themselves any less American than those who stayed home to respond to local scenes. They simply regarded their American responsibility differently. Their acceptance as artists on a universal basis, they contended, brought credit to America, proving that the democratic American society could produce artsits whose stature could affect the course of world art. They maintained that because of their free background they could advance the tradition begun in Europe beyond the possibilities of the European artsit, who was struggling to fight off the deadening effects of his exhausted environment. Others, however, with no less pride in American genius, believed that the artist must work within the character and comprehension of his own society. Speaking to the Artist Fund Society in 1840, the cultivated Reverend Mr. Bethune told the assembled artists, "You must make us feel art, and afterwards we shall be glad to hear homilies upon taste." What was it that would make Americans feel art?

American Artists in France and Italy

The American artists who went to Europe to realize their artistic goals in the early years of the nineteenth century had more expansive ideas of art than those who earlier had gone to Italy or had studied in London

under the guidance of Benjamin West. They were less concerned with rapidly acquiring the technical capacity that would allow them to earn a living at home and more inclined to linger on the Continent to absorb an atmosphere quite different from what they had known in America. Although London remained a base of operations for some years even in spite of political difficulties, France and especially Italy attracted artists for longer sojourns. By the late 1830s Italy, not England, had for some time been the center of American artistic activity abroad.

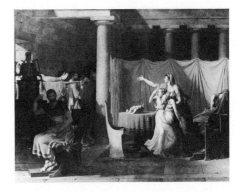

Jacques Louis David, *Lictors Bringing to Brutus the Bodies of His Sons,* 1789. Musée du Louvre, Paris.

Unlike most of his fellows, John Vanderlyn (1775–1852) went directly to Paris to study in 1796, assisted by Aaron Burr. He received a thorough training in the studio of François-André Vincent and absorbed, moreover, the classical ideals of the other strongly motivated painters around David. The American group in Paris included Joel Barlow, for whose epic of America, *The Columbiad,* Vanderlyn painted his *Death of Jane McCrea*, shown at the Paris Salon of 1804. The American subject is given the same kind of tragic sublimation found in Jacques Louis David's *Sabine Women* and *Brutus.* The forceful tectonic composition is quite different from the constructions of West and other painters in England. For the most part, however, Vanderlyn's thought took form not in American subjects but in the images of antiquity. In Rome in 1806–7 he painted a large canvas, *Marius amidst the Ruins of Carthage,* which was commended when shown in Rome in 1807 and received a gold medal from Napoleon when shown in the Paris Salon of 1808. Again it is a brooding, somewhat remote image, in a vein that David would consider philosophical. For the American public, at least, the classical remoteness was shockingly betrayed in his languid *Ariadne Asleep on the Island of Naxos,* painted in Paris, where it was favorably acclaimed, and shown in New York in 1815. Vanderlyn was quite aware of the American public's expressed horror of nudity and also of its willingness to pay an admission price to be offended by it. He painted something "in the female, to make it more engaging to the American spirit." Although the *Ariadne* was the finest academic painting of a nude produced by an American thus far, it gained Vanderlyn much notoriety but little money.

Vanderlyn was concerned with the public but looked

John Vanderlyn, *Marius amidst the Ruins of Carthage,* 1807. By permission of the Fine Arts Museums of San Francisco, California; M. H. de Young Museum.

55

upon its taste with a combination of irony and business appraisal. He had a special building constructed in New York, called the Rotunda, for the display of a panorama of Versailles, thinking the public would flock to enjoy the privilege of walking, in effect, through those matchless gardens, and there he also hung the *Marius* and the *Ariadne*. The idea for showing an encompassing panoramic view of a city was first exploited by the Englishman Robert Barker beginning in 1788, and his method was widely imitated in the United States as well as abroad. The concept was taken to France by the American painter and inventor Robert Fulton, who painted a panorama of the burning of Moscow that he showed in Paris in 1800 in a building of his own ingenious design. The venture was exceedingly profitable, and Fulton and his friend Joel Barlow took out a patent on their particular form of presentation, which Fulton later sold to get money for his other ventures. In New York a local critic remarked in 1818, while Vanderlyn's building was being erected, that views of American battles would probably be more in accordance with local taste. Possibly he was right. Unlike Fulton's panorama in Paris, Vanderlyn's effort to meet the people on their own level was a failure and eventually reduced him to bankruptcy.

It has often been remarked that had Vanderlyn remained in Paris he would have had a far more successful career; yet he always thought of himself as an American painter and was determined to make his mark in the history of his own country. Finally in 1842 he was commissioned to paint *The Landing of Columbus* for the rotunda of the Capitol. By then he was a bitter, frustrated man and his work had lost much of the quality that had earned him a reputation as a rising star in Rome and in the Paris Salons. His most momumental work gives little hint of his original promise.

A few years after Vanderlyn went to Paris, Washington Allston (1779–1843) from Charleston left Harvard to go to London. There in 1801 he was much impressed with West's mysterious and expressive later works and with the English painters of the sublime, such as the imaginative Heinrich Füseli. In 1803 he toured the Low Countires with Vanderlyn, settled in Paris for a while, where he showed his very Dutch *Rising of a Thunderstorm at Sea* at the Salon of 1803, and then, at the end

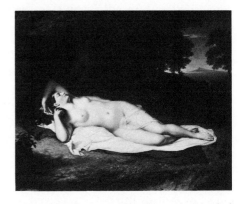

John Vanderlyn, *Ariadne Asleep on the Island of Naxos,* 1814. Courtesy of the Pennsylvania Academy of the Fine Arts, Philadelphia.

of 1804, set out for Rome. There he quickly adopted the mode of classical landscape painting then current, championed by popular painters such as the Frenchman Nicholas Didier Boguet, the Scotsman George Wallis, and the Germans Johan Christian Reinhart and Joseph Anton Koch. When in 1806 he showed his classical landscape *Diana in the Chase* in his studio in Rome, it caused enthusiastic comment for its freshness of rendering and novelty of style. As impressed with the Venetians as he was with Raphael and Poussin, Allston was already developing the technique that would make him famous in the United States as a colorist.

In Rome, Allston spent considerable time with young Washington Irving, who had seen much of Vanderlyn in Paris, and late in 1805 he became a close friend of the English poet Samuel Taylor Coleridge. Allston and Coleridge found that they had many ideas in common, each recognizing the deep intuitive content in art. Rome, seen not as a classical city but as a mellowed spokesman for the persistence of spiritual values through art, made a lasting impression on Allston. When he returned to the United States for good it was not to paint stirring patriotic scenes or perfectly proportioned academic nudes but to represent both in his life and in his art the artist seer. He believed it is the artist's responsibility to put the public in touch with the deep, mysterious strain of poetry that spoke through the age-tempered art of the past and, by extension, through that contemporary art that has been steeped in tradition.

Before settling in Boston in 1818, however, he went to England again in 1811 (he had returned home from Italy in 1808), where he painted his huge *The Dead Man Restored to Life by Touching the Bones of the Prophet Elisha*. Shown at the British Institution in 1813, it brought him an award, and he was urged to remain with his artist and literary friends in London. But he believed his place was in the United States, and he settled in Boston, becoming the respected mentor for a group of thoughtful young men who looked upon him as the resident genius. From this time on Allston communicated more through his insightful conversation—through what he stood for as an artist—than through his painting. He had begun a huge canvas of *Belshazzar's Feast* before leaving London, but the work was never finished. The work attained

Washington Allston, *Diana in the Chase*, 1805. Courtesy of the Fogg Art Museum, Harvard University, Cambridge, Massachusetts; gift of Mrs. Edward W. Moore.

Washington Allston, *The Dead Man Restored to Life by Touching the Bones of the Prophet Elisha*, 1811–13. Courtesy of the Pennsylvania Academy of the Fine Arts, Philadelphia.

57

value through its promise, not its realization. Few were allowed to see the painting as he changed it and worked on it, but every artist knew about Allston's coming masterpiece. A visit to Allston was like a visit to a shrine of art, where the flame of tradition, high ideals, and artistic insight was maintained to warm all who needed encouragement. Under his inspiration, Boston became the center for art of the spirit, of traditional values individually reexperienced, in contrast to New York, where the commercial bustle swept art along with it.

One of the first young artists to be inspired by Allston and his ideals was Samuel Finley Breese Morse (1791–1872), who accompanied Allston to England in 1811. There was no question in his mind about his goal in art: he wanted to paint historical subjects of national and moral significance in the great tradition of the masters. From a strict religious family and fresh from studies at Yale, he was moved by a kind of missionary impulse to make his painting count spiritually for the American public. He studied the Elgin marbles from the Parthenon—not yet accepted by all as worthy models—and developed a sure technique of painting. His dramatic *Dying Hercules* was shown in London in 1813, and he returned to the United States in 1815 confident of his future. Neither the public nor the government, however, was interested in his figure painting, and he was forced to devote himself to portraits. At this he was very accomplished, even though reluctant, as his striking portraits *Lafayette* (1824) and *The Muse—Susan Walker Morse* (1835) indicate. As noted earlier, his huge painting *Congress Hall* (*Old House of Representatives*) of 1822 which might have attracted the public both by its subject and by its illusionistic treatment of light and space, failed. Nor was his *Gallery of the Louvre* (1833), which managed to include tiny copies of an incredible number of masterpieces, any more attractive to a paying public than Vanderlyn's earlier panorama of Versailles.

In 1829 he again went to Europe and spent a long and happy sojourn in Italy, but it was his last blissful identification with painting. On the return trip of 1832 he developed the idea for the telegraph and devoted much of the rest of his life to scientific matters, although he served some while as unsalaried professor of painting and sculpture at New York University. He quickly rec-

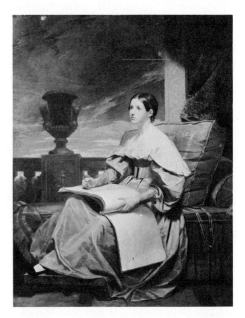

Samuel F. B. Morse, *The Muse—Susan Walker Morse,* 1835–37. The Metropolitan Museum of Art, New York, New York; bequest of Herbert L. Pratt, 1945.

ognized the importance of Daguerre's invention (1839) and became fascinated with photographic processes, although he seems never to have used photography as a basis for painting. The final blow to his hopes as an artist came in 1836 when Congress failed to choose him to paint one of the four remaining panels in the rotunda of the Capitol, although the other painter of high hopes and continuous disappointment, John Vanderlyn, was among those selected. Nonetheless, Morse became the grand old man of art in New York, chiefly through the academy which he had helped found in 1825 and of which he was president from 1826 to 1845 and again from 1861 to 1862. Many young painters owed much to his steadfast support, following the ideals of Allston.

One of those awarded a panel in the rotunda in 1836 was Robert W. Weir (1803–89), who also was inspired by a strong religious impulse and found his artistic direction in Italy. After a modest beginning as a history painter (he showed his *Saint Paul Preaching in Athens* in Philadelphia in 1823), he studied in Florence in 1825 with the prominent Davidian painter Pietro Benvenuti. In Rome he seems to have been impressed with the religious attitude current among the Italian and German painters that became known as purism, and he studied Raphael and the early Renaissance masters. Steeped in the art of the past, he accumulated a large collection of prints and books on art that served him well in his long career as professor of painting at West Point, where he taught from 1834 to 1876. His rotunda panel *The Embarkation of the Pilgrims*, with its unconventional composition and play of light, reflects the range of his interest in past art, from Raphael to Rembrandt.

In Rome Weir shared rooms with the sculptor Horatio Greenough, (1805–52), and when Greenough fell ill he returned to the United States with him in 1827. Greenough, who went to Rome in 1825 just after his graduation from Harvard, was the first of a long line of American sculptors to make Italy his home. Sculptors, even more than painters, felt the need to work abroad, since there was little in the American environment upon which they could build their art as they understood it. Like the painters, they found a market for domestic likenesses—John Frazee (1790–1852), for example, made himself a career in the United States, rising from

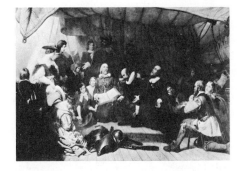

Robert W. Weir, *The Embarkation of the Pilgrims*, 1837–47. United States Capitol, Washington, D.C.

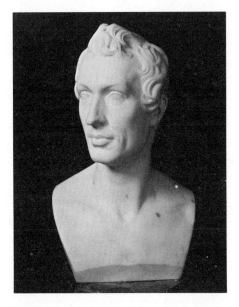

Horatio Greenough, *Samuel F. B. Morse*, 1831. National Collection of Fine Arts, Smithsonian Institution, Washington, D.C.; gift of Edward L. Morse.

tombstone carver to portraitist, and John Browere (1792–1834) gained a certain amount of fame from developing a method of taking life masks of his none-too-willing sitters, hoping to create a national gallery of heroes. But like Allston (whom he much admired), Morse, and Weir, Greenough saw art as existing on a very different level. Art was to make real to man the existence of an ideal.

Instead of returning to the classical Danish sculptor Bertel Thorvaldsen in Rome, with whom he had previously studied, Greenough settled in Florence in 1829 and came under the influence of Lorenzo Bartolini, a sculptor who was notable for combining ideality of intent with a faithful study of nature. The combination made sense to Greenough, who disliked all affectation of style or manner. He strongly believed in the classical doctrine that "beauty is the promise of function," but like his purist contemporaries he wished to discover that functional beauty in nature. He was joined in Florence by the already widely known James Fenimore Cooper, who was also a friend and supporter of Morse, then painting in Paris. It was Cooper who commissioned Greenough's first ideal work to be sent back to the United States—his *Chanting Cherubs*, based on Raphael, which was considered too naked for the American public.

Like many sculptors who would follow him, Greenough had returned to Italy with commissions for portrait busts, the studies for which he had made in Washington. These were only a means for support while he developed his ideal creations. One of his most sensitive likenesses, however, was not of a politician but of Samuel F. B. Morse. Then in 1832 he was given the commission to create a monumental statue of George Washington for the rotunda of the Capitol. This was an extraordinary concession, since it was generally believed that there was no American sculptor worthy of such a task.

Although the congressional committee might have thought of this as simply a portrait commission, Greenough viewed it differently. He saw it as a chance to consolidate the likeness of Washington the man with that of Washington as the personification of the republic. The truth of Washington lay not in his physical line-

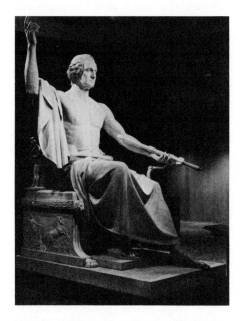

Horatio Greenough, *George Washington*, 1832–36. National Collection of Fine Arts, Smithsonian Institution, Washington, D.C.; transfer from the United States Capitol.

aments but in his symbolic existence as father of his country. The form, then, should follow the symbolic function. Had Greenough been content to create a generalized classical image, the sort of thing with which people were quite familiar, he might have had little difficulty; but his effort to combine symbol and physical activity was incomprehensible even to his sophisticated friends. The public saw only Washington stripped of his clothes, and the monumental work was a source of jokes and embarrassment, suffering a long series of indignities. Americans could accept political abstraction and were accustomed to discourse in symbolic terms, but they had come to separate moral abstraction from their judgment of daily affairs, as foreign visitors pointed out with some asperity. Greenough, with his fleshly likeness and godlike pose, had transgressed an inviolable boundary. So far as his audience was concerned, art must either be remote or present; and nakedness, like politics, was always the present.

Equally fascinated with the problem of bringing the ideal past of art into focus with the direct literal vision of the present was a man who joined Greenough in Florence in 1837. Hiram Powers (1805–73) had developed his talents in Cincinnati, sculpturing wax figures for Dorfeuille's Western Museum and eventually making portrait busts. In 1834 he made a circuit of eastern cities gathering commissions, sculpturing a formidable likeness of Andrew Jackson in Washington, as well as others of note. In Florence he settled down to translate his busts into marble and to begin planning for more ambitious works. His bust *Proserpine* (1839) was his first ideal work, and he went on to create his standing figure of *Eve Tempted* (1842), hoping that the religious context would forestall criticism of its nudity. It was his *Greek Slave* (begun in 1843), however, that caught wide public attention and established his reputation when shown throughout the country and, in 1851, at the Crystal Palace in London.

The acceptance of the *Greek Slave* and other of Powers's female figures marked something of a change in taste in America. It is not so much that the public had suddenly become responsive to physical beauty as that an artistic context—distinct from abstract symbolism on one hand and simple perceptual actuality on the

Hiram Powers, *Greek Slave*, 1843. In the collection of the Corcoran Gallery of Art, Washington, D.C.; gift of William Wilson Corcoran.

other—was now conceivable. This was due in part to a new appraisal of the artist and a greater awareness of his goals and methods and in part to a new eagerness to see everything in terms of literary overtones. The words most often used to describe the *Greek Slave* were "pure" and "innocent." Long articles were written about her innocent aloofness in the face of shocking indignity. It was impossible to see the work in the tradition of Venuses by Antonio Canova, Thorvaldsen, or John Gibson (an English sculptor who scandalized the public by tinting the flesh of his marbles). In this figure, which combines an aesthetic idea with a fleshly surface, Powers succeeded in creating a detached matrix for contemplation, the figure itself being totally without expression. Detachment was the important ingredient, and detachment became for some the touchstone of art.

There was, to be sure, much to win detachment from in the expanding mercantile world of the United States, and art could lead the way. Powers's works were especially useful because they were literal enough in their textures and detail to be the inhabitants of a material world, yet their perfection of design and the flawless whiteness of the Carrara marble elevated them into the realm of art. They were bolstered, moreover, by helpful subject matter and a literary ambience. Nor did the fact that they were made in Italy hinder their acceptance. In the 1830s and 1840s more and more people traveled abroad, visiting politically torn Italy as if it were itself a detached work of art. Works created by Americans living there could be seen as embodiments of that fair, decadent Mediterranean land. By living and working in Italy the artist acquired a stature he might not have enjoyed at home; he lived physically in the realm of tradition and would naturally be expected to speak its language. To a degree, it was a matter of genius by association.

Young Thomas Crawford (1813–57) had settled in Rome in 1835 after an apprenticeship as a stone carver and after eager study of the plaster casts of antique works in New York. Although he studied with Thorvaldsen, his work developed more in the literal direction of the Italian sculptor Pietro Tenerani; yet there was no mistaking his ideal intent. When his marble *Orpheus and Cerberus* was shown in Boston in 1844—he had first

Hiram Powers, *Eve Tempted*, 1842. National Collection of Fine Arts, Smithsonian Institution, Washington, D.C.; museum purchase in memory of Ralph Cross Johnson.

Thomas Crawford, *Armed Freedom*, 1856–57, plaster model. National Collection of Fine Arts, Smithsonian Institution, Washington, D.C.; transfer from the United States Capitol.

modeled it in 1839—he was hailed as a native genius, a characterization he was not inclined to doubt. He married Louisa Ward of New York and lived well in Rome, taking an active part in the international colony of artists. Commissions came almost faster than he could handle them. He saw to the casting in Germany of his bronze equestrian Washington and accompanying figures for Richmond, Virginia, and from 1853 he executed many works for the Capitol, his most imposing being the almost twenty-foot-high bronze figure of Freedom that tops the Capitol dome. At his early death, his Roman studio was filled with works in progress. In an incredibly few years, with the help of Italy, American sculpture had come into its own.

The attitude of these workers in the realm of art toward the sculptors who remained in the United States was one of condescension at best. Particularly despised was the ingenious Clark Mills (1815–83) who, with very humble preparation, was commissioned in Washington to produce a bronze equestrian statue of Andrew Jackson. The result was particularly remarkable since Mills had never seen a full-sized equestrian figure and furthermore, he cast the not inconsiderable work in bronze himself. Although it might offend artists and patrons who looked to Italy for their artistic blessing, when it was erected in 1853 it delighted Congress, and Mills became a favorite for official commissions. The suggestion of "Yankee ingenuity" and the myth of the self-taught artist could still stand their ground as qualifications against the ideal European context.

One other sculptor who did not establish himself abroad fared rather better in artistic reputation than Clark Mills. This was Erastus Dow Palmer (1817–1904). In spite of all the talk of Palmer as native in contrast to others, he based his work on antique models and expressed the same devotion to a detached ideal art as did those who settled in Italy. His most famous work, *The White Captive* (1857), was clearly meant to bring Powers's famous work closer to home, and as it was exhibited through the country it was hailed as an example of native white purity. Like the *Greek Slave*, however, it could be seen only under the cloak of high art and literary association. In Palmer a bit of Italy was transplanted to the United States.

Clark Mills, *Major General Andrew Jackson*, 1853. Lafeyette Park, Washington, D.C.

Erastus Dow Palmer, *The White Captive*, 1859. The Metropolitan Museum of Art, New York, New York; gift of Hamilton Fish, 1894.

There were, of course, practical reasons for sculptors to settle in Italy. There was an abundance of fine white marble, skilled workmen were at hand to help the artist translate his studies into stone, and artists made useful contacts with potential patrons who were traveling in Europe. But for painters and sculptors alike, the greatest benefit was their identification with a tradition of art. During the years when Americans were going to Italy, artists from all over Europe were also concentrated there. They came for various reasons. Some were still drawn to Rome by the classical academic principles—for which the French academy had established its Roman branch in the seventeenth century. Painters from the North were attracted by what they considered the idyllic Mediterranean life, so different from that in their cold northern climate. Then there was the attraction of Christian Rome, the center of the new aesthetic thought that stood in opposition to the pagan notions of formal beauty that Rome had earlier symbolized. By the time American artists began to settle in Italy in the 1830s and 1840s, it had also long since become the goal of landscape painters who wished to be dazzled by its light, its varied landscape, and the climate that allowed them to paint outdoors throughout much of the year. The Americans were aware of all these tendencies but became partisans of none of them. They came to Italy for its age, its ruins, and its embodiment of the past. Few could ally themselves sympathetically with the religious leanings, even though they held much in common with them, and nature they could study at home. But the galleries, the palaces, and the rich decay of ages were for them, in a way different than for their European colleagues, the fulfillment of a dream. Rembrandt Peale, who finally reached Italy in 1829, wrote in his notes on Italy, "The idea that my dreams of Italy were never to be realized seemed to darken the cloud which hung over death itself." When Thomas Cole, who was already noted for his devoted studies of American nature, went to Italy in 1831, he painted Tuscany and the campagna with a sentimental sunset glow that rarely tinged his America landscapes, though all around him European painters were celebrating in meticulous fashion the clear, incisive light. Italy provided the remembrance of a past that America had never had.

Even before getting to Italy, George Loring Brown (1814–89) was an Italian painter in a way that Italians no longer were. He had been to England and France in 1833 and devoted himself to copying Claude Lorrain. When he reached Italy in 1840, where he spent almost twenty years, he saw everything through Claudian eyes. "Claude" Brown he was called, and he could not have objected to the identification. After all, it was identification with the past masters, not imitation, that many of the artists sought. Many who had dreams of Italy and the old masters never reached Europe, but, using as best they could the material at hand, they created religious and historical paintings in what they considered to be the great tradition. Meanwhile, collectors began to accumulate European masters—either originals, fakes, or copies—so that a sense of the styles of the old masters was widely diffused. Polite periodicals began to publish reproductions of great paintings or modern engravings in a popular version of traditional styles. The Raphael "look," with symmetrically parted hair and drooping shoulders, became fashionable among ladies in the 1830s and 1840s and helped the modern young woman to see herself in the context of art. The gift book, a prettily bound collection of engravings and ineffectual literature, made its appearance, and although some included American themes and local landscape, most deliberately evoked a European aura. Through its Italian association, art had achieved its identity as art— albeit an art of remoteness and refinement—an antidote to American mercantilism and conspicuous commercial progress.

George Loring Brown, *Italian Scenery,* 1846. National Collection of Fine Arts, Smithsonian Institution, Washington, D.C.; museum purchase.

The Identification of Art with America

It may seem ironic that taste for an elevated art speaking of ideal realms and remote pleasures should have developed in the United States during the very period historians like to refer to as the age of Jacksonian democracy. But this was not the sole function of art at the time. There was another side to the cultural coin. At the very moment when some artists were finding solace in the European past, other were deliberately trying to create an art from materials that were patently local. This presented problems, however, since most of the

critical and theoretical writing that was avidly read by artists and connoisseurs alike had little encouraging to say about the rendering of commonplace subjects and literal styles. Sir Joshua Reynolds, whose *Discourses* was awarded to prize students of the new National Academy of Design, had recognized the existence of "low" painting, normally associated with the seventeenth-century Dutch, but found it uninteresting intellectually. The budding arts of the United States were of necessity concerned with status, and to elect to remain on a lower rung of the artistic ladder required a strong conviction.

For those who were swayed by a nationalistic impulse, part of the problem was to identify what was obviously local as distinct from what was foreign, and then to justify its being considered a matter of pride and artistic consequence rather than a matter for apology. As early as 1787, Royall Tyler wrote optimistically in the introduction to his play *The Contrast*,

> Why should our thoughts to distant countries roam,
> When each refinement may be found at home?

Although this sentiment was often repeated over the following decades, artists found it unpersuasive. They found in America neither the public nor the materials for creating what they considered art to be. It took a major shift both in the evaluation of the American environment and in the concept of art before one could speak sensibly about art and the familiar locale.

An American Mythology and a Colloquial Art

As Americans became more aware of themselves as an entity in relation to Europe, they could not fail to note that certain types of character as well as certain ways of doing things and ways of talking had come to belong peculiarly to the United States. European travelers were quick to point out these traits, rarely in terms of admiration. Although the larger political ideals might be respected, there was some doubt about their impact on the individual members of society. In their kindest moments, commentators looked with amusement on the boastfulness and overstatement that they associated with the youthful country and noted with amused condescension the novel turn that the English language had taken in the speech of the erstwhile colonists. Initially,

seeing these traits against the pattern of European culture, cultivated Americans were embarrassed for their countrymen. Several transformations had to take place before these unwelcome American traits—and the American environment itself—could be transformed into universal virtues instead of simply local vice.

A part of the frustration of the American with a yen for art came from his sensing a lack of historical flavor in his relatively new environment. In England the countryside spoke of the English poets and of a distinguished past, in Italy every hill and hidden lake carried a footnote to Vergil or the faded Roman Empire; but in the United States the cities and surrounding fields gave evidence only of a present society busily making a living. Americans needed a myth of their own; they were desperately in want of an ancient past. Barlow's *Columbiad* might be an epic, but it provided no mystery to feed the soul.

When he created an eager Dutch historian to review his familiar world, Washington Irving probably was less concerned with the collective soul than he was with stimulating his own fantasy, but the publication of his *History of New York* in 1809 was a milestone of sorts. Diedrich Knickerbocker's gleeful account of the shadowy Dutch past of New York peopled every bay and cove with personalities who had the virtue of belonging to the place yet being free from more recent political attachment. Even though descendents of the Dutch families might not be amused, for most readers a new dimension of myth had been added to an otherwise material environment. Ten years later, *The Sketch Book* added its legends and characters to supply the Hudson with resounding associations. Rip Van Winkle's brush with the ghostly remnants of Henry Hudson's crew was enough to make any wanderer in the hills alert to the sound of laughter echoing out of New York's past.

Few artists caught the spirit of Irving's narrative style, which promised surprise with every phrase, but as time went on many recognized the opportunities his fancy afforded. Even Washington Allston tried his hand at two illustrations for the Knickerbocker history, and Asher Brown Durand painted the *Wrath of Peter Stuyvesant* in 1835. When James Hamilton painted his *Scene on the Hudson* in 1845, he included Rip Van Winkle clutching

James Hamilton, *Scene on the Hudson,* 1845. National Collection of Fine Arts, Smithsonian Institution, Washington, D.C.; museum purchase.

his jug in the foreground and a group of bowling Dutchmen hidden in the shadows.

The one artist who caught the spirit of Irving's fantasy was John Quidor (1801–81), whose intense and grotesque style has no parallel in American painting. Beginning with his *Ichabod Crane Pursued by the Headless Horseman* of 1828, he created a series of paintings in which humor, absurdity, and lurking terror seem to be the product of the textures and mad energies of the environment itself. Like Irving, he depicts a world filled with mystery and surprises, yet recognizable as being made up of local stuff. The burgeoning art of book illustration, needless to say, profited from Irving's refreshing and irreverent descriptions. The greatest of his illustrators was doubtless F. O. C. Darley (1822–88), whose characterizations became almost inseparable from the text.

More than simply providing a cast of characters for illustration, Irving and the writiers he inspired drew attention to the possibilities of creating folklore in a folkless land. Although Irving chose to live most of his life abroad, he gave a new sense of value to the inhabitants of his own country.

Another creator of local mythology borrowed his antiquity from a different source. James Fenimore Cooper, the friend and supporter of Morse and Greenough, looked to the Indian and the frontiersman to give the American wilderness a human past. His *The Spy*, published in 1821, and *The Pioneers*, published two years later, created a whole new vision of America, appealing to Europeans and Americans alike. With *The Last of the Mohicans* of 1826, he created a sentiment for the Indian and the wilderness with which he was identified that was to haunt the mind for generations. He gave the grandeur of tragedy to what had seemed a voiceless nature. The passing of the Indian was somehow linked to the great forces of nature manifest in the sublime rudeness of the American lanscape. It seemed natural for Thomas Cole to include the tiny figure of an Indian in his dramatic painting of Katterskill Falls in 1826, and the Indians gathered in *Last of the Mohicans*, painted shortly after the book was published, appear to be one with the massive rocks and shattered trees. After reading Cooper, one might expect to hear the quiet footfall

John Quidor, *The Return of Rip Van Winkle*, 1829. National Gallery of Art, Washington, D.C.; Andrew W. Mellon Collection.

Thomas Cole, scene from *The Last of the Mohicans*, circa 1827. New York State Historical Association, Cooperstown.

of *Deerslayer* in any isolated mountain glen. America, which had long exerted a romantic appeal for Europeans (Cooper's novels had their greatest sale abroad) was beginning to take hold of the imagination of its own inhabitants.

On a lowlier level of mythmaking, the public gradually became conscious that one did not have to look to the fantasized Dutch, the majestic Indian, or the silent frontiersman for American images. The homely types that had for some caused embarrassment began to be seen as heroes in their own right.

On an American tour in 1823, the English actor Charles Matthews, though he did not feel much at home in the country, used his time to acquire a repertory of what he considered American types. Back in London the following year he delighted his London audiences with his *A Trip to America*, a one-man presentation in which he imitated the actions, dress, and dialect of the people he had found abroad. Chief among them was the country Down Easter who took nothing for granted, invented much of his own language, and perversely insisted on reexamining with extended rhetoric each new problem that arose. Seen thus extracted from his native situation, the possiblities of the garrulous American as a theatrical figure appealed to James H. Hackett, an American actor in London at that time, who created his own more authentic Yankee and became identified with a number of "American" roles that he played throughout the United States.

Matthews and Hackett were not the first to delight in Yankee speech and behavior in the theater. When David Humphrey published his comedy *A Yankee in England* in 1815, he even included a glossary of Americanisms, not in ridicule but almost in boast, suggesting that the local tongue had a character all its own. To make up words and create unlikely metaphors, rather than to use literary terms and learned references, could be considered proof of independence and native inventiveness. It carried the same virtuous overtones as being "self-taught," a phrase that was applied with pride to many American artists, much to the annoyance of those who believed that to be without teachers and noble examples was to be deprived. On her visit to the United States, Mrs. Trollope was scandalized to hear the Kentucky-born portrait

painter Chester Harding, who was constantly touted as being self-taught, compared to "our immortal Lawrence." To reach such a position and be self-taught, she was told, was certainly the highest praise, since it is "attributing genius to the author, and what is teaching compared to that?"

Colloquial speech was a badge of independence, of rebellion against the comme il faut, and the characters that used it became symbols of what many liked to regard as the true American spirit. The rural, sharp but honest Down Easter, ignorant of international custom but knowledgeable about life, was heralded as one of the first thoroughly American characters. It was this shrewd Yankee with his ill-fitting striped trousers, pinched tailcoat, and high hat who would eventually be accepted as Uncle Sam. He took on many names. By the 1840s, "American" actors such as Hackett and James "Yankee" Hill had become a distinct class performing as characters named Jebadiah Homebred, Jonathan Plowboy, Solomon Swap, or Hiram Dodge in the well-known play *The Yankee Pedlar*.

The acceptance of these traits as positive rather than negative aspects of America was just one indication of a changing attitude toward cultural standards and artistic principles in general. The assumption could be made—and indeed was—that only what was locally rooted, related to its immediate environment, could be accepted as true and trustworthy. Exaggerated as they might be in the theater, dialects were associated with particular places and communities, and the elaborate Yankee digressions were indeed homemade. To those who accepted this point of view, abstract truths and general rules had no place; the general and the abstract belonged to dangerous realms of thought associated with European systems. How deeply this was believed is hard to judge, but certainly the idea had its power. Major Jack Downing, a creation of the Maine journalist Seba Smith, became so popular for his castigations of all institutions, newspapers, and politicians written in "down home" English that he escaped from the hands of his author to become a public property. Even the Harvard-trained poet James Russell Lowell adopted dialect for his *Bigelow Papers* (1848), suggesting that true wisdom was to be found in the candid judgments of the untaught. As

America became more urban and aware of its place in the world, a large segment of its people increasingly cherished the myth that honesty and nobility were to be found in the isolated village and the countryside. Its glow has never wholly faded.

With such a climate developing in the 1820s and 1830s, it was natural that artists, in spite of their awareness of the dicta of high art, should also begin to discover new possibilities in the local scene. There had always been some interest in recording modest local activity, but now it took on the stature of an aesthetic stance. Earlier, the sprightly narrative paintings of the German-born John Lewis Krimmel (1789–1821) gained great favor in Philadelphia, but, though they depicted familiar places and recognizable types, their emphasis was on the kind of incident that might just as well have happened abroad. Krimmel was fondly referred to by his Philadelphia admirers as "the American Hogarth," which was not wholly inappropriate, since he described Hogarthian incidents in terms of Philadelphia. He probably would have preferred to be called "the American Wilkie" since he clearly much admired the works of that popular Scots painter of homely scenes, who was gaining an enormous following both in London and abroad. Some few others tried their hand at this kind of storytelling picture in the early years of the century, but in its general kind of narrative—dealing as it did with a standard repertory of human foibles—the work was quite different from a later genre that concentrated on American types and identifiably American situations.

The shift began in the late 1820s, at the same time as Americans were beginning to enjoy the image of their local selves and writers began to search for local themes and characteristic incidents. By far the most successful of the self-consciously regional artists was the Long Island painter William Sidney Mount (1807–68), who divided his time between portraits and paintings of rural pleasures. His early inclination to paint historical subjects in the grand manner—he was an early student at the National Academy of Design—was soon overcome by his desire to tell American tales. Although his 1830 painting *A Rustic Dance after a Sleigh Ride* is made up of stock types that might have peopled any contemporary painting of social habits and could have been done by

John Lewis Krimmel, *Independence Day Celebration in Centre Square, Philadelphia,* 1819. The Historical Society of Pennsylvania, Philadelphia.

Krimmel, he soon began drawing his settings and characters from local models. He was both an able painter and an acute observer, and he soon learned to avoid the quaint, humble surfaces depicted by Wilkie. His paintings of Long Island farmyards seen in clear, uncompromising light are cluttered with lovingly recorded familiar objects and neatly described textures; yet quite miraculously each part takes its place in both a narrative and a pictorial unity. His painted world is one of goodness, simple pleasures, and infinite interest in small matters of fact. None of the drudgery of farm life shows through his depictions of endless summer days. At his best he vested his strength in characters rather than in obvious narrative: two whittling farmers "coming to the point," the hidden power of fiddle music in the barn (he was himself a fiddler), a wholesome farmer sharpening his scythe. And his characters were readily understandable to the popular mind as embodying the American traits that were now much talked about. They were not caricatures like those beginning to turn up in book illustrations and theatrical prints. They demonstrated Mount's complete belief in his chosen field by simply being themselves.

Mount's public stance as an artist is nicely demonstrated in his 1838 painting *The Painter's Triumph*. What has satisfied the artist has evidently pleased his country friend as well, who looks on with the attention he might give to the results of a trotting race. He looks with an eye of recognition, not to be awed by the beyond but to be reassured in the present. Meanwhile, the head of the Apollo Belvedere seen in the drawing on the wall quietly looks away. Yet Mount was no naive country painter. He created the image of country life; he did not simply respond to it. He was a sure and ingenious composer of pictures and left nothing to chance. His effort was to make engaging works of art in an idiom his public wished to see as common. In rather sanctimonious terms, he wrote in later life: "There has been enough written on ideality and the grand style of Art, etc., to divert the artist from the true study of natural objects. Forever after let me read the volume of nature—a lecture always ready and bound by the Almighty."

Of course, Long Island farmers and Yankee peddlers were not the only possible protagonists for the crea-

William Sidney Mount, *The Painter's Triumph*, 1838. Courtesy of the Pennsylvania Academy of the Fine Arts, Philadelphia; bequest of Henry C. Carey.

tion and enjoyment of an American image. Once it was deemed artistically defensible to paint modest pictures of simple people, there were infinite possibilities. Subjects fell into two general classes: those dealing with universal themes that became standard throughout the world—the activity of children, usually naughty little boys and pretty little girls; cottage life, with most cottages looking much the same whether in Germany, England, or the United States; animals reacting to or acting like human beings; courtship and wedding scenes, and so forth—and those that emphasized types or situations immediately identifiable as characteristically American. In the first category the principle of composition was often not far different from that traditional in academic history painting: an incident occurs to which a variety of people react in characteristic ways. The mode was comedy, however, and suitable even to Aristotle's description: the people shown are to be considered either the same as or inferior to the observer. This is nonheroic painting and casts doubt on even the existence of heroes.

Francis William Edmonds (1806–63), who was a successful businessman as well as a painter, liked to depict humble interiors invaded by a foreign element—an image peddler, a land salesman, a census taker—to which simple good people of a range of ages and sophistication would react. The peddler was an ideal catalyst and, moreover, was a favorite American type. He appeared in many paintings, including one by Asher Brown Durand that combines traditional moralizing with an American scene.

Children had a particular place in this kind of painting, inhabiting for the most part the kind of idyllic, innocent world much coveted by adults. There was probably an association in the public mind between the imagined world of the child and that of the guileless farmer. Boys were usually shown as free spirits, careless in dress, destructive, and often about to be punished. Girls were serene and often identified with birds, kittens, and flowers. Whatever the subject in this class of painting, however, the painter was careful not to impinge on painful realities. For the comic mood to be sustained, an element of decorum had to be observed. This art in its way was no less ideal than the depictions of

Francis William Edmonds, *The Speculator*, circa 1852. National Collection of Fine Arts, Smithsonian Institution, Washington, D.C.; gift of Ruth C. and Kevin McCann in affectionate memory of Dwight David Eisenhower, thirty-fourth President of the United States.

Hercules and Venus, but it achieved its elevation so subtly that one might dwell in the realm of detached ideality without leaving home.

Art that dealt with more pointedly local subjects, however, led to a somewhat different kind of pleasure. Even in the works of Mount, which painted so cheerful a report of rural existence, there was an appreciation of ordinary things that focused the senses on the here and now and, to certain extent, brought the mind along with them. Artists such as David Claypool Johnston (1798–1865), who devoted more time to illustration than to painting, had a sharp, unsentimental eye for character. Starting as an engraver, then an actor, he was conscious of popular taste and showed little desire to elevate it. During the 1830s and 1840s there was an extraordinary expansion of publications in the United States—popular journals, literary magazines, magazines devoted to science, art, fashions, and anything that might find a brief public following. Through these, images were carried to a far wider audience than ever before. Newspapers became an American obsession, and though they rarely carried pictures until midcentury (the *Illustrated American News* began in 1851, Frank Leslie's *Illustrated Newspaper* in 1855, and *Harper's Weekly* in 1857) their critical and flamboyant tone served as a natural complement to caricature. Annuals, quite aside from the elegant gift books, contained essays, comments, and often illustrations. Johnston himself began publishing an annual in 1828 called *Scraps*, obviously inspired by the English illustrator Cruikshank's *Scraps and Sketches*. An extraordinary number of writers and artists felt the need to comment on individuals and society as they saw them, some viewing with alarm and some simply enjoying the sense of involvement.

James Goodwyn Clonney (1812–67) came from England as a young man and attended sessions at the National Academy of Design in the 1830s. Yet when he began to paint he turned his back on his studies from the antique in order to paint local characters and incidents. For his best-known work, *Militia Training* of 1841, he made innumerable careful drawings for the many characters, which, as often happens, are more candid and spirited than the figures that finally appeared in the painting. He avoided high drama and excessive senti-

James Goodwyn Clonney, *Fiddler*, drawing for figure in *Militia Training*, circa 1839–41. Courtesy of the Museum of Fine Arts, Boston, Massachusetts; M. and M. Karolik Collection.

ment. His commentary on the outcome of the Mexican War was a painting of a young and an older man responding with pleasure to a newspaper. A more dramatic version of the same subject was painted by the Baltimore artist Richard Caton Woodville (1825–55), who had gone to Düsseldorf, Germany, to study in 1845 and had concentrated there on American subjects. Even for an artist abroad, American subjects became a distinct category of painting, akin in that sense to the Yankee comedies.

Urban scenes and polite middle-class life also had their place, with Jerome Chapman's picnics and scenes of shopping and housekeeping. Proper middle-class urban interiors increased in popularity beginning in the 1850s. The most remarkable painter of family life as freshly observed rather than as inherited from the traditions of Greuze or Wilkie was Lilly Martin Spencer (1822–1902). Born in England and brought up in Ohio, she first established herself as a painter in Cincinnati. Although she produced the requisite number of popular sentimental paintings to support her husband and her many children, her finest works are those that depend on the immediate observation of her own household. Her pleasure in the texture of a ripe apple, a plucked chicken, or a slab of beef was communicated with astonishing technical precision. Very often there is no story—only a situation that invites one to appreciate the actual existence of things.

Something of this delight in homely objects is also evident in the American version of a traditional kind of painting, still life, which had a new vogue at midcentury. Traditionally, still-life painting served many purposes. Sometimes it provided an exercise in the organization of forms in light, at times artists painted selected objects to spell out a moral or suggest a character, story, or allegory. But whatever other purpose it might serve, still-life painting was a pictorial appreciation of the perception of things.

One of the first artists to pay major attention to the genre in America was Charles Willson Peale's son, Raphaelle Peale (1774–1825), who shared his father's fascination with phenomena. He was not above trying to trick his viewers by paintings meant to fool the eye, such as his 1802 still life of letters affixed to a board, or his

Lilly Martin Spencer, *Peeling Onions*, circa 1852. Courtesy of the National Collection of Fine Arts, Smithsonian Institution, Washington, D.C.; lent by William Postar.

famous *After the Bath* of 1823; but in his paintings of fruits, vegetables, and cuts of meat he concentrated on seemingly palpable textures and sensitively poised arrangements. His aim was not trick but material truth.

Many other members of the large Peale family tried their hand at still-life painting, repeating the early graceful formulas well into midcentury, but the taste for still-life painting that developed in the 1850s seems to have come from a fresh impulse, not unlike that which prompted Lilly Martin Spencer to paint the bruise on an apple or the sticky dough being kneaded by her housemaid. The painting became a reassuring proof of the specific, finite quality of things, encouraging a belief that values began at home, based on immediate sensuous experiences, and were not to be defined in terms of Platonic reflections of an ideal world. John F. Francis (1808–86), in his still-life paintings of the 1850s and 1860s, beguiles the viewer with a well-set table on which the elegant china and sparkling crystal complement the abundant fruits and sweets that are a dessert for the eyes as well as for the palate. There are always transparent liquids to refract the light and a variety of forms and surfaces to demand attention, keeping the mind from dwelling on more speculative matters. These might be called fascination pictures, since their goal seems to be to hold the mind in a process of untroubled discovery.

Far more complex than the appealing desserts of Francis are the monuments to abundance by Severin Roesen, who was active in the United States from 1848 to 1871. Little is known of his earlier career in Germany, where he must have developed the meticulous technique he used to advantage in painting his masses of fruits and flowers that overwhelm the bowls and vases meant to contain them. Yet in spite of the quantity of material assembled, each bud, twig, and individual grape is depicted with care, as if only the part mattered, even though the composition of the whole is bold and assertive. A few drops of water glistening on flower petals or an investigating butterfly often give a suggestion of transient reality to the earthly delights, and grape leaves often show the effects of weather and marauding insects to prove their existence in the ordinary world. Nevertheless, these bounteous collections of fruit and flowers suggested a sensuous material world without the

Raphaelle Peale, *After the Bath*, 1823, Nelson Gallery-Atkins Museum, Kansas City, Missouri; Nelson Fund.

John F. Francis, *Luncheon Still Life*, circa 1860–70. National Collection of Fine Arts, Smithsonian Institution, Washington, D.C.; museum purchase.

sting of death. They were homely bulwarks against an accusing theology and a threatening mercantilism.

It is significant that in the midcentury still lifes, no matter how elegant the porcelain and crystal or how exotic the food, if a setting is suggested it is regularly the countryside, not the urban dining room. The most comfortable image for Americans was still that of rural life, although by midcentury that often meant the summer home or the country estate.

But the growth of cities, most notably New York, did foster a new set of images for both literature and art, though possibly not so widely accepted as the rural characters. Such popular novels as Charles Briggs's *Adventures of Harry Franco: A Tale of the Great Panic* of 1839, though ultimately judging the city as evil compared with the country, nonetheless show a fascination for the excitement and activity that only a city afforded. The lively concentration of artists, writers, and publishers assembling in New York made for a productive cross-fertilization of ideas. Artists, literary people, and patrons organized societies that would eventually have a strong impact on the course of American art. The mercantile environment, although spurned by some, was looked upon by others as the only real proving ground for the American artist. Briggs, for one, looked down on the spiritual pretensions of Boston, as did his associate on the *Broadway Journal*, Edgar Allen Poe, and he considered the genteel remnants of Allston's idealism a deadening influence. Of this he warned his friend William Page, though he highly praised Page's sensitive piece of urban genre, *The Young Merchants* (ca. 1842), painted in New York. He declared at one point that an artist would learn more by studying a head of cabbage than by studying the Apollo Belvedere.

The city eventually produced some folk heroes of its own. "Mose the Bowery Boy" spoke not in rural colloquialisms but in the street slang of New York. A member of one of the important groups peculiar to cities, the volunteer firefighters, Mose made his appearance on the stage in 1848 and was memorialized in popular prints. He was tough, a fighter, but gallant with women and could lick double his weight in Europeans.

At least one artist, however, found the city and the attitudes it encouraged anything but heroic or amusing.

Severin Roesen, *Still Life with Fruit*, 1852. Courtesy of the National Collection of Fine Arts, Smithsonian Institution, Washington, D.C.; lent by the family of the late Edward Murphy, New York City.

David Gilmore Blythe (1815–65), an itinerant painter who settled in Pittsburgh, produced in the mid-1850s a series of paintings that contrasted sharply with the rural optimism and busy city paintings of others. There is nothing amusing about his wretched street gamins or his dough-faced characters who seem trapped in their flesh. He was concerned not with the sparkling face of a self-confident America but with what he saw as the modern tragedy.

Although in principle artists were concerned with characteristics of the local scene and worked in various centers throughout the country, there was surprisingly little regional distinction in their work. In part this was because so many moved from place to place, but it was also a consequence of well-circulated, rather stock images of what various American types were like. The major exception was provided by the West. The area of the Ohio and the Mississippi had its own mythology and its own subject matter. Cincinnati was early a center for artists, and itinerants usually moved from there down to New Orleans. The last panel to be painted in the rotunda of the Capitol, assigned to Henry Inman in 1836 but not completed, was conscientiously reassigned in 1846 to a young painter from Ohio, William Henry Powell (1823–79). His *The Discovery of the Mississippi River by DeSoto*, painted in Paris, was a stock academic painting in no way different from what might have been painted by a mediocre artist from any part of the United States. Yet, though most of the artists were in close contact with the East, many of them saw their area as having a more special—even more American—flavor than others. Part of this attitude came from a romantic notion of the frontier that made heroes of the hard-fighting, hard-drinking, boisterous men who roamed the forests and manned the riverboats. The notion was more deeply imbedded in the minds of the easterners than in those of the frontiersmen, to be sure, but it gave artists the necessary confidence to be local.

From the wilds of Tennessee, Davy Crockett—the legend more than the man—caught the imagination of the restive populace who found in his colorful speech and daring accomplishments a model of the triumphantly independent American spirit. Mike Fink, the riverboatman, was less well known, but the magnificent

David G. Blythe, *Street Urchins*, mid-nineteenth century. The Butler Institute of American Art, Youngstown, Ohio.

Unidentified artist, "*A Narrow Escape from a Snake*," woodcut. From *Davy Crockett's Almanack*, 1838.

though crude hyperbole of his reputed discourse was a solace to those who rebelled against European niceties. Although the legends of these boisterous heroes inspired some of the liveliest woodcuts produced so far in America, painters did not incorporate them directly into their work. Most painters were too devoted to the visually literal or the traditionally beautiful to be capable of the fantastic hyperbole the woodcuts reflect so well. Yet the legends existed in the public mind, giving a special, sometimes mythic overtone to literally rendered scenes of the West.

The man who profited most from this belief in a special western character was George Caleb Bingham (1811–79), whose family settled in Missouri in 1818. Bingham began as a portrait painter, even setting up shop in Washington for a few years. But by 1845 he recognized the commercial possibilities of paintings based on local American subjects and moved back to Missouri, where he began his very popular series of paintings on Western life. Bingham was a meticulous workman and made careful pencil drawings from life of the characters he would later assemble in a painting. These drawings are perhaps his finest work. Although filled with a sense of life, there is nothing spontaneous about his paintings. Their compositions, for the most part, are classical constructions, and the sharp light that floods them is a wonderfully polished convention. Yet their shimmering silence evokes a mood not identifiable with any other. The combination of the meticulously observed and the classically composed achieved an effect of idyllic serenity, even when the action was boisterous and casual. It was a quality everyone wanted the West to have. Land speculators, interminable litigations in country courts, and the hidden vices of gambling dens Bingham left to other painters; there were many of them and they gained little fame. Even in depicting political harangues and country elections—he was himself active in politics—Bingham proceeded with a genial equanimity.

In 1847 Bingham's painting *The Jolly Flatboatman* (of which he painted several versions) was engraved for distribution to its members by the American Art-Union in New York. The subject seemed exactly right for this remarkable organization that by then had almost 10,000

George Caleb Bingham, *Skillet-beater*, 1857. Courtesy of the people of Missouri.

George Caleb Bingham, *The Jolly Flatboatmen in Port*, 1857. The Saint Louis Art Museum, Missouri; purchase.

79

members. Begun as the Apollo Association in 1839, the Art-Union was organized to create a wider public for American art. Subscribers received an engraving as a reward for their membership and had a chance at the end of the year to win one of the paintings the society had purchased and exhibited in its galleries. These assembled purchases gave a quite different picture of American art than one would find in the National Academy, since portraits, still the principal stock-in-trade of many artists, were hardly suitable for the society's purposes. The Art-Union, which numbered among its supporters such eminent promoters of the American scene as William Cullen Bryant, became increasing emphatic about its national function. In a defensive message published in the Art-Union *Transactions* in 1848, it was stated:

> Ours is an American association, founded on American principles, fashioned by experience after American views, sustained by American patronage; and our aim shall ever be to promote the permanent and progressive advance of American art.

As for the principles by which the works were selected, the directors made it clear that they had little concern for the "mere *language*" of art. They valued "the quality of the incidents . . .the humor or the pathos—the grandeur or the beauty of the ideal—the truth to nature of the actions and the characters described" and pointed out, by no means to the satisfaction of all artists, that these were qualities the connoisseur could judge as well as the artist.

The effect of Art-Union patronage was electric. No longer exclusively dependent on portraits, artists were free to think of landscape and of subjects that would meet with popular approval. Not the least in importance were the works engraved.

To meet the tastes and demands of an expanding public, printmaking had both expanded and changed its character in the second quarter of the century. The growing use of lithography made possible more numerous and cheaper prints, although colored engravings, which often took months to prepare, still retained prestige. In 1835 Nathaniel Currier (1813–88) opened a lithographic shop in New York with J. H. Bufford, and

in 1850 he took on a young artist, J. Merritt Ives (1824–95). The lithographs produced by Currier (Currier and Ives after 1857) covered every theme that might appeal to the public—sporting, religious, western, steamboating, anecdotal—and reached to every corner of the country, including the Spanish communities in the Southwest. After about 1860, chromolithography, a rather complicated process by which prints could take on the assertive brilliance of painting, made it possible for even modest homes to boast walls adorned with art. Regardless of what one might think of the quality of many of the prints, it remains that the public vision of art was quite transformed. Furthermore, the artist looking on his own work in relationship to this new common imagery was bound to see it rather differently, even though his own paintings might not be translated into prints.

The Art-Union, with its wide distribution of high-quality prints and its raffling of paintings, was a central force in the early stages of this democratic context of art. Unfortunately for those artists who counted on its patronage, the Art-Union was declared an illegal lottery under the laws of New York and was forced to shut down its operation in 1852. Its remaining works were auctioned in 1853. The society calculated that over the course of its existence it distributed some 2,400 paintings and 150,000 engravings.

Bingham was thoroughly conscious of the virtues of having his paintings engraved, and in 1856 he went to Europe to supervise the engraving of his prints there. He soon left Paris, where the engraving was being done, and settled in Düsseldorf, Germany, in the congenial American colony headed by Emanuel Leutze (1816–68).

Düsseldorf

Düsseldorf's part in American painting beginning in the 1840s has been much discussed. Unlike Bingham, most artists went to Düsseldorf early in their careers, attracted by the discipline for which the center was famous. The Düsseldorf Academy had been reorganized early in the century when the area came under Prussian rule, instituting a method developed initially by the so-called Nazarene German painters in Rome, those who followed the purist ideal in opposing classical generali-

Published by Nathaniel Currier. Drawn on stone by Louis Maurer, *Preparing for Market*, 1856. National Collection of Fine Arts, Smithsonian Institution, Washington, D.C.; gift of IBM Corporation.

zation. Basic to the procedure was a strict discipline in drawing from nature, avoiding conventional mannerisms and unwanted flourishes. Just as important was the Nazarenes' concept of the brotherhood of artists that, largely shorn of it religious connotations, persisted in Düsseldorf. The artists in Düsseldorf were a separate fraternity, depending on each other as much as on the formal academy. Writers and public figures joined them to give the artist community a stature that existed nowhere else. For Americans, aside from the prominent painters of history and landscape, the principal lodestone was Emanuel Leutze.

Richard Caton Woodville, *War News from Mexico*, circa 1846. National Academy of Design, New York, New York.

Leutze, born in Germany and brought up in the United States, went to Düsseldorf to study in 1841. A brilliant draftsman and an engaging personality, he soon became a respected member of the community. Imbued with strong American republican convictions, he took a serious interest in the political situation in both Germany and the United States. Although he married a German woman and spent many years in Germany, like most Americans abroad he still considered himself an American. Unlike others, instead of being an expatriate, Leutze remained an active member of both cultures.

The tight drawing style associated with Düsseldorf was quite suitable to the painting of genre, and several of the painters who went there specialized in depicting homely incidents—most notably Richard Caton Woodville and, to an extent John Whetton Ehninger (1827–89) and Eastman Johnson (1824–1906). Leutze, however, following a local tradition, concerned himself with historical subjects. The concept of history painting had changed since West and Trumbull. No longer a purveyor of the grand style that could turn local men into universal heroes, it set out to present an event of symbolic importance in as immediate and detailed a manner as possible. Instead of moving the spectator into the abstract realm of heroes, it brought the heroes into sharp focus as part of the living world. Critics judged such works by two criteria: the significance of the event for the painter's public and the absolute truth of its rendering. Significance, as often as not, meant national or political significance, that which reached into the core of the society and thus effectively ruled out the heroes of antiquity. Like genre painting, such works were meant to engage the public attention directly, even though the

82

subject might be remote in time.

Leutze's first major painting in Düsseldorf was *Columbus before the High Council of Salamanca* (1842), followed by *The Return of Columbus in Chains to Cadiz* (1842). The latter was his first painting shown in the United States. Exhibited at the Apollo Association in 1843, it immediately established him with the American public. Not long after Washington Irving published his *Life of Columbus* in 1828, vividly presenting the man's personal struggles, paintings of Columbus began to appear at the salons. Columbus was a hero in Leutze's eyes because he stood up for his convictions against all odds. Like Paul Delaroche in France, Leutze also painted scenes from French and English history, but he emphasized the struggle for intellectual or religious freedom. His great hero, of course, was George Washington, and he began his huge painting *Washington Crossing the Delaware* in 1849. The work was shown in New York to great acclaim in the fall of 1851, then was exhibited for a time in the rotunda of the Capitol in Washington. History made present, though no less heroic, caught the attention of the American people in a way that the earlier paintings of heroism never had.

Other painters also made their names by bringing history to the photographic present. One was Peter Frederick Rothermel (1817–95) of Philadelphia, whose painting *Columbus before Isabella* was one of his earlier works. A younger man who settled in Philadelphia and devoted himself to both genre and history painting was Christian Schussele (1824 or 1826–79). He was born in Alsace and trained in France, but on reaching the United States he devoted himself to American subjects. Even the celebrated portrait painter George Peter Alexander Healy (1813–94) turned his hand to a historical subject, painting *Franklin Urging the Claims of the American Colonies before Louis XVI* in the mid-1840s. At this time, anyone preparing to paint such a work spent months or years doing research on every detail to make each aspect thoroughly accurate in relationship to its place and time—a quality once thought antithetical to heroic stature. Even history had become colloquial. The qualitative gap between historical paintings and paintings of local character had very nearly closed, just as historical writing had begun to veer away from heroic generalities and to concern itself with the life of men.

Emanuel Leutze, *Washington Crossing the Delaware*, 1851. The Metropolitan Museum of Art, New York, New York; gift of John Stewart Kennedy, 1897.

Early interest in the landscape of America was largely topographical or concerned with recording picturesque views, most notably such phenomena as Niagara Falls, which even Europeans admired. World travelers such as James Fenimore Cooper realized that in grandeur and human meaning American landscape could hardly compare with Europe's Alps or the Rhine or the historically impregnated campagna of Rome. Yet in the 1820s, at about the same time that new attention was being payed to the distinctive characteristics of the local inhabitants, new attitudes began to develop toward American nature that would give it a role in the higher realms of art. It was not so much the discovery of hidden places—although sticklers for historical punctuation like to date the change from Thomas Cole's 1825 sketching trip up the Hudson—as it was a new way of looking at domestic scenery.

Sometimes the transition from simple view painting to landscape painting in the more elevated sense is hard to detect. Thomas Doughty (1793–1856), who had tried his hand at a number of endeavors, timidly began to suggest that there was more to be found in the local landscape than met the casual eye, in the delicately painted works he showed at the Pennsylvania Academy beginning in 1822. Surely he was not making an accurate record of place, since he moved elements around to suit his taste and added a few of his own devising. Yet the landscapes were local; the ideal atmosphere they evoked was created out of closely observed neighborhood material. He had the audacity to look at a local pond as if it were Lake Nemi and to render the ordinary clumps of trees mysterious by diffusing their commonplace form with silvery light and transparent veils of quiet color. In the beginning Doughty was looking for a way to make the landscape around him respond to his desire for art. He worked to make his paintings artistically persuasive, until it appeared that the divine light of Claude Lorrain might at any moment burst through the haze of the local countryside. Doughty, though not an especially accomplished painter, was at his best when he drew upon what he knew firsthand, a fact some of his critics recognized.

The paintings of Thomas Cole (1801–48) were per-

Thomas Doughty, *Landscape with Stream and Mountains,* 1833. National Collection of Fine Arts, Smithsonian Institution, Washington, D.C.; museum purchase.

suasive in a more robust way. It was Cole who made it clear to the New York circle that American landscape was a potent source for artistic expression. When shown in New York, the paintings that resulted from his 1825 Hudson River excursion immediately caught the attention of artists as sophisticated as Trumbull and Dunlap, both of whom held traditional notions about the goals of art. Cole had not simply called their attention to Hudson River scenery; he had raised it to the level of art. Cole, who was born in England but grew up in the United States, had an extraordinary quality of projecting himself into the things he saw. Probably drawn to landscape by the generalized theories of sublime nature that had come down from the eighteenth century, with his fiery sense of drama and his great skill in projecting his own energy into natural scenery he gave his paintings a sense of both universal and personal vision. When he drew a tree it was not so much seen as lived. In his hands the familiar American landscape became an exciting arena in which forces and counterforces acted out the drama of existence. The sun bursting from behind a cloud could move him to rapture. What had been a modest example of the picturesque became a source for new spiritual experience.

Thought of in this way, the wild scenery of the Catskills and the White Mountains took on a quality that the more domesticated European scenery could not provide; although such scenery proclaimed a message from the primeval past, its voice had not yet been heard in the realm of art. It gave the American artist something new and profoundly spiritual to contribute to a world that appeared threatened with moral decay. Because it spoke the language of God rather than man, Cole and his admirers believed that American landscape could put the artist in touch with a moral virtue that had been lost to art.

Painters and writers shared this new assessment of the native environment. William Cullen Bryant's stirring poem *Thanatopsis* (1817) commands:

Go forth, under the open sky, and list
To Nature's teachings

And Bryant became one of Cole's staunchest supporters, providing a sonorous poetic complement to his dramatic

views. Nor were Cooper's associations without effect. The tiny figure of an Indian, the personification of wild nature, seemed to Cole a natural element in a wild view. Like Cooper's treatment of the Indian, Cole's paintings evoked a tragic reminder that the surviving wilderness was doomed to pass. American scenery was thus ushered into the public awareness with rich poetic and religious overtones. It was a simple step for Cole to translate his American views into a depiction of Eden in his *Expulsion from the Garden of Eden,* painted in 1827–28.

In 1829 Cole went to Europe with Bryant's admonition not to forget the lesson of American nature ringing in his ears. In London and Paris he studied works in the galleries, and in 1831 he settled for a time in Florence, then went to Rome and Naples. Searching for evidence of past grandeur and elements of human drama, he considered the contemporary landscape painting "dry and in fact wretched." Stirred by his studies of Claude Lorrain, Poussin, and Salvator Rosa, he could look through the mundane veil of modern Italy and see it still as a source of tragic poetry

Thomas Cole, *The Tornado,* 1835. In the collection of the Corcoran Gallery of Art, Washington, D.C.

As human drama Cole's landscapes were a great success. Surely it was in part because engravings of his *Voyage of Life* series were being offered that in 1848 the subscriptions to the American Art-Union jumped from fewer than 10,000 to well over 16,000. Engravings of his various allegorical series remained popular for many years and were widely copied by enthusiastic amateurs. His death in 1848 was looked on as a national tragedy.

Those who followed Cole to the Hudson and beyond were no less inspired to find spiritual content in natural scenery, but they were less inclined to interpret it as human drama. They followed instead his devotion to the direct study of natural phenomena, assuming that nature carried its own content. Not driven by Cole's evangelical impulse, they concentrated on recording nature's discovered beauties with as little change as possible. The artist's function, they believed, was to reveal nature to the responsive soul, not to construct human fantasies of their own. Simply being exposed to nature, with its overwhelming complexity, was enough to purge the mind. In practice they seemed to agree with Emerson that art prepared the eye to see nature. Nature and its spiritual power, not art, was the ultimate content. In a

Thomas Cole, *Expulsion from the Garden of Eden,* 1827–28. Courtesy Museum of Fine Arts, Boston, Massachusetts; M. and M. Karolik Collection.

much-quoted passage from his 1837 essay "Nature," Ralph Waldo Emerson wrote: "Standing on the bare ground,—my head bathed by the blithe air and uplifted into infinite space,—all mean egotism vanishes. I become a transparent eyeball; I am nothing; I see all; the currents of the Universal Being circulate through me; I am part and parcel of God." To be a selfless transmitter of nature was also, in its way, a means for union with God.

Asher Brown Durand (1796–1886), who began as an engraver and then a portrait painter, was one of those his friend Cole attracted to the Hudson and the Catskills. For many years he was the chief spokesman for landscape painting in New York, shepherding younger painters on campaigns into the countryside and succeeding Morse to become the second president of the National Academy of Design from 1845 to 1861. He studied nature meticulously and assembled his studies in carefully executed studio paintings in which he tried to accord each part its individual identity. In 1840 Durand went to Europe accompanied by three younger painters, Thomas Rossiter (1818–71), John Cassilear (1811–93), and John Frederick Kensett (1816–72). His study there of Claude Lorrain and other old masters reassured him in his direction of studying light and atmosphere, but he returned shortly to concentrate on American scenes. Of the younger painters who stayed on longer, it was Kensett who added the most distinctive taste to the painting of landscape, developing a precise, patterned style that effectively dramatized the silence of open, sunlit spaces. His work no longer depended on traditional compositional devices of Claudian light in which the sun seemed to radiate from the painting, but presented startlingly clear and unexpected vistas. He profited much from his seven years in Europe, where many artists were concentrating on direct landscape studies, and he brought a new expertise to America. On his return to the United States in 1848, Kensett was quickly hailed as a major painter of the American landscape. He was at once a master.

The transformation of American landscape painting in the brief span of twenty-five years from the declamatory drama of Cole to the detached serenity of Kensett was remarkable. Critics and historians jubilant at being

Asher B. Durand, *Early Morning at Cold Spring, New York*, 1850. Collection of the Montclair Art Museum, New Jersey; Lang Acquisition Fund.

John Frederick Kensett, *Along the Hudson*, 1852. National Collection of Fine Arts, Smithsonian Institution, Washington, D.C.; bequest of Helen Huntington Hull.

able to isolate a tendency that seemed peculiarly American, coined the term, "Hudson River School" for the landscape painting that started in New York in the 1820s and 1830s and flourished in the 1840s and 1850s. So popular has the term become that it has been used to encompass almost all American landscape painting until late in the century, thus losing any meaning it might once have had. Cole and his followers on the Hudson and in the Catskills introduced a new kind of painting to America—landscape painting based on the direct and careful study of the natural fact. Once this premise was established, a wide variety of landscape painting developed, and it loses much by being grouped under a single heading. It should be enough no note that during the second quarter of the nineteenth century, painters discovered that the American landscape, like local genre and newly assessed history, was a provocative source for art; and the public, in the throes of a heady nationalism, was eager to accept it.

One other influence on thinking about painting must be taken into consideration. Very shortly after they first appeared, beginning in 1843, John Ruskin's essays on art were read with particular attention in America. His subjugation of art to nature, his religious zeal, and his emphasis on tireless, selfless study exactly supported the inclination of American landscapists in the 1840s. When the first really professional art magazine began publication in 1855, edited by W. J. Stillman and John Durand, the son of Asher B. Durand, Ruskin was well represented in its pages. The Art-Union had published its *Transactions* and *Bulletin,* which contained not only news of the Art-Union's activity but essays and orations on art and news of artists working abroad and in the United States; but the *Crayon,* as it was named, belonged far more to the circle of artists. Its leanings were strongly toward landscape, and its articles combined high-sounding theory with very practical, technical discussions. Some young painters looked upon it almost as sacred writ, it meant so much to them as a fraternal publication and as a guide in shaping their goals. Ruskin's ideas were never far beneath the surface.

Ruskin and other writers on nature and art were important to many besides artists. The American public, at least those who could afford it, had begun to escape the

cities to spend their summers at picturesque resorts. From the Catskills up to the Maine coast, hardy travelers could find simple accommodations that would let them enjoy the thrills of the rough sea or the cascades and mountain views of the wilderness. In some areas practiced guides were available for those who wanted to hunt or fish, but many went chiefly to look and to record their exhilaration in their journals. Boston residents explored the Adirondacks and the Maine woods or rusticated on the still-primitive Isle of Shoals or the rocks of Marblehead. From New York vacationers could scatter up the Hudson or along the coast of New Jersey. The attitudes toward nature also had an immediate domestic impact. A. J. Downing first published his much-reprinted essay *Treatise on Landscape Gardening* in 1841, discussing landscape and landscape architecture as a reflection of character. Chiefly concerned with rural estates, he emphasized the relationship of building to nature, recommending the English cottage as especially suitable to American ideas and the Gothic style as most appropriate in mingling associational values with natural forms. His ideas of living with nature marked the beginning not only of picturesque country homes but of informal city parks and urban planting. He even designed a bosky garden to surround James Renwick's Gothic castle built for the newly established Smithsonian Institution, supplanting L'Enfant's formal rigidity with the spiritual consolation of nature. Even in token representation, nature was recognized as having a positive moral influence. By the time Henry Thoreau published his *Walden; or, Life in the Woods* in 1854, a discriminating public could read his encomiums of nature with sympathy supported by some measure of personal experience. The same sympathy gave personal importance to the images of American landscapes, painted or engraved, that made a welcome decoration for family walls. The virtue of American nature was beyond question.

The Persistence of Traditional Ideals

Concentrating on local values and awarding nature precedence over art did not wholly supplant belief in the great artistic traditions and their European associations.

The two conflicting attitudes existed side by side. By the 1840s critics had decided that American art was mature enough to merit analytical criticism rather than simply praise. But though some critics were highly partisan, collectors and the public seemed content to adjust their taste to the coexistence of various modes. Woeful as the diffused situation might seem to critics or historians, the public saw no reason to embrace a single style exclusively. Art spoke various languages—sometimes that of nature and sometimes that of the great art of the past. In the very years when local landscape and vernacular subjects were becoming popular, one of the most respected New York painters was Daniel Huntington (1816–1906), whose *Mercy's Dream*, first painted in 1841 based on Bunyan's *Pilgrim's Progress,* became one of the best-known images in America. A man of Italianate leanings (he was first in Italy in 1839 and worked in Rome from 1842 to 1845) and strong religious feelings, he saw history not as a series of photographic views as Leutze did, but always with nostalgic overtones. Like many concerned with the conflict between reason, as represented in modern science, and religious belief, he saw the spiritual values of the past and its art as redeeming forces. Similarly, William Page (1811–85), like Huntington essentially a portrait painter, was concerned with reconciling science and religion through art. His master was Titian, and eventually his arguments were phrased in terms of Swedenborg, whose writings on correspondence between spiritual qualities and physical form proved very persuasive to artists at mid-century. His *Venus,* first painted in Rome in 1856, was an effort to combine classical perfection (it was based on a well-known antique torso) with natural vitality as revealed in the technique of Titian. He wished, in other words, to unite the past and the present. Also in these years, Henry Peters Gray (1819–77) was creating his persistently old master images, alternating striking portraits with modern Venuses and allegorical figures, all of whom glance nostalgically back across the centuries. These painters were not men who turned their backs on their own time but deeply motivated artists who believed it their duty to keep within the modern grasp a spiritual legacy inherited from earlier cultures, not by imitating

Daniel Huntington, *Mercy's Dream,* 1850. In the collection of the Corcoran Gallery of Art, Washington, D.C.; gift of William Wilson Corcoran.

William Page, *Venus Guiding Eneas and the Trojans to the Latin Shore,* 1856–67, drawing.

past works but by keeping alive the values that made them possible.

Possibly it was the insistence on local values that confirmed more artists in an expatriate existence. In the 1850s the American colony in Rome was larger and more active than ever before. Artists were attracted not only by the availability of examples of past art and a landscape blessed by history, but even more by the kind of life the country provided. Many artists now went to Italy to stay. John Gadsby Chapman (1808–89) had been in Rome as early as 1828, and in 1830 he joined Morse on a leisurely sketching trip. In the United States he became well known as an illustrator and published his popular *American Drawing Book* in 1847 (it had as its subtitle *Anyone Who Can Learn to Write Can Learn to Draw*). But in 1848 he moved his family to Rome—as a relief from New York, he said—and spent most of the rest of his life there. A man of the younger generation, Stanley William Haseltine (1835–1900), was in Düsseldorf and Rome in the 1850s, then after the Civil War he settled in Italy for the rest of his life. John Rollin Tilton (1828–88), a painter of highly acclaimed Roman landscapes, settled in Rome in 1852 and spent the rest of his life there. The list is very long.

Illustration from John Gadsby Chapman, *The American Drawing Book*. New York: J. S. Redfield, 1847.

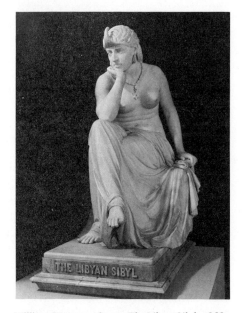

William Wetmore Story, *The Libyan Sibyl*, 1868. National Collection of Fine Arts, Smithsonian Institution, Washington, D.C.; Gift of the Estate of Henry Cabot Lodge.

Many artists felt that for their kind of intellectual and artistic life the mercantile hustle of America simply was not suitable. They formed a bridgehead with a more tranquil, less time-goaded pace of life. Conveniently overlooking the struggling Italian political situation, they made artistic detachment a way of life, maintaining their own cultural circle without much regard for any political organization. Many in the group had strong ties with Boston, whose artistic traditions quite understandably supported their values.

William Wetmore Story (1819–95), the son of Justice Story, was a member of the Harvard class of 1838 along with James Russell Lowell and others with literary aspirations. Although he went on to earn his law degree, he was active in the publication of the *Dial*, the transcendentalist periodical, for which he wrote comments on art, a subject about which he had positive ideas. He won the competition for a sculptural monument to his father in 1847 and went to Italy to execute the sculpture, thus

beginning a career in art at the expense of law. In 1851 he returned to Rome and from this time on was a permanent resident with sumptuous apartments in the Palazzo Barberini. Story became the central fixture in the Roman group, attracting to his circle artists, literary figures, and statesmen. He was a close friend of the Brownings, and Hawthorne used the first version of his *Cleopatra* for a memorable passage in the *Marble Faun* (1859), compounded largely out of his Italian journals. Story's own writings on Rome indicate that he was thoroughly at home in the realm of words.

One of the curiosities of this Roman group was its contingent of female sculptors. Chief among them was Harriet Hosmer (1830–1908), who went to Rome in 1852 with her actress friend Charlotte Cushman. Surrounded by a busy group of Roman marble-carvers, she maintained an active studio, turning out popular works for an international clientele. Her *Puck* (1856) was much admired, as was her *Beatrice Cenci*. Among the other female sculptors there were Margaret Foley, Emma Stebbins, and Edmonia Lewis, who was particularly remarked on because of her Negro and Cherokee background.

Although William Rinehart (1825–74) kept mainly to classical subjects, most of the sculptors preferred subjects with a well-prepared literary context: Randolph Rogers (1825–92), who settled in Rome after studying for some time with Lorenzo Bartolini in Florence, gained particular fame for his *Nydia, the Blind Flower Girl of Pompeii* (1855–56), taken from Bulwer-Lytton's novel *The Last Days of Pompeii*. Some fifty replicas were cut. Story's major works were all historical or dramatic figures clad in literary allusion.

The traditional procedures of the Italian studios were particularly useful to the expatriate sculptors who developed popular subjects in marble. The artist would first make a small model, which the workman would then rough out full size in clay. The artist then brought this model to the degree of completion he wanted, and it was cast in plaster. The plaster figure served the workmen as a guide in producing a more or less mechanically measured version of the work in marble, which the sculptor then finished in detail. Sometimes the sculptor himself did not touch the marble but simply directed the

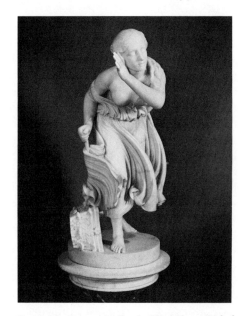

Randolph Rogers, *Nydia, the Blind Flower Girl of Pompeii*, 1855–56. National Collection of Fine Arts, Smithsonian Institution, Washington, D.C.; transfer from the National Museum of History and Technology.

most skilled of the workmen, the finisher. At least the plaster, if not the finished marble, remained in the studio to be seen by potential buyers on visiting days. There were guidebooks of Rome giving the addresses of artists' studios and the hours they were open to visitors, and the visitors' taste was influenced as they made their rounds by learning to whom various works had been sold. The sale of additional copies of a work was especially profitable since it need occupy little of the artist's own time. His was the creative spark; much of the manual labor was left to the marble-cutters, who were famed for the accuracy and delicacy of their carving. And the pure white marble was itself considered of spiritual value.

There were some notable exceptions to the cult of pure white marble. As noted earlier, Thomas Crawford, who died in Rome in 1857, had worked in bronze, supervising the castings in Germany. Henry Kirke Brown (1814–86), who started as a painter and modeled his first bust in Cincinnati, spent time in Rome in the 1840s but returned to New York to work exclusively in bronze. His very ably modeled equestrian statue of George Washington in New York was finished in 1853. His pupil, John Quincy Adams Ward (1830–1910), did not study abroad but established his studio as a sculptor in bronze in New York in 1861. Thomas Ball (1819–1911) took up sculpture in Florence and Rome in the 1850s, but his major work was also executed in bronze. His most famous work was the *Emancipation Monument* executed in the 1870s. But whether they worked in marble or bronze, in Rome or New York, sculptors were rapidly facing a problem of style that would be harder for them to resolve than for the painters.

For midcentury artists in Rome there was little that could be synthesized as the Roman style. Much of the sculpture, especially that in marble, did show classical traces, but there was a wide range. Rome was no longer a bastion of style but was only a symbolic place that stood for art, in the minds of patrons as well as artists. The sentiment it now inspired, however, was more nostalgia than grandeur.

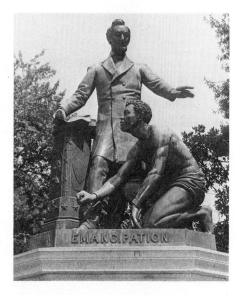

Thomas Ball, *Emancipation Monument,* erected 1876. Lincoln Park, Washington, D.C.

1860-1900

A Crisis for Art

Controversy over the various approaches to art came to a head in the early 1860s. Since the 1840s, criticism in newspapers and journals had gradually taken on a more combative stance, and adversaries recognized each other through the use of key words—expression, nature, truth, and so on—and artistic references. Much depended on whether the object depicted or the creative act was considered more important in giving significance to the work of art. Understandably, those who believed in the great traditions of art put their faith in the expression of the artist, maintaining that art was the communication of feeling—of an inner spiritual sense of the artist—and that this gave form to his work. Those who believed that nature was all condemned any manifestation of the artist's own feelings as a distortion of God's world. There seemed to be no middle ground.

The most original critical mind to make an impact on the public consciousness was doubtless that of James Jackson Jarves, who had little patience for what he considered the mindless copying of nature, dear to the hearts of many American landscape painters. Although he praised landscape as the one area of American artistic success, he pointedly ignored some painters, such as Durand, whom he felt were misguided. Persuaded by the new European art historians who saw art as a progression of styles and perceptions formulated by the genius of individual artists, he delighted in recognizing in a work of art the peculiar power of the artist's mind. In Florence in the 1850s he built up an extraordinary collection of Italian paintings, chiefly from the four-

Facing page:

George Inness, *September Afternoon*, 1887. National Collection of Fine Arts, Smithsonian Institution, Washington, D.C.; gift of William T. Evans.

teenth and fifteenth centuries, to illustrate the growth of artistic ideas. He did not advise artists to imitate Giotto, but like German and Italian predecessors he believed that the kernel of artistic expressiveness was to be found in works by the earlier artists. Although his collection was pre-Raphael, he had little sympathy for Ruskin's interpretation of early art as selfless and natural. He saw it as the work of artists who had something to say and had found their own most direct way to say it. The American artists that Jarves singled out for praise were those in whose works he could detect a creative idea, whose paintings provided a particular experience to stimulate the mind and engage the feelings. His ideas about art, well articulated in the press, were later brought together in his book *The Art Idea*, published in 1864.

Nature as Art

In the same years when Jarves was setting forth his convictions and exhibiting his collection of Italian paintings in New York and Boston, a group was formed in New York to oppose just such irreverent ideas as Jarves was enunciating. The group, formed in January 1863, called itself the Society for the Advancement of Truth in Art, and in May it published the first issue of its journal the *New Path*. At the center of the group of young painters, architects, and critics was Thomas Charles Farrer, an English follower of Ruskin who had settled in New York in 1860. All the founders were aware of English Pre-Raphaelite painting, of which a fair representation was shown in New York in 1857, and their critical basis was wholly formed on Ruskin's early writings, although they professed appreciation of Bryant, Emerson, Lowell, Whittier, Holmes, and Longfellow. In the foreword to their journal they stated: "We believe that all nature being the perfected work of the Creator should be treated with the reverence due to its Author, and by nature they do not mean only the great mountains and wonderful land effects, but also every dear weed that daily gives forth its life unheeded, to the skies."

This point of view is not much different from that expressed ten years earlier in the *Crayon*, but the critics writing for the *New Path* had a new mission because they

saw their concept of art seriously threatened. Their criticism was barbed and militant, especially in the hands of young Clarence Cook, and they insisted that there was no morally acceptable way in art but theirs. Few earlier landscape painters met the rigorous standards of selfless, humble recording they insisted on. The individual leaves of a common forest plant, the lichens on a rock, painted not in the studio but on the spot, were measures of virtue. Able painters such as Aaron Draper Shattuck (1832–1928) and Willian Trost Richards (1833–1905) met their criteria, but many they praised were little better than amateurs. It was the effort that counted, they maintained, not just the result. Charles Herbert Moore (1840–1930), the young secretary of the society, continued his meticulous studies throughout his life and transmitted his belief in art and self-sacrifice to his many students at Harvard, where he taught from the early 1870s until 1909. This was a proselytizing movement in which a spread of faith became a major factor in judging the value of the art.

Although they rather grotesquely overstated their case, the critics writing in the *New Path* were in touch with a principle that had a far-reaching effect in art. Their contention that art begins and ends with perception was a premise of revolutionary import, even if one ignored their assumption that such concentration brought one into contact with God. It was a kind of purgation, getting rid of the past, in order to begin always anew. Although the *New Path* brethren saw little beyond "every blade of grass that waves and shivers in the wind; every beautiful pebble that rolls and rattles on the sea sand," others did. Relatively few painters were willing to spend their time on blades of grass, even though they believed in the principle of an art of perception. They found their satisfaction in different kinds of involvement with the objects seen, yet remained within the strictures of a nonfabricated art.

At the same time that Shattuck and Richards were concentrating on domestic brambles and appealing weeds, a natural world on a new scale was opening up for American artists. If one wished to express the overwhelming emotional quality evoked by nature and yet, through principle, could not indulge in contrived artistic form, the answer was to discover those views of na-

Aaron Draper Shattuck, *Leaf Study with Yellow Swallow Tail*, circa 1859. Collection of Jo Ann and Julian Ganz, Jr.

Charles Herbert Moore, *Pine Tree*, 1868. The Art Museum, Princeton University, New Jersey; gift of Elizabeth Huntington Moore, the artist's daughter.

ture that were in themselves overwhelmingly expressive. Frederic E. Church (1826–1900), imbued with the sense of drama of his teacher Thomas Cole but far more direct and literal in his view of nature, spent his life searching out nature in its most spectacular moments. In 1853 and again in 1857, inspired by Alexander von Humboldt's descriptions of Latin America, he went to Ecuador to record the exotic landscape with extraordinary fidelity. Although his large paintings, such as *The Heart of the Andes* (1859), were executed in his studio, they were based on hundreds of direct studies so that nothing in the landscape need be obscured or left to chance. His searches took him on a trip to Labrador to study icebergs (1859), to the European Alps, Greece, and the Near East, always to record the fabulous as natural fact. His painting was both grandiose and meticulous, thus effecting a useful compromise between a desire for expansive expression and a worship of nature's process.

Albert Bierstadt (1830–1902) returned from studies in Düsseldorf just in time to accompany an exploring company going west. In 1858 the government sent General Frederick W. Lander to map a wagon route to the coast. Many topographical artists had recorded aspects of the West but Bierstadt was looking for pictorial grandeur—and he found it. In Wyoming, where he spent the summer, he discovered the vast craggy range of the Rocky Mountains and produced a series of paintings from his sketches that quite changed the public image of American scenery. Often painted into the sun, like the works of his German colleagues since early in the century, his grandiose views showed a luminous universe appearing through a succession of atmospheric veils that staggered the imagination and kindled a new American pride in possession. Bierstadt became the limner of America the spectacular, celebrating the recently explored Yellowstone and Yosemite. He began a whole school of painting devoted to the natural monuments of the American West, acclaimed by a public just realizing the vastness of the country it now occupied. It was difficult to concentrate on a humble ragweed when the towering Rockies were beckoning, and truth to nature became truth to a new national nature—perceptual truth infused with not a little pictorial boosterism.

Frederic E. Church, *South American Landscape*, 1856. Courtesy of the National Collection of Fine Arts, Smithsonian Institution, Washington, D.C.; lent by Mrs. Therese Davis McCagg.

Albert Bierstadt, *Western Landscape with Lake and Mountains*, 1868. National Collection of Fine Arts, Smithsonian Institution, Washington, D.C.; bequest of Helen Huntington Hull.

The most impressive painter of the West was Thomas Moran (1837–1926), who, like Church, was moved emotionally by grand aspects of nature and set out to render his subjects with scrupulous truth. Like Bierstadt and others, Moran ably used the photograph to check the accuracy of his effects of distance and description of detail. Probably the photograph also helped him achieve a unity of view, though when Moran assembled a huge painting, such as the *Grand Canyon of the Yellowstone* (1872) or *Chasm of the Colorado* (1873–74), it was as if he moved through the vast space viewpoint by viewpoint, to provide the viewer a number of advantageous positions from which to judge the immensity of the inspiring phenomenon. He was enamored of Ruskin's writing, chiefly his Alpine descriptions and his analysis of the English painter Joseph Mallord William Turner's color and light. In fact, Moran owes much of his rich color to Turner, but he would have said that Turner simply served to reveal nature to him; Moran, like his Pre-Raphaelite predecessors, believed that nature was all. But what extraordinary nature!

By the end of the century, the huge western landscapes were looked upon by connoisseurs as embarrassments, but less artistically doctrinaire members of the public seemed not to tire of them. They were true, they were emotionally moving, and they were theirs.

Thomas Moran, *The Grand Canyon of the Yellowstone*, 1872. Courtesy of the National Collection of Fine Arts, Smithsonian Institution, Washington, D.C.; lent by the United States Department of the Interior, National Park Service.

Perception and Truth

When the critics on the *New Path* talked of perceptual truth they had one thing in mind: the total depiction of an object in a particular place and time. They wanted the whole truth, and anything less was regarded as insincerity. By the 1860s, however, there were those who questioned the nature of perception, wondering just how much of the "whole truth" was a product of the unbiased eye. The French scientist Michel Eugène Chevreul had already pointed out that color was a disarmingly relative phenomenon, not the exclusive property of things, and some painters began to realize that one does not necessarily see in terms of identifiable objects and details, but more often than not perceives total visual forms and the way they relate to each other. Knowing before seeing was not necessarily the same as knowing from seeing. Visual knowing, to those who

analyzed the situation, was concerned not with weight and internal structure but with the particular configuration of shapes and shadows that was real to the eye even though remote to the touch. In the late 1860s an Italian critic described the process of perceiving by imagining a person approaching along the street. Identity is established first by shape, then by the particularities of dress, and finally by the expression on the face; but it is the first identity that strikes the mind most forcefully and establishes the basis for the successive particulars. He insisted that, though paintings might very well record details, descriptive particularity should never overpower the total visual impact, because in that purely visual assembly of relative shapes was to be found the essential power of art.

Painters had toyed with this idea for a long time, and some, such as the French painter Camille Corot, especially in his small Italian studies from the 1820s, produced works of astonishing luminosity and freshness without recourse to descriptive detail. In the second quarter of the century, painters who came to Naples and Rome from many countries were fascinated with capturing effects of space and light with the simplest formal means. But such painting based on pure vision turned up rather late in the United States, possibly because of the militant tradition that insisted on the literal transcription of things.

In the beginning, Eastman Johnson (1824–1906) was no exception. In 1849 he went to Düsseldorf to study and became proficient in the tight, literal outlined drawings for which the academy there was noted. After a stay in the Hague and in Paris, he returned to the United States in 1855 ready to make his way as a painter of genre. His *Old Kentucky Home; or, Life in the South,* which he showed in New York in 1859, was an affable painting in the tradition of works devoted to local types. It showed, however, unusual appreciation of sensuous matters such as textures and light reflections. It is this latter quality, rather than the controversial subject, that gives a clue to his later painting. Evidently Johnson found in vision itself, quite aside from the object, a source of wonder and aesthetic satisfaction. The subjects he chose for his paintings are not especially notable; they follow the taste of the day, ranging through farm

scenes, sentimental genre, and elegant interiors. But all are transformed by an impressive sobriety of vision. His people are not re-created, they are simply but sympathetically seen. As Johnson's technique of painting became bolder, this consciousness of seeing a view directly as a whole became more evident. In his paintings of people in the fields from the 1870s, there are no detailed features, but the figures jump into life as they take form in the luminous atmosphere. Caught in this way, the figures seem fixed in a moment of time, and any potential action is held back by a suspenseful silence. Although the brushstrokes are evident, they do not suggest continuous action but simply hover in space. The paintings of Eastman Johnson suggest a new kind of detachment: a consciousness of the act of seeing that, of necessity, suspends the action and separates the viewer from the thing seen. The artist becomes a bystander, no matter how impassioned, looking at the whole without identifying himself with any part. There is something peaceful but melancholy in a world so viewed; one delights in the precarious beauty of composition but is somehow moved to regret the loss of an innocent belief in the absolute reality of things. Relinquished also was the assumption that one mind is basically the same as every other, and that everyone perceives in the same way. To be aware of the individuality of perception was to recognize a new problem in human communication.

These qualities of arresting vision are even more pronounced in the work of Winslow Homer (1836–1910), who came to prominence during and just after the Civil War. He began as an illustrator and provided many drawings of scenes from the Civil War to serve as woodcuts in *Harper's Weekly*. They are characterized by a sharp sense of pattern and clear-cut shapes, qualities that in less obvious form carry through into his paintings. Above all, his compositions are graceless—that is, they are blunt observations showing little tendency to sweep all the forms into a preordained rhythmical continuity. This resistance to popularly expected graceful harmonies was not much admired, but it remained essential to Homer. He first came to note as a painter in 1866 with the showing of his *Prisoners from the Front,* an unsentimental depiction of a group of

Eastman Johnson, *Old Kentucky Home, Life in the South,* 1859. Courtesy of the New-York Historical Society, New York, New York.

Eastman Johnson, *Cranberry Pickers,* circa 1870–80. Yale University Art Gallery, New Haven, Connecticut; bequest of Christian A. Zabriskie.

101

Southern prisoners in confrontation with a young Union officer. (It is notable that many sentimental paintings of the war and of the plight of slaves were executed in the late sixties and seventies, well after the conflict and after emancipation had been proclaimed.) Equally impressive, though less remarked on at the time, were his small paintings of ladies and gentlemen playing croquet, in which individual features are subordinated to the simple patches of luminous color, or his simple rural scenes, such as *The Morning Bell,* in which the evocation of a clear, cool light that picks out the shape and relative color of each distinct object is at least as important as the implied narrative. Although Homer consistently painted people, he did not intrude on their lives or comment on their characters. As in the works of Johnson, the people were seen, not interpreted.

In 1867 Homer went to France for some months, but, though the experience may have encouraged him to loosen his technique, his vision as a painter had already been established. His evocation of the open air, as in his sunlit views of proper society at Long Branch, New Jersey, provided a whole new atmosphere for American art. The fashionable, modishly dressed ladies functioned chiefly as lively spots of color in the precisely composed, sun-shot whole. His paintings bore no narrative or social message; they simply made the viewer aware of how pleasurable looking could be.

Homer was not a gregarious man. In 1881 he settled on the northeast coast of England for two years, and then went to live at Prout's Neck on the coast of Maine. The sea became his primary object of study, although he did not regard it in quite the way American painters had seen it before. It was a source of infinite variation in color and light as storms threatened, clouds rolled in, and waves broke on the rocks. He painted fishermen and their boats as if they were part of the sea; he no more identified himself with the people than he did with the turbulent waves. This was equally true when he explored the Canadian woods or the Adirondacks: he did not boast about the wilderness or anthropomorphize its animals. There, as elsewhere, he discovered suspended moments in which people, nature, and their interwoven pattern afforded a nameless satisfaction to the eye.

Winslow Homer, *The Morning Bell,* circa 1866. Yale University Art Gallery New Haven, Connecticut; bequest of Stephen Carlton Clark, B.A. 1903.

Winslow Homer, *High Cliff, Coast of Maine,* 1894. National Collection of Fine Arts, Smithsonian Institution, Washington, D.C.; gift of William T. Evans.

In the Caribbean, which attracted him by its bleaching sun and clear, brilliant color, he produced some of his finest works, many in watercolor. Homer's watercolors, even more than his oils, demonstrate the remarkable identity between his technique of painting and the process of seeing. Every stroke falls into place as part of a poised design, yet seems to be the spontaneously recorded effect of light and substance. The ease with which some seem to be created is astonishing, and yet each stroke is so just that facility as a virtue in itself never becomes an issue.

Homer's paintings are not without human compassion, but the viewer is left to make his own judgments. Much has been written about *The Gulf Stream* (1899) and the significance of the Negro sprawled in a tossing boat surrounded by sharks. But Homer's emotional commitment was no greater here than when he painted the lost fishermen of the Great Banks or solitary boatmen facing a storm. Yes, they might be seen as dramatic. But Homer accepted such perils with a peculiar fatalism. The world provided an infinite kaleidoscope of visual experiences that involved both nature and humankind; with such a bounty to fascinate him, he gave no evidence of a compulsion to draw philosophical conclusions.

There is no reason to suppose that Homer or Johnson knew specifically of the contemporary writings of Emile Zola, but their works in a way are consistent with some of Zola's ideas about art. He believed the artist should depict what he saw around him without personal comment. The personal contribution of the artist came from his unique perception, since no two persons, Zola averred, can see alike. Physiologically and psychologically each person is different. The artist, then, must be true to his own vision just as he is true to the thing he depicts. According to such a theory, differences in art are a matter not of style but of perception. Art enlarges each viewer's world by allowing him to participate in the artist's unique vision, thus becoming more conscious of his own perception as well as of the infinite, distinctive experiences afforded by the dispassionately observed world.

The Literal Truth

Although many artists in the post–Civil War period persisted in a direct rendering of nature, few paid much

Winslow Homer, *Sloop, Bermuda* 1899. The Metropolitan Museum of Art, New York, New York; purchase, 1910, Amelia B. Lazarus Fund.

attention to such questions about perception and its relationship to what was generally considered to be visually true. Nonetheless, their works give clear evidence that their perception had changed. The most striking difference between the paintings of common life in this period—including what might be called historical genre—and similar paintings from earlier in the century is the rather diffused effect of space in the later works and the small-scale treatment of people and things. The scene somehow appears simply to be looked at, not entered into.

John George Brown (1831–1913), who was born in England, became an extraordinarily popular painter in New York in the late 1860s and 1870s and made a sizable fortune from his sentimental pictures, most of children engaged in various activities. His specialty was the street urchin, dirty but endearing. Although his anecdotes are not notably different from those of the earlier painters, the environments he created exist on quite a different perceptual level. In the paintings of William Sidney Mount, for example, each object, whether a wood shaving or a country store, is treated as a complete form in space, as if Mount were assessing its character almost tactilely. A head painted by Woodville emerges as a rounded volume in space, taking on a palpable existence, directly engaging the memory of touch and weight as well as sight. Similarly, Bingham's figures seem to have a self-determining life of their own. This palpable reality seems not to be part of Brown's consciousness. Little by little as he progressed as a painter, people and things in his paintings took their places in an environment in which they are accepted simply as existing. We know no more about them than if we were to encounter them on a walk through town, though Brown included a formidable amount of observed detail. To be sure, the artist has selected his subjects and grouped them—often rather obviously—but there his obligation to formal structure ceases. He was content to look at his carefully chosen models and paint what he saw. What he saw had little to do with the tactile knowledge of things or with a perceived sympathy among forms. Furthermore, he recorded every accident of light and shade whether it related to the purpose of the composition or not, since his people purported to

John George Brown, *The Longshoremen's Noon*, 1879. In the collection of the Corcoran Gallery of Art, Washington, D.C.

belong to a world beyond the picture frame. Light was not a means for structure but simply an observed phenomenon.

Brown was by no means alone in this tendency toward a passive vision. In the 1870s and 1880s many painters were convinced that this purely visual assessment of the object was more true than a tactile proof of things. What part the photograph played in this new passive vision is a matter of conjecture. Certainly no artist working in the 1870s was unaware of the softly graduated values and rather flat image of the photograph, and many artists, ranging from landscape painters to portraitists, used photographs in their work. By 1876, photography was sufficiently recognized as a separate art to merit its own pavilion at the Centennial Exposition in Philadelphia. On the other hand, the popularity of documentary photography may have sprung from the same tendency of mind that supported new visual literalism in painting. Perhaps documentary photography and paintings of passively viewed nature appealed to an intellectual cast that felt at home with statistics and uneasy with imagination.

One indication of the popularity of a literal view of things uncomplicated by obvious stylistic commentary was the success immediately following the Civil War of John Rogers's small sculptural groups, cast in hard plaster, which he made available by catalog to households across the country. John Rogers (1829–1904) started modeling his small figures on his own in the 1850s, then studied briefly in Paris and Rome. Works on Civil War themes, first produced in 1863, brought him to public attention, and before long his sympathetic groups, ranging in subject from *Checkers up at the Farm* to *Wounded to the Rear, One Last Shot,* were to be found in parlors throughout the United States. His little sculptures were anecdotal, sometimes sentimental, and were always carried out with extraordinary attention to detail. Their small size was important. The diminutive figures with all of the attributes of recognizable living people, going about their business with some intensity, invited the viewer to enter a miniature world that, because of its size, seemed exclusive and remote from the normal world where actions are assessed in terms of physical consequences. And all of this could take place

John Rogers, *Checkers up at the Farm,* patented 1875. National Collection of Fine Arts, Smithsonian Institution, Washington, D.C.; gift of the artist.

without seeming to change the appearance of anything. Actually, Rogers did a good deal of changing. He was a master of three-dimensional composition, and there is not a fold or a tilt of a head in his small groups that does not relate to the whole and expertly advance the narrative. For his public, however, this was sculpture to fit the times, since it told a proper story, was visually true to its form, and played on sentiments understandable to all. There was no problem of interpretation, either visual or artistic. It still seemed an art of common sense.

The fascination with appearance led quite naturally to a kind of painting that set out to fool the eye into supposing that the painted image was actually the object depicted—deliberately creating an illusion. Art that fools the eye had been a recurrent preoccupation throughout the history of western art ever since Greece, and it fascinated some of the earlier American painters. Charles Willson Peale painted his *Staircase Group* (1796) as a genial fascination piece for his museum, and Raphaelle Peale delighted in playful illusion, as did Charles Bird King and some others. But the paintings produced by William Harnett and his followers in Philadelphia beginning in the late 1870s were of a different kind.

Harnett (1848–92) began by painting rather conventional still lifes, but he carried the definition of objects to a point where the painted forms seemed more real than the objects themselves. A copper pot or a worn book intrudes into space, demanding attention well beyond what its appearance deserves. He liked to paint works that seemed to be collages; but the worn confederate money that threatened to peal off the canvas and the casually gathered envelopes with obscure addresses were all of paint. There was more art in Harnett's compositions than the public realized; no matter, it was the triumphant illusion that sold the pictures. In 1880 Harnett went to Europe and spent six years working chiefly in France and Germany. On his return in 1886 he was a more polished painter, yet illusion was still the principle on which his paintings were based. His *After the Hunt* (1885) set the tone for his later painting—and for many of his imitators. The canvas surface becomes a cabin door on which the trophies of the hunt are hung, making the painting itself into an object. There is no point of

William Harnett, *After the Hunt,* 1885. By permission of the Fine Arts Museums of San Francisco; California Palace of the Legion of Honor.

reference for going into the painting; the displayed objects push forward into space. Under proper lighting the illusion is complete.

But illusion was only the premise for Harnett. Within the illusory space he assembled a complex harmony of colors, textures, and forms that is the more riveting for being unexpected. A dead hare hung by one foot, or a plucked chicken, becomes an object of unexpected beauty, not simply a vaunted illusion. Harnett had an extraordinary sense of design and an uncanny way of making his formal perfection seem the inevitable result of his assembled objects. His paintings not only fool the eye but fool the mind into recognizing all manner of sensuous niceties in a context not normally thought of in association with art.

Harnett had many followers—some who recognized the real quality of his paintings and some who saw only his skill at illusion. The best was John F. Peto (1854–1907), who had an engaging talent for visual humor as well as a leaning toward understated sentiment. What the best of these painters made clear was that illusion is not a bar to artistic quality, provided that the creative force of the artist never lost control. Used as a language, not as substance, it could provide the pleasures of art even to a pragmatic mind.

Perception and Beyond

For an exhibition of his works in Boston in 1863, the landscape painter George Inness (1825–94) published a statement that was clearly devised as a rebuke to the *New Path* critics and all those who placed nature before art, and he quoted some comments written in his support by James Jacson Jarves. A landscape, he insisted, was a means for expression, providing the sensitive artist with the forms and colors to convey an inner feeling, a spiritual awareness. The painter selected from the view of nature only those aspects that could be identified with his expressive need. Although not orthodox, Inness was a very religious man. Like many artists of his generation, he was much impressed with the teaching of Swedenborg, though he made no effort to translate the doctrine literally into his artistic procedures as did his friend William Page. Instead, he looked upon landscape as reflecting in a general way the spiritual quality of man. It was

through the feelings evoked by landscape that one entered God's universe.

When Inness began, he painted in the manner of Durand and others who believed in the minute representation of natural fact, but by the early 1860s he had begun to paint more broadly, with richer colors, simplified forms, and radiant skies. Each painting was unmistakably intended to evoke a mood—to wrap the viewer in reflection and feeling. At the same time his simple masses and unity of view—which precluded painting all parts in fine detail—were more suggestive of a landscape as actually seen than were the tightly painted canvases of his Ruskinian contemporaries. Inness had been in Europe in 1847 and again in the 1850s and was aware of the French painters who worked at Barbizon, painting humble landscapes and trying to live like peasants. The aspect of their work that caught his eye was a quality of mood, of emotional suggestion. As he continued to speculate on the relationship between landscape and the human psyche, his works became less and less specific in detail and more openly evocative and ruminative. "The purpose of the painter," he wrote, "is simply to reproduce in other minds the impression which a scene has made on him. A work of art does not appeal to the intellect. It does not appeal to the moral sense. Its aim is not to instruct, not to edify but to waken an emotion."

By the late 1870s Inness had found his audience, which was ready to follow him even into the most shadowy, suggestive phases of his work. As if exasperated by the miniscule script of Ruskin's followers and the flamboyance of the western painters, the critics found in Inness a haven for artistic reflection and quiet sensuous enjoyment. He spoke to the spirit as an artist, not as a theologian. Although the large public—reflected in the New York art market—might have little patience for an art that was so little specific, that did not fool the eye and had no anecdotal value, there was at the same time a smaller group of patrons devoted to maintaining an art of the spirit. Spirit, once evoked, could be interpreted in many ways.

As might be expected, it was Boston, following in the tradition of Washington Allston, not New York, that husbanded the spiritual tendencies. It was to Boston that

George Inness, *Niagara,* 1889. National Collection of Fine Arts, Smithsonian Institution, Washington, D.C.; gift of William T. Evans.

William Morris Hunt (1824–79) returned in 1855, and his presence was of great importance. He had gone to Europe in the 1840s, tried his hand at sculpture, sampled and rejected Düsseldorf, and finally found his way to the studio of Thomas Couture in Paris. Couture was to be of great service to Americans who were looking for an antidote to the tight, draftsmanly painting that was their immediate inheritance. He advocated direct painting with a bold handling of masses, and he substituted soft charcoal for the hard drawing media of the more rigid academic method. He gathered students of many nationalities around him and discoursed convincingly on painterly values in art. Hunt became a favored disciple and remained five years in Couture's studio. Then Hunt discovered another painter who quite changed his focus in the matter of content. This was Jean François Millet, who in the late 1840s had joined a group of painters living the life of peasants at Barbizon in the Forest of Fontainebleau. Millet added to Hunt's pleasure in paint an awareness of human sentiment—not the sentimentality of the salons, but an earthy, humble evaluation of man. For an American to rediscover rural life in Europe is a bit ironic, but the French peasant tilling the ground in the manner of his forefathers was a long way from America and the McCormick reaper. That art should ally itself with an almost ritualistic Vergilian devotion to the soil appealed to Hunt, and he bought and encouraged his Boston friends to buy paintings by Millet and his colleagues. For Americans looking for a spiritual home, Barbizon became a holy place. It meant something quite different to them than it meant to the French. American landscape had been dramatized, cataloged, and reproduced in detail, but it had never been savored in quite this way. Bryant had praised American nature for being untouched by man; here was nature inseparable from man, steeped for centuries in man's presence until man lived according to nature and nature was the reflection of man's feelings. For years to come, Barbizon would be a talisman for art to American painters. Although he never actually lived in Barbizon, George Inness would sometimes in his late works include a stooped French peasant in a New Jersey landscape, a symbol of the Barbizon state of mind.

William Morris Hunt, *The Belated Kid,* 1857. Courtesy of the Museum of Fine Arts, Boston, Massachusetts; bequest of Elizabeth Hawes.

In Boston in 1876 a group of paintings were shown by a man most painters had forgotten, and their immediate success indicates how sensitive Boston taste had become to the painterly and suggestive. Earlier, George Fuller (1822–84) had painted acceptable but unexciting paintings, then in 1859 he had to leave New York to take over the family farm. Before giving up the world of art he made a quick tour of Europe, then settled down to a rural life. He continued to paint for his own pleasure but did not exhibit until he sent the works to Boston in 1876. His dark, mysterious canvases, out of which emerged strange, glowing figures, provided an experience that twenty years earlier would have gone largely unrecognized. Now, instead of disparaging the paintings as unfinished daubs, the discerning public saw in them an invitation to imagine, a quality it thought art should always provide.

But Boston was a special world for the artist. When young Elihu Vedder (1836–1923) showed his provocative works in New York in the early 1860s, Jarves suggested that he would do much better in Boston. In fact, Hunt saw some of his work and without further ado undertook to arrange an exhibition there. Vedder is a good example of an artist who wished to work from nature but still wanted some content beyond. He went to Paris in 1856, but after one winter he settled in Florence. There he became friends with a group of Italian painters who were experimenting in painting landscapes directly from nature, trying to catch the total impression of light and color in the simplest and most direct way. But he also was charmed by Renaissance Florence and the momuments then being restored. To Vedder, his Renaissance dreams and his fresh landscape studies were not antithetical; he savored the testimony of his senses, but his imagination always kept pace. He saw no reason to draw the line between what some were beginning to call the subjective and the objective. In New York during the war he produced a series of startling paintings—*The Questioner of the Sphinx, The Lair of the Sea Serpent,* and *The Lost Mind,* among others—that satisfied the *New Path* critics in their exactness and fascinated others, including Jarves, by their mystery and fantasy. It was a rare painter who could please both New York and Boston.

Vedder settled in Italy in 1867 and spent the rest of

George Fuller, *Fedalma,* 1883–84. National Collection of Fine Arts, Smithsonian Institution, Washington, D.C.; gift of John Gellatly.

Elihu Vedder, *The Lost Mind,* 1864–65. The Metropolitan Museum of Art, New York, New York; bequest of Helen L. Bullard in memory of Laura C. Bullard, 1921.

his life there. Although he continued to paint his sensitive small landscapes, his love of strangeness and fantasy dominated his later work, for which he devised a persuasive, rather haunting rhythmical style. His extraordinary illustrations for the *Rubáiyát of Omar Khayyám*, published in 1884, were a great popular success, confirming his personal fantsy as a part of the public mind. By the 1880s even New York critics could accept an evocative art.

The one artist Vedder's works call to mind was an extraordinary older man whose activity centered in Boston but also extended to New York: William Rimmer (1816–79). Almost compulsive with respect to learning, Rimmer was a physician, a sculptor, and a painter, published a book on anatomy for artists, and gave classes in anatomy and drawing. Like Vedder he was interested in physical fact—in his case, anatomy—but his fantasy drew him into strange and frustrating worlds. His sculptures *The Falling Gladiator* (1861) and *The Dying Centaur* (ca. 1871) are as disturbing in their way as his paranoiac painting *Flight and Pursuit* (1872). At this point fantasy and fact were not—for some artists, at least—necessary antagonists.

Although painters like Henry Ward Ranger (1858–1916) appreciated the Barbizon example as a means for attaining the larger atmospheric effects of landscape without unnecessary drama or detail, others found in the shadowed, richly colored Barbizon canvases of Narcisse Virgile Diaz de La Peña and Jules Dupré a poetic mystery. French painters would have been surprised at the association of Fuller with Barbizon taste, but many Americans saw Barbizon painting less as a return to the earth and the ritual life of peasants than as means for a new expressive freedom. The individual trees in the Forest of Fontainebleau were of less interest than the mood of wonder and speculation produced by the painterly evocations of woodland shade. Ralph Albert Blakelock (1847–1919), for example, often seems to have created his moonlit scenes out of manipulations of paint, rather than through observation. A generation younger than Hunt, he accepted the expressive manipulation of thick paint as a normal procedure and worked over his impastoed canvases until the right effect emerged. He was fascinated by the American West,

Elihu Vedder, illustration from *The Rubáiyát of Omar Khayyám*, 1884. National Collection of Fine Arts, Smithsonian Institution, Washington, D.C.

William Rimmer, *The Falling Gladiator*, 1861. National Collection of Fine Arts, Smithsonian Institution, Washington, D.C.; gift of Miss Caroline Hunter Rimmer.

and his strange forests sometimes held half-concealed encampments of Indians rather than Barbizon peasants. Initially his paintings were not well received in New York, but, ironically, later in his life when he could no longer paint they were highly praised and widely copied.

Robert Loftin Newman (1827–1919) was not well known by the public at large because he rarely showed his small, jewellike works; yet he was highly regarded by those few who knew him. He worked much in France and at one point was associated with the Barbizon group, but he showed little interest in imitating nature. What interested him most was making paintings—constructing out of patches of sometimes brilliant paint unforgettable images that took on definition only in the imagination. Although his works have something of the mood of Barbizon—at least of Diaz—they may be allegories, holy families, or strange happenings in magical forests. Like the others, he took what began as a fresh perception of natural effect and translated it into a haunting stimulus to the mind. The simplified forms derived from observation became the actors in a drama of the imagination.

Edgar Allen Poe, in an essay on poetic composition published in 1846, purported to describe how he had composed *The Raven*. Instead of developing it as a literary argument decorated with poetic conceits, he weighed each word for its sound and evocative power and assembled the poem in accordance with a subjectively planned series of emotional responses. The poem's meaning was not to be found in a plot or philosophical statement. It lay in the structured emotional response of the reader. Far from being a poetic statement of an idea expressible in prose, a poem was a construction of words and images that played upon the feelings and the imagination in a way unique to itself.

In a way this also describes what these painters were doing. Inness, Hunt, Newman, and the rest were less concerned with explaining nature than with prodding the mind of man. A vision of nature provided the vocabulary, but the power of the work of art lay in its capacity to move the viewer. The artist communicated through nature, if need be; he was not nature's servant. Furthermore, his work led not to a greater appreciation of nature, but to a greater realization of the inner sense

Ralph Albert Blakelock, *Moonlight, Indian Encampment*, circa 1885–89. National Collection of Fine Arts, Smithsonian Institution, Washington, D.C.; gift of John Gellatly.

Robert Loftin Newman, *The Flight into Egypt*. National Collection of Fine Arts, Smithsonian Institution, Washington, D.C.; gift of Mr. and Mrs. Donald Webster.

of beauty and wonder that, for him, was the province of art. That such an attitude developed simultaneously with a completely literal kind of art is worthy of note.

The most extraordinary American painter to develop from this approach to art is doubtless Albert Pinkham Ryder (1847–1917). In a way he began where some of the others finished, assuming from the start that a painting was like a poem by Poe or music by Richard Wagner. Even his early farm scenes suggest myth more than reality. Each form struggles to achieve its final shape, not to be more like a tree or a cow, but to impress more strongly the receptive eye. As Vedder did in his works of the 1880s, Ryder realized that forms in themselves can be persuasive, that they can carry the viewer along in an eccentric rhythmic pattern that can be experienced as if it were an effortless dance. The viewer, in a manner akin to that of the artist, might also participate in an active artistic creation, and thus the work of art becomes his own. Yet the work of art is a private experience for both the artist and the viewer. Ryder was indeed a very private artist. He lived as something of a recluse, although he exhibited his works with the Society of American Artists when that independent group first exhibited in 1878, and was a close friend of many artists, many of whom much admired his work. His preoccupation was with his paintings, and in his late years he worked over them constantly until the many layers of paint created problems conservators have had to struggle with ever since. He produced few paintings, but each was the distillation of a long period of work and judgment.

Although Ryder's written poetry may be less poetic than his paintings, he obviously saw all the arts—music, poetry, painting—as manifestations of the same impulse. Furthermore, if the impulse were to be defined, it could be understood only in terms of art itself. There was a deeply rooted segment of human experience that belonged only to art.

A World of Art

The idea that art was not concerned with morality, the intimation of God, or some socially significant cause but had qualities of its own that were in themselves important to humankind was foreign to a public brought up to

Albert Pinkham Ryder, *Moonlight*, 1880–85. National Collection of Fine Arts, Smithsonian Institution, Washington, D.C.; gift of William T. Evans.

believe in the coincidence of godliness and natural beauty. Many never did grasp the idea. Nonetheless, supported by an eager public or not, from the 1860s on there were artists willing to stake their careers on the premise. In one sense it was the beginning of a schism between the artist and the larger public, and in this instance the artist and his supporters saw themselves as an aesthetic elite. Rather than considering themselves the underdogs, they looked down on the unbelievers. This was not a necessary consequence of belief in art as art, but at times it seemed necessary for the artist to adopt such an attitude to make his point. Actually, what was needed to understand such an art was far less demanding than the effort required by an art steeped in allegory and remote mythology, but it did require a personal commitment that few members of the public were willing to risk.

The situation was made both easier and more difficult by the expatriate American painter and etcher James Abbott McNeill Whistler (1834–1903). His art was very persuasive, especially to other artists, but his public behavior confirmed all that good burghers suspected about young, self-willed artists. After an unhappy three years at West Point, where he seems to have excelled only in drawing classes, and a brief period with the Coast and Geodetic Survey, where he learned the technique of etching, in 1855 Whistler left for Paris to study art. He never returned to the United States. He studied with Charles Gleyre and became a intimate of Gustave Courbet and his circle. His painting developed rapidly, and in 1863 he enjoyed the distinction of having a painting shown at the famous Salon des Refusés, an exhibition held in Paris by the French government to justify its decision to exclude such works from the official Salon. Most of the public and many critics in Paris agreed with the government taste, and certainly the reaction in New York would not have been much different.

Whistler's painting at the salon, *The White Girl*, was puzzling if one had no notion of the direction he was going. The full-length portrait of a red-haired girl who was not conventionally pretty, dressed in white and standing on a white bear rug in a white room, had no meaning in the usual context of subject matter. Furthermore, it was intentionally antipretty so as to call at-

James A. M. Whistler, *The White Girl (Symphony in White, No. 1)*, 1862. National Gallery of Art, Washington, D.C.; Harris Whittemore Collection.

tention to the pattern of colors and textures, rendered with deliberate simplicity. As he went along, Whistler made more explicit his belief that the content of the painting was to be found in its arrangement of shapes and color, and he delighted in Japanese prints and Chinese porcelains because the forms and compositions, lying quite outside the Western tradition of proportion and symmetry, offered new and satisfying experiences to the eye. Settling in England, which served as his base of operations for most of his life, he produced innumerable small studies that were remarkably subtle in color and pattern and memorable landscapes and portraits that were so simple and decisive in their design that they almost became emblems in the mind. He eventually called the portrait of his mother (1871) *Arrangement in Gray and Black* to call attention to its formal quality, and for some of his small paintings he adopted the musical terms "nocturne" and "symphony." It was one of the nocturnes, based on a burst of fireworks in the night over the Thames, that brought about the much-publicized libel suit that Whistler filed against Ruskin in 1879. The venerable critic, once such an inspiration to the young had accused him of "flinging a pot of paint in the public's face." Understandably, this kind of painting was totally incomprehensible, even immoral, from Ruskin's point of view. It showed neither truth to nature, in his sense of the term, nor moral industry. The London public was entirely in sympathy with Ruskin, as the New York public would have been, and looked upon Whistler as representing a most dangerous and wrong-headed view of art. (Whistler won the suit but was awarded only a farthing and had to pay court costs.) Possibly in Boston Whistler would have had a more sympathetic hearing, although his arrogance as an artist was hardly in the tradition of Allston or Hunt.

Whistler's patrons were mostly American, and the American artists who were seeking a rationale for their new artistic values drew much inspiration from his work. His etchings and pastels first caught their attention, especially among Duveneck's group, with whom Whistler was associated in Venice in 1880, but his persistent refinement of visual judgment was of great importance to those who sought satisfaction in a special world of art.

The consciousness of a world of art, as distinct from

James A. M. Whistler, *Nocturne in Black and Gold: The Falling Rocket,* 1877. The Detroit Institute of Arts, Michigan; Dexter M. Ferry, Jr., Fund.

the workaday environment or Ruskin's "nature," developed another dimension in the United States, chiefly in the 1870s and 1880s. For John La Farge (1835–1910), who had initially been attracted by Ruskin but later rejected many of his principles as misleading and false, the sensuous refinement of art was inseparably mingled with a sense of history and a moving spiritual satisfaction. Although he was aware of French painting and studied briefly in Paris, it was William M. Hunt who first inspired La Farge to take up art seriously. He worked closely from nature but always strove to imply more than met the eye. As early as 1864, in his illustrations for *Enoch Arden*, he evinced fascination with Far Eastern art, and he also found special comfort in studying the early art of the West. His awareness of art as creating an environment for the mind was given an impressive chance for expression in the 1870s when Henry Hobson Richardson chose him to decorate the interior of his imposing Trinity Church in Boston. The use of medieval styles of architecture for ecclesiastical structures was hardly new in the United States; in fact, Gothic as a symbol for piety had become something of a cliché. But by sensitively adapting specific Romanesque forms, Richardson molded an expressive space that combined historical association with direct sensuous appeal to create an environment that effectively merged past and present. The worshiper did not have to pretend to be a twelfth-century monk to feel at home in the building; the references to the past could be appreciated as they might be by a sensitive historian or a well-prepared traveler working his way through the monuments of Europe. In spite of Richardson's meticulous study of sources, his church was far from a disinterested presentation of history; he looked at the past as an extension of personal experience, as a way of defining one's spiritual abode.

Like the master of a medieval guild, La Farge set to work with his helpers to carry this dual message of the senses and history throughout the interior of the church, decorating the walls with patterns, creating paintings, and eventually designing stained glass. In his attitude toward the crafts he was inspired by William Morris and his associates, who were later invited to contribute to the decoration. When it was finished in 1877,

Henry Hobson Richardson, *Trinity Church*, Boston.

Trinity Church provided an environment in which art proved it could weave a spell transporting man's consciousness to a contemplative world suspended in time yet not remote from the pleasures of sense. This world could be described as spiritual, and in fact La Farge believed that most refined artistic experience was identical to the most transcendent spiritual experience. That such a synthesis was first realized in Boston was quite appropriate. According to La Farge's way of thinking, what many late-nineteenth-century critics liked to call "art for the sake of art" could be translated into "art for the sake of spiritual experience." In the United States, with its long moral tradition in art, this was a more persuasive way for artists to judge their new aesthetic consciousness. Whistler's teaching was thus modified by a desire to keep close to a sentiment of the spirit. Art provided more than just refinements for the eye.

This world of art, with its implications for the spirit, existed side by side with the pragmatically judged art devoted to science and to things. Not only that, it developed through precisely those years in which American industry and commerce were expanding at such a rate that Europe was inclined to judge American and Americans in purely materialistic terms. Actually, both kinds of art were very much of their time and thoroughly part of American culture. If the one expressed quite directly the kind of material values necessary to sustain the late nineteenth century pride in technical progress, the other equally well sustained a belief in the freedom of intellectual speculation and human perfectability. Whistler's most important patron was Charles Freer, who was led by Whistler's refinement of taste to amass a dazzling collection of oriental art. Among the moderns, he collected works by only those painters who carried on a kind of spiritualization of Whistler's teaching. Yet Freer was an industrialist, as shrewd and ruthless in his commercial dealings as he was demanding of the ultimate in refined sensuous pleasure in his collecting. Art for art had its social purpose. It was necessary leaven, a way to maintain contact with the kind of innocent optimism so persistent in American culture, while functioning in a competitive society in which innocence and its attendant virtues could easily spell financial and social disaster.

John La Farge, *Visit of Nicodemus to Christ*, circa 1876–80. National Collection of Fine Arts, Smithsonian Institution, Washington, D.C.; gift of William T. Evans.

Also consistent with the time was a new concern for systematic organization in the arts. If art was going to take its place in the progressive march of modernity, it needed to reassess its procedures and make public its scheme of values. Willy-nilly, from the mid-1860s on artists found themselves in a new category. Art was caught up in the same movement that drew up extensive curricula for the training of engineers and sent architects to study in Paris. The artist, recognized as a man apart, was to become a professional, and many young artists liked the idea.

The Professional Artist

Of course American artists had thought of themselves as professional for a very long time, but the definition of the profession changed rapidly in the years following the Civil War. The training of artists had been rather haphazard through the first half of the century, and though many did spend time in academies abroad, the study was looked upon as supplementary training and rarely could be described as systematic. Native talent was considered more important than years of tiresome studio practice, and even at Düsseldorf artists learned more from each other than from the academy masters.

Standards of studio practice were changing in Europe also. The organization of the Prussian art schools earlier had been much commented on, and critics in Italy, the Scandinavian countries, and England began theorizing about basic artistic discipline and rhapsodizing about sound drawing and skill at painting. In France, academic training had been consistently strong, at least in drawing, but under the Second Empire there was much talk of raising standards and weeding out the capricious and the unfit from the accepted ranks of art. Napoleon III and his ministers were determined to make Paris the cultural center of the world, and artists throughout Europe gathered in Paris with great expectations for taking part in the increased activity, as if to prove the success of the regime's program. They came looking forward to the popularized "artist's life" so colorfully pictured in Henri Murger's *Scènes de la Vie de Bohème* (1847–49) and welcomed the rigors of a competitive system. George du Maurier lovingly recorded his recol-

lections of these years in *Trilby* (1894), which well into the twentieth century carried the delight in a mythic existence associated with art to a vast audience. In the 1860s Americans went to join their European confreres in ever growing numbers. The definition of the artist began to be transformed from one who had artistic talent to one who had proper schooling under the guidance of internationally accepted masters.

Sheer number also had its impact. More young people, both men and women, were taking up art as a profession, and their demands outstripped the former facilities. Art students became an international class, regarded with some suspicion by the middle class because of the life they supposedly led but respected because eventually they might well figure usefully in the national economy. One could not disregard a profession whose members might spend their time in villas in Italy, be awarded international prizes and titles, and live an international life that the new industrialists might well envy and wish to emulate. Most artists never achieved such status, to be sure, but examples were plentiful enough to give the profession a good name and to fire the aspirations of the hopeful young. Furthermore, more artists now came from families that were wealthy enough to allow them an independent life, and many were college-educated. The new Bohemia had social status.

International exhibitions also raised the prestige of art. Quite aside from the Paris and London salons, which admitted foreign artists, the huge exhibition in Paris in 1855 and successive expositions throughout the century paid as much attention to art as to manufacture and gave artists and patrons a chance to compare the works of their countrymen with others. International medals became as important to the status of art as spectacular gold frames. For all its democratic pretensions, American society was not at all reluctant to appreciate titles and official honors, and many a work was proudly purchased at a high price because it had won a medal in a European salon.

As a result of competitions and honors, art became news, and even the most popular journals were likely to include articles on what was happening in the foreign art circles with which Americans were associated, and on

who were the starring artists of the day. Sales prices from salons and auctions were quoted with wonder and satisfaction, and not a few collectors looked upon art as a competitive investment. But for an artist to achieve eminence, to acquire the requisite international vocabulary, he had to work hard. In the eyes of the public, to study art became more understandable, possibly even more laudable, than simply to paint.

The Study of Art

The only rival to Paris as a center of study was Munich for a short time in the 1870s, especially for Americans. Possibly there were lingering echoes of Düsseldorf in its attraction, but instead of the harsh linear specificity that critics regularly referred to as the Düsseldorf manner, Munich stood for somber, rich paintings with overtones of the Renaissance, Velázquez, and the seventeenth-century Dutch. Not all of this was attributable to the Royal Bavarian Academy itself. Munich provided artists with extraordinary collections of art to study and an intellectual climate that accorded the history and practice of art a notable stature. It was a center keenly aware of the history of art, and the works of Munich artists often reflected the somber tonalities of the masters.

Probably the first American to study in Munich was David Neal (1838–1915), who left California to settle there in 1861, studied with Karl von Piloty, and achieved an international reputation as a painter of historical subjects. But it was the group gathered around Frank Duveneck (1848–1919) in the 1870s that gave Munich major importance in the history of American art. Like Duveneck, many of the artists who went to Munich came from families of German origin, many from the Middle West, and so language was no problem. They were prepared to take full advantage of what the city offered. Duveneck settled in Munich in 1870. A painter of extraordinary facility, he absorbed the full painterly method that became associated with Munich and became a major exponent of the bold, facile technique so well adapted to the richly cluttered canvases then popular. Initially his colors, and those of his followers, were dark and bituminous, suggesting the darkened works of Hals and other seventeenth-century Dutch masters.

Frank Duveneck, *Portrait of Walter Shirlaw*, circa 1873. National Collection of Fine Arts, Smithsonian Institution, Washington, D.C.; gift of Mrs. Walter Shirlaw.

They were a part of history from the time they were painted.

After some time back in Cincinnati, Duveneck returned to Germany, where in the little town of Polling he was surrounded by a group of painters popularly referred to as "Duveneck's boys." Following the path of many Munich painters, the group began spending seasons in Venice and there changed to painting in lighter, more varied colors, impressed by the tradition of Venetian painting and possibly by Venetian contemporaries such as Guglielmo Ciardi and Giacomo Favretto. The expanded palette, however, in no way dampened their painterly zest or their preoccupation with the masters.

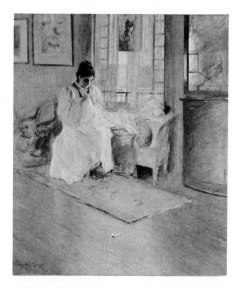

William Merritt Chase, *For the Little One* (formerly *Hall at Shinnecock*), 1895. The Metropolitan Museum of Art, New York, New York; Lazarus Fund, 1913.

The works of Munich painters were readily identifiable when shown in New York exhibitions from the mid-seventies on, and their extraordinary display of facility and "old master" assurance made a distinct impact on judgments in art. Certainly much of the older painting must have seemed weak and uncertain in contrast to so well-schooled a manner. Equally important was the impact some of the Munich men had as catalysts in the new art world forming in America, many of them serving as influential teachers. They were active in forming the Society of American Artists in 1877 (Walter Shirlaw was its first president); Duveneck became associated with the art school in Cincinnati; and, of greater importance as a teacher, the irrepressible William Merritt Chase (1849–1916) returned from Munich and Venice in 1878 to teach at the newly formed Art Students League in New York, which had gotten under way in 1875.

The Art Students League was organized by a group of serious students to supply a consistency and rigor of training that the National Academy could not or would not provide. Instructors were invited by the students, who became members of a cooperative organization. A balance was attempted between the Munich- and the Paris-trained painters, and as the school rapidly grew in size, artists from a wide range of backgrounds were attracted to teach the eager and hard-working young aspirants.

Chase brought with him his Munich facility, a Venetian palette whose colors expanded as he went on,

and an extraordinary zest for painting and teaching. For many years he took groups of students to Europe for the summer, introducing them to the international art world. His vast Tenth Street studios in New York, which he occupied from 1878 to 1896, were like artist studios abroad, filled with artistic bric-a-brac—brocades, brass, exotic furniture—and an impressive collection of paintings so that both he and his patrons could see art in an environment of art. For Chase and many painters brought up in the atmosphere of the schools, the studio was the basic environment upon which they drew, and it figured often in their paintings. The life of the artist, his special training and his contact with foreign ways, fascinated the public and, in its way, became an inseparable part of artistic content.

It was Paris, however, not Munich, that was the major attraction for American students. Some aspirants succeeded in being admitted to the Ecole des Beaux-Arts, other worked in private studios, particularly the Académie Julian or the Académie Colarossi. In general they sought a more draftsmanly training than that offered by Thomas Couture. Instruction was organized in Paris according to an atelier system in which the studios were under the jurisdiction of an established artist, some of whom paid more attention than others to the work of the students. As often as not, students learned from their fellow students. Young artists of all nationalities were to be found drawing and painting from models, and by the 1880s there was no open studio in Paris that did not include Americans. At the Atelier Julian several worked under Adolphe William Bouguereau, Joseph Robert-Fleury, Gustave Boulanger, and Jules Lefebvre, all well-known salon painters whose works began appearing in American collections. Some worked under Léon Bonnat. One of the masters most popular with the serious students was Léon Gérôme, whose meticulous works were based on a rigid discipline of drawing. In his studio there was none of Thomas Couture's bold blocking in of lights and darks, but a careful linear definition of forms. Regardless of how his students would paint later—and they included such diverse personalities as Frederic A. Bridgman, Thomas Eakins, Abbot Thayer, J. Alden Weir, Wyatt Eaton, and George de Forest

Brush—they began with an intensive program of strict drawing.

The favorite student of Léon Gérôme was Thomas Eakins (1844–1916) from Philadelphia. He had studied at the Pennsylvania Academy before going to Paris in 1866 and had attained a certain degree of proficiency. Having successfully passed the requirements, he was admitted to the Ecole des Beaux-Arts where he worked chiefly under Gérôme, whom he always regarded as his master and with whom he remained in contact for some years. For Eakins the intensive discipline he learned in the schools became a way of life. Like many intellectuals of his generation, he was fascinated with science and the extraordinary progress it was making in many fields. It became his mission to bring the same analytical procedure to bear on art, making art an investigation as serious and intellectual as microbiology or medicine. Although enamored of the richly painted works of Veláz-quez and Rivera, which he saw on a trip to Spain, and the eloquent shadows of Rembrandt, he wished to tie his work more to the kind of truth proved by science than to a past realm of art. In this he was quite alone, and as his work developed it seemed strangely out of keeping with the aesthetic directions most American painters fol-lowed.

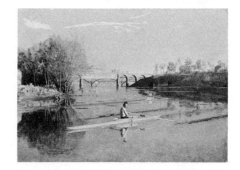

Thomas Eakins, *Max Schmitt in a Single Scull,* 1871. The Metropolitan Museum of Art, New York, New York; purchase, 1934, Alfred N. Punnett Fund and gift of George D. Pratt.

Eakins worked for almost three years in Gérôme's studio, then studied portraiture with Léon Bonnat and sculpture with Augustin Dumont. Yet, for all his serious application, when he returned to Philadelphia in 1870 it was not with the confidence of a master but with the conviction that he still needed to study—a conviction he seems never to have lost.

In Philadelphia Eakins painted family portraits, con-tinued his study of anatomy, and began his series of paintings of sportsmen rowing on the Schuylkill. Not trusting simply to the eye, he created elaborate perspec-tival structures for his outdoor paintings so that they became rational proofs of vision rather than personal impressions. A proof of knowledge was an indispensable part of Eakins's aesthetic. This is also evident in the ex-traordinary painting he completed in 1875, a portrait of Dr. Samuel Gross lecturing to medical students while performing an operation. It was painted for the Jeffer-

son Medical College where Eakins had periodically studied anatomy ever since he had first entered art school. *The Gross Clinic* was both a triumph and a failure; it is a masterly composition, powerful in its psychological interpretation as well as in its unrelenting insistence on physical fact, but it won few friends in aesthetic circles. At the Philadelphia Centennial Exposition it drew much attention, in the Medical Department where it was hung; it was not included in the section of fine arts. To recognize that it was one of the greatest paintings ever executed in America was within the critical compass of very few.

Eakins's rigid sense of academic discipline was to be experienced in another way. The Pennsylvania Academy, recognizing the new demands for professional training in art, had begun in the late 1860s to reform its school and in 1876 it opened a new building carefully designed for the serious preparation of professional artists. Eakins became instructor of the evening life classes on a part-time, semiofficial basis. From that time until 1886, when he resigned under pressure, he served various functions in the academy, always working to create a more demanding program of instruction that reflected his own driving discipline. Emphasis was on the study of the live model, with supplementary courses in dissection, and although the board disapproved, photography was introduced to sharpen the study of natural fact. With the help of Eadweard Muybridge's photographs and Eakins's own experiments, this included the study of people and animals in motion. With the presence of Eakins, the Pennslavania Academy became the most demanding and single-minded art school in America, and this eventually brought about the downfall of his involvement with the institution, for taste in art in America did not move in Eakins's direction. Although his concept of art as visual discipline provided useful training, few but he found it fulfilling as an ultimate goal. It included too little that allowed for charm or artistic detachment, too little of the studio of art, exemplified by Chase, and too much of the medical school and the sports arena. So at the request of the board, after a trivial incident in a controversial life class, Eakins resigned in 1886.

Eakins persisted in his constant studies, which gave his

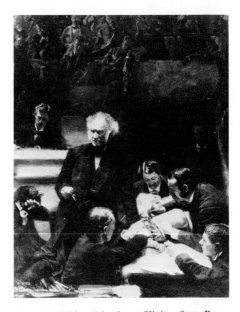

Thomas Eakins, *The Gross Clinic,* 1875. Property of the Jefferson Medical College of Thomas Jefferson University, Philadelphia, Pennsylvania.

art—his paintings of boxers and his thoughtful portraits of friends—a taut astringency very nearly unique in America. Later critics have liked to cite Eakins's art as characteristically American; few of Eakins's contemporaries would have agreed.

Meanwhile, professional art schools opened throughout the country. Besides the Art Students League in New York, between 1870 and 1880 schools were established in San Francisco (1874), Saint Louis (1879), Providence (1878), Boston (1879), Chicago (1867 and 1879), and other cities, all with carefully devised curricula. Study always began with drawing from classical casts, then drawing from models, but by the 1880s most also had classes in painting directly from the figure at a relatively elementary level, a method advocated by Eakins. There was an increasing amount of talk about how artists should be trained; conferences were held, and ponderous reports were published. Most would now have agreed with Mrs. Trollope that "self-taught" painters were simply deprived. In fact, so standardized were the acceptable techniques of painting—although of an impressive range—that a self-taught painter would have little chance of recognition. His language would not be understood.

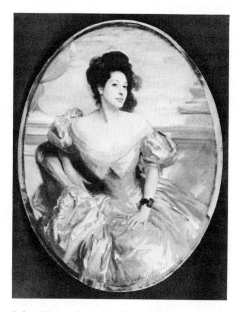

John Singer Sargent, *Betty Wertheimer,* 1908. National Collection of Fine Arts, Smithsonian Institution, Washington, D.C.; gift of John Gellatly.

It would be hard to imagine an artist less naive, more obviously the master of his métier, than John Singer Sargent (1856–1925), whose brilliance became legendary. Born in Europe of American parents, he grew up in an international environment that would be the envy of many Americans. While very young he studied with Carolus Duran in Paris, one of the few French masters who emphasized facility in painting. Facility came naturally to Sargent, and he dominated a technique so sure in the immediate recording of what he saw that his images seem as breathless as his brushwork is dazzling. He made Paris his base of operations until 1885, when he moved to London, and he developed an international clientele for his portraits that afforded him a life as glamorous and fashionable as his painting. Sargent's paintings were in no sense contemplative; they were spontaneous reactions to seeing. At times, as in the hauntingly composed painting of the daughters of Edward Darley Boit of Boston, the seemingly momentary image is fixed in a pattern of lasting effect. At other

times a portrait catches the sitter at an especially significant moment to become a revealing character study. But for the most part, the brio of his execution makes the affluent sitter and his world seem untroubled and easy.

Less breathless but nonetheless boasting of faultless though seemingly spontaneous brushwork were the paintings of Cecilia Beaux (1863–1942) and those of Irving R. Wiles (1861–1948), who had also been a student of Carolus Duran. Their brushstrokes do not mold a lyrical, ideal form, as in the works of Sully, but lie on the surfaces of things, masquerading as light and adding the liveliness of paint to the solemn surfaces of nature. The style of these paintings con brio became almost synonymous with portraiture, although not limited to that, and in modified form still persists in the painting of likenesses.

Sculptors and architects were no less attracted to the new concept of professional discipline than were painters, and they also found a home in Paris. Rome, which had for some years been the center for sculptors, began to lose out in the later 1850s to the Paris schools. Although the earlier generation stayed on in Italy, with Willaim Wetmore Story in Rome and Hiram Powers and Thomas Ball in Florence, gleeful artists in Paris urged their young colleagues to join them there "where the action is."

The tradition of sculpture for Americans had been formulated in Florence and Rome and had based its form on the cutting of marble, pure white Carrara marble, which by mid-century had been accorded a moral virtue in its own right. Only subjects worthy of the material could be executed. Sculptors had studied in the studios of Bartolini, Thorvaldsen, and other marble sculptors and had depended heavily on the skilled Italian marble-cutters to carve their finished works. Even when the artists modeled works to be cast in bronze, like those of Thomas Crawford, the forms remained those customary for marble. Paris meant not only the new discipline of systematic training but a shift in sculptural medium and concept. The sculptors with whom the aspirants worked, men like Alexandre Falguière, Antonin Mercié, Emmanuel Frémiet, and Henri Chapu, were basically modelers, not carvers, and their principal

works were executed in bronze. If earlier bronze sculpture had tended to follow the forms of marble, now the situation was reversed. When sculpture now was carried out in marble, it had the flowing forms and impressionable surfaces more characteristic of modeling suitable to bronze. The modeling seemed to record the actual process of building the forms and also purported to record the hand of the artist himself, for the artist was involved with the work through to its final stages, at least until casting. The emphasis on process was consistent with the expertise now demanded of the artist; he was expected to show off his acquired ability.

Augustus Saint-Gaudens (1848–1907) went to Paris to study at the Ecole des Beaux-Arts in 1867, the year after Eakins began his studies with Gérôme. Although he set up his studio in Rome during the Franco-Prussian war, Paris reamined his artistic home throughout his career. Daniel Chester French (1850–1931) was reluctant to give up Italy, where he studied in Florence with Thomas Ball, but in the 1880s he recognized the changes taking place in art and went to Paris, where he studied with Mercié and accepted the goals of his fellows trained at the Ecole des Beaux-Art. Many of the sculptors, like the painters, came home to teach and spread the gospel from Paris throughout the country. Lorado Taft (1860–1936), who studied in Paris from 1879, was an indefatigable propagandist for art and taught in Chicago from his return in 1886. Charles Grafly (1862–1929), in Paris from 1888 to 1892, taught in Philadelphia from his return until his death. By the 1890s a student did not need to go to Paris to be trained in the methods of the French atelier. Sculpture courses were introduced into all serious art schools and were frequented by both men and women. It is noteworthy that in the last decades of the century, the percentage of women attending regular art classes increased appreciably, and many studied sculpture. Now that organized study became the introduction to art, women were accepted as a normal part of the artisitic scene and were influential in many areas. Beginning with William Morris Hunt's in Boston, a great many art classes were supported largely by the devoted participation of women.

The common denominator in the curricula was "the life," the study of the posed nude model. Once the stu-

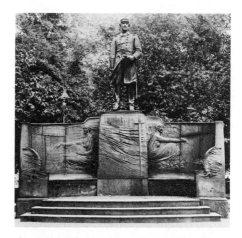

Augustus Saint-Gaudens, *The Farragut Memorial*, 1881. Madison Square, New York, New York; photograph courtesy of the National Sculpture Society, New York, New York.

Daniel Chester French, *Abraham Lincoln*, 1918–22. Lincoln Memorial, Washington, D.C.

dent had proved his competence in drawing from plaster casts, he drew—then painted or modeled—throughout his art school training from the static figure posed in the studio environment. To this other studies were added—portrait, drapery, still life, anatomy, and perspective courses—but the core of the study was the nude. This inevitably had its impact on the subject matter of art. Unless an artist was going to paint landscapes or peasants, the nude was likely to be the given around which his subjects had to evolve. In painting, this posed a problem for Americans, since there was still a certain amount of resistance to nakedness at home (it was associated with the immoral French). The solution was allegory, which everyone could recognize as not dealing with the real world. So painters and sculptors alike created a whole population of nude or scantily clad virtues and personifications. Allegory provided the means by which academic figures could become intelligible to the general public, and as often as not a simple academic figure stood for knowledge, history, or tradition—subjects quite consistent with the academic concepts that gave them birth.

America in the last decades of the century was in a mood for learning on a broad public scale; knowledge was good and study was virtuous. In a way, the studiously produced, earnest academic allegory was a strikingly suitable artistic expression of its time.

The Artistic Summer

As artists moved out from the schools, many habits from their student days persisted. For the painters, the year was divided into winter work in the studio and summer painting away from the city, gathering material for the exhibitions of the coming season. This routine was not especially different from that of earlier painters, except that with the greater number of artists used to working in atelier groups, summer painting was often as gregarious an activity as work in the studio. "Colonies" of artists became common, each standing in general for one kind of painting. In France, Americans still gathered at Barbizon and Pont Aven, but they also found spots in Normandy, the south of France, and as far away as the coast of Holland. Where one went determined what one painted, and all of France seems to

have been divided by subject matter into artistic provinces. For an American to paint Breton peasants was not considered in any way odd, nor did it require the justification of social commentary. Peasants from various areas were a part of the summer repertory, accepted subjects for art. All the artist asked was that the peasants not modernize their dress, that they pose for a modest sum, and that they remain expressions of bucolic innocence.

The artists who reestablished themselves in the United States after their Paris study usually looked for a place in the country that would serve as their artistic foster home. Little by little they established their country houses on Long Island or in Connecticut, New York, or New Hampshire, which became in many ways both the place and the substance of their art. There they surrounded themselves with their prized objects from Europe, and some even collected American oddments. Those who could not afford homes of their own rented cottages or stayed with friends, becoming no less a part of the community life. The significant aspect of this effort in the United States was the artist's desire to live what he painted, not to unite himself with nature so much as to make life itself into art. His subjects were the well-known fields, his family and friends, and his house or studio. He recorded months and months of afternoons. The time was usually summer.

This pattern of the artists was parallel to that followed by an expanding affluent society that was not content with the simple rustication of earlier generations. The summer home in the 1880s and 1890s was where the imagination had freest rein, where social contacts were made and maintained, and where family life was the center of interest. The people who lived such a life were potential patrons for the artists who dwelt in a lingering summer, and they often shared their summer communities with the artist. Like the clubs in the city, the summer colony was a place for useful contact between the artist and his patron.

But the artists who summered in the country were not necessarily devoted to family genre or domestic landscape. They took their European sensibilities with them and recreated their ideal images in the relaxed country environment. Saint-Gaudens established his studio in

Cornish, New Hampshire, in 1885, and French created
his idyllic home and studio "Chesterwood" in 1893 in
Stockbridge, Massachusetts. There they continued to
create their classical figures and ideal groups.

Abbott H. Thayer (1849–1921), who worked in Dub-
lin, New Hampshire, had studied with Gérôme in Paris
and had become enamored of Renaissance art in Italy.
No single painter of the Renaissance seems to have im-
pressed him so much as did the quiet dignity of Floren-
tine palaces and the monumental quiet of Italian
churches and cloisters. Yet he was a man who loved the
American countryside and was fascinated by what he
found in nature, so much so that he eventually devoted a
major portion of his time to studying the protective col-
oring of wildlife and speculating on the nature of color.
When he painted a symbolic figure—an angel or a
virgin—his models were often from his family, and it is
difficult to decide from the results whether it is a famil-
iar model impersonating a virtue or the reincarnation of
a virtue in the domestic circle. His somber colors and
monumental compositions suggest the quiet of history,
and yet the fresh brushwork and intimate expression
bring the image close to home. Through all his work
runs a quiet strain of pleasurable melancholy like the
ruminations at the end of a perfect summer day. When
he painted a landscape his colors could be clear and
bold, but there was always an overriding state of mind to
give the scene an aura of art historical memory. He
painted not pictures but masterpieces, and he saw to
their being set off in frames appropriate to their stature
as deliberate works of art. It is not surprising that his
works were among those Freer collected as worthy com-
panions to Whistler.

The refinement of Thomas W. Dewing (1851–1938),
another summer-dweller who was drawn to Cornish,
New Hampshire, also leads one to speculate about the
relation of summer fields to the art historical past. Dew-
ing, too, studied in Paris, and his early work also shows
sympathy with English painters associated with the
aesthetic movement. Whereas Thayer's paintings are
boldly monumental in structure, Dewing's are disarm-
ingly intimate. His soft greens and golden hues seem
more like the memory of colors than colors seen, and yet
his elegantly dressed women—reciting in empty rooms,

Abbott H. Thayer, *Virgin Enthroned*, 1891. Na-
tional Collection of Fine Arts, Smithsonian In-
stitution, Washington, D.C.; gift of John
Gellatly.

fishing in a summer haze, or just sitting bemused—could be the belles of any fashionable summer colony. If they play an instrument it is an ancient lute or a clavichord, the refinement of the imagined sound matching the delicacy of tone and understated harmony of the color. Such paintings could not have been produced by a European painter because the European past was too close. Dewing's art was spun from the recollection of antique remnants of paintings in palaces and of forgotten spaces that haunted the modern mind in the summer quiet of an American retreat.

The paintings of Dewing, Thayer, George de Forest Brush, J. Alden Weir, and others express an appealing nostalgia for a past that obviously did not belong either to the artist or to the people painted. Like a wistful Botticellian glance at a Platonic perfection, sensed but not realizable by humankind, their paintings suggest a past perfection only to be glimpsed through the fragments of history recollected in the quiet of a summer's day.

This general attitude toward art in the 1880s and 1890s was shared by many of the American artists interested in the technique introduced by some of the French painters who, since 1874, had widely been called "impressionists." By using smaller strokes of separate colors and expanding the range of prismatic hues, impressionist painters were able to attain a distinctive quality of airiness and light. But with their bias toward paintings that manifest a particular state of mind, more often than not one of nostalgia, few Americans were interested in emulating the emotional detachment of Monet or willing to give up their tonal harmonies completely for a more even distribution of hues. To them the technique meant freeing color from the description of isolated things. Those with more academic leanings, such as Daniel Ridgway Knight (1840–1924), felt happiest with the work of Jules Bastien-Lepage, who succeeded in creating the effect of bright daylight yet maintained his obligations to carefully drawn form and narrative subject matter. Conservative critics praised Bastien-Lepage's painting as synthesizing the old and the new and thus establishing the basis for the future.

Such blandness and continued concentration on the isolated object was of no interest to a man like Julian Alden Weir (1852–1919) and his colleagues. Weir had

Thomas Wilmer Dewing, *Music*, circa 1895. National Collection of Fine Arts, Smithsonian Institution, Washington, D.C.; gift of John Gellatly.

dutifully studied with Gérôme in Paris and developed the draftsmanly expertise by then taken for granted among painters. When he became interested in the method of painting in small strokes of separate colors he adapted the means to his very subtle color harmonies, in which many variations take place but within a very narrow range of hue. Settled on a farm in Branchville, Connecticut, Weir painted the surrounding fields in a technique that broke up forms with small strokes of color to merge them in a luminous atmosphere. Yet, although his palette cautiously lightened in the late 1880s, Weir never relinquished his preference for a controlled tonal harmony.

Although John H. Twachtman (1853–1902) used a much lighter and brighter range of color, he was, his fellow painters said, a lyricist enjoying the harmony of misty forms and intermingled color. Theodore Robinson (1852–96) in his later landscape views came much closer to the French detachment and drew much from the work of Monet, whom he knew. One of the most interesting of the painters who embraced what was loosely called impressionism was Childe Hassam (1859–1935), who was probably the most able in dealing with the divided color technique. He first studied in Boston, then went to Europe in 1883. In Paris from 1886 to 1889 he was attracted to the color and atmosphere of the paintings by the French artists then called impressionists. At times he approached the French detached point of view, but usually he too was concerned with rich harmonies and mood rather than with simple observation. The brilliant, clear light of his oil and watercolor paintings on the Isle of Shoals contrasts with the mellow coloring of his works at Old Lyme and his later allegorical paintings. Though fascinated with the complexities of coloring in nature, he never lost sight of the poetic mission of the artist.

In December 1897 these painters led by Twachtman, Weir, and Hassam formed a group in order to show their works together. There were ten painters, and the critics quickly dubbed the group "the Ten." Their purpose in exhibiting together was not to make a specific aesthetic point but to show off more effectively their quiet sunny paintings, which, they believed, were submerged in the large, heterogeneous exhibitions of the

Julian Alden Weir, *Upland Pasture*, circa 1905. National Collection of Fine Arts, Smithsonian Institution, Washington, D.C.; gift of William T. Evans.

John H. Twachtman, *The Brook, Greenwich, Connecticut,* circa 1890–1900. National Collection of Fine Arts, Smithsonian Institution, Washington, D.C.; gift of John Gellatly.

132

Society of American artists and not especially welcome at the National Academy. Although each artist differed from the others, their works when contrasted with those of others had a kind of family resemblance. Thus isolated, their painting had a greater impact on the course of art and art criticism in America than it might otherwise have had. Critics could not resist calling them American impressionists; but if one thinks of Monet and Renoir this has little specific meaning. They shared a general technical procedure with the French, and had painted French scenes, but their outlook was much in the evocative tradition that had developed among the Americans themselves. Yet by being called American impressionists they were accorded a historical role that was possibly useful in gaining support for their works.

The one American who really belonged with the French group had nothing to do with the Ten American Painters. This was Mary Cassatt (1844–1926) from Philadelphia, who went to France in 1866 and spent most of her life there. She was a superb draftsman and had a sure and original sense of composition. Through association with Edgar Degas she was drawn into the circle of the independent painters who became known as impressionists and by the later 1870s was using the group's light, full-hued palette. In 1879 and later she exhibited with the impressionists and was considered one of them. From 1880 she was best known for her paintings and pastels of mothers with children, which were often striking in pattern and were devoid of sentimentality. Equally fine and original were her color prints, made in the 1890s, which show extraordinary discipline of line and great subtlety in color. She was without a doubt one of the most accomplished and original painters to come out of the United States in the nineteenth century; yet she had little if any impact on the direction other American artists were taking. At a time in which artists gathered together for moral support, Mary Cassatt went her way alone.

Mary Cassatt nonetheless had an influence on the course of American art in another way. Through her introduction, some American collectors, notably her family and friends, began to acquire paintings by the French impressionist painters. Foremost among her friends was Mrs. H. O. Havemeyer, most of whose

Childe Hassam, *Ponte Santa Trinità*, 1897. National Collection of Fine Arts, Smithsonian Institution, Washington, D.C.; gift of John Gellatly.

Mary Cassatt, *The Caress*, 1902. National Collection of Fine Arts, Smithsonian Institution, Washington, D.C.; gift of William T. Evans.

choice collection ultimately went to the Metropolitan Museum in New York. On the advice of Mary Cassatt, she had purchased a pastel by Degas in 1873, the first of many such works she acquired. Of course Mary Cassatt was not the only American painter to encourage Americans to buy the new painting. William Merritt Chase, J. Alden Weir, and even John Singer Sargent were among those who encouraged a serious interest in works by the impressionist painters. To the American painters of the summer scene, works by the Paris painters were in no way strange. By the time Durand Ruel brought an exhibition of more than three hundred paintings to New York in 1886 billed as Works in Oil and Pastel by the Impressionists of Paris (in Paris the group never called their exhibitions "impressionist"), the public reaction was such that he believed he had finally discovered a sympathetic market. For a time the works had even been shown in the galleries of the National Academy. As for the word "impressionist," it had already become settled in the American vocabulary, with as many meanings as there were critics to use it.

By the mid-1890s, painting students had begun to expect summer sessions out of doors. They gathered at various spots on the northeast coast or in the hills of New Hampshire and worked under a teacher who believed in painting in open light. In a way they were preparing for the summer life that was so central to their mentors. Later they might well spend their summers in Europe at one of the populated outposts for artists. William Merritt Chase began an outdoor summer school at his Long Island home in Shinnecock in 1891, and eventually groups could be encountered from Cape Cod to Old Lyme. After the turn of the century art schools themselves sponsored regular summer classes at country spots, and the relaxed summer vision was built into the very discipline of American art.

Diversity

By the time of the Centennial Exposition in Philadelphia in 1876 it was already apparent that in the past ten or fifteen years such strong divergencies had come into art that older standards no longer applied. The contrast between the new painting and sculpture and the old was

made more dramatic by something of a retrospective exhibition of American art, assembled as appropriate to the centennial occasion. It was the first time, in fact, that a serious glance had been cast back over the years to see what had been achieved in the field. American art had now been around long enough to have a history, even in the public mind.

The critics had to struggle with new concepts and to search out a new vocabulary to describe some of the works. Standard categories of subject matter and simple distinctions such as "real" or "ideal" no longer were applicable. New groupings were devised often based on techniques—"boldly painted," "tight linear treatment," and so forth—recognizing that in much of the painting emphasis was shifting from content and the thing painted to the artist and the way he created. In Earl Shinn's publication on the fine arts at the exposition (he wrote under the pseudonym Edward Strahan), categories moved from subject matter to style and back again. Meticulous painting of things, views of the great west, monumental statements by Daniel Huntington, and new works from Munich and Paris all existed side by side. So foreign to each other were their basic concepts, however, that in no sense could they be blended into a whole. Just what constituted American art was not easily agreed upon.

Sculpture provided fewer problems than painting, since the new wave of Paris-trained sculptors had not yet made a major impression. It was generally agreed that the Italian marble sculptures, unbelievably meticulous in detail and devoted to understandable anecdotal subjects, took the prize. American sculptors had not enjoyed the same recognition as their compatriots who were painters. Only in 1874 was a sculptor resident in the country prominent enough in relationship to painters to be elected president of the National Academy of Design— John Quincy Adams Ward (1830–1910), who had studied with Henry Kirke Brown (1814–86) in New York. Although Ward traveled abroad, he preferred to produce his bronze sculptures in New York. Brown had been trained in Italy, and until quite late Ward showed more of the Roman tradition than the French in his forms.

At the exposition, the most talked-of American work

John Quincy Adams Ward, *Indian Hunter*, 1864. Courtesy of the New-York Historical Society, New York, New York.

from Paris was by the Philadelphian Howard Roberts (1843–1900). *La Première Pose,* a work in marble, caught the attention of the public both because of its extraordinarily fluid execution and because it depicted a nude that was not an ideal subject but the frank rendering of an artist's model. Most popular comments had more to do with the idea of artists' working from nude models than with the new sensuous fluidity of the form, but in either case, remarked Lorado Taft, who saw the work at the centennial, it heralded a change in the nature of American sculpture.

The art crowded into the splendid Memorial Hall and its extensive annex was the largest assemblage ever seen by the American public. The several thousand American works exhibited brought a glow of pride, but they were also baffling in their diversity. Since the exhibition was a meeting ground of the old and the new, shaking many established ideas, there were bound to be difficult moments in its preparation.

The conflict was not confined to the Philadelphia exposition. The National Academy of Design exhibitions in New York had been under fire for some time. In 1874 a group of works by John La Farge were rejected, and in 1875 what works by new artists were shown at all were badly hung. Defiantly, the painters of some of the works rejected in 1875, including Ryder, Hunt, Thayer, and La Farge, showed their paintings privately. As if in answer to the mounting criticism, the hanging committee for the 1877 exhibition not only included many works from the young Paris and Munich painters but hung them in the best locations. The academy exhibition presented a whole new face. The new appearance, however, was not at all approved of by many of the older academicians such as Daniel Huntington, who saw their own creations being pushed aside. In self-defense they vowed to establish safeguards to make sure that such a thing would never recur in the academy's galleries.

In disgust at the academy's attitude, some of the young artists decided to organize a new society that would give a proper showing to the new ideas and reflect what they considered to be the more up-to-date, open view toward art. First called the American Art Society, by the time of its first exhibition in 1878 it was named the Society of American Artists. Twenty-two artists were

Howard Roberts, *La Première Pose,* 1873–76. Philadelphia Museum of Art, Pennsylvania; gift of Mrs. Howard Roberts.

represented in the exhibition of 1878, most with backgrounds from Paris and Munich. Yet also among the exhibiting members were George Inness, an early dissident, and Ryder. Recognizing the international spread of American painters, the society established a Paris committee so that those working abroad would not be left out. They were accused of being foreign in their outlook, but they took pains to make clear that this international outlook now represented for them the American spirit.

To gauge the impact of the new sense of discipline, the art of the schools, and its rapid expansion, it is enough to compare the place of art at the Philadelphia centennial in 1876 and at Chicago's World's Columbian Exposition just seventeen years later. The young people of 1876 were now the mature, influential artists; the tie of art with France was so well established that no one remarked much on it anymore; and the idea that the world of art would be everybody's world—at least everybody in polite society—seems by 1893 to have gained wide support.

The Columbian Exposition was a monument to the Paris-trained and to those who believed that one could be most true to American art by studying and perhaps living in France.

Most of the architects, sculptors, and painters in charge of designing the exposition were trained in Paris or had studied with Paris-trained teachers in the United States. Based on good Beaux-Arts principles, the entire architectural complex was designed as a formal unit with a dominant style; it was not just a collection of heterogeneous buildings scattered in a park. From the first, the planning was carried out by architects, sculptors, and painters working together as if carrying out a joint project in the schools. The camaraderie of many summers in France and in summer colonies at home was central to the way artists came together to work, and their great exuberance at feeling they had brought the modern renaissance to America sustained them in completing what must have seemed impossible tasks.

If sculpture had been a secondary art in the United States until now, the Columbian Exposition allowed it to make up for lost time. Almost every building was

View of the World's Columbian Exposition, Chicago, 1893.

crowned with massive sculptural groups, and monumental fountains abounded. Augustus Saint-Gaudens, who had been angered when his plaster sketch was rejected for the National Academy exhibition of 1877, and who had helped to found the Society of American Artists, was now the highly respected central figure in American sculpture. Since the 1870s he had been a friend of Charles McKim and Stanford White, who were among the principal architects of the fair, and White had designed the base of his Farragut monument, erected in 1881. Daniel Chester French created the towering gold statue of Columbia that dominated the great lagoon, and the young Frederick MacMonnies (1863–1937), who had begun work with Saint-Gaudens, then continued his studies in Paris with Falguière, created the most elaborate sculptural fountain yet seen in America. His *Barge of State* or *Triumph of Columbia* was a decorative bark rowed by eight fashionable young women and steered by Father Time. In the prow was the winged figure of Victory, his energetic version of the Victory of Samothrace, and seated high above was the self-satisfied personification of Columbia, a triumphantly half-nude young woman. The whole was surrounded by cavorting hippocamps and sprays of water. MacMonnies's sketchy modeling had been criticized in his *Nathan Hale* of 1890, and the frolicsome nudity of his *Bacchante with Infant* of 1894 led to its being removed from Boston's new public library as unseemly. Seen in the full Beaux-Art context of the fair, however, in the White City, MacMonnies's work seemed the quintessence of the new, self-confident internationalism.

Frederick MacMonnies, *Barge of State*, 1893. World's Columbian Exposition, Chicago.

The fair required an army of artists, all trained uniformly enough to work cooperatively and to understand the intentions of the primary designers. Such a group could not have been gathered twenty years before. A surprisingly large percentage of the skilled helpers were women, products of the new art academies now functioning throughout the country, according to Parisian standards. A professional uniformity had been well established.

Even more impressive than the exhibition of painting at the fair was the fact that painting made its appearance throughout, closely allied with the sculpture and the architecture. Since La Farge had embarked on the deco-

ration of Trinity Church less than twenty years before, mural painting had developed as an accepted public art. The Paris-trained architects began to integrate painting as well as sculpture into their designs in emulation of the Renaissance palaces, and in this it mattered little whether they were creating elaborate mansions for the rich, public libraries, or city halls. Mural painting was looked upon in a far different way than when the Italian painter Constanino Brumidi (1805–80) was hired by Congress in the 1850s to decorate the Capitol dome on a daily salary and devoted the rest of his life to historical and allegorical adornments of the building. The mural became as much a part of the environment as the architecture itself, and Americans entering these monuments to fantasy could for the first time feel themselves immersed in art. Crude as it might have been, since it was executed in record time and many of the artists had not before worked on such a scale, the mural decoration at the Columbian Exposition gave stimulus to a movement that was to have a major influence on the stature of art as seen throughout the country. Nor is it without significance that this artistic extravaganza took place in Chicago, a booming commercial city of the Midwest. This new artistic culture, effete as its ideals might seem, was not in opposition to the material values of expanding industry, or even merely its complement. It was the optimistic celebration of the new oppulence and its promise for the future.

The great monument to the sentiment of learning and to the marriage of the visual arts with the world of intellectual pursuits was the florid construction of the Library of Congress. Planned some years before, it was realized only in the 1890s, and its architects made the most of what they had learned at the exposition. From Blashfield's custodial ladies in the dome of the great reading room to the lowliest vault, it was planned as a great decorative scheme that caught up references to the past in the all-encompassing enthusiasm of a self-confident present. It was the first federally commissioned building in which all the arts were included in the initial planning, and it presented an integrated expression of belief in the world of art and learning. Almost every well-known muralist worked in some part of the building, creating paintings that pay tribute to the book;

Library of Congress, Washington, D.C.

The Main Reading Room of the Library of Congress.

139

it was, after all, a new belief in learning that had changed the course of their art.

Mural painting was more than simply covering walls with pictures; it expressed an attitude toward art that was also reflected in easel painting. The small paintings of Kenyon Cox (1856–1919), for example, speak in the same dignified public voice as his murals, expressing Cox's belief that the arts were the link with the great cultural moments of the past. As late as 1916 he presented the idea clearly in his painting *Tradition*, in which a Grecian figure stepping down from the dais of the past cautiously presents the lamp of tradition to two Titianesque women representing poetry and painting.

Similarly, sculptural monuments tended to embody high thoughts and elevated feelings, in such works as Charles Grafly's *In Much Wisdom* (1902). These were examples of an art that was public, though well bred, suggesting that the goals of art and learning were of value in themselves and had little to do with the social turmoil that beset the times. Above all, this art reflected a complacency born of optimism.

In 1905 Samuel Isham, in his *History of American Painting*, remarked of art at the present, "The younger artists no longer have the 'deep insight into spiritual things' that Page or Inness possessed. They are of their time, with its cheerful optimism, its absorption in material affairs, and its desire to know and enjoy." As many liked to say, it was a new renaissance, a rebirth of confidence in human activity.

What had been a disturbing diversity in 1876 was considered a richness of creative effort by the end of the century. In 1906 the Society of American Artists merged its activity with the National Academy of Design, since the outlook of the two organizations had become nearly identical. Earlier, in 1894, the American Academy in Rome had been founded so that the ideals of the Renaissance might persist in the arts, and so that architects, painters, sculptors, musicians, and even archaeologists might work together in a proper classical atmosphere. Its chief organizers were among the architects and artists of the Columbian Exposition. To those who believed in an art of discipline, tradition, and high thinking it seemed that the foundation for the future of art in America had been soundly laid.

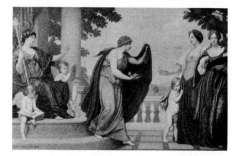

Kenyon Cox, *Tradition*, 1916. The Cleveland Museum of Art, Ohio; gift of J. D. Cox.

Collectors and Collecting

Amassing large collections of art had never been a popular activity in the United States, though any family with pretensions to culture was expected to have pictures and possibly even a few works of sculpture. There were exceptions. Luman Reed was a patron to American artists in the 1820s and 1830s and built up a sizable collection of their works before his death in 1836, as did Jonathan Sturgis; in Philadelphia, Edward L. Carey was a major patron and collector, and there were others, though their number was small. More typically, American travelers abroad brought back paintings that they hoped were old masters, and purported masterpieces occasionally appeared on the New York market to tempt collectors' tastes. Thomas J. Bryan of Philadelphia had built a collection of European paintings during a twenty-year stay in Paris, and on his return to New York he exhibited them in his home as the Bryan Gallery of Christian Art. The catalog published in 1853 listed 230 paintings. The collection continued to grow, and a selection of American portraits was added. Briefly shown at the newly founded Cooper Institute in the late 1850s, in 1866 the collection was deeded to the New York Historical Society, in whose galleries it had been displayed since the preceding year. Although he had included some American works, it was clear that Mr. Bryan sensed no obligation to be a patron to artists.

While Bryan was first exhibiting his paintings in New York, James Jackson Jarves was putting together his extraordinary collection of early Italian painting in Florence. But these two men were exceptions; systematic collecting did not become a major pursuit until the last quarter of the century.

American artists, not without reason, believed that in general they were pushed aside in favor of historical works and the works of their foreign contemporaries. The Art-Union had been their one great resource, and that was dissolved by court order in 1852. Possibly inspired by the public developed through the Art-Union's efforts, commercial dealers had began to multiply from the 1840s on, but most of them, like Goupil, Vibert and Company from Paris, handled only foreign works. Twice, in 1856 and again in 1867, the National Academy

of Design petitioned Congress without success to levy restrictive taxes on imported contemporary works. But the government's general feeling was that collectors bought the best art, and if that was European, so be it. There was, in fact, a modest import tax on modern works of art until 1913, but it was not such as to "protect" the American artist. When auctions were held, American paintings invariably brought less money than European works, even though the latter were often unimpressive in quality. Art was simply not what one expected of America.

Toward the end of the century, when larger collections were being built, the situation was not much different. The artists themselves had called attention to the excellence of the European schools by going to Europe to study, and they could hardly blame collectors for going to the source and purchasing works by their teachers. Furthermore, with travel in Europe greatly expanded, collectors became just as aware as the artists of who was who in the international exhibitions and on the honor rolls. It gave them satisfaction to buy what Europe prized. Although the National Academy strove to make its exhibition openings more festive and though artists tried to attract the buying public to their studios with gala events and special exhibitions, nothing could compete with the exciting news of art from across the waters. Even institutions such as the Pennsylvania Academy of the Fine Arts safely collected mostly European works, at least until the 1870s. In the West, when art institutions were formed, the nucleus of a collection was invariably contemporary European art. When Corcoran established his gallery in Washington in 1859, his collection was made up in large part of modern European works.

Two notable exceptions among collectors were Thomas B. Clarke and William T. Evans. Clarke was a major supporter of George Inness from the mid-1870s and both collected and sold his work. Through his activity in the New York social clubs and among business acquaintances, he did much to stimulate the purchase of works by Inness and other Americans. Evans built up more than one collection of comtemporary American paintings, and in 1906 gave the first of what was to be an extensive collection to the Smithsonian Institution's Na-

tional Gallery of Art. Freer's American collection, which emphasized Whistler and men of the taste of Dewing and Thayer, also was given to the Smithsonian in 1906, together with his extensive collection of oriental objects. But for most collectors in the last decade of the century, collecting meant acquiring works by European contemporaries and, eventually, the serious purchase of works by old masters.

The first art museums in the Unites States, as the institution now is understood, were opened in the 1870s as part of the awareness, so well exemplified by John La Farge, of past art as an extension of modern aesthetic consciousness. The Metropolitan Museum in New York was founded in 1870, as was the Boston Museum of Fine Arts. The Philadelphia Museum of Art was founded in 1876, and the Art Institute of Chicago in 1879. Something of a missionary zeal underlay all of them. They were established to raise the public taste by introducing artists and public alike to the special world of art created by assembled masterpieces from the past and the present. Many of them counted an art school as a part of their operation—in fact some, such as the Art Institute of Chicago, grew out of an art school organization—since the serious study of art was what helped to make art respectable. There was a pragmatic basis for the aesthetic undertaking. Many museums grew out of local associations that fostered both art schools and exhibitions, such as those in Cincinnati in 1881, Indianapolis in 1883, Detroit in 1888, and Portland, Oregon, in 1892.

The buildings that were eventually constructed for the museums were in themselves public symbols for art. The first museum in Boston, opened in 1876, was built in a reminiscent Venetian Gothic style associated with places of spiritual or intellectual concentration, such as libraries and academic buildings. The new building by Frank Furness for the Pennsylvania Academy's galleries and school, also opened in 1876, expressed a similar spirit, the exterior being an ingenius compromise between a church and a massive secular building. But this suggestion of otherworldliness did not last long as a symbol of museums. As early as 1859, with his design for Mr. Corcoran's gallery in Washington, bearing the motto "Dedicated to Art" (the gallery was not opened

until 1869), James Renwick adopted the festive architecture of the new Louvre construction in Paris to strike a totally different note. It hints of the palace instead of the church.

The palace style, with its great stairway, spacious halls, and high, paneled galleries, was to prevail well into the twentieth century. The National Gallery of Art in Washington, opened in 1941, was possibly the last monument to this concept. To bring the treasures of kings to the people a proper setting was required, so that everyone could recognize at what social—or financial—level of society art properly existed. Collecting art was a noble tradition, and the palatial buildings granted a certain touch of nobility to the wealthy donors on whom museums depended for the major portion of their collections. Nor was the symbolic character of architecture lost on the wealthy when it came to constructing their own houses. Such structures as those built for the Vanderbilts by Richard Morris Hunt, who designed the imposing administration building at the Columbian Exposition, left no doubt about the association between modern wealth and the French nobility of the sixteenth and seventeenth centuries. Architects and their assistants scoured Europe for paneling, tapestries, furniture, and whole rooms to make these abodes appropriate treasure-houses. Artists were commissioned to paint ceilings and murals—some were brought from France and Italy for this purpose—and to embellish the interiors with stained glass. John La Farge, who first became interested in stained glass while decorating Trinity Church, devised an extraordinary technique of his own to produce windows of almost Byzantine richness that served equally well in churches or in private homes. By the end of the century, a modest bit of stained glass in even the most humble structure put its owners in touch with the palatial environments of art.

The logical step beyond palatial spaces and antique furnishing was collecting paintings and sculpture. Initially this meant purchasing works from the European salons, but eventually under the pressure of adroit dealers such as Lord Duveen and of new scholarship in the history of art, some few began to acquire major works of earlier European art. The great collections built up by J. P. Morgan, Henry Marquand, Henry Clay Frick, Ben-

jamin Altman, and Henry Walters, to name but a few, served as the basis for a wholly new representation of art in the United States. By the early years of the twentieth century New York, Boston, Philadelphia, Baltimore, Chicago, Cleveland, and other cities throughout the United States could offer their citizens a dazzling array of masterpieces, largely culled from private collections that had been broken up abroad. In a relatively few years' time these works were to be considered America's true cultural heritage.

Scholarship in art grew with the mounting collections. Beginning in the early nineteenth century with the publications of the abbé Luigi Lanzi, Franz Kugler, and others, the study of past art broke away from the generalized, repetitious stories about artists that had served so long and began to concern itself with a systematic analysis of movements in art and with the accurate cataloging of verifiable works. Caught up in the historical theories of Hegel, Burckhardt, Taine, and others, the historians of art saw their subject as intimately associated with the cultural development of nations, with a significance well beyond that of the artists themselves. As studies progressed, ever finer distinctions were made between cultures and between the work of one artist and another, until a scholar like Giovanni Morelli could insist that a new discipline of connoisseurship be fostered whereby the hand of the master could be distinguished from those of his followers. From being an impressionable, somewhat sentimental study, the history of art began to move toward the methods of science. German scholars took the lead in these investigations, and many Americans eventually went to German universities to study. By the middle of the century scholars throughout Europe were beginning to regard the monuments of art with a sharp, analytical eye. In the United States in the 1860s, Jarves's collection of early Italian painting was looked upon as a strange anomaly; it would have been looked at with greater sympathy in England, where Sir Charles Eastlake, who had been trained as a painter in Rome and had ample contact with his German confrères, had been busily organizing the early paintings of the National Gallery. Reading about art had long been fashionable in America, however, and Ruskin's *Mornings in Florence* and *Stones of Venice* had

extraordinary popularity. Such works provided a fruitful sentiment for past art and doubtless gave an extra dimension to historic architecture, as had the *Seven Lamps of Architecture*. But they did little to stimulate either collecting interest or an interest in systematic history. Charles Eliot Norton, who was keenly aware of studies in Germany and England, brought some of this learning to his lectures in the history of art at Harvard beginning in 1874, and there were other efforts. Nonetheless, through the latter part of the century the new study of art only slowly worked its way into the standard curricula of American universities. For the most part, the history of art was the preoccupation of studious amateurs.

With the approbation and support of his fellow students, Bernhard Berenson went to Italy immediately after leaving Harvard in 1887, one of the first Americans to engage in the serious connoisseurship of western art. His little books on Italian Renaissance paintings and painters that began appearing in 1894 served as an important introduction to a more sensitive understanding of past masters for both collectors and the public. Working closely with Isabella Stewart Gardner of Boston, as well as with the dealer Lord Duveen for a time, he was also instrumental in bringing an extraordinary number of Italian masterpieces to the United States. In his persuasive writing, Berenson introduced a new vocabulary, as well as new concepts, to American critical prose and fostered a more sensitive way of looking at past works.

American universities did not grant graduate degrees in the history of art until well into the twentieth century, but there was much effort spent by museums and art organizations to educate the public and provide visual material to the schools. The American Federation of Arts was formed in 1909 to further education in art by means of exhibitions and lectures throughout the country. Its magazine *Art and Progress* appeared in the same year. The term "art appreciation" came into currency, originally signifying, though no one would think to question the matter, the appreciation of an accepted group of masterpieces. If nothing else, masterpieces served, in Matthew Arnold's words, as "touchstones" to taste. It was inevitably a very special taste.

Not to be overlooked are the collections of oriental art assembled in these years. Japan's open contact with the West after 1867 brought many American technicians and scholars to Japan and, ironically, as Japan tried more and more to emulate the West, American scholars devoted themselves to preserving the traditions of Japan. One of these scholars was Ernest Fenollosa (1853–1908), who first went to Japan to teach philosophy in 1878. He began a study of traditional Japanese art, which was being pushed aside in Japan's haste to become Western, and in Japan as well as in the United States he became a force for understanding traditional Japanese artistic principles. His critique of Louis Gonse's *L'art japonais* in 1884 revealed a greater knowledge of the field than had yet been shown by any westerner. In 1886 his large collection of Japanese art was purchased by the Bostonian Charles G. Weld, who presented it to the Boston Museum of Fine Arts. By the time Fenollosa became curator of the newly formed Japanese Department at the museum in 1890, Boston had one of the richest collections of Far Eastern art and artifacts in the western world.

Fenollosa was as interested in Eastern theories of art as in the art itself, and beginning with him the Boston museum not only amassed an impressive collection of Japanese art but interpreted oriental ideals in art to the American public—a service that extended well into the twentieth century under Ananda Coomaraswamy.

Impetus for the collection of early Chinese art came chiefly by way of France. Although Chinese textiles and artifacts had been imported into the United States since the eighteenth century, and though western businesses maintained establishments on the coast of China, little attention was paid to earlier Chinese art and its aesthetic principles until toward the end of the nineteenth century. In their search for new aesthetic refinement, artists and collectors discovered in Chinese works an inspiring example. Not surprisingly, John La Farge was one of the earliest American artists to look with sympathy on Chinese painting as well as on Japanese art, on which he wrote several articles.

The range of artistic works being collected in America by the end of the century indicated an expansion of taste that would have been unthinkable fifty years before. Ar-

chaeological collections had grown—the New-York Historical Society had purchased Dr. Henry Abbott's extensive Egyptian collection in 1860 and placed it on public view the next year. One of the early major acquisitions of the Metropolitan Museum was Colonel Luigi Palma di Cesnola's collection of ancient Cypriot sculpture in 1872. (Colonel Cesnola served as director of the museum from 1879 until 1904.) Collecting thus was associated with a new systematic archaeology. The Archaeological Institute of America was founded in 1879 and began publication of the *American Journal of Archaeology* in 1897; the American school in Athens was founded in 1882, and the school for classical studies in Rome in 1894. Any corner of the world might become a subject of scholarly investigation and, in consequence, a source for collecting. The art market expanded accordingly. By the 1890s New York dealers could offer collectors fine objects of art from around the world and from all periods. One could develop an international taste without leaving home.

Max Weber, *Chinese Restaurant,* 1915. Collection of Whitney Museum of American Art, New York, New York.

1900-1945

The Break with Institutional Values

In spite of the growth of art as a major institution, with museums, schools, public education programs, and expanding private collections, the American artist in the early years of the twentieth century was not wholly satisfied with his situation. In the first place, the market was in no way organized in his favor, and except for public commissions for murals and sculptural monuments—most of which fell to those who were already well entrenched in the art organization—there was only a slim chance of maintaining oneself. Artists began to depend for sustenance on teaching in the newly established art schools, a practice that has continued to the present. Equally grievous, however, was what many felt to be the oppressive effect of the historical values in art upon which much of the institutional art world was based. For those such as Kenyon Cox, who eloquently made the case for traditional values, contemporary art should provide the link with all that was best in the past, adding its small offering to the accumulated wealth of culture. Traditional craft and discipline were necessary to maintain this continuity, and to attack the method would be a vital assault on the content. To be sure, the formation of the Society of American Artists had been a rebellious act, but its rebellion produced only what were eventually considered the enlightened standards of a nonetheless traditional academy.

In supporting conservative views, American institutions were no different from the governmental agencies and recognized art societies abroad. A trip through the national pavilions at the Venice *biennale* at the beginning

of the century would have provided nothing to seriously challenge such a view. There one might find a wide variety of styles, from the bold, patterned canvases of the well-known Spaniard Ignacio Zuloaga, much discussed as audacious, to the well-brushed portraits from England and the sly eroticism of the German Franz Stuck and the versatile Max Klinger. Yet nothing broke the mold of traditional craftsmanship and the accepted limits of artistic taste. One could look in vain for the works of Cézanne or Gauguin and his followers, those who later were considered the instigators of the modern movement. As for American representation in Venice, few artists were shown until 1909, when a sizable exhibition was assembled, chiefly from artists associated with Paris. Dominant were the works of "the Ten." The exhibition organized for Venice by the critic Forbes Watson in 1920 was only a little more startling.

Arthur Wesley Dow, Poster for *Modern Art*, 1895. Courtesy of the Museum of Fine Arts, Boston, Massachusetts; gift of L. Prang & Co.

Formal Values

One kind of modernity was acceptable to the general public. It was to be found not in painting and sculpture but in the crafts. That crafts could be considered serious art in the last quarter of the century—thanks to the polemicizing of William Morris, Walter Crane, and others—is in itself revealing. If form in furniture could fascinate by rhythms unassociated with the past, as in the work of the Belgian Henry Van de Velde, why could form not function with equal freedom in painting or sculpture? In the 1880s Elihu Vedder had concluded that it could, but his "decorative values" were not regarded as any threat. So long as one was concerned with decoration, considerable freedom was possible, even the freedom of form that came to be known as art nouveau—art that was deliberately antitraditional in its rhythms and without historical precedent. But art nouveau was a definable style and could, at least by the more liberal followers of art, be fitted into the scheme of things. It was a modern style, a symbol of being with the times. The word "stylize" became popular—meaning to give formal style to something—because it stood for the fact that artists change things. To stylize meant to bring nature into the camp of art, quite obviously and deliberately.

From the 1880s on there was a belief in "modern"

design supported by a new conception of craftsmanship that came most directly from William Morris. It invaded architecture, furniture, pottery, and graphic design, always insisting on a clear relationship between artistic means and aesthetic ends. Rookwood Pottery in Cincinnati (commercially begun in 1880), the pottery at Newcomb College in New Orleans that produced its distinctive designs beginning in 1895, and the work of many commercial firms throughout the country made a select public conscious of qualities in design that contrasted with the rococo historicism of the Columbian Exposition. The arts and crafts books produced by Elbert Hubbard's Roycrofters in Aurora, New York, which had wide circulation throughout the country, were only one manifestation of an extensive private press movement that introduced a new and disciplined graphic design to America. Openly basing their work on the activity in England, the designers set out to establish an American identity in printing and the graphic arts, which was certainly achieved in the works of graphic artists such as Will Bradley (1868–1962).

Although books probably carried the taste for stylized design to the public most effectively, posters and magazine covers also played an active part. Posters such as those the young Maxfield Parrish (1870–1966) produced in the 1890s were bold in pattern and jaunty in effect. By the mid-1890s, posters were taken seriously enough to be accorded special exhibitions. Edward Penfield's posters for *Harper's* had many imitators, and the simplified designs even invaded magazine and newspaper illustration. To suppose that the public eye was not attuned to an art that took the burden of representation lightly and delighted in the play of form would be to misunderstand the level of perceptual sophistication at the end of the century. Yet all these tendencies were craftsmanly, disciplined in their own way—and kept their place. They all belonged to the world of art, yet a poster was a poster and a salon painting was a painting, reaching for higher values. One liked to say that there were decorative values and pictorial values, and the two should not be confused.

However, a young painter from Connecticut was beginning to doubt this duality. Arthur Wesley Dow (1857–1922) had studied in Paris and painted with other

Will Bradley, *The Twins,* poster for the *Chap-Book,* May 1894. Library of Congress, Washington, D.C.

Edward Penfield, *Harper's Christmas,* circa 1898. National Collection of Fine Arts, Smithsonian Institution, Washington, D.C.; museum purchase.

American artists at Pont Aven. On his return to the United States, a chance encounter with a book on the Japanese artist Hokusai confirmed his notions that more was available to the artist than Western art provided. He became a friend of Ernest Fenollosa in 1891 and soon devised his theories of composition based on the Japanese works that Fenollosa could show him in the Museum of Fine Arts collection—and on his conversations with the articulate Fenollosa. Preoccupied with the effect of shapes and colors organized on a flat surface, rather than with the effects of recession and volume, he came to the conclusion that decorative and pictorial values were inseparable. By the summer of 1892 he was teaching his students at Ipswich, Connecticut, by the new principles, carefully avoiding the usual kind of instruction in landscape painting. In 1899 he published his method in a book, called simply *Composition*, that was an immediate success and was continually reissued over the next several decades. He had taught his compositional procedures at Pratt Institute in Brooklyn since 1895, and in 1904 he moved to Columbia Teachers College, where his instruction had a tremendous impact on how art was taught in the schools for many years to come. His doctrine spread across the country by means of his book and the work of his devoted followers who taught in the new programs of art being introduced in public school systems.

Arthur Wesley Dow, *Rain in May*, circa 1907. Ipswich Historical Society, Massachusetts.

Rather than concentrating on the imitation of objects and perspectival renderings, Dow's students began at once to consider the organization of lines and shapes in a given two-dimensional space. They then moved on to the interplay of flat shapes of light and dark (Dow used the Japanese word *notan*), and then to color. Dow and his students analyzed both Eastern and Western paintings in terms of these active elements, which Dow considered to be the foundation of all artistic expression.

For all his opposition to what he considered misguided approaches to art, Dow was no revolutionary. He was attempting to reestablish what he believed to be the fundamentals of traditional art, more widely considered than by the existing painterly tendencies. The realm of art was no less special for Dow than it was for La Farge or even Kenyon Cox, though each defined it rather differently.

The first active revolt to surface in modern art in America was precisely against this sophisticated realm of art, no matter how it was defined. It was not a revolution in form but a revolution in artistic context. To any acute observer, the difference between the image maintained by art, with its infinite refinement, and what was going on among the larger population of the burgeoning cities seemed too dramatic to be ignored. The group of young men who created a violent stir in art in 1908 were acute observers of the social scene. Several of them had started in Philadelphia as pictorial reporters for newspapers and were quite aware that the aesthetic of optimism did not cut deeply into actual society. The sensational occasion they provoked was an exhibition at the Macbeth Gallery in New York of works by eight little-known painters, "the Eight," three of whom had been rejected by the jury of the National Academy in 1907. Ironically, the painters had been chosen by Arthur Davies (1862–1928), a painter of idyllic, poetic landscapes complete with nymphs and unicorns but nevertheless a keenly independent artist with a broad appreciation of art. Taken as a group, the painters had nothing in common other than their general lack of popularity. The tone of the exhibition was set, however, by five painters, among whom Robert Henri was central. Henri (1865–1929) had been through the usual training in Paris in the 1890s after initial training under Anshutz at the Pennsylvania Academy. Possibly some of the spirit of Thomas Eakins had gotten to him, because he was determined that his art be imbued with life—and he did not mean the cloistered study of posed models. The turbulent life of the newly expanding city fascinated and inspired him, since he saw optimism for the future more in the teeming vitality of the working classes than in the more rarefied upper-class society of his day. On his return to the United States in 1899 he became a popular teacher and urged his students to participate in the life around them rather than lose themselves in the world of art. Like his somewhat older contemporary, the fiercely independent and creative architect Louis Sullivan, Henri believed that each artist had to come to grips with himself and the realities of his environment before he could produce

Robert Henri, *Himself*, 1913. Courtesy of the Art Institute of Chicago, Illinois; Walter H. Schulze Memorial Collection.

anything significant. His Whitmanlike enthusiasm for discovering artistic expression in the commonplace activities of society was contagious and inspired his students to the point of combative self-confidence and optimism.

The works that Henri and four of his followers—George Luks (1867–1933), William J. Glackens (1870–1938), John Sloan (1871–1951), and Everett Shinn (1876–1953)—exhibited at the Macbeth Gallery in 1908 were lively, broadly and enthusiastically painted scenes of what more careful levels of society would have called common life. The people depicted had none of the charm of French peasants and, as a kind of impertinence, seemed to be enjoying themselves. Lacking in grace, quite without mystery, and yet without the serious recording of material detail that had made the paintings of J. G. Brown popular, the paintings were judged as simply ugly. With so much beauty in the world, the critics complained, why should one concentrate on the ugly? The critics were unsympathetic with Paul Gauguin's onetime remark: "The ugly may be beautiful but the pretty never." The group eventually became known as the founders of the "Ash Can School," since the painters showed so little respect for elevated sensibilities. In this context the critics spurned even the delightful puddles of pattern by the Bostonian Maurice Prendergast (1859–1924), showing people enjoying themselves at the park or the shore, as well as the rather blunt landscapes of Ernest Lawson (1873–1939). Somehow the lack of reverence for art expressed in the exhibition, and its restless vitality, were seen as a threat to all that the preceding twenty-five years had accomplished. Nonetheless, the exhibition moved to the Pennsylvania Academy, where several of the painters had studied, and was circulated by the academy to other cities as well.

A far more serious threat of a different kind was developing, which the critics seemed quite unaware of, or at least were hardly inclined to regard seriously. In the early years of the century, some few young Americans abroad, like their European contemporaries, began to discover values in the work of some of their predecessors who had been overlooked by officialdom. Retrospective exhibitions of the work of Cézanne (1907) and Gauguin (1903 and 1906), and the new appraisal of Van

William J. Glackens, *Chez Mouquin,* 1905. Courtesy of the Art Institute of Chicago, Illinois; Friends of American Art Collection.

Maurice Prendergast, *Summer, New England,* 1912. National Collection of Fine Arts, Smithsonian Institution, Washington, D.C.; anonymous donor.

Gogh and Seurat (in exhibitions in 1905), could not be ignored by those who were restive about accepted values. The huge exhibitions of the Salon des Indépendants and, from 1903, the more audacious Salon d'automne, provided a startling range of old and new work. In many new galleries, some of them very small but well known among the artists, one could see many challenging works. In Austria and Germany, the secession exhibitions continued to present new ideas in the arts, including the arts of decoration, and the Brücke painters and those who would be known as the Blaue Reiter group were beginning to show their work. In 1906 a large exhibition of Russian painting, past and present, arranged by Diaghilev was shown in Paris at the Salon d'automne, followed in succeeding years by opera and the Russian ballet with its exotic color and design. Beginning with their exhibition at Bernheim-Jeune in 1912, the Italian Futurists clamored to be heard, and manifestos had been appearing in various languages, including English, since 1909. And of course from 1910 or 1911 one could not avoid hearing talk of cubism, a term that provoked as much discussion as the works for which it supposedly stood.

The term "modern," which had come into currency in the 1890s to refer to the patterned art that deliberately eschewed reference to traditional Western practice, became in the early years of the twentieth century an aggressive battle cry against all that was conventional. "Modernism," "modernistic," and other variations on the word were used as boast as well as disparagement. Although the young wished to be modern in every way possible, the keepers of academic values looked upon the search for the new as fallacious and destructive. They had little patience with those who ignored accepted standards of drawing and the established craft of painting. Modernism was simply a phase, they supposed, akin to the momentary passions for exotic styles that had occasionally erupted in the nineteenth century. The conservative critics assumed that the excesses of modernism would eventually be absorbed into what they considered the mainstream of art, as "impressionism" had been, once the young experimenters realized the sterility of extremes.

Those who upheld the standards of the modern, how-

ever, believed they were involved in a fundamental artistic revolution, not simply in a stylistic experiment. Like typical revolutionaries, they celebrated their victories and measured the step-by-step advance of their cause. They spoke of an advance guard in their march away from the known precincts of art toward a promising infinity of artistic experience.

Out of the various "modern" directions, each of which provided its particular excitement, came no particular style in America, but rather the encouragement to experiment, to accept the premise that art had no fixed formal principles but followed the dictates of the artist's free will. The most influential embodiment of such an ideal—and most dangerous from the standpoint of English and American critics—was the mild-mannered Henri Matisse. He first came to international attention in 1905 when his paintings and those of his followers were grouped together at the Salon d'automne in Paris. Not unsympathetically, the group was dubbed "the wild beasts" (*les fauves*), a term that in the hands of critics became for some a badge of honor and for others a comment on the painters' level of civilization. What American critics found so totally unacceptable in Matisse—some of his works were shown in New York in 1908—was his disturbing capriciousness. Simplified form, bright colors, and flat compositions were not new; the teaching of Arthur Dow and popular design standards could admit all of this. But Matisse gave no clue to a central principle by which his seeming improvisations could be rationalized. Each work had to be looked at as if it were the first. There seemed to be no basis for his procedure other than contrariness. Of course, that was precisely the principle that opened the gates of the imagination to many dissatisfied artists. It was the privilege of modernity.

Matisse's *Woman with the Hat,* shown at the Salon d'automne in 1905, was purchased from the exhibition by two Americans, Leo and Gertrude Stein, and the purchase became important for many of their countrymen. Leo Stein had settled in Paris in 1902 and was joined there by his sister Gertrude and by his brother Michael and Michael's wife Sarah. He had been a disciple of Berenson and had been much impressed by the works of Cézanne, but the discovery of Matisse opened

the way for a more audacious attitude toward art. The Stein apartment at 27 rue de Fleurus was eventually a showplace for many aspects of "the modern," and both French and American artists and writers gathered there to discuss their ideas and to provide mutual sustenance. Gertrude Stein became especially interested in Picasso, and various phases of his work were to be seen on the walls. From about 1906 to the outbreak of World War I, 27 rue de Fleurus was a vital nerve center for those persuaded by the concept of the modern.

There were, of course, many American artists living in France who were not impressed by the earnest discussions at the Café du Dôme or at 27 rue de Fleurus. The Society of American Artists in Paris kept the more conservative artists in touch with one another and served as spokesman for the American group. Few Americans who went to Paris in the first decade of the century were drawn there by ideas of a revolutionary aesthetic. Alfred H. Maurer (1868–1932), for example, went to France in 1897 and worked in a Whistlerian mode, often with a touch of end-of-the-century languor. By 1907, however, he had discovered Matisse and had begun to paint in vivid patches of color, scattered in defiance of any established precepts of visual order. Similarly, Max Weber (1881–1961), arriving in France in the fall of 1905, enrolled in the usual academies. It was only on seeing Cézanne's paintings at the Stein apartment and in the retrospective exhibition of 1907 that he allied himself with the modern concepts. In January 1908 he joined Sarah Stein and others in a class in Matisse's studio. The instruction he had had from Arthur Dow in the composition of flat surfaces now took on new meaning. Like other Americans, he was concerned not with one particular style or movement, but with the idea that modern art was an open-ended pursuit of new creative experience. He studied African and oriental works and became a trusted friend of Henri Rousseau, several of whose works he acquired. Another painter of academic accomplishment who discovered in Paris reason to change his concept of art was the Philadelphian H. Lyman Saÿen (1875–1918). He had made advertising designs for Wanamaker's, had painted murals for the Capitol (installed in 1905) and had significant scientific patents to his credit before going to Paris in 1906. There

Alfred H. Maurer, *Still Life with Artichoke, II,* circa 1929–30. National Collection of Fine Arts, Smithsonian Institution, Washington, D.C.; bequest of Bertha Schaefer.

H. Lyman Saÿen, *Blue Trees,* 1915–17. National Collection of Fine Arts, Smithsonian Institution, Washington, D.C.; gift of H. Lyman Saÿen to his nation.

he discovered Matisse and the joy of color and spontaneous painting, and he brought back a totally transformed body of work when he had to return to the United States in 1914 because of the war. So many Americans in Paris opted for the new that in February 1908 the New Society of American Artists in Paris was organized in opposition to the existing society that remained loyal to earlier ideals. Few had anticipated what they would see before getting there, but they were quick to find in the new work an answer to their quest.

Alfred Stieglitz

Not many years later, artists began to go to Paris not because they wished to discover new tendencies but because they already knew much about them and wanted to make contact with the source. Many had, in fact, experimented with new modes of expression before leaving the United States. Several notable factors had contributed to knowledge of the principles of the change that was spreading through the art world. One small but powerful voice calling attention to the new tendencies was that of Alfred Stieglitz, through his tiny Photo-Secession Gallery at 291 Fifth Avenue. The address is important because the gallery quickly became known in the art world simply as "291."

Alfred Stieglitz (1864–1946), who was born in New Jersey, became fascinated with photography while studying in Germany in the early 1880s. Convinced that photography was no less an art than painting or printmaking, he was determined to see it accepted on its own merits. Shortly after his return to the United States in 1890, he allied himself with other photographers to gain acceptance for the artist photographer, and through the Camera Club of New York and its journal *Camera Notes*, which he edited until 1902, he was able to bring his ideas and those of equally serious photographers before the public. What was heralded as the first international salon of artistic photography was held at the Philadelphia Academy of the Fine Arts in 1898, and Stieglitz was an influential member of the jury.

Stieglitz's rigid standards of technical and pictorial excellence were not viewed with sympathy by all, and in 1902, in connection with an exhibition he put together in New York, he formed his Photo-Secession, separating

himself and associates from the more conservative photographers, many of whom saw photography as an extension of painting, as Stieglitz himself had once done. In 1903 the new group began to publish *Camera Work,* a journal whose elegant design reflected the taste of Edward Steichen (1879–1973), a younger photographer who was to have a strong influence on Stieglitz and the gallery the group founded in 1905 at 291. In 1907 the Little Galleries of the Photo-Secession began to include shows of works of art other than photographs, many of them sent back from Paris by Steichen, who a year before had returned to France, where he had earlier studied. In January 1908 an exhibition of Rodin's unconventional drawings caused a stir, and in April an exhibition of drawings, prints, and one painting by Matisse brought that stimulating Parisian force to the attention of the New York art public. From then on 291 became a center in which to view and discuss the works of European and American "modern" artists and other works they held in esteem. Alfred Maurer, John Marin, and Marsden Hartley from the Paris group were shown in 1909, and in 1910 an exhibition entitled Young American Painters introduced to the local scene the work of many of the adventuresome painters working abroad. In 1912, and again in 1914 and later, works by untaught children were shown. In 1914 a spectacular exhibition of African sculpture was mounted, followed by a showing of preconquest Mexican pieces. Until its closing in May 1917, the small gallery 291 made accessible to New York much that was fundamental to the modern movement in art.

Aside from its exhibitions, the gallery was also a place for the exchange of ideas and the encouragement of independent artists. One of those closest to Stieglitz was John Marin (1872–1953). He first prepared to be an architect, studied at the Philadelphia Academy, then went abroad in 1905. His early etchings from Paris have much in common with those of Whistler, but by the time he was ready for his first exhibition with Stieglitz in 1909, he was painting watercolors in bright hues and slashing strokes that entangled themselves in an active, luminous effect of space. Little by little he moved to a more structured but no less free manner of painting that eventually became identified first with the turbulent

John Marin, *Pertaining to Stonington Harbor, Maine, No.* 4, 1926. The Metropolitan Museum of Art, New York, New York; Alfred Stieglitz Collection, 1949.

streets of New York, then with the pine-fringed coast of Maine. Marin was alert to the works of many European artists—Cézanne, Matisse, Delaunay, the Italian Futurists—yet he followed his own directions, integrating his ideas with a personal vision of the American landscape.

Another artist close to Stieglitz in his early years was Marsden Hartley (1877–1943), a thoughtful young painter who more than most responded to the philosophical principles underlying the modern tendencies. He read widely and was drawn to works such as those by Ryder, in which form served as evocative symbol. His meeting with Stieglitz and his circle in 1909 spurred him on in his independent direction, and by the time he went abroad in 1912 he was already accepted as a modern artist, surprisingly knowledgeable about European works and theories. In Paris Hartley became familiar not only with the French artists and their American colleagues, but also with German artists associated with the Blaue Reiter group. He was enthusiastic about Kandinsky's *On the Spiritual in Art* (selections from which appeared in *Camera Work* in 1912). He became a friend of many of the Blaue Reiter painters in Germany from 1913 to 1915 and, though his painting was distinct, identified himself with their ideals. When he finally settled in Maine, all his expressive, structural strength came together in powerful paintings of waves and rocks, and the rugged images of the local Portuguese fishermen suspended in a brutish kind of visual poetry.

Marsden Hartley, *Painting No. 47, Berlin*, 1914–15. Hirshhorn Museum and Sculpture Garden, Smithsonian Institution, Washington, D.C.

Hartley's absorption of the ideas of the German painters was well documented in New York by his frequent exhibitions at 291. His works opened up further vistas for the artists at home.

Arthur Dove (1880–1946) introduced quite a different element of lyricism into the Stieglitz circle. In 1908 he gave up a successful career as a commercial illustrator to go to Paris, where, in company with his fellow Americans, he discovered the works of Cézanne and Matisse. His stay was brief, but it was enough to set him free to follow his own bent toward the expressive use of color and largely abstract forms, a kind of painting he was developing by 1912. Once the idea had taken root he needed little stimulus from the works of others

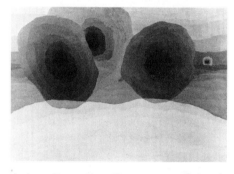

Arthur Dove, *Fog Horns*, 1929. Colorado Springs Fine Arts Center collection, Colorado; anonymous gift.

to carry out his suggestive harmonies of shapes that seem akin to nature and yet remain unidentifiable. Unlike Hartley, he was not drawn to elaborate theories but tried to remain open-minded in assessing in terms of forms and colors the personal experience of his immediate environment. Of all the Stieglitz artists, however, he was the least successful in winning a following, and his work had to wait for a later generation for proper assessment.

Although Stieglitz with his gallery was looked to as something of an oracle of modern art, and though his exhibitions were of extreme importance to those who encountered them, the general public had little reason to know of their existence. Although friendly and—more numerous—hostile critics noted their occurrence, the gallery's public was small, and Stieglitz gave no indication that he wanted it otherwise. It is doubtful that he believed the larger public was even capable of appreciating what his painters, sculptors, and photographers were doing.

Yet the public press was not silent about events in modern art abroad. Radical ideas such as those provoked by the fauvist painters and the cubists—the popular press especially like the new terms, which were invariably misapplied—were given extensive coverage, often only half seriously, in the Sunday supplements. Scandalous news in the visual arts was often mixed up with the latest reports on free love, alienists, and other offenses to convention, but it was considered exciting enough to pique the interest of the Sunday reader. The noisy advent of Futurism in 1909 and the exhibition of the Italian Futurist painters in Paris in 1912 were written about at some length, and the popular *Literary Digest* carried an extensive article with illustrations. Futuristic became a favorite word in the American press, used to describe any iconoclastic activity that was not at once understandable. The public was convinced that science was making such rapid progress that it assumed, with some satisfaction, that the future would be incomprehensible to present intelligence, as baffling as futuristic modern art. Puzzling art events were news, and the fact was important for the development of the self-consciously modern movement in the United States.

In 1913 the New York press was furnished a local news event concerning art that kept serious as well as more sporting journalists occupied for some weeks. A huge exhibition opened in February at the 69th Regiment Armory that promised to bring the New York art world up to date in artistic matters in unequivocal fashion. The so-called Armory Show was a long time in gestation. At first the Association of American Painters and Sculptors, which organized the exhibition, had intended only to give a liberal exposure to independent American artists, but as matters developed the exhibition became not only a presentation of contemporary works, both European and American, but a pictorial history of what its organizers considered to be the foundations of modern art. Arthur Davies, who headed the organization, was well informed about modern achievements in Europe, though his earlier painting rarely reflected his knowledge. On a sudden impulse he dispatched the painter Walt Kuhn, one of the organizers, to Europe to see the Sonderbund Exhibition of 1912 in Cologne, which was just closing, with the idea of acquiring a major European representation. In Cologne, Paris, and London, helped by the painter Walter Pach and others, Kuhn assembled a broad representation of modern European works, to which were added works by earlier painters who were admired as forerunners. By choosing carefully, a direct line could be extablished from Ingres and Delacroix, through the impressionists, to Cézanne, Gauguin, and Van Gogh, and finally to such artists as Matisse, Picasso, Kandinsky, Archipenko, and Duchamp. This was the first exhibition in America to suggest that modern art itself had a tradition. In this ancestry it was convenient to forget the Barbizon painters and any other of the artists with whom Americans had habitually worked abroad. By implication, this nicely eliminated much of American art from a line of historical consequence, although those painters who had followed the French impressionists most closely were given special attention. Modernity, then, was to be considered not simply a recent, disruptive phenomenon, but a gradually developing tendency. It had its own tradition to justify it as a worthy rival to what had thus

far been considered a proper artistic tradition. This selective history of modernity was to become a standard procedure by the 1920s, and for many years, references to it continued as a substitute for helpful criticism.

The exhibition was a great popular success and made a hit with the newspapers. Articles and cartoons abounded, pointing up what was considered to be the absurdity of Marcel Duchamp's *Nude Descending a Staircase* or Archipenko's sculpture. There was some serious criticism, but little that helped understanding. Although Kenyon Cox, as keeper of the flame of tradition, was angry, most reporters seem to have viewed the exhibition as a kind of sport, which possibly was not all bad. Their labored wit made the papers throughout the country, and anyone who read newspapers with attention knew that something startling was going on in art. When it closed in New York, the Armory Show moved to the Art Institute of Chicago, where again it created a stir but also sparked some serious thought. Chicago, like Philadelphia, had its own ties with Paris and the modern movement and later amassed one of the great collections of French impressionist and Postimpressionist painting. In 1914 the thoughtful collector Arthur Jerome Eddy published his *Cubism and Post-Impressionism* in Chicago, one of the early serious efforts in America to rationalize the new movements.

So far as the American public was concerned, whether they had seen the exhibition or not, the term "modern art" now meant something far different than it had when Prang published his manuals of stylized designs under that title in the 1890s. It stood not for a new style—like art nouveau—but for disruptive activity that was quite unintelligible to people of established culture, yet was clearly a force to be reckoned with.

Knowledge about modern tendencies was not confined to the East. At the Panama-Pacific Exposition in San Francisco in 1915, organized to celebrate the opening of the Panama Canal, there was a curious contrast between most of the art that decorated the buildings and some of the art chosen for the exhibitions. The range of selection was much wider than it would once have been, and even a representation of works from the Italian Futurists was invited. This was largely the doing of John Nilson Laurvik, who in 1913 published his book

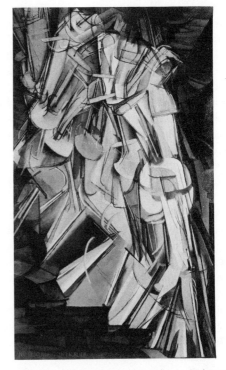

Marcel Duchamp, *Nude Descending a Staircase, No. 2*, 1912. Philadelphia Museum of Art, Pennsylvania; Louise and Walter Arensberg Collection.

Is It Art? Post-Impressionism, Futurism, Cubism. California craftsmen and architects had already shown themselves knowledgeable about modern design. The architecture and furniture of Charles and Henry Greene and the paintings and craft designs of Lucia and Arthur F. Mathews were persuasive testimonials to new conceptions of art. When Marguerite Thompson (who later married the sculptor William Zorach) left California for Paris in 1908, she was quite prepared to be stimulated by the works of Matisse and his followers, and she came back to paint views of Yosemite in brilliant splashes of color. It is not too surprising that the directors of this exposition were allowed to invite the Italian group that had published such shocking manifestos.

One immediate effect of the Armory Show was an extraordinary increase in the collecting of modern works and the creation of commercial galleries to make the process easier. The new dealers did not share Stieglitz's reticence, and New York began to develop as a major market for modern art. Even some galleries that formerly had refused to show works by the new painters now became promoters. The active collector John Quinn, who had supported Irish nationalists, independent writers, and many Irish and English artists, began to collect much more audaciously. Advised at times by Walt Kuhn and a growing circle of friends in Paris, by his death in 1924 he had amassed one of the great collections of modern art, beginning with Cézanne. He aided the support of such authors as Joseph Conrad and Ezra Pound and helped get the writings of Joyce and Eliot published in America, thus becoming one of the strongest supporters of independent efforts in art and literature of his time.

Another major collector and supporter of modern art after the Armory Show was Walter Arensberg, who between 1914 and 1921 maintained a much-frequented salon of artists, writers, and musicians in New York. It harbored European as well as American artists during the war years, including Francis Picabia, who had first come to New York in 1913 and had exhibited his New York studies at 291 that year, Albert Geizes, and—most important for American artists—Marcel Duchamp, who arrived in New York in 1915. Arensberg became a particular patron of Duchamp, who livened an occasional

exhibition with his irreverent entries. In 1915 he exhibited a snow shovel with the caption *In Advance of the Broken Arm,* and in 1917 he startled the Society of Independent Artists, of which he was one of the organizers, by submitting a urinal under the title *Fountain,* signed R. Mutt. Duchamp, supported by Arensberg, was also prime mover of the publications *Blind Man* (1917; only two issues were published) and *Rongwrong,* drawing inspiration from the Dada movement in Zurich.

The short-lived activity of irreverent fantasy existing around the Arensberg circle in New York, usually referred to as the New York dada movement, had few immediate followers but had a leavening effect on those who seriously worried over whether art was art. As a rebellious act it had little of the bitterness and none of the political overtones that overtook Dada in Europe. Meanwhile, Arensberg assembled an impeccable collection of works, largely European but many by Americans, that could not fail to affect the vision of the many who gathered at his handsome apartment. There his visitors would see, besides the works of Duchamp, cubist works of Picasso and Braque, Brancusi sculpture, and a wide-ranging selection of works that were challenging in both form and content.

Stieglitz also contributed to maintaining the image of provocative Paris art and ideas between March 1915 and February 1916 in a magazine called *291*, largely in the care of the Mexican caricaturist and later art dealer Marius de Zayas—who had been an indispensable aid to Stieglitz—and Agnes Meyer. Designed according to the most modern standards deriving from the Futurists and Dada, and anticipating somewhat the format of the Dutch magazine *De Stijl*, it was sharply intellectual in its choice of verse and criticism and in its illustrations. For interested artists and patrons, New York in these years offered as sophisticated a menu of art and ideas as could be found anywhere.

To prove the coming of age of modern tendencies in the United States, an exhibition of seventeen American painters of modern persuasion was shown in New York at the Anderson Galleries in 1916. The Forum Exhibition of Modern American Painters was organized under the aegis of Willard Huntington Wright, critic for *Forum* magazine and author of *Modern Painting: Its Tendency*

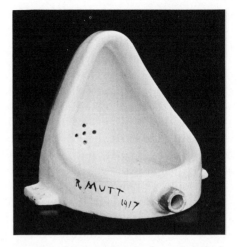

Marcel Duchamp, *La Fontaine* (second version), 1917. Courtesy of the Sidney Janis Gallery, New York, New York.

and Meaning (1915), a book that was to have wide circulation. Artists from the Stieglitz and Arensberg circles, painters fresh from abroad, and some young newcomers made it clear that modern art not only had arrived, but presented a complex, varied face.

It was now clear to artists that art was beyond the borders of juries or unified theories of art. In late 1916, chiefly through the encouragement of the artists associated with Arensberg, a new society was founded in New York called the Society of Independent Artists, patterned after the Paris Société des Artistes Indépendants, established in 1884. Its purpose was to hold exhibitions at which all artists would be welcome, and for which there would be neither juries nor prizes. To avoid any suggestion of ranking, artists were granted exhibit space alphabetically with no concern for style or school (the idea was suggested by Marcel Duchamp). The hanging committee for the first exhibition included Marcel Duchamp, George Bellows, and Rockwell Kent. John Sloan was president. Since the exhibitions contained more than a thousand works, the effect was likely to be confusing to the eye as well as to the mind, but each artist had his chance without the involvement of critics or juries of his peers. Works by academicians were by no means excluded, nor were they barred from the exhibitions of the New Society of Artists, organized in 1918. Yet the principle of the exhibitions could not be more opposed to the principles of the National Academy, which based its existence on its selectivity—its belief in maintaining a single standard of excellence. Creative effort and fresh ideas were now quite enough. "Is it art?" had become an irrelevant question.

To Be Modern

Thus, in the years just before and after World War I, modernity in the United States was not characterized in any one way. Abstractness was no more modern than was a candid look at contemporary life. Although the scheme of modern art's history had been formulated, excluding many approaches to art from its progressive and assertively inevitable line of march, it was not confirmed in the minds of most critics until the late 1920s and 1930s, and even then there were many doubters. Even for those with the most liberal concept of

modernity, however, certain things clearly were not to be included: a traditional idealism of form and subject; the polite reveries of turn-of-the-century art; ingratiating prettiness that sapped all strength from an artist's formal procedures; and any subject matter or technique that seemed to be only the repetition of a traditional, preordained model. Retrospection and languor had no part in the modern movement.

Too much emphasis, however, should not be placed on the importance and necessity of becoming modern. Simply to be denied a place in the definition of modernity was not enough to discourage those artists who believed that art should both renew and perpetuate traditional standards; in numbers they surely surpassed the artists of modern bent. To support timeless values was as much cause for pride as to consider oneself modern. Furthermore, such artists by no means considered themselves alien to their own time. Although some art schools, such as that of the Pennsylvania Academy, early in the century produced an extraordinary number of bold artists eager to experiment, most had settled down to a modest compromise between impressionism and the facile style of Sargent. The enlightened teaching of Arthur Dow had more impact on public schools than on art academies. The position of the National Academy of Design had probably never been so strong as in the 1920s. Its members dominated every governmental or quasi-official commission on the fine arts and represented the voice of the artist on museum boards and juries for scholarships. In 1914 and 1915, the National Society of Mural Painters (founded in 1895) and the Society of Beaux-Arts Architects (founded in 1894) joined forces with the academy to present classes in mural painting, and it is not to be wondered at that most mural commissions for public buildings went to artists so trained or to their teachers. Most public buildings, after all, were still designed by Beaux-Arts architects. Sculptural commissions followed a similar pattern. The American Academy in Rome flourished, and its alumni stepped easily into the roles of their predecessors. Until the advent of the fine arts program of the Treasury Department in the 1930s, most public art was selected and created by members of the academic community.

Since almost the beginning of the nineteenth century

there had been talk of establishing a national gallery in Washington, thus committing the federal government to acknowledge art at least by association. At the turn of the century the matter again began to be discussed with some urgency. Theodore Roosevelt recommended it to Congress in 1904, but no action was taken. The year before, Harriet Lane Johnston, President Buchanan's niece, had left her collection to the nation should a national gallery be established, and in 1906 a court decision designated as the proper recipient the Smithsonian Institution's art collection, which had been accumulating over the years. So in 1906 the country had its first officially designated National Gallery of Art, guided from 1908 by an appointed group of artists headed by Frank Millet, all reflecting the principles of the established institutions. Two members were appointed by the Smithsonian, and the other three by the Fine Arts Federation, the National Academy of Design, and the National Sculpture Society. The gallery was assigned its first full-time director in 1920, and in the following year a larger commission was appointed, but the basis of its membership was largely the same. However, it included five public men and five experts in the fine arts in addition to five artists. The patron and the expert had gained importance over the years. Certainly, in assembling the group, no thought was given to new currents of art or their supporters. No "modern" works came into the collection until more than forty years later.

The National Commission of Fine Arts had a similar makeup. It was finally brought into being by act of Congress in 1910, although there had been many earlier attempts to create useful advisory commissions. A group of "seven well-qualified judges of the fine arts," heavily weighted toward architecture and sculpture, its judgments helped to perpetuate academic ideas until well after World War II.

In 1925 the National Academy of Design celebrated the centennial of its founding with a sizable exhibition that opened at the Corcoran Gallery of Art in Washington and later moved to the Grand Central Galleries in New York. Made up of works by past or present members of the academy, it was heralded officially—

Edwin H. Blashfield, *Academia,* 1925. American Academy and Institute of Arts and Letters, New York, New York.

President Coolidge opened it in the presence of the diplomatic corps and an elegant crowd of selected guests—and publicly as a reaffirmation of academic principles, assuring them as a continuing force. In spite of the critical writing of Willard Wright, Forbes Watson, Duncan Phillips (who had opened his gallery in Washington in 1918), and many others, the public press welcomed this pledge to tradition. All talk of modernism in the United States through the 1920s, as opposed to an aesthetic of tradition, must be understood in terms of the still-dominant force of academic thought and its institutions. In fact, in 1927 the National Academy felt secure enough in its position to invite a group of "modern" artists to show their works at the annual exhibition. Many of those exhibiting later were elected members of the academy.

To the artists and critics of the time, the relationship between the artist and the academic establishment was often treated as a battle between David and Goliath, which provided a stimulating sense of drama. Looking back on the period, it is no longer necessary to take sides. Rather than judging works as "advanced" or "retardataire," appellations dear to the time, they can now be appraised on their own merits without regard to the order of battle. Academic artists also had their place in the march to the present.

Purity

Once he thoroughly accepted the concept that art drew its content from the organization of form and color, not from some degree of verisimilitude, an artist hardly needed stylistic models to create his independent works. Much verbal worrying has been spent on the meaning and virtues of "abstraction," but for the time it meant only the dependence on form and color to carry the work's import, even though in many cases the forms themselves might suggest beings or objects. Many artists could turn their attention to direct creations of form as they wished, even though they might at the same time be producing more conventional paintings. Abstraction became a particular mode of expression, like lyric poetry in contrast to prose. Exploring formal values was not essentially different from exploring the effects of light.

Nonetheless, at least by 1913 it was evident to many who were exhilirated by the new freedom of form that a controlling discipline was needed. "Self-expression" might develop as an aspect of childhood education, but artists were more concerned with an expression beyond the self, whether supported by a particular theory of form or by an uncompromising sense of perfection. The necessary ingredient was a quality that forswore any association with a muscle-impelled gesture or the groping of a touching hand. Although the mind might speculate, the body should be set free from spatial or temporal involvement.

In Paris by 1913 there was much talk of what Guillaume Apollinaire was calling "orphic" values, the satisfaction derived from the simultaneous interaction of prismatic colors, as in the works being created by Robert Delaunay. Several American painters working in Paris were persuaded by this orphic purity. Both Patrick Henry Bruce (1881–1936) and Arthur Burdett Frost, Jr. (1887–1917) from Philadelphia had been following the lead of Matisse from about 1908, but in 1912 they moved toward the purely patterned works of Delaunay. Two other painters, Morgan Russell (1886–1953) from New York and young Stanton Macdonald-Wright (1890–1973), who had been studying in California, launched their own movement in Paris in 1913, which they called synchromism. Although they built on generally orphic principles, they wanted their art to have more structural, and at times more emotional, content than they found in Delaunay.

Morgan Russell, *Synchromie Cosmique*, 1915. Munson-Williams-Proctor Institute, Utica, New York.

At the *Forum* exhibition in New York in 1916, the new abstract ordering of color made a decided impression. Not only were Macdonald-Wright and Russell well represented, but works by many others—Andrew Dasburg (b. 1887) and the young Thomas Hart Benton (1889–1975), for example, reflected the new use of color. The fascination with color theory was deeply rooted in American artists, as if the scientific theory gave particular sanction to their aesthetic ventures. For these painters, it allowed them to see color much as a musician regards sounds that can be built into chords; hence they could explore the nature of harmony and dissonance as systematically as composers writing music. Even when painting the figure, to which most returned, they gained

Stanton Macdonald-Wright, *Conception Synchromy*, 1914. Hirshhorn Museum and Sculpture Garden, Smithsonian Institution, Washington, D.C.

a new sense of structure in light that removed the image from the realm of simple vision. Although the works might not be apprehended intellectually, there was the assurance of an intellectual foundation, a basis in idea that could justify the seeming caprices of the eye.

Few painters were encouraged to persist in such a highly theoretical way of painting, but by 1916 the point was well established in the United States that a painting could be built directly from purified color and form (pure by virtue of the analyzed color spectrum and the ministrations of geometry) without reference to nature and need not, moreover, be expressive in the sense of Wassily Kandinsky. A painting might be an object of infinite visual satisfaction without reference to anything else at all.

Such pure visual poetry, however, had no common following. "In proportion as it gets purer," wrote the English painter and critic Roger Fry in 1917, "the number of people to whom it appeals gets less. It cuts out all the romantic overtones of life which are the usual—by which men are induced to accept a work of art. It appeals only to the aesthetic sensibility, and that in most men is comparatively weak." More and more critics spoke of the separation between art and society. Some deplored it, while some believed that only by means of such a separation could quality in art be maintained. In 1925 José Ortega y Gasset's widely read essay "The Dehumanization of Art" set forth what seemed to be the inevitable and necessary separation of art as pure experience from the world comprehended by the masses. Yet the separation in America did not begin with the self-conscious moderns; the refined values of a man like Freer and the artists he patronized were no less based on the assumption that they were removed from the comprehension of the vulgar. The "modern" artists, however, received the blame, and art without identifiable subject matter became a symbol for art that was beyond reach of the common man. Modern art was inhuman.

One aspect of "inhuman" art, however, was basic to the growing urban consciousness in the United States. Attention was fixed on structures built by men—cities, factories, gigantic buildings—which in turn overwhelmed the individual man. The importance of the total structure was emphasized, quite at the expense of

the constituent part. America's cities were soaring; man seemed always to look up at skyscrapers, losing himself in their grand isolation in space, rather than peering down into the chasms they created. In the very engineering feat there was an element of transcendence that became a source of spiritual satisfaction. The urban machine, shorn of all individual vagaries and passing incident, was in the poetic view an abstraction for all. It was an optimistic symbol of intellectual and technological achievement and of the beneficent domination of sensuous chaos and individual caprice by unified, constructive ideas.

A personal identification with the dynamism of the impersonal urban scene could be marked by passion, however. Joseph Stella (1877–1946), who was born in Italy and arrived in America at eighteen, had no reason to admire the city in his early years in the United States. He lived in crowded immigrant slums and was keenly aware of the conditions of the workers, most notably the coal miners of Pennsylvania, whom he depicted. Returning to Italy in 1909 and then going on to Paris, he made contact with the liveliest artists there and attended the opening of the first Futurist exhibition at Bernheim-Jeune. When he returned to New York in 1913, he was ready to see urban life in a new light. In 1913 he created his dynamic flashing interpretation of Coney Island called *Battle of Lights,* hailed at the time as "in all probability...the last word in modernism." Although in many ways it suggests the paintings of Gino Severini and Umberto Boccioni, whose Futurist works Stella had seen in Paris, in all of its vital turmoil there emerge no human figures with which the viewer can identify. The complex structure of color and form provides the vitality; one can lose himself in the unending whirl of Coney Island lights. Stella's great experience, however, was found not in the frolicsome rhythms of an amusement park but in the towering austerity of that great feat of engineering, the Brooklyn Bridge, which he encountered in poetic circumstances during the last stages of the war. As he later expressed it in an article in *Transition* in 1929, "It impressed me as the shrine containing all the efforts of the new civilization of AMERICA—the eloquent meeting point of all the forces arising in a superb assertion of their powers, in APOTHEOSIS."

Joseph Stella, *The Bridge,* 1922. Collection of the Newark Museum, New Jersey.

His emotional reaction he translated into forms as machine-tooled as the engineering he came to adore, and yet the poetic evocation is irresistible. The soaring structure of the city became as personal to Stella as were the pines of Maine to John Marin; yet the expression lay not in the spontaneity of execution but in an impersonal structure of forms.

In the years following the war, the cool impersonal ordering of form took precedence for many over an earlier expressiveness. The rigid, structural concepts of the *De Stijl* group in Holland, from 1917 on, were widely diffused, and Russian artists in Paris and Berlin and later in Russia formulated images that expressed an abstract dynamism that stood for a way of life as much as for an aesthetic principle. Naum Gabo and Antoine Pevsner launched their constructivist manifesto in Moscow in 1920. In 1921 the erstwhile Futurist Gino Severini published his treatise *From Cubism to Classicism*, extolling the virtues of mathematical precision, and Amédée Ozenfant and Le Corbusier had introduced the word "purism" in Paris to stand for a new taste in rational, formal perfection. The image of the United States figured interestingly in what was considered a new materialist aesthetic.

In 1921, shortly after Stella had begun his paintings celebrating the Brooklyn Bridge, Charles Demuth (1883–1935), who had just returned to France, wrote to Alfred Stieglitz in surprise that, while he had come to Paris to be in touch with the furthest reaches of the modern age, his French colleagues were looking to New York as the symbol of modern ideas. They were, to be sure, referring not to the New York art world but to the city itself—its soaring buildings that made up in engineering skills for the disappointment of their architecture, its constant and relentless activity, and its stupendous scale. New York seemed everything a European city was not: it was new, its changing forms were dictated by wholesale use, and, in the European view, its mad dash to the future paid little heed to the past. When the Italian Futurists burst upon the scene in Paris and London in 1912, an event that had much impressed Stella, critics called their views American. Most American artists would have shown no sympathy with the characterization; they were in full flight from the urban,

Charles Demuth, *Aucassin and Nicolette*, 1921. Columbus Museum of Art, Ohio; gift of Ferdinand Howald.

mercantile scene, and many were still fostering an art that nurtured nostalgia for European antiquities. Now, after the war, artists who were sympathetic to the new taste for spare structure and starkly purposive forms began to see their urban environment with new eyes.

At least in part the association between the Americans and the growing international taste was more a matter of coincidence than of influence. In the United States, Charles Sheeler (1883–1965), who had studied at the Pennsylvania Academy before going to Paris in 1909, early felt the need for a more ordered and impersonal art. On his return from Europe in 1912 he made his living as a photographer, and as he understood the medium, photography pointed the way to the precision and dispassionate view he strove for in his drawings and paintings. Whether in recording the stark patterns of Pennsylvania barns—he produced a whole series between 1915 and 1918—the skyscrapers of New York, or the industrial architecture of the Ford plant at River Rouge (1927–30), he found satisfaction in an airless perfection that, though compounded of manmade things, gave little account of the existence of man himself. He had an uncanny ability to transform the material world, in all its specificity, into abstraction, allowing the viewer to forget his own situation as he gazed in wonder at the purity of a brave new world.

Charles Demuth also, although he added an element of whimsy, produced a few hymns to smokestacks and commercial towers, as did Preston Dickinson and many others. Artists suddenly saw the most utilitarian aspect of the American scene as providing forms to express modern optimism and spiritual transcendence.

Before Louis Lozowick (1892–1973)—who came to the United States from Russia as a boy—went to Europe to study in 1919, he made trips to the most commercially active cities in the country to gather material that would help him make his way in Berlin, where he settled until 1924. His dynamic views of Seattle, New York, Chicago, and other cities, imposing with their sense of serious activity, yet devoid of people, were favorably received in Germany as quintessentially American. "The skyscrapers of New York, the grain elevators of Minneapolis, the steel mills of Pittsburgh, the oil wells of Oklahoma, the copper mines of Butte, the lumber yards of Seattle give

Charles Sheeler, *Offices*, 1922. The Phillips Collection, Washington, D.C.

Louis Lozowick, *Pittsburgh*, 1922–23. Promised gift of Mr. and Mrs. Joseph Wissert to Whitney Museum of American Art, New York, New York.

176

the American cultural epic in its diapason," he wrote in 1927.

By the mid-1920s, the optimism generated by what some called "the machine aesthetic" was obsessive. Based on a belief that man could solve all problems through the application of mind, science and mechanics became the symbolic center of a new faith. The outward manifestation of the faith was the worship of the city, not for its teeming masses but for its soaring wonder that pointed to a new, free, impersonal world.

Georgia O'Keeffe, *Ranchos Church*, circa 1930. The Phillips Collection, Washington, D.C.

Among those affected for a time was Georgia O'Keeffe (b. 1887), who first exhibited in Stieglitz's gallery in 1917. From 1920 she was an intimate member of the Stieglitz circle and in time, with Sheeler and Demuth, produced a series of pristine skyscraper paintings. Although clarity and formal purity were to characterize Georgia O'Keeffe's work from then on, the urban symbol was short-lived.

There were two different aspects to the urban works of the 1920s. Some artists, like Lozowick, admired great utilitarian buildings and machines for what they meant in terms of function, as encouraging to the mind as spare, pragmatic reasoning. Lozowick's ornaments based on machines are not whimsical double entendres, as in Duchamp or Picabia, but respectful appreciations of efficiently functioning mechanical parts. When the Machine Age Exhibition was held at Steinway Hall in New York in 1927, Lozowick was an enthusiastic participant and wrote an essay for the catalog, "The Americanization of Art." The promise of the machine, including the urban machine, was very American and vividly real to him. Other artists, however, were moved primarily by an aesthetic taste for which they found their initial model in the city. It was a taste that prompted Sheeler to be an early admirer of the simple, spare forms of Shaker furniture as well as of city buildings, even though the two had nothing in common with respect to their production or how they related to their respective cultures. Although Shaker furniture had "the promise of function," to use Greenough's term, it gave no promise of production. O'Keeffe could transfer her interest from the precise forms of tall buildings to the equally precise contours of Santa Fe adobes, bleached bones, and isolated flowers. This delight in precise

177

forms that appealed to the mind rather than the muscles and had nothing to say about individual vagaries, tending to ignore the presence of people, did not use city imagery. It was nonetheless an urban phenomenon, sustained by a highly sophisticated notion about how one lives. It was so sophisticated, in fact, that it could even allow one to identify with a naive or primitive view, entertaining no thought beyond the beauty of function.

Of great support in this movement, which gained sophistication by its detachment from bodily limitations, was a center founded in New York in 1920 by Katherine S. Dreier, Marcel Duchamp, and Man Ray. They chose as a punning title the "Société Anonyme," which on one hand suggested the disinterestedness—anonymity—of their approach and on the other was simply French for "incorporated." Their exhibitions, which continued until 1939, were devoted largely to nonfigurative works ranging from the constructions of Naum Gabo to the provocative fabrications of Duchamp and Man Ray. In all, they held that the work of art was not a depiction but an object that provoked experience, a pure creation that spoke to the mind in its own terms.

Surprising as it might seem at first, the camera was the logical tool for this art of abstract detachment. Although the photographer usually deals with recognizable images, Charles Sheeler clearly demonstrated that he can direct attention to the precise forms of things rather than to the objects' narrative context. The most telling abstraction is possibly that which at first glance does not seem abstract at all, since the unique formal order seems not constructed, but found. The precise, unretouched camera image professes to belong to common reality; yet in Sheeler's hands the photograph—possibly of the side of a Bucks County barn or the harsh canyon of a city street—could become a complete and changeless formal structure in its own right. Thus an ordered, abstract quality of vision could intrude on the shapeless habits of normal perception.

Much of this precise and formal photography can, understandably, be traced to Stieglitz, who himself made admiring photographs of skyscrapers in the 1920s. In 1916 he introduced the work of a young photographer, Paul Strand (1890–1976), who carried his delight in precise images even to the point of photographing the

Paul Strand, *Picket Fence,* 1915, gravure from *Camera Work.* Collection, the Museum of Modern Art, New York, New York; anonymous gift.

mechanism of his motion picture camera. Edward Weston (1888–1957), a California photographer, began in the early 1920s a series of photographs so sharp in their focus that they provided a whole new education for the eye. He believed so thoroughly in the artistic reality of the photograph itself that he worked with large negatives and refused to soften his images by enlarging them. Although reflecting nature, the photograph became an object with its own intrinsic quality. Stieglitz was sympathetic to this principle and forbade the reproduction of his photographs. In a 1931 statement he wrote, "The quality of *touch* in its deepest living sense is inherent in my photographs. When that sense of *touch* is lost the heartbeat of the photograph is extinct. In the reproduction it would become extinct—dead. My interest is in the living." Touch "in its deepest living sense" surely did not refer to the superficial textures of objects, but to the sublimating quality of the work of art, in this case the photograph. A pure, detached object, it provided a satisfying lesson in abstract clarity to the willing and receptive mind.

An Art Community

While the art shown by Stieglitz in 291 and later in "the American Place," and that collected by Arensberg and fostered by the Société Anonyme seemed chiefly concerned with matters of form and qualities that were to some degree abstract, another kind of art, considered no less modern in its way, was finding support elsewhere. Although most of the artists had spent time abroad and were abreast of the various theories and movements, they showed little interest in emulating the more austere formal tendencies but wished to draw vitality for their art from local sources. They were concerned less with the detached purity provided by abstraction than with a sense of human togetherness. Many of them were obsessed with people—their fellow artists, the people in the street, artists' models—as if it was only through commitment to individual personality that they could make their increasingly commercial civilization come alive. No less devoted to the city than those who saw it as the promise for an ordered and intellectual future, they regarded it as a place of gathering, a place in which one

lived surrounded by others. They gathered in Greenwich Village, where rents were cheap and they could mix with the immigrant population, living outside the restrictions of middle-class society. In the summer they had homes in New Hope, Woodstock, Provincetown, or other spots where artist colonies were formed. In many ways they were the continuers of "the Eight," but with a greater awareness of the open possibilities of art. Cézanne was no stranger to them, nor were their French and German contemporaries, yet they chose not to be distracted from their own pursuits.

Many of the artists were trained at the Art Students League, where they had direct contact with a forceful and imaginative group of teachers who handed on not only an energetic way of working but a vigorous philosophy of art and life as well. These artists also showed a kind of optimism, but it was expressed mostly in a restless energy not too burdened by thought or theories. Their belief was in the creative spirit as expounded by Henri, and they avoided any doctrinaire stance that might limit the freedom of outlook they believed was unique to the artist. In the immediate postwar years the term "creative art" became common, and by the early 1920s the more alert public schools were offering their students art classes that attempted to awaken creative expression rather than inculcate traditional disciplines. Art was to be the freeing of the mind, not (as it had been looked to in 1800) the ordering of thought. The theories of John Dewey advocating "art as experience" (his book of that title was published in 1934), when added to the methods begun by Arthur Dow, encouraged curricula that placed more emphasis on intent, on the artistic impulse, than on polishing an artistic product. Each sincere expression was as valid as another. A similar attitude was expressed by many artists who valued in the work of their fellows the quality of hand, of artistic personality, from which they derived assurance that they were all individuals seriously striving together for expression. Theirs was not an art of forms but an art of artists, a convivial art that depended much on an artists' community.

Artists Together

Artists had such a community in New York in the Whitney Studio Club, founded in 1918 by Gertrude

Vanderbilt Whitney. The quarters, initially on West Fourth Street, provided a place for fellowship and the exchange of ideas, as well as a gallery for exhibition, supervised for many years by Juliana Force. The incomparable Peggy Bacon (b. 1895) celebrated their consciousness of each other in her witty, trenchant caricatures that included just about everyone known in the New York art world, from artists to critics and gallery directors. Her prints wonderfully caught the restless energy of the artists and their supporters who were self-consciously trying to sustain a sense of community. In 1920 the magazine the *Arts* was founded by Hamilton Field and served well the interests of the American group. Forbes Watson, its editor from 1923 to 1931, became a major voice in formulating the ideals of modern American art. Less consciously intellectual that the *Dial*, it looked with equanimity on many aspects of the arts without insisting on a concept of the avant garde. Yet with all the artists' sense of purpose, the helpful patronage of Mrs. Whitney, and the support of new galleries that wished to help the expansion of American art, life for the art community was not easy. Most collectors, and a large portion of the public, still believed art had to come from France.

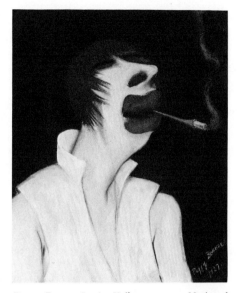

Peggy Bacon, *Louise Hellstrom*, 1927. National Collection of Fine Arts, Smithsonian Institution, Washington, D.C.; museum purchase.

John Sloan, *Roofs Summer Night*, 1906. Delaware Art Museum, Wilmington; gift of Mrs. John Sloan.

The exhibitions at the Whitney Studio Club (the forerunner of the Whitney Museum of American Art, formed in 1930), often provided a link between younger artists and the past. Works by the painters who had become famous as "the Eight" were shown, and the fresh, vital painting of Sloan, Glackens, and Luks made a strong impact on their younger contemporaries. Sloan, especially, both through his teaching and through his enthusiastic paintings and prints of New York life, had a great effect. Glackens, whose prints were equally witty comments on the everyday, developed a lush, prismatic palette that encouraged a sunny outlook on the scene observed. Hailed as a young champion for his athletic painting of communal life in the city was George Bellows (1882–1925), who dazzled his admirers with a facility devoted not to grace but to force. He was best known for his paintings of the boxing ring. His prizefighters are far different from those of Eakins, since Bellows was not one to lose himself in the analysis of anatomy and the sensitive coordination of mind and body. The glamor

and excitement of a scene attracted him, whether a prizefight or a revival meeting, and he made no criticism or comment. It was enough to live. Yet for all his seeming spontaneity Bellows was fascinated, as were many of his colleagues, with Jay Hambidge's complicated theories of dynamic symmetry and placed his faith in an elaborate fixed color system. Systems and theories were so much a part of modern thinking that even those artists devoted to the artistic impulse could not resist looking for a systematic rationale.

There were a surprising number of "artists' artists," possibly better known in the art community than by the general public. For the artist they stood for something special. Often they were influential teachers at the League or artists around whom students gathered in the summer. Jerome Myers (1867–1940) in his quiet way belonged to this group. He painted New York street life with a kind of sentiment unknown to Sloan or Bellows. His patterned canvases with their richly colored daubs of paint expressed a sweet humility in their deliberate understatement. So deliberately did Myers avoid bravura that his works served as a useful antithesis to those by followers of Sargent, still prominent in the exhibitions. His paintings served as persuasive lessons in the avoidance of grandeur. The seeming hesitancy in his technique helped create an air of innocence that made his noisiest street festivals appear like the remembered wonder of a children's party.

A totally different personality was Kenneth Hayes Miller (1876–1952). All students at the League knew of his creative struggles and his idealistic views on art. Yet somehow among his paintings, neither his ideal works nor his lady shoppers succeed in conveying the full message of his convictions as understood by his supporters. The idea that an artist was somehow greater than his works strongly appealed to many in the 1920s who saw art in terms of personality. The artist community was now large enough to have its own heroes—its teachers, mentors, and favorite patrons—who might remain unsung in the larger annals of art. Teachers were particularly important, and with the expansion of art schools and the scarcity of patronage, it was a rare artist who did not live largely by his teaching. Sometimes their students constituted their major public.

George Bellows, *Cliff Dwellers*, 1913. Los Angeles County Museum of Art, California; Los Angeles County funds.

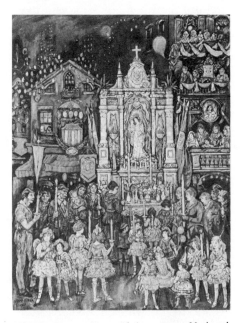

Jerome Myers, *Street Shrine*, 1931. National Collection of Fine Arts, Smithsonian Institution, Washington, D.C.; bequest of Henry Ward Ranger through the National Academy of Design.

182

Most of the art community looked upon the act of painting as an ultimate pleasure and were not too concerned about subject matter as long as it was local and, preferably, American. Painters such as Alexander Brook (b. 1898), Arnold Blanch (1896–1968), Louis Bouché (1896–1969), and Yasuo Kuniyoshi (1893–1953), all of whom settled in Woodstock, clearly loved to paint and, in their individual ways, enjoyed the sensuous quality of the medium itself. This was also true of Henry Varnum Poor (1888–1970), Henry Lee McFee (1886–1953), Raphael Soyer (b. 1899), and many others. Yet, except for a few experiments, they avoided anything that looked stylishly forced or according to formula. Out of this pleasure there developed a respect for *la belle peinture*, for fine painting as such. Still-life arrangements, flowers, and posed figures, were the vehicles for this painterly sensitivity. The well-mannered figures of Eugene Speicher (1883–1962) served as models throughout the country, as did the impeccably painted nudes of Leon Kroll (1884–1974). The somewhat exotic works of Maurice Sterne (1878–1957), who had painted in Indonesia, also appealed because of their compositions of perfect aplomb, with slight reminiscences of Cézanne and possibly Derain. The colors of these painters were fresh, their compositions had been freed by the new visions stemming from Cézanne, and their paintings as a whole were voluptuous without overstepping the bounds of a persistent American modesty.

The art community was by no means homogenous and respected variety in its midst. In fact, Edward Hopper (1882–1967), who by the early 1930s was much admired, preferred to stay clear of the community to develop his quiet art in his own way. He first exhibited at the Whitney Studio Club in 1920, but it was only over the next decade that he developed his own way of looking at things. The more the art world buzzed with isms and international theories, the more determinedly he set himself to concentrate on the local. Nonetheless, a mood not unrelated to that of the Italian Scuola Metafisica pervaded his earlier works, and yet the mood seemed to grow out of the unmistakably American situations he chose to etch or paint. In his hands, the American city was not teeming with Sloan's humanity, nor was it inspiring as in the reaching skyscrapers of Hugh Ferris's imag-

Kenneth Hayes Miller, *Shopper*, 1928. Collection of Whitney Museum of American Art, New York, New York.

Yasuo Kuniyoshi, *Self-Portrait as a Golf Player*, 1927, oil on canvas, 50½ x 40¼ in. Collection, the Museum of Modern Art, New York, New York; Abby Aldrich Rockefeller Fund.

183

inative views of ideal cities. It was a place of aloneness, bordering on what Giorgio de Chirico called a metaphysical solitude. A suggestion of emptiness lay beneath the brilliance, the business, and the intellectual chatter. His consolation lay in defining that quiet center as a defense against excessive optimism or complacency that threatened to lose contact with what he felt were real values.

Another man who preferred to live outside the community but whose work was yet considered part of the American art scene was Charles Burchfield (1893–1967). He made a hasty sally into the New York art world as a young man and quickly returned to his hometown, Salem, Ohio. From that time on he stayed away from cities. Yet he was by no means unaware of the expressive freedom now granted to the artist. He studied art briefly, but for the most part his original watercolor style was a product of his own experiments. From the beginning he was moved by obsessive fantasies in which aggressive forms seemed to do battle with the visual impressions of nature. Later the fantasy appeared to spring from the old houses and reaching trees that lined the streets of small towns. These interpretations of the American town brought Burchfield to the attention of the Eastern art community, for by the early 1930s a new rural mythology had developed.

The idea of an art community was not reserved for New York and its summer satellites. Artists throughout the country tended to group together in "colonies," and many cities could boast of or deplore their own Greenwich Village. Rural retreats for artists were within the range of every major city and did much to determine the character of the art that appeared in winter exhibitions. To be associated with a group and a place gave the local artist a special authenticity. By the beginning of the century, Carmel on the coast of California had become a center for artists from many parts of the country, drawn there by the fine weather and spectacular setting. Like most such centers, it mixed writers and artists and an occasional musician to provide a rounded cultural exchange. Of particular significance were Taos and, a few years later, Santa Fe, in New Mexico.

By the early 1880s artists were attracted to Taos with its nearby pueblo, and in the early years of the century both Taos and Santa Fe had permanent settlements of

Eugene Speicher, *Babette*, 1931. Museum of Art, Carnegie Institute, Pittsburgh, Pennsylvania.

Edward Hopper, *People in the Sun*, 1960. National Collection of Fine Arts, Smithsonian Institution, Washington, D.C.; Gift of S. C. Johnson & Son, Inc.

artists and also a following among artists who came from many areas to paint there in the summer. In 1912 the Taos Society of Artists was founded by E. Irving Couse (1866–1936), Ernest L. Blumenschein (1874–1960), and others. Paul Burlin (1886–1969) and Walter Ufer (1876–1936) settled in the area in 1913 and 1914. New Mexico offered not only an excellent climate and impressive scenery, but a native population that provided a special appeal. Both the Hispanic and the Indian inhabitants, so remote from urban sophistication, were ideal subjects for artists and writers bent on escaping a culture that seemed increasingly rootless. Books on local customs began to appear, weaving a mythological veil that blended folklore with dreams of innocence imported from Chicago and the East. The war years brought more artists and writers, and in 1917 Santa Fe opened an art museum where sizable exhibitions could be shown. Henri discovered Santa Fe the year before, and in 1917 Leon Kroll, Bellows, and many others of note were there for the summer. Mable Dodge Luhan, then wife of artist Maurice Sterne, settled in Taos in 1916 and wrote back to New York to invite her friends. Leo Stein spent some months with her, and Andrew Dasburg responded to her invitation in 1917. The clear atmosphere and the sparse natural forms attracted photographers from the Stieglitz group, most notably Weston and Paul Strand, and Georgia O'Keeffe began her long association with the area in 1929. For almost thirty years beginning in 1919, John Sloan painted in Sante Fe during the summers, serving as an attraction for many from the Whitney group and the Art Students League. New Mexico was Brittany with a uniquely American flavor.

Sculpture and Effigy

In the transformation of artistic vision, the sculptor faced more serious difficulties than the painter. Whereas the painter could use audacious color and deny illusory space to emphasize the formal freedom of his creation, the sculptor was held to the actual space his work shared with the viewer and, by tradition, was limited in his subject matter to the living figure, human or animal. If the figure created by the sculptor was simply an imitation of a natural model, it served not—as in a still life by Harnett—as a critique of vision but only

Charles Burchfield, *Ice Glare,* 1933. Collection of Whitney Museum of American Art, New York, New York.

Ernest L. Blumenschein, *Canyon Red and Black,* 1934. Dayton Art Institute, Ohio; gift of Mr. John G. Lowe, 35.14.

185

as a weak rival to the thing itself, a lifeless effigy. It was up to the sculptor to find a way to transform his model in such a way as create around it an ambience that would move it from dead life to live art. Cut off from an unquestioned tradition, the new sculptor had to find the means to do this for himself.

The impact of Auguste Rodin at the turn of the century was a great antidote to the well-mannered classical style, since he pushed the literal rendering of the body to a new level of expressiveness. Americans such as Lorado Taft and especially George Grey Barnard carried Rodin's bodily expressiveness about as far as it would go. But the persuasive gestural line, for all its power to express human aspirations or anguish, had its limitations.

As did the painters, some sculptors broke through the polite traditional forms by an abrupt shift in subject matter. Mahonri Young (1877–1957), inspired by the Belgian Constantin Meunier, opposed allegorical placidity with vigorously modeled figures of workmen and prizefighters. Abastenia St. Leger Eberle (1878–1942) modeled active little figures of slum children playing. Her little girl roller skating was done about the same time as "the Eight" exhibition in 1908. Anna Hyatt Huntington (1876–1973) was one of many who used actively engaged animals as subjects to escape the limitations of a human effigy.

Another means for breaking with what had become the cliché of classical form yet avoiding the pictorial dangers of sculptural genre was to adapt a strong formal style that would clearly stand apart from the all-too-familiar art of fifth-century Greece. To "stylize" had even more significance for sculpture than it had for painting. In Europe, the stark figures of Antoine Bourdelle served as an antidote to Rodin's fluency, and the Yugoslav sculptor Ivan Meštrović (1883–1962) had by 1910 become well known for his angular figures that fused a kind of folk spirit with Assyrian simplicity of form. In 1909, Paul Manship (1885–1966) won a three-year fellowship to work at the American Academy in Rome, and there began his fascination with the precise forms of archaic Greek sculpture. The smooth surfaces and taut, sharp lines of the pre-classical works were unequivocally products of art yet conveyed the vitality of nature. What he understood

Abastenia St. Leger Eberle, *Roller Skating*, before 1909. Collection of Whitney Museum of American Art, New York, New York.

Paul Manship, *Diana*, circa 1925. National Collection of Fine Arts, Smithsonian Institution, Washington, D.C.; gift of the artist.

as archaic style gave Manship the key to his art, which had a major influence on monumental sculpture in the United States, especially in the 1920s and 1930s. By the time of his first one-man exhibition in New York in 1916, his elegant works were already well known to private collectors, and his preference for polished, decorative figures was widely shared.

In the 1920s and 1930s there developed what might be considered a public style suitable to monuments and to the new style-conscious architecture. The delight in stylization was especially well expressed in sculpture for architecture, in which the tectonic lines of the building provided the motif for the style of the sculpture. The Century of Progress fair in Chicago in 1933 served as a dramatic occasion for the exploration of this "modern" style, and the Federal Triangle buildings in Washington, built between 1929 and 1938, are a lasting monument to the design-conscious taste in sculpture, even though the architectural theme is classical. Many sculptors worked on Washington projects in the 1930s, not only for federal buildings but also, among others, for the Folger Library (finished in 1932), which had carefully styled sculpture by John Gregory (1879–1958) and Brenda Putnam (1890–1975). Another monument to the decorative style, one that did not compromise with the classical tradition, was Rockefeller Center in New York, on whch many sculptors worked—John Storrs, Gaston Lachaise, Isamu Noguchi—and for which Paul Manship provided his Prometheus Fountain, which quickly became the public symbol for the center. Older sculptors were also affected by the taste. James Earle Fraser (1876–1953), who had first modeled his famous *End of the Trail* in 1894 and who had received a large number of government commissions in his long career (among other things he modeled the buffalo nickel in 1911), had by the 1930s modified his way of working to suit the monumental concepts of the day. His huge bronze groups, *The Arts of Peace*—designed in 1925 for the Arlington Memorial Bridge in Washington but not executed until 1951—almost meet the challenge of the bold modern stylization of the younger Leo Freedlander (1890–1966), whose two groups of heroic figures, *The Arts of War,* also commissioned in 1925, approved in 1933, and erected in 1951, completed the bridge's embellishment.

John Gregory, *Macbeth,* 1932. By permission of the Folger Shakespeare Library, Washington, D.C.

James Earle Fraser, *The Arts of Peace,* 1925–51. Arlington Memorial Bridge, Washington, D.C.

Public acceptance of stylized sculpture was quickened by the ingratiating works of the Swedish sculptor Carl Milles (1875–1955), which were much publicized in the 1930s. Milles received several major commissions in the United States after settling here in 1929. The extensive grounds of the Cranbrook Academy in Michigan were liberally decorated with his works. Ivan Meštrović also settled in the United States after World War II and was given an extensive exhibition at the Metropolitan Museum in 1947, but his great influence belonged to the prewar period.

Although some few American painters were experimenting with nonfigurative painting and discussing the virtues of "pure" form as early as 1913, sculptors were not quick to follow suit. The idea that sculpture had to do with the forms of live creatures was too deeply implanted in the minds of sculptors, in Europe as well as in America, to permit thoughts of pure structure. Without the figure, how could one distinguish sculpture from a decorative ornament, a chair, or an architectural model? The painter Max Weber, possibly as early as 1910, carried out some of his compositional ideas in small sculptures, and at least by 1915 was content to drop any obvious figurative association; but his sculptural suggestions were not taken up by professional sculptors. John Storrs (1885–1956) of Chicago was a student of Rodin in Rodin's last years, but during his long sojourn in Paris he became restive with the modeled form and began to work in simple planes and geometric volumes. His works of 1915 are not much more daring than those of Meštrović, but in the 1920s he more strongly emphasized abstract construction and even created a series of small sculptures based on skyscrapers. Although he exhibited in the United States, Storrs worked almost wholly in Paris and had little direct effect on the American sculptural scene. Possibly of more influence were the works of the Russian-born Alexander Archipenko (1887–1964), who settled in the United States in 1923.

Archipenko was one of the first sculptors to approach his medium with a freedom akin to that of the painters. In Paris from 1908, he associated with the painters who were to be called cubists, and he began showing his unorthodox sculptures in Germany in 1910. By the time he reached New York he had experimented widely with

Carl Milles, *Jonah*, 1932. Cranbrook Academy of Art, Bloomfield Hills, Michigan.

John Storrs, *New York*, circa 1925. Indianapolis Museum of Art, Indiana; discretionary fund.

188

color, materials, and compositions of negative and positive space. Devoted to theory, he was an inveterate teacher and taught classes in the United States from coast to coast. But by the late 1920s Archipenko was accepted as representing just one more aspect of the decorative style, and his creations blended easily with the tectonic work of the style-conscious sculptors. At times his inventiveness sparked minor controversies, but since he was never given a major commission he was not considered a public threat. His teaching, however, certainly hastened the acceptance of sculpture as structure, as distinct from sculpture as effigy, especially in the classrooms of the country.

Archipenko was not the only sculptor in the 1920s in whose works the will to stylization blended imperceptibly with more audacious notions of formal construction. Hugo Robus (1885–1964) began as a painter and absorbed the full range of cubist ideas in Paris between 1912 and 1915. Although he had briefly studied sculpture with Bourdelle, he did not devote himself principally to the medium until the 1920s. His elegantly polished works are sometimes humorous, sometimes mysterious and expressive, but always dependent on stylish, perfectly finished design. Elie Nadelman (1882–1946), born in Warsaw, was well launched on his career in Paris before coming to New York in 1914, where his work was shown by Stieglitz and found immediate acceptance in the art community. Some of his smart and lively figures of dancers and portly matrons carved in wood reflect his interest in American folk art, of which he assembled one of the early large collections. For him, stylish form was an expressive language, not simply an end in itself, and was inseparable from the sculptural conception. He did not stylize—that is, impose style on an existing form; his figures grew out of the highly styled forms themselves.

A more complicated figure was Gaston Lachaise (1882–1935). He came to the United States from Paris in 1906, well trained as an artist and a craftsman, and eventually became Paul Manship's studio assistant on Manship's return from Rome. He shared with Manship a pleasure in precision and elegance of line, but he was not inclined to give up his robust sense of physical form for a chaste archaism. Lachaise's constant motif was the

Alexander Archipenko, *Woman Combing Her Hair*, 1915, bronze, 13¾ inches high. Collection, the Museum of Modern Art, New York, New York; acquired through the Lillie P. Bliss Bequest.

Hugo Robus, *Water Carrier*, 1956. National Collection of Fine Arts, Smithsonian Institution, Washington, D.C.; gift of Hugo Robus, Jr., in memory of his father.

Elie Nadelman, *Hostess*, circa 1918–20. Hirshhorn Museum and Sculpture Garden, Smithsonian Institution, Washington, D.C.

female form, and his sense of style never negated the voluptuousness of his inspiration. On the contrary, his fully rounded, fleshly forms seem to be the originators of the stylish rhythms that mark their contours. They are stylistic sublimations, not flesh disciplined by style.

By the 1930s, then, an obvious formal style was widely considered appropriate for sculpture, whether its sources lay in a desire to simplify and stylize natural form or in a belief that structure provided the content of art and that natural reference was secondary. When a commission required it, even sculptors such as Storrs or Nadelman could temper their art to meet decorative requirements, obscuring the line between those who looked upon the consciousness of form as a revolutionary departure and those who, like Manship, saw it as the perpetuation of tradition.

Probably the movement in sculpture that most caught the attention of the larger art community was that developed in rebellion against the long-existing custom of having assistants translate the artists' work into the final material. Esteeming the artistic act, these sculptors wished to make it clear that their sculpture was the product of a direct dialogue between the artist and his material. As in architecture, artists talked of the need "to express the material," by which they meant that they wished to find inspiration for the form in the nature of the material itself. Such works also gave off an air of inevitability, as if the artist had produced exactly these forms and these images out of a natural necessity. The work of art was a cooperative product of man and nature.

This is nowhere more evident than in the works of John B. Flannagan (1895–1942), whose knowing little animals seem to have been hiding in fieldstones and boulders until he revealed them by chipping away the excess. He first exhibited in New York in 1923, and his talents were soon recognized and appreciated by the art community. But Flannagan had a tragic life, and his sensitive production was not large. Nonetheless, the humble dignity of his self-effacing creations made his sculpture the symbol for qualities held dear in the 1920s and 1930s.

The man who, quite possibly, was the first sculptor in the United States to emphasize direct carving had a to-

Gaston Lachaise, *Walking Woman*, 1919. Hirshhorn Museum and Sculpture Garden, Smithsonian Institution, Washington, D.C.

John B. Flannagan, *The Lamb*, 1939. Hirshhorn Museum and Sculpture Garden, Smithsonian Institution, Washington, D.C.

tally different background from Flannagan. Robert Laurent (1890–1970) came from Paris in 1910, already well trained and well traveled. He first showed his sculpture with its fluent, directly carved forms in 1917, and in his long career as a teacher he emphasized direct carving as the basic means of the sculptor. There was nothing humble about Laurent's imagery. From the 1920s his sculpture consisted mainly of elegant variations on the female figure, often cut in fine material, meticulously finished.

The strongest of the early sculptors dedicated to working directly with their material was doubtless William Zorach (1887–1966), who was born in Lithuania and developed as a draftsman and painter in Cleveland, New York, and Paris. An able painter, adept at his own interpretation of cubism, he turned to sculpture as his major interest in 1922. Beginning by carving directly in wood, he quickly moved to cutting stone, which he chose with care to fit his sculptural purposes. From the time of his first one-man sculpture exhibition in 1924, he was recognized as a major artist of the new sculptural concept that was fiercely maintained as a challenge to past academic methods.

Both Laurent and Zorach, as well as José de Creeft (b. 1884), who came from Spain in 1929, were influential teachers and succeeded in conveying to their students not only a technique but a notion of aesthetic morality. Zorach in particular made the act of sculpting in direct association with the material a kind of religious experience. One spoke of the "honest" use of materials, and the direct carving of sculpture became a moral crusade. What it offered, at least in the hands of Flannagan and Zorach, was a down-to-earth antidote to the cerebral and highly refined aesthetic theories that tended to obscure the artistic roots of individual craftsmanship. It is interesting to note that this sculpture flourished at the same time that Laszlo Moholy-Nagy in Europe was proving the wholly intellectual nature of art by transmitting a work through telephoned instructions. Although direct carving had actually begun in Europe, it became identified with an American attitude toward art and as such was praised in opposition to constructivist tendencies when they made their appearance in the 1920s and 1930s.

William Zorach, *The Artist's Daughter,* 1946. National Collection of Fine Arts, Smithsonian Institution, Washington, D.C.; gift of Tessim Zorach.

The Artist and Society

By the end of the 1920s there was a manifest uneasiness in the art community about the future direction of art. The financial failure of 1929 certainly produced its own kind of shock, effectively wiping out what patronage the American artist enjoyed. But the unrest preceded Wall Street's fall. Talk of "pure" art and of conflicting isms had begun to wear thin, and the technological promise of the expanding urban culture seemed less reassuring as a substitute for personal accomplishment. In a way the 1933 fair, A Century of Progress, was more the hollow echo of earlier expectations than a program for the future. Its smart, angular decoration and "futuristic" look mocked rather than expressed the sentiments many artists now shared.

The idea of an art community, with its special values and private heroes, seemed suspect, too limited as a basis for creativity, too self-perpetuating. The glow had faded from the image of the artist as a professional living apart; the rhetoric of the school was no longer sufficient when viewed from the standpoint of the larger society. More and more the artist wished to identify himself with society as a whole, to find his place in a broadly based culture. The problem he faced was how to go about it.

In general, artists turned in one of two directions. In spite of the fact that more than half the population now lived in cities—or possibly because of it—some set out to rediscover rural virtues. They tended to ignore the accusations of small-town bigotry leveled by Sinclair Lewis and others in their efforts to reestablish local histories and memorialize the homely practices that survived beyond the reaches of the dehumanizing cities. They searched for folk heroes, and they discovered new values in folk art. Surviving ballads from Appalachia, spirituals, and foursquare tunes from Protestant hymnals became the musical accompaniment to a search for a well-rooted naive culture.

The other direction had to do with the city itself—its effect on the individual and what might be done about it. Although some artists preferred simply to record their response to city life, others considered it their duty to advocate social change. In either case, the artist was operating in a broader social context than before. His

in such a way that they never cease to be fallible human beings.

In December 1934, *Time* magazine published a sensational article heralding Benton, Wood, and Curry as the masters of a new Midwestern American school of painting that had freed the country from incomprehensible European movements and restored art to its rightful place in American culture. A needless controversy was fanned into violence by the intemperate remarks of Benton and the critic Thomas Craven, pitting "regionalist" painting against all formal tendencies as well as against all painting advocating social change. What began as the artists' serious pursuit of aesthetic roots became a political and nationalistic charade. Serious artists like Curry and Wood were hurt by the propaganda; lesser painters profited from the association.

Reginald Marsh, *Twenty Cent Movie*, 1936. Collection of the Whitney Museum of American Art, New York, New York.

The Masses

By 1930 the image of the city had changed. It was no longer a place of spunky, optimistic tenement-dwellers as depicted earlier by John Sloan, nor was it the inspiring, soaring precision machine celebrated in the renderings of imaginary architecture by Hugh Ferris. Whether New York, Chicago, or Detroit the city was a teeming, bewildered, and often angry mass of humanity speaking many languages, struggling for existence against impersonal odds, and conscious that somehow all sense of order in life had been lost.

Reginald Marsh (1898–1954) found much to admire in this chaotic mass of humankind left to its own resources in a directionless world. He painted the panderers, the burlesque queens, the competitive life of the street taking pleasure in the assertions of vanity and desperate individuality in the sign-littered environment of lower New York. His mounds of perspiring bathers at Coney Island are too filled with themselves to be pathetic. Marsh was not a reformer; he accepted the character of the people he painted without comment, finding in their enthusiastic vulgarity an escape from aesthetic dicta and bloodless refinement. When he painted derelicts on skid row he did not question the turn of society that had sent them there but used them as proof of a fleshly reality. He did not identify himself with those he painted, but viewed the kaleidoscopic variety of people

that poured into the street with the eager eye of an artist looking for fresh material to paint. In this he was the best, but he was not alone. Social reality, as one liked to call it, became an accepted theme in art, providing many artists with a new means of expression without necessarily committing them to a social stance.

Of a very different kind are the sensitive paintings of shopgirls dreaming in the crowd painted by Isabel Bishop (b. 1902). They convey the bewilderment of the individual caught in the mass, and yet they suggest a quiet acceptance of the tedium of city life that makes their lonely figures modestly heroic. The world of the depression was a world turned upside down. To preserve intact an inner quiet in the midst of social chaos was indeed a heroic feat.

For the most part, the city was seen as the center of work, and the seriousness of the working masses became a valued point of contact for many urban artists. Although artists had been fascinated with factories and laborers at the end of the nineteenth century, conditions had changed over the past forty years. They now could see the individual workingman as a heroic representative, the basic element on which the whole of modern technology depended. Whether this is translated into Marxian terms or seen as evidence of the growing power of American labor organizations, it represents a distinct state of mind. Cities and factories could no longer stand as abstract dreams; they were built and maintained by men who no longer were to be ignored. In the purposiveness of the workers' efforts, some artists found a remedy for the seeming arbitrariness of their aesthetic choices. They wished to be identified not with perfectly operating urban machines but with men working. In his search to belong, the artist began to regard himself as a laborer—to think in terms of craft and workmanship and to resort to unions and cooperative organizations. In all of this it was easy to confuse an aesthetic need with a social outlook. In part the artists' problem was indeed a product of economic depression, but it was also the result of an aesthetic crisis; to solve one was not necessarily to solve the other.

Socialist thinkers, of course, would not agree. They saw the crisis in artistic direction as reflecting disillusion in a decaying but still vicious capitalism, and they of-

Isabel Bishop, *At the Noon Hour,* circa 1932. Museum of Fine Arts, Springfield, Massachusetts; the James Philip Gray Collection.

fered the Marxist revolution as a salvation for both society and art. The John Reed Club of New York was founded in 1929, an affiliate of the International Union of Revolutionary Writers and Artists, and in 1933 it sponsored its first exhibition in New York under the title The Social Viewpoint in Art. Almost any artist who showed the worker or the more despairing aspects of city life was admitted, but there was a heated debate over art that simply depicted the state of things in contrast to art that advocated change. To the true socialists, not to emphasize the need for social change was to be reactionary. To be consciously regional, of course, was not only to deny the necessity of change but to ignore the international solidarity of the working class.

Among the strongest artists to emerge from the group of social advocates were William Gropper (1897–1977), Ben Shahn (1898–1969), and Philip Evergood (1901–73), although each pursued his own style. Both Gropper and Shahn used their barbed imagery in graphic works and murals as well as in painting, and all were outspoken in their opinions of how society was run and the deplorable results. Many artists depicted the sad lot of the unemployed, difficulties between labor demonstrators and the police, and the plight of powerful laborers grimly working in mines or on construction projects. The byword was "social significance," and any work that failed to exhibit the necessary concern was considered frivolous and decadent by the socially aware.

All artists, especially those concerned with social problems, were conscious of what was happening in Mexican art. Under the patronage of the Mexican government, artists had been painting murals in public buildings since 1922. Unlike the well-mannered, traditional murals being painted in the United States, the Mexican works were bold in design and color and carried a clearly stated nationalistic and social message. That the public responded unfavorably did not affect the artists' admirers. Diego Rivera, José Clemente Orozco, and David Siqueiros all worked in the United States in the late 1920s and 1930s, and their work was widely discussed. Not least in importance was the fact that the artists had organized a union and worked as laborers; they were not interested in being a group apart.

Mural painting was not the only artistic means the

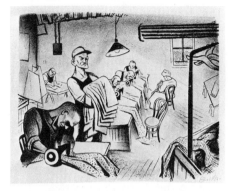

William Gropper, *Sweatshop*, 1934. National Collection of Fine Arts, Smithsonian Institution, Washington, D.C.; museum purchase.

Ben Shahn, *Scott's Run, West Virginia*, 1937. Collection of the Whitney Museum of American Art, New York, New York.

197

Mexicans used to speak directly to the public; they also revived the tradition of popular graphics following in the footsteps of the graphic artist José Guadalupe Posada. The hortatory revolutionary woodcuts and lithographs that emerged from their centrally organized graphic workshop had wide circulation.

American artists, whether in sympathy with the Marxist doctrine or not, were impressed both by the social involvement of the artists and by the mural and graphic techniques. They too wanted to be part of a movement.

The Government as Patron

With the depression, artists found themselves almost totally without support. There was little private patronage, and the teaching positions that had for some years furnished sustenance to artists were sharply curtailed. In 1933, prompted by the painter George Biddle, who much admired what had been accomplished in Mexico, the government launched a limited program, to be underwritten with relief funds, called the Public Works of Art Project (PWAP). Organized by Edward Bruce under the Treasury Department, with New York critic Forbes Watson as technical director, the program was not formulated without difficulty, since it was opposed politically and also by the conservative artist group that had heretofore controlled government commissions. Nonetheless, late in 1933 unemployed artists throughout the country were hired on modest salaries to create murals for public buildings and also to paint smaller works. At the close of the project in the spring of 1934, some 500 works of art were exhibited in Washington to attest the program's quality, and local exhibitions were held elsewhere. Not surprisingly, the major themes in the exhibition were drawn from industry and the working classes; the fact was commented on, not always favorably.

Later in 1934 the Treasury Department announced a program to commission works of art for federal buildings, the commissions to be awarded through competition, not on the basis of financial need. As a result, post offices and other federal buildings across the country began to take on a new atmosphere with mural paintings that showed little relationship to earlier adornment of

public buildings. By the time it ceased operations in 1943, the program had awarded 1,371 commissions for work, in 1,083 cities. Although most of the commissions were for murals, sculpture also was included, a little over 300 works being commissioned. The Treasury Department also had a relief program (TRAP) that commissioned paintings, posters, and many other works of art until its demise in 1938.

When the huge Works Progress Administration (WPA) relief project was launched in 1935, a Federal Art Project (FAP) was organized for artists on relief, headed by the knowledgeable and able Holger Cahill. Under this program, artists carried on work in painting, sculpture, graphics, and design, worked with schools, staffed community art centers, and contributed in every way possible to make art a live element in the community. One project of particular importance was the Index of American Design, which set out to record, in meticulous watercolors, selected objects of folk art. Cahill had been instrumental in organizing the first museum exhibitions of American folk art in 1930 and 1931, and now specially trained artists of the FAP could make a permanent record of this once-neglected material.

By 1938 political sniping at the relief projects came to a head, and the House Un-American Activities Committee under Martin Dies conducted a much-publicized investigation of the art projects to determine to what extent they were un-American (that is, socialist or communist) in their leanings. Again the question of what was American as opposed to European in art became confused with patriotism or with political ideologies. In 1939 the FAP was drastically weakened, and by 1943 the entire program had been phased out.

The impact of the Treasury Department programs and the Federal Art Project was felt by both artist and public. More art reached more people than ever before, and the artists became known in their communities. Large numbers of artists could for the first time consider themselves active members of society, as much a part of the system as the laborer or the engineer. Furthermore, the control of patronage by a few established organizations had been eroded and was not to be reestablished. The entire image of official art in America had changed.

Fearing that the Treasury Department program

would not be continued, its supporters succeeded in
getting the Senate to pass a bill in 1938 making way for a
Smithsonian Gallery of Art in Washington that would
not only show the Smithsonian's collection of largely
American art but support contemporary American ar-
tists, circulate exhibitions, and promote art education in
the schools. A spot was allotted on the Mall, across from
the site where Andrew Mellon's national gallery was
being constructed—a museum that was to show only
works of artists no longer living—and money was
appropriated for an architectural competition. The
competition was won by Eliel and Eero Saarinen's hand-
some and functional design that was promptly con-
demned for its modernity by the Fine Arts Commission.
The matter, however, never came to a showdown be-
cause further money was never allotted, and it was clear
that systematic government support of the arts was
drawing to a close. The Mellon National Gallery of Art
opened in 1941 in its beaux-arts building, and although
artists were pleased with its rich collection of old mas-
ters, they openly expressed their disappointment that
the government no longer was interested in supporting
their efforts.

Persistence of Art

There was no official ban on nonfigurative art under
the various federal projects, but certainly the situation
was not such as to encourage such works. The public was
not prepared to accept nonfigurative art in public
places and, more often than not, it was considered
foreign and thus possibly subversive. But many artists
had already turned away from the formal explorations
of the preceding decades in their search for new artistic
roots before government patronage intervened.
Nonetheless, the exposure to new ideas in art continued
unabated through the 1930s, and a relatively small
group of artists persisted in their own formal directions.

One of the most influential factors in the continuous
exposure to the untraditional aspects of contemporary
art was the Museum of Modern Art in New York,
founded in 1929. Through its exhibitions and publica-
tions, and eventually through its extraordinary perma-
nent collection, it molded the concepts of the modern
tradition into a convincing historical design. While

others were worrying about regional concepts as opposed to social significance, the Museum of Modern Art mounted authoritative exhibitions such as Cubism and Abstract Art as well as presentations of surrealism and works of the German expressionists. Under the guidance of Alfred Barr, the museum showed no particular interest in the local scene or in social advocacy; it persisted in its concern for art and ideas as existing outside national or political boundaries. The closest the museum came to local interests was its support of folk art and works by untrained artists. From the beginning also it accepted industrial design, architecture, photography, and film as part of its artistic province. By the time its new building opened in New York in 1939 the Museum of Modern Art was known throughout the country for its promotion of the modern arts and had already established a basic visual repertoire for what was called in its 1939 exhibition, Art of Our Time.

Museums around the country were also active in keeping varied ideas about art alive. In 1938 a large Van Gogh exhibition took the country by storm; an exhibition of contemporary Italian painting was circulated under sponsorship of the Italian government; the expressionist painters persecuted by Hitler in Germany were much talked of, and their works were collected and shown. Contemporary European works were likely to appear on museum walls anwhere, and with the outbreak of the war in Europe in 1939 many European artists were welcomed to America.

Although the activity of the Museum of Modern Art had great influence in the way American artists formulated their ideas, many of them were unhappy that the museum felt no particular obligation to show works by Americans. The museum was frank in stating that it was concerned with quality, and in most cases it found American abstract artists derivative and less successful than their European counterparts. This was especially galling to the artists concerned with abstract painting, who in 1936 organized their own group in New York, the American Abstract Artists, which included, among others, George L. K. Morris, Josef Albers, Ilya Bolotowsky, and Ibram Lassaw. In Chicago in 1937 the Chicago Bauhaus was organized with Moholy-Nagy at its head and, although it was ostensibly devoted to design,

through its various transformations it served also as a center for abstract painting and sculpture. In almost every area of the country some artists remained loyal to their ideals of pictorial abstraction, even though they might submit more traditional designs for official commissions.

One artist of considerable note who made no concessions to the taste for figurative art, even in work for the Federal Art Project, was Stuart Davis (1894–1964). He early moved from rather gloomy paintings of workmen and pathetic subjects to a personal kind of painting with bright, lively forms drawn from advertising and the commercial aspects of the city. There is a jaunty humor in much of his work that separates it from the work of more theoretical abstractionists. Although he was not drawn to social realism, he was very active in artists' movements in the 1930s and was secretary of the American Artists Congress, a group formed in 1936 in New York to fight for continued government support of the arts.

Possibly of more subsequent importance than abstraction as such was the growing interest during the 1930s in ideas associated with the surrealists. The appeal of an art that led away from the recording of mundane actions or the simple dynamic interplay of colored shapes was not to be denied. There were artists who were fascinated with the still, empty space that had been created by Giorgio de Chirico and the *Scuola Metafisica*—qualities critics saw repeated in such Hopper paintings as *Nighthawks*—and others who picked up images from André Masson, Joan Miró, and Picasso's recent works.

Joseph Cornell (1903–1972) was particularly fascinated by the collages of Max Ernst and early became an associate of the Julian Levy Gallery, a center for the Paris surrealists. When the Museum of Modern Art produced its important exhibition, Fantastic Art, Dada and Surrealism in December 1936, one of Cornell's works with its enigmatic collection of objects was included.

Interest in the deeper reaches of the psyche was not necessarily associated with surrealism. In the 1930s there was not only an extraordinary expansion of interest in psychology—the term "Freudian" became a commonplace—but also new interest in non-Western

Stuart Davis, *Abstract Landscape,* circa 1936. National Collection of Fine Arts, Smithsonian Institution, Washington, D.C.; transfer from General Services Administration.

Joseph Cornell, *Soap Bubble Set,* 1936. Courtesy of the Wadsworth Atheneum, Hartford, Connecticut; Henry and Walter Keney Fund.

religions. India in particular provided the basis for mystic sects. The Near Eastern Bahai organization caught the imagination of many, and Ch'an or Zen Buddhism texts were included in some university programs of general study. Mark Tobey (1890–1976) came in contact with Eastern thought in the Northwest. He moved to Seattle, Washington, in the early 1920s, then spent time in Paris, England, and the Far East, where he studied calligraphy and Zen. By the time he again settled in Seattle in the late 1930s, he had developed a personal calligraphic style of painting that suggested the light and movement of his environment yet hinted at unseen inner rhythms. There was nothing "surreal" in the orthodox sense in his paintings; yet they clearly moved from the perceptual into an inner world. Also drawn into an Eastern suggestiveness, each in his distinctive way, were Kenneth Callahan (b. 1905) and Morris Graves (b. 1910), both working in the Northwest.

For all the cant about regionalism and the fear of European radical influences, the 1930s was a decade in which many ideas about art had a chance to develop quietly—ideas that would flourish in the decades to come.

Mark Tobey, *White Night*, 1942. Seattle Art Museum, Washington; gift of Mrs. Berthe Poncy Jacobson.

Morris Graves, *Folded Wings—Memory—& the Moon Weeping*, circa 1942–43. National Collection of Fine Arts, Smithsonian Institution, Washington, D.C.; gift of Michael and Caryl Marsh.

Jackson Pollock, *No. 1, 1950 (Lavender Mist)*.
National Gallery of Art, Washington, D.C.;
Ailsa Mellon Bruce Fund.

Since 1945

A Center for Art

Intimations of Meaning

As government patronage drew to a close, American art was more diverse and more in evidence than at any time before. The 1939 fairs in New York and San Francisco provided an opulent ending to a turbulent but fertile decade in which the whole gamut of contemporary art, from folk interests and the local scene to flatly painted abstractions and surreal imagery, jostled together in the consciousness of both public and artists. By the end of the period there was much less temptation to take sides with one artistic faction or another. Although the public still harbored many doubts, art was accepted as diverse and often not a little puzzling.

Few major figurative painters persisted in simply recording a scene. An extra quality of suggestion was required. Peter Blume (b. 1906), who had initially developed a sharp, clear method of representing rural scenes, used his deadly clear vision in strange symbolic evocations, two of which were shown at the Museum of Modern Art's surrealist show in 1936. The uncompromisingly sharp eye of Louis Guglielmi (1906–56) made the corner of a street seem a lonely, haunted place. Ivan Le Lorraine Albright (b. 1897) had long since made it clear that meticulously painted objects might carry their own sense of mortality. His moldering door, painted in 1941, bore the title *That Which I Should Have Done I Did Not Do.* The colorfully brushed paintings of Franklin Watkins (1894–1972) of Philadelphia always seemed on the edge of fantasy, and in his large panels on the Resurrection or his *Birth of Spring*, the visionary expression became overt. Representation no longer meant simply looking.

Ivan Le Lorraine Albright, *That Which I Should Have Done I Did Not Do,* 1931–41. Courtesy of the Art Institute of Chicago, Illinois.

In 1943 the Museum of Modern Art mounted a large exhibition entitled American Realists and Magic Realists. The latter was an infelicitous term, but it did suggest an awareness that content was not divisible by styles. The exhibition was not a tribute to skills at representation but a signal that a cool, steady look at actuality might produce a magic of its own.

The public was less fascinated by the magic than by the meticulous depiction. The artist hero for museum-goers through the 1950s and 1960s was Andrew Wyeth (b. 1917), whose numbingly pathetic *Christina's World* was painted in 1948. He and his many imitators carried on the myth of rural America and the pleasure of the technically hard-to-do without swerving. Yet in the context of the time even these paintings took on an aura of special content, radiating an isolation unknown in the equally detailed paintings of the brethren of the Society for the Advancement of Truth in Art a century before. Art was looked at in terms of expectancies.

The work of Ben Shahn, shown in a one-man exhibition at the Museum of Modern Art in 1947, retained its bite of social protest but also carried an added suggestion of man's fate, as did the powerful graphics and sculpture of Leonard Baskin (b. 1922). The increasingly cryptic compositions of Jack Levine (b. 1915) suggested that one could share a certain element of human sympathy even with his bloated capitalists and gangsters.

In the years immediately after the war there was talk of a new romanticism in works of such painters as young Walter Stuemfig (b. 1914). Eugene Berman and his brother who painted under the name Leonid were among the European painters who settled in the United States in the 1930s, as was Pavel Tchelitchew (1898–1957), and their sophisticated nostalgia had a wide appeal. Both Berman and Tchelitchew designed for ballet, an art form that had increasing attraction for Americans in the 1930s and 1940s and that brought the designs of many artists—Picasso, Derain, Miró, Masson, and others—to the attention of a wide public. Nostalgia was just one more way of seeking a content beyond the ordinary.

The Search for an Expanded Content

The major movement in art of the 1940s and particularly in the years following the war was not, however, to

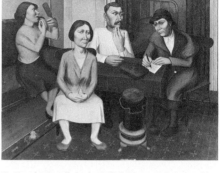

O. Louis Guglielmi, *Relief Blues,* 1939–40. National Collection of Fine Arts, Smithsonian Institution, Washington, D.C.; transfer from the Museum of Modern Art.

Andrew Wyeth, *Christina's World,* 1948, tempera on gesso panel, 32¼ x 47¾ in. Collection, the Museum of Modern Art, New York, New York; purchase.

be found among the various uses of representation. Adolph Gottlieb (1903–74) remembered discussing the content of art with Mark Rothko (1903–70) in 1941, and they decided that what art lacked was a sense of myth. Art must partake of the old before it could contribute to the new. They and many of their fellow artists were fascinated with prehistory and remote classical art in which the forms hinted at a significance confirmed by ancient or lost traditions. According to the psychology of Jung, a person could find within himself resonances of meaning shared by the human race through all time. So they created paintings suggesting pictographs of an unknown origin that transformed otherwise formal compositions into provocative engimas. Theodoros Stamos (b. 1922), William Baziotes (1912–63), and others created forms that some would call abstract but that suggested ancient meanings lying just beyond the viewer's grasp.

The one thing all avoided was a smartness of style. The image had to seem self-generated. Automatism—drawing without rational control—much discussed by the surrealists in Paris in the 1920s, was explored as a way to arrive at forms that were evocative but not rationally explainable. The greatest fascination was with the intent of surrealism. Pablo Picasso's work, especially from the period of the *Guernica* (a forty-year retrospective exhibition of Picasso's work, including the *Guernica*, was shown at the Museum of Modern Art in 1939), the paintings of Miró, the sculpture and drawings of Hans Arp, the late paintings of Wassily Kandinsky, were convincing proof that forms could carry human meaning in a profound and curiously timeless way without identifying themselves with known things.

That the artists should have rediscovered surrealism at this point is not surprising. Many members of the French surrealist group fled France during the war to live in New York. In 1942 the group held an exhibition in New York, and between 1942 and 1944 the surrealist review *VVV* was edited by the American David Hare, who at that time began his sculpture using forms associated with the surrealists. Peggy Guggenheim opened her influential gallery, Art of This Century, in 1942 and showed surrealist works in a special environment designed by Frederick Kiesler.

Many times, the forms that appealed to the artists were convincingly organic, yet were not specifically beings or parts of beings. Willem de Kooning's (b. 1904) stretching and embracing forms, the Picassolike drawings of Jackson Pollock (1912–56), the paintings and early sculptures of David Smith (1906–65), and the work of many others expressed life in an intensive, primitive state. One of the most significant artists to make this kind of imagery his own was Arshile Gorky (1904–48) whose energetic reaching and entangling forms took on a highly personal character, acting out a moving but enigmatic drama. Gorky's impact on the others was in some ways decisive, so powerful and evocative were his works, which could not readily be classified by critical definition.

From this concern for works of art that created a mythic dimension for a material age two major directions developed, both devoted to creating images that involved the participation of the artist—and by extension the viewer—in a rite of passage to an expanded world of feeling. One depended upon act, the other on contemplation.

Jackson Pollock had worked with Thomas Hart Benton, produced social-conscience works on the Federal Art Project, and admired the Mexican muralists. He was moved by Picasso's *Guernica* and experimented with archaic symbols. But what he responded to in all of these works was an insistent, earthy rhythm that moved with one intensely human pulse or urgency. His mural painted for Peggy Guggenhiem in 1943 had only a trace of tribal imagery; its power lay in its irresistible, somewhat convulsive motion. The artist's forceful gesture led the viewer in a relentless dance. Insofar as it was clearly the artist's hand that made the gesture, the expression remained personal, even though the spectator was invited to share. But by 1947 Pollock freed his lines from the association with his own motion by dripping and spattering paint to create involving complexes and multilevel patterns of action that existed independently. In this way the painting became, for both spectator and artist, a detached object that invited endless participation and discovery. It all seemed a product of chance and thus could open up a range of speculation not limited by identifying the expression with a single per-

Arshile Gorky, *The Betrothal, II,* 1947. Collection of Whitney Museum of American Art, New York, New York.

Jackson Pollock, *Portrait of H. M.,* 1945. The University of Iowa Museum of Art, Iowa City; gift of Peggy Guggenheim.

son. If one attempts to follow a single line of motion in one of Pollock's paintings, he is quickly absorbed into the complexity and must eventually be content to follow many paths at the same time. As a result, it is not the identification with a single line of action that counts, but the acceptance of an infinite variety of simultaneous rhythmic motions. It is a paradoxical situation in which one participates in motion yet loses his limiting sense of personal action. Both time and distance, in the usual sense of measurement, cease to be of consequence.

Willem de Kooning was no less concerned with the vital movement of lines and forms that insist on being followed and identified with, yet leave off suddenly to lose themselves in an ambiguous space. To those who had fixed notions about abstraction and the inevitable course of modern art, it came as a surprise when in 1950 he produced a series of paintings in which rather barbed images of women erupted from his active surfaces. But de Kooning's paintings were the product of a total environment that might include remembered images as well as present action; no area of the mind was closed when the painter began work on his canvas. As a result, his paintings demand that the viewer participate with his full mind. Action and association are inseparable; yet the ultimate effect does not bog down in either.

At first glance the paintings of Franz Kline (1912–62) may seem like impersonal structures, but the brutish black bars carry an expression of power that transforms the promised tectonic composition into an intensely personal activity. Blending power and tentativeness, the strokes seem in the process of clarifying themselves. They rest in a precarious moment at which, as if by fate, the forceful strokes and masses reveal a magical, momentary relationship to each other. It is a moment affording a personal transcendence.

But engaging in a releasing action was not the only way the painters moved toward transcendence—or the sublime, as they referred to it in 1948. Clyfford Still (b. 1904), Mark Rothko, and Barnett Newman (1905–70) provided images of intensive but quiet contemplation. All three, in their very different ways, were creating their large, often mysteriously simple canvases by the late 1940s. In his rough forms and earthy colors, Still evoked an often somber, moody atmosphere that was

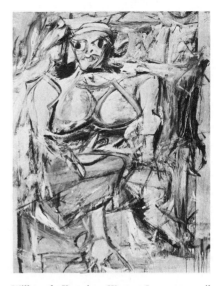

Willem de Kooning, *Woman, I,* 1950–52, oil on canvas, 75 ⅞ x 58 in. Collection, the Museum of Modern Art, New York, New York.

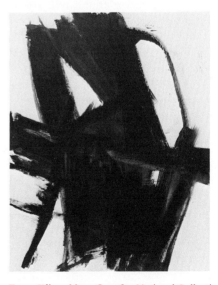

Franz Kline, *Merce C,* 1961. National Collection of Fine Arts, Smithsonian Institution, Washington, D.C.; gift of S. C. Johnson & Son, Inc.

linked to nature yet free of the limitations posed by recognizable objects. They invited search, as if one were groping for illumination in a dark space. Rothko's paintings, on the other hand, seemed to be composed of positive yet insubstantial forms of colored light hovering in a dimensionless space. In Newman's work the plane of the painting as a beginning of the experience was emphasized even more by absolutely simple surfaces cut by startling, precisely placed luminous bands.

None of these paintings began with the analysis of an object or a setting, nor were there formal structures to diagram or systems to help with interpretation. The paintings developed in the act of painting, without a prior scheme, and even though a painter might paint and scrape and make many small studies, each work grew as a unique interaction of art and feeling. Style, in the sense of cubism or other identifiable movements, played no part in the process. In fact, the artist tried to avoid anything that could be singled out as a preordained element.

Critics had to scurry to find words to discuss such paintings. Harold Rosenberg suggested "action painting" to emphasize that their content evolved as the painter worked at his canvas, an arena for action. Clement Greenberg preferred "abstract expressionism," since it described the appearance of the paintings in terms aleady assigned meaning in art history. Neither term is descriptive of the intense concern for content, not method, that characterized the painters' procedures.

Whatever term was adopted, painters throughout the country recognized the importance of the step the New York painters had taken and began in their own way to do their visual thinking on large canvases. Nor was the impact limited to the United States. In 1950 in Venice, Gorky, Pollock, and de Kooning, among others, were shown at the Biennale, and a large exhibition of Pollock's works was shown at the Museo Correr. Many of the works went on to exhibitions in Amsterdam, Brussels, and Zurich. In 1952 the exhibition American Vanguard Art for Paris was shown in Paris. By 1958, when the Museum of Modern Art circulated a large exhibition, The New American Painting, to eight European countries, works by the New York artists were known and imitated throughout the world.

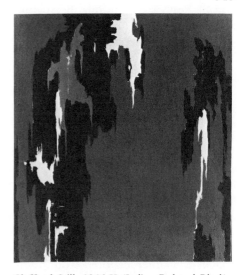

Clyfford Still, *1946-H (Indian Red and Black)*, 1946. Courtesy of the National Collection of Fine Arts, Smithsonian Institution, Washington, D.C.; lent from the Vincent Melzac Collection.

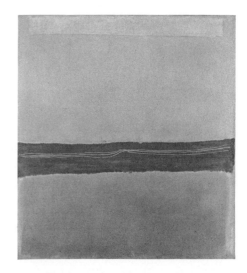

Mark Rothko, *Number 22*, 1949, oil on canvas, 117 x 107⅛ in. Collection, the Museum of Modern Art, New York, New York; gift of the artist.

It is foolish to debate who was and who was not a part of the movement, since it had no stylistic boundaries. Although the New York artists got together to talk about art, they discussed goals and content, not style. Their experiences in the 1930s and their contact with European artists who had spent the war years in New York gave them confidence to speak as artists who need look nowhere other than to themselves for artistic guidance.

Some painters whose work was understandable in terms of the New York school had little or no contact with the group. Mark Tobey, for example, who had again settled in Seattle in 1939, developed his own abstract but suggestive and mystical painting. Although the New York painters discussed oriental calligraphy and Zen in the late 1940s, Tobey had studied Zen and calligraphy several years earlier. There was ferment in art throughout the country.

One pillar for the young in developing ideas sympathetic to the new painting was Hans Hofmann (1880–1966), who came to the United States from Germany in 1930 and settled first in California. His schools in New York (1933) and Provincetown (1934) drew young artists from all over the country and later, when he began to exhibit his own works, he was hailed as a distinctive member of the new school.

Sculptors were no less active than the painters. Freed from the necessity of improvising on the human figure by constructivist experiments of the 1920s and 1930s, they too built their works directly in their material, following an interior impulse rather than an existing model. Ibram Lassaw (b. 1913) had created abstract spatial pieces even while on the Federal Arts Project. By 1950 he was welding knobby spatial labyrinths that seemed to belong to a strange, forgotten world. Theodore J. Roszak (b. 1907) started as a painter but in the 1930s began to make precise and elegant constructivist sculptures. In the mid-1940s he shifted to brutal animallike forms that seem to draw their violent life from an ancient past. It was also in 1945 that Seymour Lipton (b. 1903) began his aggressive totemlike figures wrought directly in metal sheets.

Of greatest importance among the sculptors was David Smith, who began to make welded sculptures in the 1930s using forms that, as in his paintings, related to

Barnett Newman, *Covenant,* 1949. Hirshhorn Museum and Sculpture Garden, Smithsonian Institution, Washington, D.C.

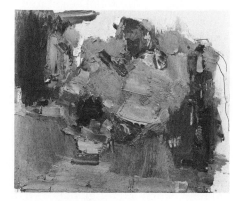

Hans Hofmann, *Fermented Soil,* 1965. National Collection of Fine Arts, Smithsonian Institution, Washington, D.C.; gift of S. C. Johnson & Son, Inc.

some of the works of Picasso and the surrealists. Deeply aware of the potentially totemic quality of sculpture, in the 1940s he developed a formal language that was both personal and hauntingly universal. His twisted metal shapes are like mystical writing suspended in space, to which one automatically ascribes meaning. By 1950 he was working on his "totems," gaunt figures in welded steel that hover between the human form and the totemic symbol. Although Smith's later work might seem more abstract, it never lost its effect of guardian presence.

Some sculptors, instead of creating enigmatic presences, were concerned with creating a sensitized environment. Such were the sculptures of Louise Bourgois (b. 1911), shown in 1949, which in their grouping dominate the character of the space. In the early 1950s Louise Nevelson (b. 1900) began to produce her strange boxlike structures that also had to be considered in terms of how they affected their surroundings. The word "environment" referring to an artistic creation began to make its appearance and would go through many mutations in meaning over the coming years.

With the growing success of an original American art, the market increased apace. Most of the artists owed their public introduction to sympathetic dealers, and it was to the dealers that one looked for new developments in art. The number of private collectors interested in purchasing contemporary works expanded enormously, and most depended for guidance on dealers rather than on museum activity. As the market quickened, rapid decisions were of significant economic importance. One of the strengths of the market was that art was undergoing rapid change, more rapid than ever before in America, and a new product was always available. The necessity of continuous newness was so built into the system that the market and extraordinary quantities of related critical writing threatened to become the major impulse for creative activity.

A Finite Model

Although the bold explorative painting that usually was lumped under the term abstract expressionism stimulated a new creative excitement among artists, it was not long before a reaction set in. The open-ended

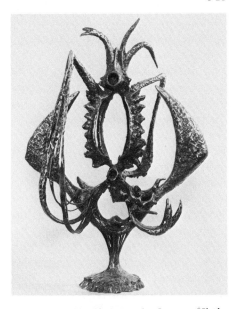

Theodore J. Roszak, *Invocation I,* 1947. Hirshhorn Museum and Sculpture Garden, Smithsonian Institution, Washington, D.C.

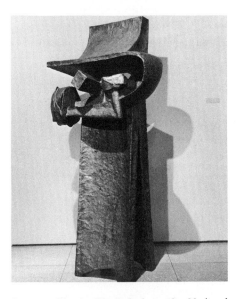

Seymour Lipton, *The Defender,* 1962. National Collection of Fine Arts, Smithsonian Institution, Washington, D.C.; museum purchase.

212

experience with its purposive lack of definition did not provide satisfaction for those looking for a bulwark against a threatened intellectual and emotional chaos. Such artists agreed in the objectivity of the painting—that it was first of all a material object—but wished the work to be a focus of attention, not an invitation to free association and sensuous speculation. In his "Twelve Rules for a New Academy," first published in *Art News* in 1957, Ad Reinhardt (1913–67) insisted that there be "no accidents or automatism . . . everything, where to begin and where to end, should be worked out in the mind before hand." Above all, he added, there should be "no symbols, images or signs." By then he was painting rigidly geometric works in a single color.

There was a long precedent for this point of view, ranging from the belief in a disciplined relationship between head and hand in 1800 to the efforts of the Russians Malevitch and Tatlin in Paris in 1914–16 and the pronouncements published in *De Stijl*. Closer at hand were the chastely geometric color organizations of Josef Albers (1888–1976), who had come to the United States in the 1930s and became an influential teacher at Yale and in the program at Black Mountain College in North Carolina, which for some years was an important center for all the arts. Then too, Mondrian himself lived and occasionally exhibited in New York from 1940 until his death in 1944, and the Solomon R. Guggenheim Collection of Non-Objective Paintings, shown under the tutelage of Hilla Rebay, emphasized precise, geometric work.

But the various directions undertaken by artists in pursuit of an engrossing, finite image did not necessarily follow any one precedent. Ellsworth Kelly (b. 1923), who was working mostly in Paris, created a series of rectangular panels in 1952, each of which was painted a single flat color. Leon Polk Smith (b. 1906), who began with Mondrianlike constructions, in 1954 began a series of round paintings with the surface divided in zones by a tautly drawn curving edge. A few years later he began to create canvases of different shapes, further breaking with the conventional notion of a picture. These were not paintings of geometric forms in space but were themselves accountable geometric objects. Such works were meticulously executed so as to reveal no touch of the hand or suggestion of improvisation. They were as

David Smith, *Agricola I*, 1951–52. Hirshhorn Museum and Sculpture Garden, Smithsonian Institution, Washington, D.C.

Josef Albers, *Homage to the Square—Insert*, 1959. National Collection of Fine Arts, Smithsonian Institution, Washington, D.C.; gift of S. C. Johnson & Son, Inc.

detached as abstract expressionist paintings were engaging.

By the late 1950s this "hard edge" kind of art was a much-discussed mode. It was materially advanced by the critic Clement Greenberg, who set forth a critical system as defining and rational as the art itself. Using a historical formula of progress, he made the tendency seem inevitable and necessary. His vocabulary, following the tradition of Wölfflin, was devoted wholly to formal values, and he assumed as a premise for modern painting that the surface of the picture plane must remain inviolate. Such positive dicta proved reassuring to many painters who had grown uneasy with an expressive art.

The somewhat mysterious "targets" of Jasper Johns (b. 1930), begun in 1955, Kenneth Noland's (b. 1924) paintings of concentric circles beginning in late 1958, and the black paintings by Frank Stella (b. 1936) all concentrated attention in almost hypnotic fashion on the isolated forms themselves. Johns later developed a quite different kind of painting, remarkably sensitive of surface, but Noland and Stella continued to develop within the idiom. Paintings began to be discussed as series, either chronological or thematic, and each painting's place in the series formed a part of its content for the critical mind. Some series, such as those devised by Larry Poons (b. 1937) in the early 1960s, were explications of a perceivable system, and a recognition of the system itself was part of the enjoyment.

In 1964 the term "op art" became current in the popular press, and though it helped to sell paintings it distorted what many artists were doing by calling attention to a superficial means. There was nothing new in the realization that certain forms and colors in juxtaposition produce the effect of action and sometimes evoke an additional unrepresented form. Artists such as Richard Anuszkiewicz (b. 1930) made use of this in almost mesmerizing, luminous paintings. But the aim was not to irritate the eye but to hold the attention within a self-contained, perfectly articulated space in an enjoyable act of play. That the paintings were rationally planned and visually inexplicable provided an added element of fascination.

By no means were all works that shared this general artistic goal made up of clean-cut, sharply defined

Kenneth Noland, *Split,* 1959. Courtesy of the National Collection of Fine Arts, Smithsonian Institution, Washington, D.C.; lent from the Vincent Melzac Collection.

Richard Anuszkiewicz, *Center Mores Primary,* 1964. National Collection of Fine Arts, Smithsonian Institution, Washington, D.C.; gift of Frank B. Hand, Jr.

forms. In the 1960s some artists began to work on un-sized canvas so that the color stained the fabric, uniting with the material rather than remaining on the surface. This dictated a certain degree of improvisation, but as in many of the works of Helen Frankenthaler (b. 1928) the color washes themselves tend to remain as poised, transparent shapes. In a way the ineffable becomes permanent without losing its reference to transience. This is also true in the stained canvases of Morris Louis (1912–62), in which veils of subtle, transparent color harness what otherwise might be considered the fleeting quality of light in stable and undisturbed patterns that remain a part of the pristine texture of the raw canvas.

As for sculpture, in California Robert Irwin (b. 1923), who had begun under the influence of abstract expressionism, commenced in 1959 to paint very simplified canvases and eventually moved to aluminum or Plexiglas disks braced out from the wall so that under careful lighting they lost all effect of material substance. Donald Judd (1928) by 1963 was exhibiting simple, systematically spaced rectilinear sculptural forms. Many sculptors—Robert Morris, Robert Grosvenor, Anne Truitt, Ronald Bladen, and Tony Smith, among others—concentrated on irreducible forms in polished, commercially produced materials that fascinated the mind with their literal wholeness. The term that became popular in the 1960s for such works was "minimal," suggesting that reducing form and materials to a state of complete comprehension creates an object of contemplation that frees the mind from associational distractions and histrionic involvement. Another term used in the mid-1960s was "primary structures"; but of course "primary" as applied to this art is the end product of a highly sophisticated process in which content is dependent on an extensive intellectual awareness. More and more emphasis was placed on the concept, the intellectual preparation, as compared with the unique sensuous experience. Many of the artists were well prepared in philosophy and fascinated by recent studies in perception. The final work of art for them was the solution to a problem well rooted in the rational mind.

In 1964 a collection of works that served as subtle but finite objects of contemplation was celebrated in an exhibition at the Los Angeles Museum under Clement

Morris Louis, *Aurora,* 1958. Courtesy of the National Collection of Fine Arts, Smithsonian Institution, Washington, D.C.; lent from the Vincent Melzac Collection.

Donald Judd, *Untitled,* 1968. Collection of the Foundation for Contemporary Performance Arts, New York, New York.

Greenberg's title, Post-Painterly Abstraction, suggesting that history, in its cyclical fashion, had moved into a new phase. History, however, is less clean-cut than "hard edge" or "color field" painting. Painterly nonfigurative works continued as artists pursued their individual goals, and many other directions, figurative as well as abstract, were also current.

The Unsettling Image

At the same time that artists were developing their ideas of a disciplined art of pure form, others were concerned with creating an artistic experience quite outside the normal boundaries of conventional art and picture-making. They were content with neither expressive sublimation nor the reality of defined forms. While Ad Reinhardt was developing his "rules for a new academy," Robert Rauschenberg (b. 1925) was incorporating everything within reach into his provocative conglomerate works. In 1955 he showed *Bed*, which was indeed the quilt, pillow, and sheet of his bed, enhanced with broadly brushed and dripped paint, displayed on the wall as if it were a conventional painting. In 1959 he showed a shaggy stuffed goat with a tire around its middle, standing in the center of a large collage. Obviously, anything that might strike his fancy was potential material for Rauschenberg's "combines"—stuffed birds, photographs, reproductions of works of art, newspaper clippings. Once incorporated, the objects became part of a sure but seemingly spontaneous design, yet they retained their identity and their associations. Rauschenberg's art recognized no boundaries.

Jasper Johns, working from an entirely different sensibility, used easily recognizable things—the American flag, letters, and numbers—to create series of subtly varied, unique artistic images. In 1958 he presented an obviously handwrought metal light bulb and in 1960 showed two faithfully painted Ballantine Ale cans cast in bronze. These were not objects in the tradition of Dada, but objects transformed by the hand of the artist. Yet they remained objects, creating a deliberate confusion between the world of art and the world of everyday things. It was, in a way, a mutual invasion. In the same years Allen Kaprow (b. 1927) and later Claes Oldenburg (b. 1929) began staging "happenings"—partially

Robert Rauschenberg, *Monogram*, 1955–59. Moderna Museet, Stockholm.

Jasper Johns, *Light Bulb, II*, 1958. Collection of the artist.

Claes Oldenburg, *Three-Way Plug, Scale A (Soft), Prototype in Blue*, 1971. Des Moines Art Center, Iowa; Coffin Fine Arts Trust Fund, 1972.

216

planned, partially spontaneous activities in which the viewers also were participants. Any pretense of artistic remoteness was impossible, and the force of artistic creativity was patently evident. Among the arresting creations at this time were the soft sculptures by Oldenburg in which familiar mass-produced objects were reproduced on a huge scale in appealing, ineffectually stuffed forms. In 1960 Oldenburg exhibited a complete store stocked with artificial products. Andy Warhol (b. 1928) exhibited a carefully reproduced stack of Brillo boxes in 1964. Quite evidently, art was not in the object but in the encounter.

Less benign images impinging on the assessment of man's life and environement were being produced elsewhere. California painter Rico Lebrun (1900–1964) transformed his earlier images of beggars into tortured expressions of the human state. Artists in Chicago had never been so carried away by purely formal values as those in New York and Washington, and in the 1950s painters such as Leon Golub (b. 1922) were concentrating on tormented imges that called attention to a state of inner anguish or hopeless heroism. They were not alone, and in 1959 the Museum of Modern Art noted this in an exhibition called New Images of Man. The new image was rarely reassuring. In both graphics and sculpture Leonard Baskin (b. 1922) created blunted figures often on the edge of hysteria. In California, Edward Kienholz (b. 1927) created strange maimed figures, half-human and half-machine, and in 1961 he began to make tableaux of a sinister, sometimes perversely erotic sort. In the mid-1960s a younger group of artists in Chicago, painters such as Jim Nutt, Karl Wirsum, and June Leaf, drew upon comic books and other popular sources to create a rowdy, often erotic and disturbing, but undeniably vital picture of man and his inner life.

The white plaster figures cast directly from life by George Segal (b. 1924), which he began in 1960, present a different view of modern man. Like the other works bridging the worlds of art and the common environment—by 1961 he was using actual objects with his figures, including a complete tub and shower for *Woman Shaving Her Leg* (1963)—they create a thoughtful distance that allows one to feel that he is inside and

Rico Lebrun, *The Magdalene*, 1950. Collection of the Santa Barbara Museum of Art, California; gift of Wright Ludington.

Leonard Baskin, *Icarus*, 1967. National Collection of Fine Arts, Smithsonian Institution, Washington, D.C.; museum purchase.

outside the situation at the same time, sensing in the process the poignancy of an individual's isolation even in the midst of daily routine.

Something of this reflective mood is also evident in the works by some San Francisco painters of the later 1950s and early 1960s. Even Richard Diebenkorn (b. 1922), who had been painting bold abstract canvases, was moved to explore for a time quiet landscapes and figures in empty rooms. Nathan Oliveira (b. 1928) extracted lonely figures from masses of thick paint, David Park (1911–60) created planar figures that seem dazzled by the sun, and Wayne Thiebaud's (b. 1920) thickly painted still lifes seem to live a lonely existence under the uncompromising bleakness of flourescent lights.

The concern for provocative imagery gave a new stimulus to printmaking, which had made continuous progress since its expansion under the federal art projects in the 1930s. Innovating techniques in engraving and etchings popularized by the Englishman Stanley William Hayter and the introduction of silkscreen printing, added to the already developed lithography, vastly enlarged the concept of what prints could achieve. The creation of specialized workshops to give artists access to master craftsmen made possible larger and more complex prints of high technical quality and introduced to the medium many artists who might not otherwise have thought in terms of prints. Through the decade of the 1950s, the graphic arts became an increasingly important medium of expression, and the market for prints increased accordingly. Robert Rauschenberg's prints, making use of various photomechanical processes, had a forceful influence, as did those of Jim Dine and others working with commonplace images. Of a totally different character were the complex and searching intaglio prints of Mauricio Lasansky and his circle at the University of Iowa. Artists working in purely formal modes also produced prints, making the whole range of modern expression available in this medium and significantly increasing the availability of works to a wide public.

Commercial Cool

The commercial multiplication of visual images was bound to have its effect eventually on the artists sensitive

George Segal, *Woman Shaving Her Leg*, 1963. Collection of Mrs. Robert B. Mayer.

Richard Diebenkorn, *Girl with Plant*, 1960. The Phillips Collection, Washington, D.C.

to their environment. In newspapers, magazines, and films and on television and billboards, repeated mechanically reproduced likenesses had become so omnipresent that they began to take on a reality of their own, usurping, or at least merging with, the existence of the original person or deed. On the street, in the markets, and in the home, the uniform, slickly produced objects and images were an inescapable part of the mind's visual repertory. The United States was not the only country to provide such an environment; in fact, the English artists and critics in the late 1950s were the first to speak of the phenomenon as having a character of its own—but it was thought of as basically American.

Fascinated by the cool, impersonal reproduction of scenes and characters that were in themselves emotive, Andy Warhol began to silk screen photographically enlarged reproductions onto his canvas. The method allowed him to repeat the image as many times as he wished, the repetitions emphasizing the discrepancy between the dispassionate procedure and the original emotive nature of the image. Like a word repeated so often that it loses its meaning, fifty identical smiling likenesses of Marilyn Monroe (1962) beaming through the coarse screen of newspaper reproduction become a rhythmical mockery; a newspaper reproduction of an electric chair repeated uniformly in lavender over a large canvas loses its horror the way a repeated news report on television separates itself from the event to become a detached fact in itself. One hundred reproductions of reproductions of Campbell's soup cans (not precisely an emotive image) are far removed from the taste of soup. Unlike Rauschenberg or Johns, Warhol did not bring media fragments into the sphere of art through painterly modification but used the mechanical methods of the mass media themselves. Thus his works remained in the disembodied realm of mass communications, acquiring a detachment as complete as any ideal art.

Roy Lichtenstein (b. 1923) enlarged coarse-screen reproductions to the point at which their component dots became as important as the total image, usually a frame from a serial comic strip. His paintings from the early 1960s have a formal elegance that contrasts bizarrely with their source, and the elegance seems purely a mat-

Stanley William Hayter, *Falling Figure*, 1947. National Collection of Fine Arts, Smithsonian Institution, Washington, D.C.; museum purchase.

Andy Warhol, *The Six Marilyns (Marilyn Six-Pack)*, 1961–62. Carter Burden Collection, New York, New York.

ter of discovery because the comic strip image gives no evidence of being tampered with. This discovery of formal interest where least expected was not new to Lichtenstein or to James Rosenquist (b. 1933), who drew upon the superlife of billboard illustration; but unlike the so-called realists of the nineteenth century their raw material was not nature, the usual font of discovery, but the banal stuff and mechanistic technique of the commercial world.

Although he also dealt with prefabricated images, Tom Wesselmann (b. 1931) played more deliberately on associative qualities. His florid nudes remain sensual, lounging in his paintings of mass-produced department store environments that might be complete with practical hardware and operating television sets. There is comic irony in the contrast between the sanitized surroundings and the erotic lumpiness of flesh.

These artists were not satirizing mass communication and the standardization of manufactured products but creating out of the very monotony of the system works of art that beguiled the eye and piqued the mind. In a way, theirs was as pointedly inexpressive an art as that of the artists of pure form; expressiveness somehow seemed out of place in an expressionless environment and was not to be trusted. Rather than rebel against the impersonality of a society dominated by motivation surveys, opinion polls, and packaged goodness, they used the mechanized uniformity as a means for personal creativeness.

In spite of the wide range of character extending from Rauschenberg to Lichtenstein, much of art using the products of the commercial environment was lumped by the critics under the heading "pop art," a term first used in England in the late 1950s. Such a tag was doubtless useful to critics and the public in a period so avid for terminology. In fact, the urge to package art with brand names—"pop," "op," "minimal," and so on—was a part of the social climate that furnished the artists of commercial "cool" their substance.

Reality and the Photograph

So basic to modern vision is the photograph that it has often been accepted as the criterion in judging reality. Artists of the 1960s, however, having grown up in an

Roy Lichtenstein, *Forget It! Forget Me!*, 1962. Rose Art Museum, Brandeis University, Waltham, Massachusetts; Gevirtz-Mnuchin Purchase Fund.

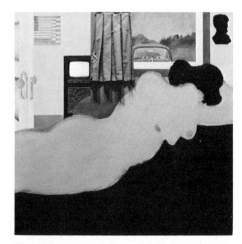

Tom Wesselmann, *Great American Nude #43*, 1962. Collection of Mrs. Robert B. Mayer.

environment dominated by the photographic image, were aware that the photographic likeness was not a substitute for the thing but was, in fact, an isolated image that gained an abstract detachment by unceremoniously severing an object from its context. A photograph could be about the world yet not be of it.

Since the middle of the nineteenth century, artists had used photographs as aids for the eye or as useful, economical models for study, but now some recognized them as means for a neutral vision, giving the artist a distance from the object that allowed him to consider it freely in terms of his aesthetic preoccupations.

Late in the 1960s several young artists began to paint dazzlingly precise works that depicted common subjects but that, for all their specificity, gave little sense of immediate contact with the things depicted. Richard Estes (b. 1936) painted the intricacies of reflections in shop windows and the neat clutter of unpopulated streets; Californians Ralph Goings (b. 1928) and Robert Bechtle (b. 1932) celebrated the smooth forms of the American automobile as encountered at the curb in a middle-class neighborhood or lodged in a parking lot. People, when they appeared, were as if seen in a snapshot or a glossy commercial photograph. Some painters suggested a slightly out-of-focus photographic source to emphasize the distance between the depicted objects and the painter's vision.

There is a marked difference between this kind of painting and another equally precise and remote in its way—for instance, the explicit paintings of nudes by Philip Pearlstein (b. 1924) or the floral and architectural paintings by Lowell Nesbitt (b. 1933), which did not necessarily use the intercession of the photograph. Many painters in the 1960s emphasized a harsh candor of vision that viewed human subjects as if they were still lifes, painting portraits or nudes with unclassical specificity. But, although the photograph may have influenced the vision, these works are quite unlike those that proclaimed the photograph itself as source.

Possibly it is to this kind of work that some sculpture of the time relates; the tiny, meticulously rendered sporting females encased in hermetically sealed worlds by Bob Graham (b. 1938), and the full-size carefully costumed characters by Duane Hanson (b. 1925). These

Richard Estes, *The Candy Store,* 1969. Collection of Whitney Museum of American Art, New York, New York; gift of the Friends of the Whitney Museum of American Art.

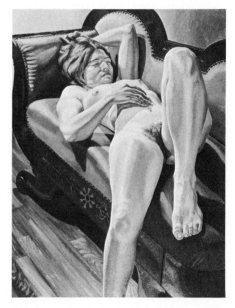

Philip Pearlstein, *Reclining Nude on Green Couch,* 1971. In the collection of the Corcoran Gallery of Art, Washington, D.C.; gift of the Friends of the Corcoran Gallery of Art.

last, going about their business in the very space of the viewer, dramatically pose the rivalry between likeness and reality. Somehow Hanson's characters proclaim that they are who they are without doubt or question, leaving the uncertainty and doubt about values and meaning to the less self-assured spectator.

Out of the preoccupation with the photographic image itself there often came a polished beauty of design that appropriated to itself the interest that might otherwise be spent on the subject matter. Robert Cottingham (b. 1935) transformed seemingly chance photographs of commercial signs into immaculate patterns without appearing to intrude in the rendering of the literal image. Even when photographs were not directly involved, an effect of breathless perfection quite remote from the nature of the subject was sought after, as in the series of formally perfect filling stations painted by Ed Ruscha (b. 1937).

Photo-realist, the general tendency was called, but what the photograph taught was quite the opposite of reality in the common, materialist understanding of the word. It provided the basis for a refined aesthetic consciousness that fed on abstract qualities, yet maintained a nominal link with the world at large.

Space

The traditional conception of sculpture was based on the organization of mass, a quality emphasized by the advocates of direct carving in the 1920s and 1930s. Linked with this was the notion that sculpture had to be creatural. Probably the most revolutionary step taken by sculptors in modern times was their avowal at about the time of World War I that sculpture was first of all structure in space—that the consciousness of space was at least as important as the form of the material substance.

In Paris in 1926, Alexander Calder (1898–1976) began making his little circus figures of bent wire, active drawings in space. By 1932 he had begun the two kinds of sculpture identified with him: one, freestanding constructions of metal sheets he called "stabiles"; the other, carefully balanced planar forms and wire that floated in space in response to air currents, which he called

Duane Hanson, *Hard Hat, Construction Worker,* 1970. Collection of Frances and Sydney Lewis.

Robert Cottingham, *Dr. Gibson,* 1974. National Collection of Fine Arts, Smithsonian Institution, Washington, D.C.; museum purchase with the aid of funds from Mr. and Mrs. Jacob Kainen and the National Endowment for the Arts.

"mobiles." The stabiles were different from the constructions of many of his contemporaries, since the shapes were free in form, often organic in suggestion. They, as well as the mobiles and Calder's drawings and prints, suggested a vitality and playfulness not common in nonfigurative art. His mobiles gained tremendous popularity in the late 1930s and 1940s and were much imitated both by professional artists and by amateurs. Probably no one was a greater influence in changing traditional notions of sculpture.

Sculpture thought of in terms of either actual or implied motion in space, thus negating the effect of mass, caught the interest of many. José de Rivera (b. 1904) began about 1940 to make highly polished forms that seemed to spiral in space, and he later contrived to have his shiny linear shapes revolve by motor. George Rickey (b. 1907) began in 1945 to use taut wire and rustling sheets of metal in constructions whose shimmering movements defied a sense of mass. In the 1960s he used tall, simple blades that moved languidly at their own stately pace.

The wire sculptures of Richard Lippold (b. 1915) were made not to move but to create tensions that seem to imply invisible actions in space. That a nonfigurative sculpture could be called *New Moonlight* (1947) indicates the extent to which sculptural perception had changed. Sculpture could now be more a manifestation of light and space than of solid mass, quite incapable of being rolled down a hill, as Michelangelo is supposed to have recommended as a proof of sculptural form.

By the time a younger generation of sculptors began to exhibit in the late 1950s, they were hampered by restrictions of neither form nor material. As in the "combines" of Rauschenberg, any material was suitable—with the possible exceptions of traditional bronze and white marble. Richard Stankiewitz (b. 1922) and Mark di Suvero (b. 1933) could choose their materials from scrap heaps and lumberyards. John Chamberlain (b. 1927) concentrated after 1959 on monumental pieces of classic sobriety made from crushed automobile bodies. Welding became a basic sculptural technique, and by the early 1960s it was taught in most art schools.

Sculptors, like painters, became obsessed with size,

Alexander Calder, *Sumac,* 1961. Collection of Mr. and Mrs. David Lloyd Kreeger.

José de Rivera, *Infinity,* 1967. National Museum of History and Technology, Smithsonian Institution, Washington, D.C.

Richard Lippold, *New Moonlight #2,* 1949–50. Collection of Louise Lippold.

223

and in the early 1960s they moved outdoors to create what were often gigantic structures. Di Suvero's first large outdoor pieces, composed of massive wooden beams, chains, and metal bars, were begun about 1964, and by the end of the decade outdoor sculpture exhibitions of monumental proportion were common, in which the open design of the sculptures challenged an entire landscape. Some of the sculptures were simple geometric forms of dark metal, as in the work of Tony Smith; some depended on polished surfaces; and some, like those of di Suvero, were compiled of gaunt structural steel. All, however, were largely concerned with the activation or modulation of space—the space that contained the viewer as well as the sculpture.

Space, however, is determined psychologically as well as perceptually, and by the mid-1960s many young sculptors were concerned with both as they created environments. By environment they meant something different from those created by Oldenburg, Kienholz, and Red Grooms (b. 1937) a few years before, although some, like Lucas Samaras (b. 1936), had earlier engaged in "happenings" with that group. In fact, Samaras's environments, such as his *Mirror Room* of 1966, are filled with associative as well as purely visual surprises, unlike the modular constructions of Sol Lewitt (b. 1928), which always suggested a precise conceptual system. Although the carefully placed fluorescent tubes of Dan Flavin (b. 1933) or Keith Sonnier (b. 1941) did not make the same intellectual demands as Lewitt's modular spaces, they created luminous spaces that were formally sensitive and psychologically moving.

Once one looked upon a space as artistically sensitized, anything encountered within it took on significance. In the late 1960s, Barry Le Va (b. 1941) created exhibitions by scattering material on the gallery floor in accordance with a stated principle; Walter De Maria (b. 1935) covered a gallery floor with an even layer of dirt; and Carl Andre (b. 1935) arranged rectangular forms of concrete or metal on the floor in regular patterns. The space of the room itself was part of the work and influenced its direction, and by 1970 museums were inviting artists to create works for exhibition directly in the galleries. For these artists space, as perceived by the eye and conceived of by the mind, had won out over matter.

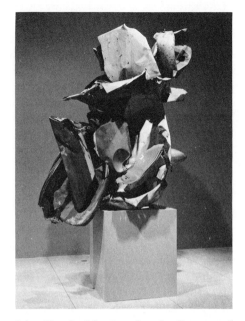

John Chamberlain, *Fantail,* 1961. Courtesy of the National Collection of Fine Arts, Smithsonian Institution, Washington, D.C.; lent by Jasper Johns.

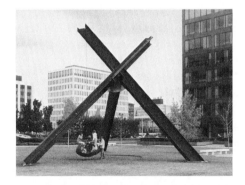

Mark di Suvero, *Motu,* 1977. U.S. courthouse and federal office building, Grand Rapids, Michigan. Photograph courtesy of the General Services Administration, Art-in-Architecture Program.

As a natural consequence of a concept of art that placed the idea above the sensuous form, various tendencies developed during the 1960s in which the creation of an object was of little or no concern. At recurring moments in the past, acrimonious debates waged over the relative importance of the intellectual and the sensuous aspects of art, and often the decision was that the intellectual assumes importance to the degree that the sensuous is minimized. Solutions, however, had never before been quite so radical as to eliminate the work of art itself. The "happenings" of the late 1950s and early 1960s were an immediate forerunner of art without a formal product, and certainly some of the activity of Dada was remembered as a precedent. Yet much of what took place in the mid-1960s was not capricious or improvised, as were many Dada accomplishments, but was compounded in accordance with a careful rationale.

The term "conceptual" ran through many different kinds of activity, from the logical environment constructions of Sol Lewitt to the "non-site" presentations of documentary information by Robert Smithson (1938–73). In all, emphasis was on the process of planning itself, not on the product that resulted.

Robert Smithson and some of his colleagues were fascinated with the earth in its matter and in its extension. In the late 1960s Smithson explored various areas of the country with the kind of attention expected of a geologist or a cartologist. In 1968 he began to create what he called "non-sites," gallery presentations of aerial charts, photographs, and boxed samples of the terrain of specific locations as a kind of intellectual penetration into the very surface of the earth. About the same time he set about executing immense projects in the landscape itself, one of the most successful of which was his *Spiral Jetty* of 1970, constructed at Great Salt Lake in Utah, a fifteen-hundred-foot spiral fill reaching into the lake.

Many of such "earthworks" were carried out in inaccessible places and were not made to last, their public record being photographs and the charts and plans that preceded their construction. They lived in memory and were perpetuated in legend. Their existence was pre-

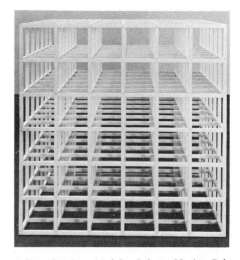

Sol Lewitt, *Open Modular Cube,* 1966. Art Gallery of Ontario, Toronto.

Barry Le Va, *Centerpoints and Lengths (through points of tangency): Three Layers Separately Overlaid.*
 *each layer consists of 4 circular areas tangent (externally) to each other.
 *1 out of the 4, tangent to only one of the adjacent walls.
 *1 out of the other 3 being comprised of 5 circular areas tangent to (internally) and inscribed within each other.
1974–75. Photograph courtesy of the Contemporary Arts Center, Cincinnati, Ohio.

dicated on the premise that art persists in the mind, not solely in created objects.

Even less tangible than earthworks, with their photographic and other documentation, were performances in the gallery by the artist, sometimes with associates, which were then simply recorded as having taken place, the exhibition for most of the public being the notification that such action had taken place at the spot they were confronting. The art existed in the imagination, communicated by the least tangible means.

Robert Smithson, *Spiral Jetty,* 1970. Photograph © 1978 Gianfranco Gorgoni / CONTACT.

The term "software," borrowed from computer programming, was used to distinguish the intellectual programming of a presentation from the mechanics. Interest in computers and other highly technical investigative and communication equipment did not stop with a borrowed word, however. In the early 1970s artists experimented with all manner of machines designed for industrial purposes, the emphasis being not on the function of the machine but on its serving as an extension of or complement to the artist's volition in creating a program. In 1970 the Jewish Museum in New York mounted an elaborate exhibition dedicated to "software," with a dazzling assortment of programmable machines, and in the same year the Museum of Modern Art presented Information, an exhibition devoted to various complex means for the transmitting of ideas through words and symbols. The art in these exhibitions lay somewhere within the process, unseeable, yet shaped by human intellect.

The conceptual range of art in the United States by the 1970s was so great—from art of unadorned conceptions to minutely painted visionary landscapes—that old distinctions and terminology no longer applied. Words such as "abstract" or "figurative" became meaningless as art took in all reaches of the mind and senses. With bases from scientific experiments in perception to drug-induced imagery, art represented too wide an exploration of human activity to be encompassed in a single set of terms or aligned in a particular direction. Significantly, by the late 1960s it was becoming suspect to discuss an "avant garde"; the advance proceeded simultaneously in so many directions that one would have to conclude that the only common quality among artists was diversity.

After World War II, those returning from service with the armed forces were granted money by the government to continue or catch up on their education under the "GI Bill," and accredited art schools were among the institutions that veterans could attend. A surprising number who had not seriously considered it before opted for training in art, and art schools across the country expanded with crowds of serious students, many of whom were well traveled and mature in determining their goals. Partially because of pressure from the strongly motivated students, partially as a continuation of a trend begun before the war, art schools transformed themselves into turbulent centers of experiment and change rather than comfortable havens for the preservation of past values. Instead of beginning with drawings from classical casts, students likely as not were introduced through "basic courses" in two- and three-dimensional design, courses reminiscent of those initiated at the Bauhaus in the 1920s. Although work from the posed human model continued, by the late 1950s there were likely to be welding equipment for sculptors as well as facilities for direct casting in metal. One of the most popular areas was ceramics, and pottery studios began to occupy a major place in the art school plant, providing the basis for the enormous craft interest of the 1960s and creating new possibilities for sculpture. In some instances, especially in some of the California ceramics of the 1970s, the division between craft and fine arts became wholly arbitrary.

The generation of artists born in the early 1930s encountered art schools at this exciting moment of expansion. The attitudes they developed toward art had little in common with those shared by artists in the schools some ten or fifteen years earlier. Many concepts that earlier artists had to discover for themselves were now built into the curriculum, as schools competed to keep up with the new. When the new ceased to be obvious in the early 1970s, many institutions had to face the question of just what purpose an art school served. No single answer was immediately forthcoming.

The change in art museums was no less dramatic than the change in the schools. Not only were a great many more museums founded, but long-established museums

were enlarged by the addition of wings and extensive remodeling. Much of this structural change was dictated by new public demands for museums services. Many more temporary exhibitions were scheduled, a fair portion of them devoted to contemporary art, and the old palacelike structures, made to glorify the permanent collection, were not especially adaptable to the new concerns for exhibition display. So new spaces had to be added. With the increase of museum activity, staffs were expanded, and little by little public education departments, which had often been considered minor and not always welcome adjuncts, began to take on importance until in the early 1970s they were regarded as essential parts of the museum operation. In addition, the public began to look toward the local museum as a source for renting works of art and buying art-related books and objects. Merchandising became a new museum function. So with some misgivings, boards and architects had to accept the fact that the palace structure was no longer an adequate model for the modern museum.

Not only art schools but university programs in the history of art attracted many more students after the war, and the increasing numbers of professionally trained art historians produced by university graduate departments quite changed the nature of research in the field. Greater specialization was the rule, and the influence of many eminent German art historians who had settled in the United States during the later 1930s was much in evidence. A government-sponsored competitive scholarship program, inaugurated in the late 1940s, made it possible for both artists and art historians to study and work in various European countries and Japan with "Fulbright grants." Experience abroad became customary for a far larger group of young people than ever before.

In 1966 the government created a National Council for the Arts and the Humanities, under which two endowments were organized to support the arts and to support and diffuse humanistic study, considered in the broadest sense. The Endowment for the Arts made grants to instittutions and individuals in the performing arts and to individual artists. It also made grants to museums for the purchase of works by living Americans.

In 1971 it began a program to support many aspects of museum activity, recognizing the expanded public function of museums. Initially the largest sums went to help defray the cost of temporary exhibitions, which had become the center of museum interest, but money also went for conservation, a much expanded field, and for the cataloging and use of collections. To assist museums of all kinds that were struggling to maintain themselves and increase their facilities, the government established a new office in 1977 under the Secretary of Health, Education, and Welfare, authorized under the Museum Service Act. All this new patronage, even though limited, meant that activity in art was beginning to build upon a much broader base, releasing artists and institutions from the possible control that comes from dependence on a single, local source of support. Not only did art serve a wider public, it depended on the confidence of a larger segment of society.

Although by no means all of the public was willing to accept each new development in contemporary art, its existence was now a matter of general knowledge. News magazines and local newspapers felt obliged to report on activities in art, and by the 1960s newspapers that had earlier looked upon contemporary art as a source of journalistic sport were publishing reports and criticism that attempted to keep abreast of the most unexpected activity of artists.

New collections built after World War II were largely devoted to modern art, very often American, and the influence of the new collectors, many of whom sat on museum boards, was reflected both in museum exhibitions and in the building of permanent collections. Hardly an art museum in the country was without representative works by major contemporary American artists. In fact, art museums across the nation took on a certain sameness, subscribing to a kind of standard repertory of contemporary achievements, much as they had subscribed to the accepted list of old masters.

In the 175 years since a group of society leaders in New York moved to organize an art academy, art in the United States had slowly become rooted as a fundamental ingredient of American culture. It had become a part of the intellectual, economic, and even political life of the country and, to the utter astonishment of many, had

eventually transformed the United States into a pro-
ducer, not simply a consumer, of artistic products and
ideas. As the nation spread out, so did art, and although
New York remained the principal market—a position it
had held since the 1840s—by the 1970s artistic creativity
and knowledgeable appreciation were not dependent on
any one center. America had acquired confidence in
art, and, without necessarily acquiescing in its political
activity or its economic system, the artist had gained
confidence in America.

Chronology

EVENTS IN ART	OTHER EVENTS
	1682 William Penn founds Philadelphia.
	1693 College of William and Mary, Williamsburg, Virginia.
	1701 Yale College founded.
1711 Gustavus Hesselius arrives in New Sweden.	
Before 1717 Justus Englehardt Kühn painting from Maryland to South Carolina.	
1718 Pieter Vanderlyn arrives from Holland and paints in Albany area. Many painters executing portraits and religious paintings among the Dutch settlers on the Hudson.	
1728 John Smibert comes to America; settles in Boston in 1729.	
1720s and 1730s Monumental architecture in New England and the South; Independence Hall, Philadelphia, begun in 1732.	
	1731 Library Company of Philadelphia founded.
1730s and 1740s Portraits by Robert Feke, Boston to Philadelphia.	
From ca. 1740 Jeremiah Theüs from Switzerland painting in South Carolina.	
	1746 College of New Jersey, Princeton, founded.
From ca. 1747 William Williams from England painting in Philadelphia.	
1749 John Wollaston arrives from England to work in New York, Philadelphia, Maryland, and Virginia.	
	1754 King's College founded in New York City; becomes Columbia College in 1784
1755 Joseph Blackburn from England painting in Boston.	1755 The College and Academy of Philadelphia founded; medical school established in 1765.
1759 Benjamin West leaves for Europe.	

EVENTS IN ART		OTHER EVENTS	
1760s	John Singleton Copley has following in Boston.		
1763	Benjamin West settles in England.		
1766	Copley sends *Boy with a Squirrel* for exhibition in London.		
1768	Royal Academy established, London.		
1769	Charles Willson Peale returns to Maryland after two years in England.		
1770	Benjamin West's *Death of Wolfe* exhibited in London.	1770	The Boston Massacre.
1772	West named historical painter to George III. Patience Wright, sculptor in wax, arrives in London. Charles Willson Peale paints George Washington at Mount Vernon, the first of many likenesses.		
		1773	The Boston Tea Party.
1774	Copley goes to England by way of Italy; settles in London in 1777.		
		1775	The battles of Lexington and Concord, 19 April; Bunker Hill, 17 June.
1776	Jean-Jacques Caffieri commissioned by the Continental Congress to sculpture a monument to General Montgomery, to be executed in France. Medal celebrating George Washington at the siege of Boston commissioned from Piere Simon Duvivier in Paris. John Trumbull goes to England to study with West.	1776	Declaration of Independence, 2 July.
		1781	Surrender of General Cornwallis at Yorktown.
1782	C. W. Peale's gallery of famous men opens in Philadelphia.	1782	First seal of the United States adopted.
1783	Academia de San Carlos established in Mexico City, the first academy of art in the Americas.	1783	Peace treaty with England, signed in Paris, 3 September. Noah Webster's *Grammatical Institute of the English Language* published, re-

EVENTS IN ART		OTHER EVENTS	
			published in 1788 as *The American Spelling Book.* His *Compendious Dictionary of the English Language* comes out in 1806.
		1784	Direct trade with China begins with sailing of the *Empress of China* from New York in February.
1785	Jean Antoine Houdon comes to America to model a likeness of George Washington.		
1786	C. W. Peale opens his museum in Philadelphia. Trumbull makes sketch in London for the *Death of Warren at Bunker Hill,* first of his historical series.	1786	The *Columbian Magazine,* Philadelphia, begins publication; it includes engravings.
		1787	Constitutional Convention, Philadelphia.
		1788	First settlement in Northwest Territory at Marietta, Ohio.
		1789	30 April inauguration of George Washington in New York as first president. Beginning of revolution in France.
		1790	Power-driven cotton spinning introduced by Samuel Slater; by 1830 it becomes vast mechanized industry. United States copyright law; revised 1909.
1791	Giuseppe Ceracchi, Italian sculptor, in America.	1791	Bank of the U.S. opened in Philadelphia. L'Enfant draws up plan of Washington.
1793	Gilbert Stuart returns from Europe, paints Washington in 1795.	1793	First national coinage issued, Philadelphia Mint. Eli Whitney develops his cotton gin.
1794	C. W. Peale organizes the Columbianum in Philadelphia with an exhibition in 1795. William Birch comes to Philadelphia from London.	1794	Thomas Paine publishes *The Age of Reason.*

EVENTS IN ART	OTHER EVENTS

EVENTS IN ART

1796 Architect Benjamin Henry Latrobe arrives from England.
John Vanderlyn goes to Paris to study.

1801 Washington Allston leaves for London; 1803 in Paris, 1804 to Italy.

1802 New York Academy of the Fine Arts formed; chartered in 1808 as the American Academy of the Arts.

1803 John James Audubon in Pennsylvania. Over next few years begins his studies of fauna.
Classical casts on display in New York.

1805 Pennsylvania Academy of the Fine Arts founded; chartered in 1806.

1806 Italian sculptors brought to work on the Capitol.
Adolph-Ulrich Wertmüller exhibits his nude *Danaë* in Philadelphia.

1808 William Rush carves *Comedy* and *Tragedy* for the Chestnut Street Theatre in Philadelphia.

1808–13 *American Ornithology,* with plates by Alexander Wilson, published in Philadelphia.

1809 Thomas Sully goes to London to study.

OTHER EVENTS

1797 John Adams becomes president.
1799 Death of George Washington.
1800 Capital is moved to Washington.
1801 Thomas Jefferson becomes president.
The *Port Folio,* Philadelphia, begins publication; includes engravings.
1802 U.S. Military Academy established at West Point.
1803 Louisiana Purchase from France.

1804 Lewis and Clark expedition; reaches Pacific on 7 November 1805.
Napoleon becomes emperor of France; abdicates 1814.
1805 Zebulon M. Pike expedition to Rockies.

1807 *Clermont* steamboat built by Robert Fulton.
1808 *Missouri Gazette* established, first newspaper printed west of the Mississippi.

1809 James Madison becomes president.
Washington Irving writes *A History of New York by Diedrich Knickerbocker.*

EVENTS IN ART

OTHER EVENTS

1810	Society of Artists of the United States organized in Philadelphia.			
1811	Samuel Finley Breese Morse goes to London.			
		1812	War with Great Britain.	
		1814	Washington, D.C., burned by the British, 24 August. Steam frigate *Robert Fulton* launched in New York.	
		1815	Peace accord signed at Ghent, Holland, December 1814, ratified February 1815. First issue of *North American Review*, Boston.	
1817	John Trumbull given first of commissions for the Capitol rotunda.	1817	James Monroe becomes president. William Cullen Bryant writes "Thanatopsis," published in the *North American Review*.	
1819	Lithograph by Bass Otis printed in the *Analetic Magazine*, Philadelphia, marking the beginning of lithography in the United States.	1819	Washington Irving writes *The Sketch Book of Geoffrey Crayon, Gent.* Florida acquired by the U.S. from Spain.	
1820	Engravings after John Lewis Krimmel's genre paintings in the *Analetic Magazine*, Philadelphia. Rembrandt Peale's *Court of Death* shown.			
1820–21	*Picturesque Views of American Scenery* published in Philadelphia, with drawings by Joshua Shaw engraved by John Hill.			
1821	Charles Bird King begins portraits of Indians who come to Washington.	1821	James Fenimore Cooper writes *The Spy*. David (Davy) Crockett elected to the Tennessee legislature; elected to Congress in 1827.	
1825	Group organized in New York which becomes the National Academy of Design in 1826.	1825	John Quincy Adams becomes president. Erie Canal opened; begun in 1817, it	

EVENTS IN ART	OTHER EVENTS
Horatio Greenough makes first trip to Italy, settles in Florence in 1829. Thomas Cole takes sketching trip up the Hudson; other painters later follow suit.	links the Great Lakes with the Atlantic.
1826 Athenaeum Gallery built in Boston; first exhibition 1827.	1826 Robert Owen founds community at New Harmony, Indiana, formerly a Rappite commune.
1827 *Hudson River Portfolio* published in New York, with drawings by W. G. Wall engraved by Hill. First of J. J. Audubon volumes published in London.	
	1828 Noah Webster's *American Dictionary of the English Language* published in New York.
	1829 Andrew Jackson becomes president.
1830 George Catlin begins his systematic depiction of Indians. William Sidney Mount paints *A Rustic Dance after a Sleigh Ride*.	1830 Godey's *Lady's Book* begins publication in Philadelphia.
	1831 Cyrus McCormick demonstrates his McCormick reaper.
1832 Horatio Greenough commissioned by Congress to make a statue of Washington for the Capitol, the first such commission given to an American sculptor.	
1835 Thomas Crawford settles in Rome. Nathaniel Currier sets up lithographic shop; in 1857 it becomes Currier and Ives.	
	1836 Texas declares independence from Mexico. Battle of the Alamo.
1837 Alfred Jacob Miller paints in the West with the Scotsman Captain Stewart. Hiram Powers takes up residence in Florence.	1837 Martin Van Buren becomes president. Samuel F. B. Morse files his telegraph experiments at Patent Office. Financial panic.

237

EVENTS IN ART	OTHER EVENTS
	John Deere develops his plow for prairie lands.
	Ralph Waldo Emerson writes his essay "Nature."
	1838 Regular steam travel across the Atlantic begins with arrival of British *Sirius* and *Great Western*; crossing time a little more than sixteen days.
1839 George Catlin shows his Indian gallery in England, later in France.	**1839** Daguerreotype announced in France; develops quickly in U.S.
The Apollo Association is formed in New York; becomes the American Art-Union in 1844.	
1841 Emanuel Leutze settles in Düsseldorf.	**1841** President William Henry Harrison dies after one month in office and John Tyler becomes president.
	Transcendental commune established at Brooke Farm.
	1844 Telegraph line from Washington to Baltimore opened 24 May.
1845 George Caleb Bingham begins his Missouri paintings.	**1845** James Knox Polk becomes president.
	Broadway Journal established in New York, E. A. Poe and C. Briggs, editors.
	1846 War with Mexico; 1847 treaty gives California and what was known as New Mexico to the United States.
	The Republic of Texas had become a state in 1845.
	Smithsonian Institution established.
	Edgar Allen Poe publishes essay on "The Raven."
1847 William Wetmore Story goes to Rome; settles there in 1851.	**1847** Mormons settle at Great Salt Lake, Utah.
	Henri Murger's *Scènes de la vie de Bohème* begins in serial form.
	1848 Gold discovered in California.
	1849 Zachary Taylor becomes president.
	1850 Taylor dies and is succeeded by Millard Filmore, vice-president.

EVENTS IN ART	OTHER EVENTS
1851 Leutze's *Washington Crossing the Delaware,* painted in Düsseldorf, shown in New York.	1851 Telegraph lines are extended across the Mississippi. Crystal Palace Exposition, London.
1852 Harriet Hosmer settles in Rome. American Art-Union dissolved by court order.	1852 Harriet Beecher Stowe writes *Uncle Tom's Cabin; or, Life among the Lowly.* Napoleon III declared emperor of France.
1853 Clark Mills's equestrian bronze of Andrew Jackson erected; cast in the United States. Frederick Church goes to Equador to paint; again in South America in 1857. Bryan Gallery of Christian Art on exhibition in New York.	1853 Franklin Pierce becomes president. Commodore Perry sails to Japan; treaty of 1854 opens Japan to world trade. The Exhibition of the Industry of All Nations opens in New York (the New York Crystal Palace).
	1854 Kansas-Nebraska Act. Henry Thoreau publishes *Walden.*
1855 The *Crayon* begins publication in New York. William Morris Hunt returns to Boston from France; encourages taste for Barbizon painters. J. A. M. Whistler leaves for Paris to study art.	1855 International Exposition, Paris; extensive art exhibitions. Walt Whitman publishes *Leaves of Grass.*
1856 Artistic center begins to shift from Rome to Paris.	1856 Illinois Central Railroad system extends from Chicago to Cairo, Illinois; lines reaching westward.
1857 English Pre-Raphaelite exhibition in New York.	1857 James Buchanan becomes president.
1858 Albert Bierstadt visits the Rocky Mountains with General Lander expedition.	
1859 Eastman Johnson paints *Old Kentucky Home; or, Life in the South.*	1859 Charles Darwin publishes *On the Origin of Species.* John Brown seizes arsenal at Harpers Ferry and is executed. Petroleum discovered in Pennsylvania. Colorado gold rush, "Pikes Peak or

EVENTS IN ART		OTHER EVENTS	
		Bust." Mass migration to the West during 1860s.	
	1860	Confederation of Southern States formed.	
1861	Wiliam Rimmer models *Falling Gladiator*.	1861	Abraham Lincoln becomes president. 12 April, Fort Sumner fired on; beginning of war between the Confederacy and the Union.
		1862	Emancipation Proclamation.
1863	Society for the Advancement of Truth in Art founded in New York; the *New Path* first published in May. John Rogers begins production of small sculptures. Salon des Refusés held in Paris.	1863	French take over Mexico with Maximilian as emperor; Mexico returned to the Juarez government in 1865; Maximilian executed.
1864	J. J. Jarves publishes *The Art Idea*. George Inness emphasizes expression in landscape. Elihu Vedder shows *The Lost Mind*.		
		1865	Lincoln begins second term; assassinated 14 April; Andrew Johnson becomes president. Civil War ends.
1866	Winslow Homer paints *Prisoners from the Front*. Thomas Eakins goes to Paris, works under Gérôme. Mary Cassatt in Paris.		
1867	Augustus Saint-Gaudens studies sculpture in Paris.	1867	United States acquires Alaska from Russia. Dominion of Canada formed. Indians deprived of land in western settlements carry on combat; Custer killed at Little Big Horn; Chief Joseph surrenders in 1877, Geronimo surrenders in 1886. International Exposition, Paris.
		1869	Ulysses S. Grant becomes president. Period of financial opportunism and political scandals.

EVENTS IN ART | OTHER EVENTS

Brooklyn Bridge designed; completed in 1883.
First transcontinental railroad line completed; three lines to Pacific by 1883.
Knights of Labor organized.

1870 Frank Duveneck settles in Munich.
Metropolitan Museum of Art and Boston Museum of Fine Arts founded.

1870 Clarence King begins publication of *Exploration of the Fortieth Parallel*.
Cattle driven from prairies to railroad terminals in North by cowboys.
Rome becomes capital of Italy.

1871 San Francisco Art Association organized.

1871 Chicago fire.

1872 Thomas Moran paints *Grand Canyon of the Yellowstone*.
Trinity Church, Boston, begun by H. H. Richardson.

1872 Yellowstone National Park established by Congress; other parks follow.

1873 Financial panic.
Typewriter introduced on market.

From 1874 Art schools established throughout the country.
Charles Eliot Norton begins lectures on history of art at Harvard.

1875 Art Students League formed in New York.
Eakins completes *The Gross Clinic*, Philadelphia.

1875 Mary Baker Eddy publishes *Science and Health*.

1876 Retrospective and contemporary art exhibitions at the Centennial Exposition, Philadelphia.
Philadelphia Museum of Art founded.

1876 Centennial Exposition, Philadelphia.
Alexander Graham Bell invents telephone.
Henry James publishes *Roderick Hudson*.

1877 Society of American Artists formed; first exhibition 1878.
John La Farge and assistants finish interior decoration of Trinity Church, Boston.

1877 Rutherford B. Hayes becomes president.
Massive railroad strike; organized labor takes on importance.

1878 Ernest Fenollosa goes to Japan.

1879 Whistler's lawsuit against Ruskin.
Mary Cassatt exhibits with "impressionist" painters in Paris.

1879 Thomas A. Edison invents the incandescent light bulb.

EVENTS IN ART	OTHER EVENTS
Archaeological Institute of America founded.	
	1881 James A. Garfield becomes president; assassinated four months after taking office; Vice-President Chester A. Arthur succeeds him. Boston Symphony founded.
	1882 Highest point of immigration to New York City (789,000); heavily southern European.
1885 William Harnett's *After the Hunt* shown.	1885 Grover Cleveland becomes president.
1886 Fenollosa collection of Japanese art given to Boston Museum of Fine Arts. Works by "impressionists of Paris" shown by Durand Ruel in New York. Statue of Liberty completed.	1886 Haymarket Square riot, Chicago. American Federation of Labor founded.
	1887 Eiffel Tower built in Paris.
	1888 G. Eastman introduces Kodak camera.
	1889 Benjamin Harrison becomes president.
1890 Alfred Stieglitz returns to New York; he becomes associated with Camera Club of New York and edits *Camera Notes*.	
1891 W. M. Chase opens outdoor summer school at Shinnecock, Long Island.	
	1892 Corbett wins heavyweight crown from John L. Sullivan.
1893 Columbian Exposition, Chicago. Joint planning among architects, painters, and sculptors.	1893 Grover Cleveland becomes president. Financial panic. Bicycling facilitated by invention of pneumatic tire.
1894 American Academy in Rome founded. Bernard Berenson publishes his first book on Italian Renaissance painters.	
1895 First international biennial exhibition of art held in Venice, Italy.	

EVENTS IN ART	OTHER EVENTS

National Society of Mural Painters founded.

1896 Supreme Court condones "separate but equal" facilities for blacks.

1897 Alfred Maurer in Paris.

1897 William McKinley becomes president (wins election over William Jennings Bryan).

1898 Ten American Painters (American impressionists) organize and exhibit.

1898 U.S.S. *Maine* blown up in Havana harbor 15 February; war declared on Spain in April; hostilities cease in July.
Puerto Rico ceded to U.S.; Philippines acquired.

1899 Arthur Dow publishes *Composition*. Charles Hawthorne establishes his school in Provincetown, Massachusetts.

1899 Andrew Carnegie libraries established.

1900 Automobile, or "horseless carriage," gains wide public attention.

1901 McKinley reelected president; assassinated 6 September (died 14 September); succeeded by Vice-President Theodore Roosevelt.

1902 Leo Stein settles in Paris; later joined by sister Gertrude. By 1906 they hold salon at 27 rue de Fleurus.
Photo Secession group formed by Stieglitz in New York; *Camera Work* begins publication in 1903.
Art colony established at Woodstock, New York.

1903 Panama Canal Treaty signed; canal opened to commercial traffic in 1914.

1905 "Les Fauves" show at Salon d'Automne, Paris.

1905 First nickelodeon opened in Pittsburgh.
Einstein first publishes theory of relativity.

1906 National Gallery of Art designated in Washington, D.C.

Society of American Artists joins National Academy.

Woodstock, New York, becomes summer school for Art Students League.

1907 *Little Galleries of the Photo Secession,* opened in 1905, begins to exhibit works other than photographs. Known as "291," continues until 1917.

1908 Exhibitions of "the Eight" at Macbeth Gallery.

Americans are associated with Henri Matisse's class in Paris.

New Society of American Artists in Paris organized.

1908 Model T Ford introduced; mass production begins in 1914.

D. W. Griffith directs his first film.

1909 American Federation of Arts organized; *Art and Progress* begins publication.

Futurist manifesto published in Paris, also distributed in English.

1909 William H. Taft becomes president.

Admiral Perry at the North Pole.

The Ballets Russes acclaimed in Paris.

1910 Young American Painters exhibition at 291.

1910 Mexican revolution against dictator Porfirio Díaz; continues into 1920s.

Sigmund Freud publishes *On Psychoanalysis; The Ego and the Id* published in 1923.

1912 Taos Society of Artists founded; artists there and in Santa Fe since turn of century.

Exhibition of Futurist painters, Paris; publicized in United States.

1912 C. G. Jung's *Theory of Psychoanalysis* published in English.

1913 "Armory Show" in New York; shown later in Chicago.

Marsden Hartley goes to Germany; there again in 1915.

Synchromism launched in Paris by Morgan Russell and Stanton Macdonald-Wright.

1913 Woodrow Wilson becomes president.

Graduated income tax established.

1914 Walter Arensberg maintains salon and collection in New York.

1914 Germany invades Belgium and France; World War I begins, in Europe.

| EVENTS IN ART | OTHER EVENTS |

EVENTS IN ART

1915 Panama-Pacific Exposition, San Francisco, shows Italian futurist paintings. Marcel Duchamp arrives in New York.

1916 *Forum* exhibition; New York. Society of Independent Artists formed; first exhibition 1917.

1918 Whitney Studio Club organized.

1920 The Société Anonyme organized in New York; holds exhibitions until 1939. The *Arts* begins publication.

1922 Mural movement begins in Mexico.
1923 Alexander Archipenko settles in United States. John Flanagan first shows carved sculptures in New York.

1926 Mrs. John D. Rockefeller, Jr., plans colonial Williamsburg; has been building folk art collection.

1927 Machine Age Exhibition, New York.

OTHER EVENTS

1915 May—*Lusitania* sunk by German U-Boat.

1916 Dada movement, Zurich, with Tristan Tzara.

1917 6 April, U.S. declares war on Germany. October Revolution in Russia.

1918 Nikolai Lenin becomes premier of Russia. 11 November, armistice declared, ending World War I.

1920 Eighteenth amendment outlaws alcoholic beverages; repealed in 1933. Women's suffrage, nineteenth amendment, passed. First commercial radio station begins operation, KDKA Pittsburgh.

1921 Warren G. Harding becomes president; dies in 1923; Calvin Coolidge succeeds him and serves until 1929.

1922 Benito Mussolini takes power in Italy.

1924 Surrealist exhibition in Paris under André Breton.

1926 Admiral Byrd flies over North Pole; flies over South Pole in 1928. National Broadcasting System creates first permanent radio network.

1927 Charles A. Lindbergh flies nonstop from New York to Paris. First scheduled passenger air service established, between New York and Boston.

EVENTS IN ART

OTHER EVENTS

<table>
<tr><td></td><td></td><td></td><td>Neon signs begin to be widely used in 1920s.

The Jazz Singer, with Al Jolson, popularizes moving-picture sound.

Joseph Stalin assumes power in Russia.</td></tr>
<tr><td>1928</td><td>Thomas Hart Benton and José Clemente Orozco paint murals in New School for Social Research, New York.

John Steuart Curry paints *Baptism in Kansas.*</td><td>1928</td><td>Rockefeller Center, New York, planned.</td></tr>
<tr><td>1929</td><td>Museum of Modern Art, New York, founded (MoMA).

John Reed Club founded in New York.

Carl Milles settles in Cranbrook.</td><td>1929</td><td>Herbert Hoover becomes president.
24 October, stock-market crash; beginning of Great Depression.</td></tr>
<tr><td>1930</td><td>Whitney Museum of American Art founded.

Grant Wood shows *American Gothic* in Chicago.

Exhibition of folk painting, Newark Museum; exhibition at MoMA, 1932.</td><td></td><td></td></tr>
<tr><td>1932</td><td>Alexander Calder shows mobile sculpture.</td><td></td><td></td></tr>
<tr><td>1933</td><td>The Century of Progress Exposition, Chicago.

Exhibition The Social Viewpoint in Art sponsored by John Reed Club.

Public Works of Art Project organized under Treasury Department; exhibition of works shown in Washington in spring 1934.

Hans Hofmann opens school in New York; in 1934 opens school in Provincetown.</td><td>1933</td><td>Franklin D. Roosevelt becomes president.

National Industrial Recovery Act, replaced in 1935 by National Labor Relations Act; New Deal instituted.

Adolf Hitler assumes power in Germany; English translation of *Mein Kampf* (written 1924).

Black Mountain College founded in North Carolina; summer art programs begun in 1944.</td></tr>
<tr><td>1934</td><td>December issue of *Time* first hails regional painting.

Treasury Department begins pro-</td><td></td><td></td></tr>
</table>

	gram of works for federal buildings; continues until 1943.
1935	Federal Art Project organized under the Works Progress Administration for artists on relief; phased out between 1939 and 1943.
	Abstract Painting in America exhibition at Whitney Museum, New York.
1936	American Abstract Artists organized. American Artists Congress organized.
	Cubism and Abstract Art and Fantastic Art, Dada, and Surrealism exhibited at MoMA.
1937	Chicago Bauhaus opened, headed by Moholy-Nagy.
	Solomon R. Guggenheim Museum founded; formerly S. R. Guggenheim Collection of Non-Objective Art.
1939	Museum of Modern Art opens new building in New York.
	Picasso retrospective, Museum of Modern Art, including *Guernica*.
	New York World's Fair.
	Golden Gate International Exposition, San Fransisco.
1940	Mondrian in New York; dies there in 1944.
1941	The National Gallery of Art, gift of Andrew Mellon, opens in Washington, D.C.
1942	Art of This Century gallery opened by Peggy Guggenheim in New York.
	Surrealist exhibition in New York, chiefly by resident European artists; *VVV*, edited by David Hare, published until 1944.

1936	Civil war in Spain; Francisco Franco assumes power in 1939.
1938	Congress of Industrial Organizations (CIO) formed.
1939	World War II begins; France occupied by Germany in 1940.
1940	Regular television broadcasting begins.
1941	7 December, Japanese attack Pearl Harbor.
	United States enters World War II.

EVENTS IN ART		OTHER EVENTS	
1943	Pollock exhibition at Art of This Century. Other artists associated with "abstract expressionism" begin to be recognized.	1943	Italy surrenders to Allies.
		1945	President Franklin D. Roosevelt dies; Harry S. Truman assumes presidency. Germany surrenders to Allies, 7 May. 6 August, atomic bomb dropped on Hiroshima. Japan surrenders, 2 September.
		1946	Fulbright Act permitting scholarships for study abroad.
		1947	Land introduces Polaroid camera.
		1948	Long-playing phonograph records introduced. Transistor invented.
		1949	Harry S. Truman elected president.
1950	New York painters shown at Venice Biennale.	1950	War in Korea; concluded in 1953. McCarran Internal Security Act; Sen. Joseph R. McCarthy begins sensational charges of communist activity.
1952	American Vanguard Art exhibition shown in Paris.		
		1953	Dwight D. Eisenhower becomes president.
		1954	Public television broadcasts in color. Supreme Court rules against segregation in schools.
1955	Rauschenberg exhibits Bed. First Documenta exhibition, Kassel, Germany.		
		1956	Russian invasion of Hungary.
1957	Ad Reinhardt writes "Twelve Rules for a New Academy."	1957	Russia launches first earth satellite, Sputnik.
1958	The New American Painting exhibition circulates through Europe.	1958	Stereophonic phonograph records marketed. Fidel Castro assumes power in Cuba.

1959	New Images of Man exhibition, MoMA, New York. Welding becomes widely used technique in sculpture.		
1960	Jasper Johns exhibits bronze Ballantine Ale cans. George Segal begins figures cast from life. The term "pop art," first used in England, becomes common.		
		1961	John F. Kennedy becomes president; assassinated in 1963; Lyndon B. Johnson assumes presidency.
1964	"Op art" becomes popular term. A. Warhol exhibits Brillo boxes. Mark di Suvero shows constructions. Painting based on photography becomes current.	1964	United States begins more active involvement in Vietnam War.
		1965	Lyndon B. Johnson elected president. National Foundation on the Arts and Humanities established by Congress.
		1968	Dr. Martin Luther King, Jr., assassinated.
		1969	Richard M. Nixon becomes president.
1970	*Spiral Jetty* constructed by Robert Smithson. Soft Ware exhibition at Jewish Museum, New York; Information exhibition at MoMA, New York; the term "conceptual art" widely used.		
		1973	Cease-fire in Vietnam.
		1974	Richard Nixon resigns; Gerald Ford becomes president.
		1977	James Carter becomes president.

Bibliographical Note

The bibliography of American art has grown enormously in the last decade, both in extent and in specificity. Monographic studies of most notable artists now exist, many of them museum publications. A critical bibliography of the visual arts in America is in process of publication by the Archives of American Art, Smithsonian Institution, and will be the best guide to publications in the field. For research in all aspects of American art, the Archives of American Art is an indispensable source. The National Collection of Fine Arts' *Inventory of American Paintings Executed before 1914* is useful in locating works by specific artists, including those who remain obscure.

For brief and accurate information on individual artists born before 1860 one should consult *The New York Historical Society's Dictionary of Artists in America, 1564–1860,* compiled by George C. Groce and David H. Wallace (New Haven, Conn., and London: Yale University Press, 1957), and for these and others, Mantle Fielding, *Dictionary of American Painters, Sculptors and Engravers,* Philadelphia, 1926. Paul Cummings's *A Dictionary of Contemporary American Artists,* 2d ed. (New York: St. Martin's Press, 1971) is a useful source for information on recent artists. For sculptors, Wayne Craven's *Sculpture in America* (New York: Thomas Y. Crowell, 1968) is useful, and for painting, see Barbara Novak, *American Painting of the Nineteenth Century: Realism, Idealism, and the American Experience,* (New York: Praeger, 1969).

In studying American art, certain publications are a necessary starting point. Some major sources, listed chronologically, are the following:

Dunlap, William. *A History of the Rise and Progress of the Arts of Design in the United States.* 2 vols. New York: George P. Scott, 1834. New ed., ed. Frank W. Bayley and Charles E. Goodspeed, 3 vols., Boston: C. E. Goodspeed, 1918. Reprinted in 3 vols., introduction by James Thomas Flexner, ed. Rita Weiss, New York: Dover Publications, 1969.

Lester, C. E., *The Artist, the Merchant and the Statesman of the Age of the Medici and of Our Own Time.* 2 vols. New York, 1845.

The Crayon. Ed. W. J. Stillman and John Durand. New York, 1855–61. Published weekly during the first year, then monthly.

The New Path. New York, 1863–65. Associated with the Society for the Advancement of Truth in Art.

Jarves, James Jackson. *The Art Idea.* New York, 1864.

Cummings, Thomas S. *Historic Annals of the National Academy of Design.* Philadelphia, 1865.

Tuckerman, Henry T. *Book of the Artists: American Artist Life.* New York: G. P. Putnam and Sons, 1867; New York: James F. Carr, 1867 (reprint).

Benjamin, Samuel Greene Wheeler. *Art in America: A Critical and Historical Sketch.* New York: Harper and Brothers, 1880.

Hartmann, Sadakichi. *A History of American Art.* 2 vols. New York, 1901; new revised edition, 2 vols., New York: Tudor Publishing Co., 1934.

Taft, Lorado. *The History of American Sculpture.* New York: Macmillan, 1903, 1924 (new ed. rev.); New York: Arno Press, 1969 (reprint).

Isham, Samuel. *The History of American Painting.* New York: Macmillan, 1905, 1927 (new ed. with supplementary chapters by Royal Cortissoz).

La Follette, Suzanne. *Art in America.* New York, 1929.

Richardson, Edgar P. *Painting in America.* New York: Thomas Y. Crowell, 1956.

Index